ROBERT SMITHSON: SCULPTURE

ROBERT SMITHSON: SCULPTURE

ROBERT HOBBS

WITH CONTRIBUTIONS BY

LAWRENCE ALLOWAY

JOHN COPLANS

LUCY R. LIPPARD

CORNELL

UNIVERSITY

PRESS

ITHACA AND LONDON

First published 1981 by Cornell University Press.
Published in the United Kingdom by
Cornell University Press Ltd.,
Ely House, 37 Dover Street, London WIX 4HQ.

International Standard Book Number 0-8014-1324-9
Library of Congress Catalog Card Number 80-69989
Printed in the United States of America
Librarians: Library of Congress cataloging information
appears on the last page of the book.

CONTENTS

6 CONTENTS

THE WORKS, by Robert Hobbs

COLOR PLATES follow page 128.

FOREWORD

In addition to its physical presence, every work of art presents to the viewer an embodiment of the ideas and feelings of its creator. In the case of Robert Smithson, those ideas and feelings are unusually varied and provocative, and they dominate his sculptural work to a degree almost unprecedented in American art. Beautiful though many of his creations seem to us, they were rarely, if ever, intended merely to gratify our senses. He was above all an explorer in the realm of ideas, and his inspiration came from the insights of a broad range of thinkers, from Blaise Pascal and Ludwig Wittgenstein to Frederick Law Olmsted and Marcel Duchamp. Nor was his interest limited to philosophy and art; he was equally fascinated with science fiction, information theory, and aspects of geography, psychology, and economics. Absorbing ideas constantly from his readings, Smithson weighed them in the light of his own observations and poured out, within a tragically brief time span, a marvelous succession of writings and sculptural works to demonstrate his discoveries, extending the very definition of sculpture in the process.

Because of the cerebral nature of Smithson's work, a simple showing of the sculpture in an exhibition would be far from adequate to convey its meaning and significance. When a retrospective exhibition was organized at the Herbert F. Johnson Museum of Art in the autumn of 1980, therefore, it was important to schedule concurrently a symposium and several lectures on the artist and his work. It was also important to document Smithson's work in a more permanent form. To that end, this book focuses on Smithson's sculpture with many illustrations and essays by distinguished contemporary critics, each investigating the artist and his sculpture from a different perspective. The initiator of this project was Robert Hobbs of Cornell University, who has been working for several years with Nancy Holt, the artist who was married to Robert Smithson, on the preparation of the first major museum exhibition of Smithson's work. Robert Hobbs has written extensively on contemporary American art, and he brings to this undertaking the same perceptiveness and analytical ability that have informed his writings on Abstract Expressionism and major contemporary art movements. The form and content of this book have from the beginning been under his competent guidance.

The other contributors to this volume, Lawrence Alloway, John Coplans, and Lucy R. Lippard, are also well-known writers about the art of our time. Lawrence Alloway, now at the State University of New York at Stony Brook, has long been recognized for his brilliant critical treatment of newly emerging artists and art movements, and he was an early champion of Robert Smithson. John Coplans, while serving as editor of *Artforum* and director of the art gallery at the University of California at Irvine, curator of the Pasadena Art Museum, and director of the Akron Art Institute, wrote frequently about new art trends, and he continues to do so today. Coplans knew Smithson well and respected him immensely as an artist. Lucy Lippard also knew and admired Smithson; she wrote about the increasing dematerialization of the art object at the same time that Smithson was considering the subject in his own writing and in his sculpture.

No one volume could do complete justice to the complex mind and art of Robert Smithson: the subject appears inexhaustible. For many years to come critics and scholars will be coping with the ideas of Robert Smithson. Sculpture, however, was always a central concern for Smithson, and this volume should clarify many of the critical issues raised in his sculptural work.

Thomas W. Leavitt
Director
Herbert F. Johnson
Museum of Art
Cornell University

ACKNOWLEDGMENTS

The following people (listed in alphabetical order) have been most generous with their time, expertise, and friendly support, and have helped enormously in making this book a reality: Gertrude Calvert, Jill Chambers-Hartz, Peter Chametzky, Douglas Christmas, Timothy Collins, Peggy Cyphers, Virginia Dwan, Glen Hartley, Thomas W. Leavitt, Lisa R. Legow, Robin Liebmann, William C. Lipke, Lisa Lyons, Lewis Manilow, Miles Manning, John Neff, Joyce Nereaux, Tony Shafrazi, Susanna E. Singer, Daniel Snodderly, Paul Toner, John Weber, Claudia Whiteley. I especially thank Carol Betsch of Cornell University Press for her fine editing and Nancy Holt for making available the Smithson material.

In addition I gratefully acknowledge the generous support of the National Endowment for the Arts, which awarded a substantial grant under its Museum Program, directed by Tom Freudenheim, for the preparation of the manuscript and for the organization of the exhibition "Robert Smithson: Sculpture" which has been or is to be shown at the following institutions: Herbert F. Johnson Museum of Art, Ithaca, New York; Walker Art Center, Minneapolis, Minnesota; Museum of Contemporary Art, Chicago, Illinois; La Jolla Museum of Contemporary Art, La Jolla, California; Laguna Gloria Art Museum, Austin, Texas; Whitney Museum of American Art, New York, New York.

Artforum International Magazine, Inc., granted permission to reprint the following materials by Robert Smithson: "The Monuments of Passaic" (December 1967), "Incidents of Mirror-Travel in the Yucatan" (September 1969), and excerpts from "Entropy and the New Monuments" (June 1966); copyright Artforum International Magazine, Inc.

ROBERT HOBBS

Ithaca, New York

INTRODUCTION

Before his fatal accident in 1973 Robert Smithson was a leading vanguard artist, but after it he became an even more significant figure, especially for those who viewed him as the equal of such innovators as Jackson Pollock. Soon after his death, a retrospective of Smithson's drawings (organized by Susan Ginsberg) was held at the New York Cultural Center. Later, in 1979, Smithson's writings, which had won him acclaim as a provocative thinker in the sixties and early seventies, were gathered into a book that was published by New York University Press. Although the exhibition and accompanying catalogue, as well as the book of writings, helped to ensure him prominence in art circles, they also lent him a certain mystique, making him appear more a dreamer of unbuilt projects than a sculptor who had created a significant body of work. Consequently, many of Smithson's early fabricated pieces are still largely unknown. The relationships between these works, the later Nonsites (gallery sculptures of 1968 containing bins, rocks, and maps that refer back to the Site), and the projected land reclamation pieces are greatly misunderstood, and the influences on his art, as well as the significant influence his sculpture has had on others in the past decade, still need to be investigated.

In the present volume we have attempted to fulfill some of these needs. The book contains detailed analyses of major works and important projects, with particular emphasis on circumstances germane to the projects, the reasons for deciding on particular locations, and the people who supported Smithson in his innovations. Comprising over seventy essays on individual pieces, the book also contains four critical overviews that place Smithson in various contexts—stylistic, historical, political, and social. Lawrence Alloway examines the significance of the Site/Nonsite dialectic; Lucy Lippard studies the political ramifications of his thought; John Coplans takes up the last major Earthwork of Smithson's career; and I investigate the artist's formative interests.

From 1960 to 1973 Smithson evolved a diverse and thought-provoking group of works. Unlike many artists who are contented with creating a single formalist style, which serves as a comfortable identifying label, Smithson viewed style as a consequence not a determinant, as a result not an aim. His art developed out of an embracing attitude that enabled him to appropriate increasing aspects of the modern world and deal with them aesthetically. He expanded art's realm; he did not attempt to reduce art to an essence. He used unconventional materials which, by their very nature, would manifest and not illustrate meaning.

In the interest of clarification I have divided the work Smithson created during this approximately thirteen-year period into the following nine categories: (1) *Presculptural*, when Abstract Expressionism was still the ruling sensibility; (2) *Transitional biological*, when he used bottled specimens and chemicals, and concentrated on systems; (3) *Quasi-Minimalist*, when he constructed "crystalline" fabrications in which traditional artistic values are subverted and negated; (4) *Cartographic*, when he made collaged map drawings in which space is viewed as both subject matter and formal element; (5) *Dialectical*, when he began his Sites/Nonsites, the first Earth sculptures; (6) *Conceptual narrative*, when he wrote essays in which the definition of art as object or idea is left ambiguous; (7) *Gravitational*, when he made structures that were also large-scale, ironic manifestations of New York School ideas; (8) *Monumental*, when he constructed massive land pieces in which the mass media become a significant means of disseminating aesthetic information; and (9) *Land reclamatory*, when he proposed projects in which art would be used as a means of land reclamation.

Before 1963 Smithson regarded himself as a painter. He belonged to the large group of post-Beat, existentialist followers of Abstract Expressionism. Like many frequenters of the Cedar Bar in New York City in the late fifties and early sixties, he attempted to use himself as a crucible for forging a genuine, felt experience. In his

early works, which focus on a religious trauma concerning orthodoxy and an identity crisis he was then undergoing, he used paint as an expressive device. Dripped and splashed, it became a weapon for attacking the canvas and a means for creating rugged and brutal overlapping shapes. Unlike many followers of Abstract Expressionism, Smithson did not use the general vocabulary of gestural painting for decorative ends: he attempted to become as forceful as the early Abstract Expressionists, going even further in some areas, particularly in his disregard for traditional color harmonies. But in combination with these agonized painted conceptions that were both Christian and science-fictional in nature, he drew on the canvas lyrical, airy figures representing angelic hosts. In these early paintings he united the high and the low, the celestial and the demonic, the lyric and the brutal, and the past and the future. These antinomies represent a sustained effort to reinvigorate Abstract Expressionism so that it would become more delicate and more forceful and avoid neither beauty nor ugliness but admit both. Although the goal is an admirable one, the results are at best uneven. Smithson later destroyed many of these works, as he considered the majority of them unresolved pieces. He felt that although the emotions were quite real and the religious questions he was depicting were genuine and disturbing, the experiences were forced once they entered the domain of art. From these early works he retained an interest in opposites and a desire to resolve them through art. In his mature works he turned away from the idea of art as confessional and began to think of art as form and subject matter. Gaining more distance on himself, he became interested in what makes an object a work of art.

The next identifiable group of works developed out of Smithson's new emphasis on the world around him and a consequent deemphasis of his own traumas. Less subjective, they deal with defining art's function. This group of works, which were exhibited at the Richard Castellane Gallery in 1962, shows a renewal of his boyhood interest in natural history catalyzed by Nancy Holt's concern at that time with biology. In these biological works, art is presented as a means of categorizing life. Like traditional landscape artists, Smithson collected aspects of life, but unlike them he did not allow his work to simulate living forms. He ironically commented on the vital presence of art when he drily made art in the form of biological specimens such as sponges or chemical samples such as ammonium hydroxide that are lined up in actual labeled bottles. The implication of these works is that art and life are separate categories, just as biology and nature are. Like biology, art is a way of understanding life, a means of symbolizing certain values; however, it preserves not life but death, and contains not living presences but inert substances. Smithson's biological specimens represent his transition between painting and sculpture, a change from emotionally charged canvases to inert objects.

When Smithson started in 1964 to make sculpture, the appearance of his work changed significantly. Although he continued to examine the idea of art as a container, which was first developed in the biological specimens, the forms his art now assumed were more in line with the Minimalist idioms that were just being established by Carl Andre, Donald Judd, and Robert Morris. Sharing Judd's interest and following Wilhelm Worringer's exploration of the duality between the organic and the crystalline (in *Abstraction and Empathy*), Smithson became interested in crystals. Crystallography provided a major impetus to his art, for it allowed him to conceive of ways of dealing with nature without falling into the old trap of the biological metaphor. Crystals, those regular geometric structures that make up great portions of the earth's surface, form aggregates and "grow" without being alive. With crystallography as a generative idea, Smithson's new art did not have to continue to simulate living presences; it could simply be a static object. The important area of investigation for artists such as Smithson and the Minimalists was no longer the organic, with its consequent implications of living, struggling, breathing, and feeling. Instead it was the fine differences that separated art from things: how close could one get to creating a thing and still have art? Needless to say the art that developed was cool and intellectual. Neither frenetic nor rhetorical, it was calm to the point of being inert. The art has affinities with the New Novel in France, particularly Alain Robbe-Grillet's work, and innovations in real-time cinema. An important example of the development of real time in film is Michelangelo Antonioni's *L'éclisse*, in which a minute of silence becomes an actual minute, and a shot is held for the length of time it takes an actor to walk across the area it encloses. These preoccupations of the European writers and filmmakers and the American Minimalists are the opposite of Abstract Expressionist concerns. Instead of drama with its heightened intensity, theatricality is played down; in place of bombast, the laconic statement takes over; and rather than the presentation of a climaxing vision accompanied by sublime statements, perception is slowed down to the real, not virtual, time it takes a person to examine an object that is labeled a work of art, and not the time it takes someone to look at a work of art which has been proclaimed a sentient being.

Smithson was not, strictly speaking, a Minimalist. He used the vocabulary of Minimalism—clean geometric

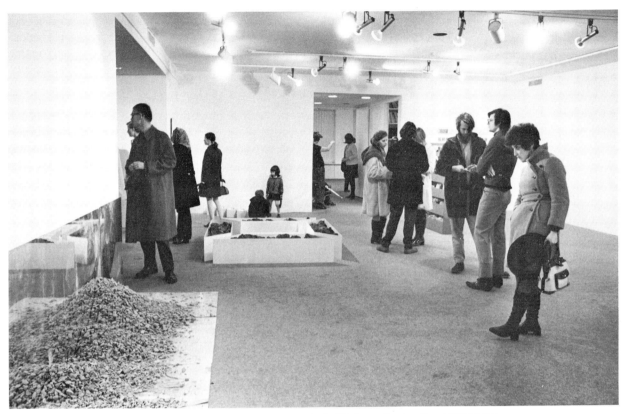

Installation view, Dwan Gallery, New York, February 1969. Photograph by Sy Friedman, Courtesy Dwan Gallery, Inc.

forms, industrially fabricated parts, the look of objectivity, and the appearance of rationality—as a means of undercutting simple-minded logic and as a way of pointing out the weaknesses of systems and networks. The innovations he made are to be found in the opposites he exposed. Although the approach sounds philosophical and dry, the intent was not without humor. Along with a cool approach, Smithson also developed a greater sense of humor in his work in the early sixties, an almost Zen humor that recognized the absurdity inherent in narrow forms of logic. In such works as *Enantiomorphic Chambers*, he posed himself the question, "If art is about vision, can it also be about nonvision?" Traditionally art has been a means of mirroring reality. In *Enantiomorphic Chambers* Smithson constructed a situation in which art mirrors no external reality but only its ability to reflect itself. Art becomes a tautology, a reflexive statement of its supposed function. Art's subject is its own being, and the result is a type of nonseeing or visual blindness. In this piece, then, the logic of the mirror is short-circuited, and an alogical system prevails.

At the same time that Smithson was making quasi-Minimalist pieces, he also began a series of cartographic drawings in which he used maps because they are well-known conventions for depicting space. These spatial

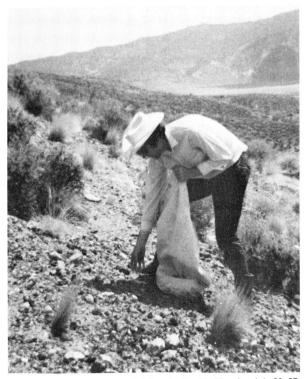

Robert Smithson collecting obsidian for *Double Nonsite*, July 26–27, 1968. Photograph by Nancy Holt.

elements, the maps, are cut out and thus removed from their context (where there are legends for decoding the symbols they employ) and are transformed into abstract shapes in new compositions. Here again, as in some quasi-Minimalist sculptures, Smithson short-circuited logic. He turned maps into decorative elements that depict two different types of space: one is referential (the maps outline land formations and sea masses), while the other is tautological (the maps picture themselves).

In 1968 Smithson initiated what might be regarded as the fifth stage of his art. In that year he began his first full-fledged examples of Earth art, his Sites/Nonsites. The pun on nonvision, I think, is fully intended as part of the work. It is worth noting that Earth art had been anticipated in Smithson's 1966 Dallas–Fort Worth airport proposals, 1967 *Tar Pool and Gravel Pit* model and narrative essay "The Monuments of Passaic," as well as in his map drawings. The Sites/Nonsites also continue the interest in antinomies which occupied Smithson in his early paintings and intrigued him in such works as *Enantiomorphic Chambers*. The Sites/Nonsites are dialectical propositions that constantly disrupt the premises of traditional sculpture. The Nonsite in the gallery refers back to the Site, and if one goes to the locations from which the rock was originally taken, one views the Site and recognizes the material but cannot see the extraction from it that forms the Nonsite. In these works Smithson was more subtle than most Earth artists because he was not simply interested in the earth as another sculptural material so much as he was concerned with new concepts of space—with hereness and thereness, with mobility and mental projection. Mental projection or vicariousness does not deflate one's sense of distance but instead cancels out one's sense of hereness, that sense of being rooted in a single place. In his gallery pieces Smithson stressed this modern condition by using the term "Nonsite" to connote nonspace.

Smithson's definition of Nonsite and nonspace is indebted to Tony Smith's well-known car ride, which Smith recalled in a conversation with Samuel Wagstaff, Jr., published in *Artforum* in December 1966. A car ride along the New Jersey Turnpike at night, suggesting space and also the negation of space, was regarded by Smith as a profoundly modern experience. Though the experience is distinctly modern, Smith assumed it to be beyond the bounds of contemporary sculpture. His statement about space/nonspace as well as his pessimism about manifesting it in art became a challenge to Smithson, who made the understanding of this new space/nonspace one of the main goals of his art. The first works that clearly deal with this challenge are the Nonsites.

After the Nonsites, which were made in 1968 and early 1969, Smithson embarked on what one might call a more conceptual phase, a phase documented by his 1969 essay "Incidents of Mirror-Travel in the Yucatan." Contemporaneous with the development of Conceptual art, "Incidents" deals with a series of mirror displacements in which the status of art as object is left ambiguous. In the essay, which represents a full-blown development of the narrative work that first appeared in 1967 in "The Monuments of Passaic," a series of mythic-poetic operations on the landscape are recorded in a superobjective style that has affinities with those Robbe-Grillet novels in which scrupulous objectivity serves as a manifestation of obsessive subjectivity. In the essay Smithson records the creation of temporary mirror displacements of light, atmosphere, and changing environments, and documents them with color photographs. In this narrative piece, even more than in "The Monuments of Passaic," the creative role of the art network is underscored. With increased popularity in recent decades, art has become a subject for the mass media. Except for a small dedicated group of gallery frequenters, viewers of art in the modern world are dependent on such secondary media as magazines, books, video, and film for communication. The vast majority of people now know most works of art only through secondary sources. Smithson plays on this situation when he creates a new brand of written work that consists of temporary constructions in space but lasting monuments in prose. One might say that in "Incidents of Mirror-Travel in the Yucatan" secondary media become primary, the work of art is replaced by the critical-literary essay, and the gallery is supplanted by the periodical.

Soon after the creation of this piece, Smithson conceived of gravitational "flows" and "pours," outdoor Earth pieces that dealt with industrial techniques. In addition to being the most "entropic" of his works (those most vividly manifesting energy loss), these massive flows also parodied aspects of New York action painting. In such works as *Asphalt Rundown* (Rome), *Concrete Pour* (Chicago), and *Glue Pour* (Vancouver), he subverted the well-established ideas of action, existentialist gesture, and large scale. He turned what had become in the hands of color-field artists quick, wet, and decorative sprays and spongings into slow, dry, and lugubrious pours upon the land. Not only did these works parody Abstract Expressionism and its adherents, but they also made fun of the Earth artist as monument builder who creates large pieces that lack the heroic stamp because of their innate passivity: they are dumps, flows, and pours that have succumbed to the force of gravity, not heroic monuments that dominate the landscape.

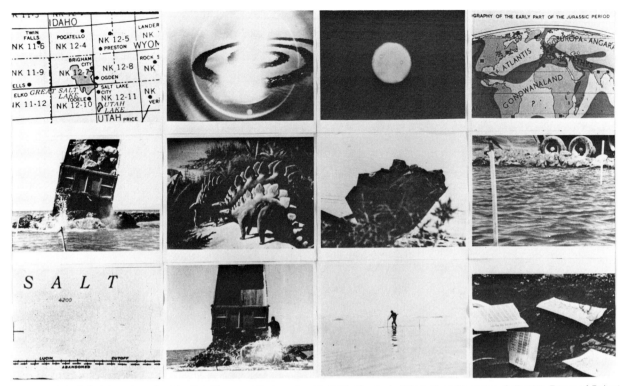

Stills from *The Spiral Jetty* (co-edited by Bob Fiore and Barbara Jarvis), 1970; 35-minute 16mm film with sound. Collection Estate of Robert Smithson, Courtesy John Weber Gallery. Photograph by Walter Russell.

The conceptual nature of art which was elaborated in ''Incidents of Mirror-Travel in the Yucatan'' became a pervasive aspect of Smithson's work. Art could no longer depend merely on being an object, because the primary art object was becoming less and less familiar to greater numbers of the art audience. In the next phase of his work, Smithson stretched the traditional definition of art as object for direct viewing by using conceptual frameworks that stressed particular contexts for seeing. He made the art object imposing, even though he intended it to be viewed mainly through photographs and films. Such secondary media, then, became significant means of communicating his art. What Smithson did when he created *Spiral Jetty* was to turn art centers into provincial outposts and the province into a new center for art. When the new art moved out of the traditional art network, when it became accessible only to a few on a primary level, and to all as secondary media, it achieved an experiential status that equaled mass knowledge of interplanetary investigations. In the huge Earthworks such as *Spiral Jetty* and *Broken Circle/Spiral Hill*, Smithson undercut monumentality when he placed as much emphasis on the new communication circuits as on the traditional art objects. Because the Earthworks are often not known directly, they can become subjects for rumor and consequently assume a mythical status.

The ninth and final stage of Smithson's career involved a totally new conception of land art. Here I use the word ''park'' advisedly because parks traditionally refer to enclosed areas for the display or cultivation of plants. Smithson was unconcerned with growth, even though he was fascinated with change. What he proposed were postindustrial Earthworks that take into consideration the havoc wreaked on the land by industry. In these land reclamation pieces he attempted to deal with sludge heaps, strip mines, and tailing berms, in large-scale ''parks'' that focus on entropy. He neither lamented industrial waste nor supported sound ecology-minded programs: he was at this point more a formalist who was so distanced from the world that he was fascinated only by the look and scale of waste and pollution. His proposed parks become focal points on the landscape: they force a visual consideration of large-scale changes in the land wrought by both pollution and reclamation, and do not attempt to make value judgments. Unfortunately this phase of Smithson's career was cut short at the planning stage by his untimely death, and may appear—since it exists only in drawings—more a visionary endeavor than it would have been were the projects actually carried out.

In my opinion Smithson's main contributions to art lie in his realistic assessment of mid-twentieth-century life. In an era of rootlessness, massive reordering of the land-

scape, large-scale temporary buildings, and media explosion, he viewed people's essential apprehension of the world as a rejection of it. Vicariousness, projection to some other place by rejecting where one actually is, has become a dominant mid-twentieth-century means of dealing with the world. Making the Nonsite (which brings together nonseeing and nonspace under one rubric) a primary determinant of his aesthetic forms, Smithson emphasized ways people nonperceive.

Smithson referred to this mid-twentieth-century inability to deal with the here and now when he turned sculpture into structures that manifest art's varying roles as signifier and signified. He focused (in the Sites/Nonsites) on the dialectic between sign and referent, forcing the viewer to recognize the futility of ever directly grasping the artwork in its entirety. In Smithson's art one thing refers to another, isolation is broken down as connections take over. Smithson, the aesthetic spokesman for suburbia and the parking lot, the nonspaces, is also the artistic formulator of the contextual work of art, the no longer isolated and no longer autonomous art object that is both a sign and a symbol of interconnectedness. We must examine, therefore, not only the objects but also the contexts, the frames, that are Smithson's art. Sometimes they are one and the same. The context of his art is, then, other works of art that enclose it (such as the *Spiral Jetty* film and essay) as well as the larger nonartistic world that surrounds it both physically and intellectually.

ROBERT HOBBS

Ithaca, New York

ROBERT SMITHSON: SCULPTURE

SMITHSON'S UNRESOLVABLE DIALECTICS

Robert Hobbs

A Plea for Complexity

Artists are not straightforward thinkers, even though they may be logical and concrete in their use of materials. Artists think indirectly in terms of a medium. Whenever historians and critics consider themselves to be doing an artist a service by tidying the peripheral morass of difficulties surrounding a work of art—unclear meanings, possible uncharted courses of significance— they do an artist a disservice because they recreate the art, substituting in place of the difficult and even contradictory work their own narrow, carefully reasoned, and often clearly articulated point of view. With some the damage would not be permanent, but with Robert Smithson, who constantly strived to conflate and expose the complexity of issues, elaborate on possible interpretations, and remove clear focal points for the more difficult periphery, the damage would be severe. Smithson was a clear thinker about muddled issues. As an artist he was a maker of objects that seem rational and consistent, but his works usually represent the uneasy conjoining of contradictory systems of thought.

Exemplary of this unresolvable dialectic is the seminal work *Enantiomorphic Chambers* (1965) which joins together many ideas into a purposeful ambiguity. Composed of bracketed mirrors obliquely positioned, the sculpture relies on the look of the Minimalist style that it appears to perpetuate but instead ironically refutes. Looking almost like a Donald Judd machined form, the sculpture resembles the very quintessence of rational technology. This approach to the work is confirmed in part by the clear articulation of elements and fabrication by industrial techniques that make the piece appear to be more the design of an engineer than of an artist. The modern-day, suprapersonal articulation of the piece, however, is quickly dispelled when one peers into the glass chambers and finds that the mirrors reveal only their silvered pools of reflection. Each gives an abstract vision of a mirror looking at itself and becomes a significant image of reflexiveness. To a viewer acquainted with the Minimalist need to reduce sculpture to its absolute essence, even to the point of appearing more object than sculpture, *Enantiomorphic Chambers* might be distressing. While the piece does appear to be more object than presence and does not seem to strain belief by suggesting anything more than the materiality of its constituent elements, there is something confusing about it. Even though viewers face two obliquely angled mirrors, they do not see themselves. The enantiomorphic mirrors make viewers feel disembodied and unreal as if they have been sucked into some new realm, maybe a fourth dimension in which commonly understood space/time coordinates are no longer applicable. In his writings Smithson confirms this idea, for he indicates that the vantage point of *Enantiomorphic Chambers* is the void on the horizon usually found in one-point perspective paintings and drawings, where all transversals meet.[1] Consequently, the vantage point is outside conventional space or indicates the convergence of time and space in another dimension. *Enantiomorphic Chambers*, then, looks rational and coherent even though it is not. The piece becomes an entry into a new way of perceiving, or perhaps one should say a way of nonperceiving, in which the void is apparent both visually and somatically, because the disembodied viewer forms its nexus. These nonvisual aspects of Smithson's art represent a continuation of ideas important to Ad Reinhardt, who was famed for his black paintings that, in Reinhardt's own words, served to "push painting beyond its / thinkable, seeable, feelable / limits."[2] These studies of the nonvisual and intimations of the fourth-dimensional also sug-

[1] "Interpolation of the Enantiomorphic Chambers," in *The Writings of Robert Smithson*, ed. Nancy Holt (New York: New York University Press, 1979), p. 39.
[2] Ad Reinhardt, *Art-as-Art: The Selected Writings of Ad Reinhardt*, ed. Barbara Rose (New York: The Viking Press, 1975), p. 81.

gest an interest in Marcel Duchamp's investigations of N-dimensional geometry which began early in the century, and they also indicate shared concerns with Will Insley who began to develop concepts of totally abstract, uninhabitable architectural spaces in 1963. In *Enantiomorphic Chambers* the rational thus becomes irrational; the mute and apparent, puzzling; and the sculpture, an entropic time/space vehicle for draining conviction in the Cartesian system by casting one into a wholly different realm.

Throughout his art Smithson used mirrors. The mirrors are not, however, always glass. Sometimes, as in *Spiral Jetty* and *Broken Circle*, they are bodies of water. At other times objects and situations mirror: Sites and Nonsites (actual designated locations and gallery pieces consisting of bins containing ore from the location) tend to reflect each other; like mirrors they focus attention on that which they reflect rather than on what they themselves reveal. In *A Nonsite, Franklin, New Jersey*, an ironic form of mirroring takes place. The Nonsite contains an aerial map of Franklin which repeats the outlines of the trapezoidal bins and which is shaped according to the rules of linear perspective. The irony of the piece occurs at the point in Franklin where the lines of perspective would converge: an actual dead-end street in the town. Frequently in the Nonsites Smithson created three-dimensional parodies of two-dimensional schemata such as perspective to suggest in still another way that the objects are three-dimensional images of a fourth-dimensional world. If perspective (a two-dimensional concept) mirrors a three-dimensional realm, then three-dimensional perspective (it should follow by the same logic absurdly applied) mirrors a fourth-dimensional world.[3]

Mirrors confuse what they reflect: they reverse images and serve as uncritical recorders of visual phenomena. Because mirrors displace reality, they provide an important sine qua non for a work of art. They contain within themselves the possibility of embodying the fourth dimension when they become art, because works of art commonly transcend notions of real time and conceptions of real space in the creation of their own temporal and spatial standards.

In the mid-sixties Smithson wished to underscore confusion rather than to simplify and clarify it. He wished to employ cool, austere shapes indicative of rational thinking and then assemble them in ways that would under-

mine their rationality. In his *Alogons* (systems devoted to "alogic") he created tensions between two generative equations—linear and quadratic (curves suggested by diminishing shapes)—to confuse clear thinking and replace it with what he termed "solid-state hilarity." The *Alogons,* which diminish in size from one vantage point, were intended to be a concrete section of the infinity of reflections that occur when an object is positioned between a pair of parallel mirrors.

Smithson's humor is low-key, at times almost unapparent. Carefully he planned, structured, and measured his humor, giving it crystalline shapes that appear to mirror crystals' supposed clarity and transparency. Because humor is usually spontaneous—at least it sports the look of immediacy—Smithson's carefully worked-out factory-made wit may appear foreign. If his wit is less than a chuckle, not quite a giggle or even a mild titter and in fact produces nothing ribald or infectious, still it is so beautifully concealed in the work, so much a part of its formative process, that it is capable of at least producing a grin in those who take issue with this culture's insistent blind faith in logic. He made fun of such rational systems as the Hegelian dialectic of thesis, antithesis, synthesis in his Sites/Nonsites.

Smithson's dry, almost bland, wit is all-embracing; it even encompasses his practice of leveling through which he made the prosaic significant and the glamorous prosaic. Or as Virginia Dwan has said:

You want to know what was most important about Bob? Well, I don't know. All I do know is that he had this—call it an uncanny ability to take the most mundane things and make them seem—well, make them seem fantastic and intensely exciting. Like the Golden Spike Motel, for example, that dumpy nowheresville kind of place with linoleum rugs and strange heaters up high on the wall. To Bob the Golden Spike was not just a dump, it was an adventure, a place of mystery, so strange and exciting one would swear he was in a science fiction world. He communicated this idea, he made those around him feel it, and I guess that's what was so exciting about Bob and his work.

It took me a while to catch on to it, his work. It appeared so cool and rational—cold really, and yet there was this other quality, kind of underneath like a subtle dry wit, a slow almost sardonic ha ha. I guess that's what was important about Bob—this other quality that was not exactly on the surface, and yet was there all the same, especially in his personality.[4]

In addition to mirrors, crystals were important to Smithson because they helped him to enlarge his world view beyond the anthropomorphic and organic: crystals

[3] In developing this analogical conception of the fourth dimension, Smithson was no doubt influenced by Marcel Duchamp's art. And for the elaboration of this idea I am particularly indebted to Craig Adcock, who is giving it its most complete explication in his forthcoming dissertation on Marcel Duchamp and N-dimensional geometry (Cornell University).

[4] Conversation with the author, January 1980.

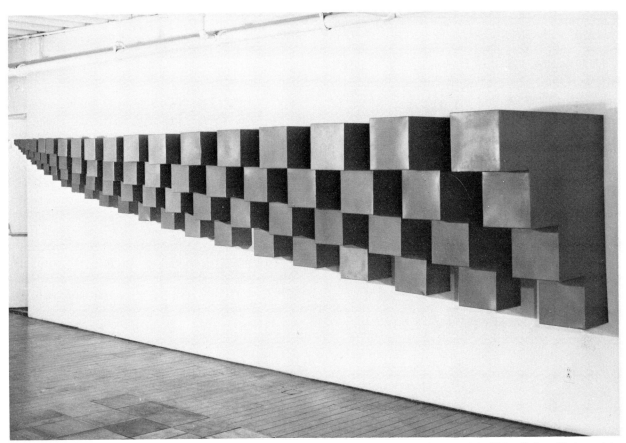

Alogon #3, 1967; steel; 20 units, largest 46 x 11½ x 46". Collection Estate of Robert Smithson, Courtesy John Weber Gallery. Photograph by Walter Russell.

account for most of the crust of the earth, all metals, and many synthetics and plastics. Similar to plants and animals, crystals grow and form aggregates. Unlike living forms, however, crystals are highly representative of entropy, of energy channeled into unavailable states; they represent the cooled-down state of liquids and gases and so require additional outside energy in order to be converted into another form. Traditionally crystals suggest clarity and translucence, and yet scientifically they exemplify only regularity and entropy.

In his art Smithson depended on all these connotations and characteristics of crystals. When he created precise geometric forms, suggestively crystalline in structure, such as the *Alogons*, he hinted at clarity and easily understood regularity, but instead he created static structures that become models of entropy when considered in terms of their unvarying structure. Rather than clarify, some of his crystalline forms incorporate such oppositions as the Site/Nonsite dichotomy. Similar to Zen *koans*, these contradictory works compel viewers to transcend mere systems of logic in order to gain real understanding.

Smithson's interest in crystals received impetus in 1966 when J. G. Ballard's science fiction tale *The Crystal World* was published. Elaborating on the structural properties of viruses that exist at the threshold between animate and inanimate worlds, between both crystalline and organic forms, Ballard constructs a glittering realm in which all living forms are encased in a faceted jewel-like encrustation, enshrouded in living-death immortality. This strange world, frozen and crystalline, resembles a Cubist painting, and may well have suggested to Smithson the entropy of a modern art that has become overrefined, insular, and incapable of being understood except by the initiated. Instead he tried to alter this course of development in his criticism, and his work ironically became both a comment on and a manifestation of the entropy (the unavailable energy) in modern art.

Tough Art

In recent years New York artists in particular have felt the need to assume the look of difficulty, to create what

has been called "tough art" (an updating of the macho sensibility that prevailed among the Abstract Expressionists), one that is not easily conformable to age-old standards of beauty, radiance, and presence. Certainly no exception to this tendency toward the abstruse, Robert Smithson's work is perhaps a most outstanding example. To the uninitiated his art appears at worst to be about nothing and at best to be a picture of the void. His writings at times seem exemplary expositions, but then they trail off into convoluted passages or multiply meanings and possible ramifications to the point that readers are inevitably saturated, even though they are often exhilarated by the numerous possibilities.

Like many artists Smithson made objects, though he had ways of discounting their importance. His first mature works, beginning in 1964, are quasi-Minimalist constructs in which he provided a bare envelope of form—machined parts of thin rolled steel coated with flat paint that makes the pieces appear dead and inert. Later, in 1968, he started creating the Nonsites, comprising metal or wood bins filled with rock and usually accompanied by photographic and written documentation. Acting in a dialectic with the Sites, the Nonsites negate both the gallery's space and the primacy of perception as they point away from themselves and to the Site. In this way the art object's actual presence is undermined.

Instead of becoming easier to understand as he became established, Smithson tended to become more difficult. He left the gallery and went out into the world to create monuments like *Spiral Jetty*, but the monuments are hollow testimonials to man's dominance of the landscape. Instead of glorifying man and modern technology and making Earth art a means for directly acting on the landscape, Smithson, in *Spiral Jetty*, created a largely inaccessible antimonument that gave on-location viewers a vertiginous sensation as they stumbled over the rocks, salt crystals, and mud forming its causeway. The *Spiral Jetty* becomes an ironic focal point in the landscape, a convoluted question mark that casts in doubt man's relationship with the land as well as with monuments.

For the larger number of people to whom the *Spiral Jetty* was inaccessible—it is now inaccessible to all since it is under water—Smithson's film and article on the work provide important, but problematic, glimpses. When he became a filmmaker and essayist as well as an Earth artist, Smithson appropriated large segments of the art network, placing in question traditional limits of the aesthetic: Is the art object really autonomous? Does the artist's creative act begin and end with the work of art per se? Then he even subjected to scrutiny the very significance of meaning when he piled one interpretation on

another so that the sculpture is about all truth or no truth: it is a vortex of crystals and a void whirlpool of thought.

Never placing himself solely within the art network and always probing untraditional sources (crystallography, cartography, physics, science fiction, and literature), Smithson went even farther afield in the early seventies. At this point in his career his motives were highly complex and at times ambiguous. What he wanted was to rid art of its ivory tower, its art-for-art's-sake orientation, and make art out of the forgotten spaces, the "nonspaces" of the present—strip-mining sites, industrial sludge heaps, and polluted parks and streams. His goal, not idealistic but also not pragmatic, was to sell big corporations on the need to use art as a tool for land reclamation. Smithson did not, however, view art as a new means for land improvement. He used the term "reclaim," but he was actually referring to the symbolic potentialities of art, to its way of turning devastation and reclamation into signs of the precarious balance between man and nature. Although his plans would save corporations vast sums of money and provide them with high visibility as patrons of art, the corporations were less than enthusiastic about them. One could write off their lack of interest as an inability to understand, but that explanation does not provide an adequate assessment. For even though Smithson intended to turn a strip mine into a backdrop for an artwork, to add a curving terracing of berms to a tailings pond, he wished to leave exposed tracks of the corporation's despoliation of the land, to focus on it and not simply eradicate all vestiges of change, all ravages incurred in mining. What he wanted was to create an art that serves as a bridge between mining and reclamation, that points back to one as it hearkens the future of the other. Art in the form of land reclamation projects was not so much aimed at providing an Eden-type gloss over the landscape as it was intended to expose and symbolize change. For those corporate executives who felt compelled to cover the tracks of mining, Smithson's proposals looked like impediments. Earthworks emphasized the change without taking sides, and his proposed land reclamation pieces, such as the one for the Bingham Copper Mining Pit, were immensely political in orientation even if they were not partisan in their focus. Smithson was no ecologist: he took an almost perverse delight in the look of devastation. Had his Bingham Copper Mining Pit project been built, it would have turned this Grand Canyon of strip mining into an excuse for a central art work.

Smithson's art partakes of the anti-"Establishment" temper of the late sixties. Paralleling many of his contemporaries who were becoming disenchanted with bigness, with bureaucracy, and with traditional definitions

of success, and who were seeking instead "alternative lifestyles" in the form of communes and pioneered settlements, Smithson shifted his art from a gallery context to the out-of-doors. The main focus of his art became the landscape itself, although he still partially relied on the gallery and the museum. Smithson was realistic—he wanted to make and sell art. He accepted the gallery as a necessity, but chose to allocate to it the residue of the art process which it was capable of containing.

His politics represented part of an attitude that he shared with his contemporaries without ever wholly subscribing to it. Smithson never endorsed the nature-worshiping, anti-"Establishment" shibboleths of the day, even though his art springs from a similar need to break away from entrenched ideas. He turned from galleries but still used them. He moved away from cities while still maintaining more than a foothold within them. He appeared to be a pariah of the art world, and yet he actually accepted many of its limitations. He wanted, as he once stated, to understand the network through which he was being cycled. Not an uncompromising purist, he was a pragmatist who bemoaned the status of museums as repositories. Even though he made several statements about the problems of museums and current art criticism (particularly that of Michael Fried and Clement Greenberg), he continued to make art as best he could in an impure world. He was more fortunate than most artists. He found encouragement in Virginia Dwan, surely one of the most enlightened of gallery owners, and he exhibited in museums that were willing to explore new alternatives. He rebuked the system and yet partially worked within it and used it to his own advantage. He accepted aspects of the art world, and yet he did not relinquish quality—he merely adapted himself to the status quo and created artistic statements applicable to it.

In spite of Smithson's marked affiliations with his generation, his art is independent, pragmatic, irritating, and complex; it is concerned with deflecting meaning, with taking the narrow course between extreme positions and pointing to those positions without becoming part of them. His art could be called the art of unresolvable dialectics: it maintains its gratuitousness even though at times it looks as if it has taken up a particular point of view. This type of nonpartisan thinking is clearly exemplified by proposals for land reclamation that side neither with the industrialists nor with the ecologists, but attempt to serve as constant irritants that point to change and devastation without making moral judgments.

If Smithson's art rested on "either/or" propositions, it would not be so difficult to understand. But rather than an "either/or" situation, he created a "both/and" proposal where the "both" is "either/or," the "and" adds

up to confusion, and the combination of the three terms is equally valid and useless at the same time. Smithson constantly strove to achieve a state of indeterminacy in which meanings are projected as well as canceled out. To examine his art is to tread over a mine field, for one is always in danger of finding one's own reflection in the mirrors he used, instead of the intended state of mirrored reflexiveness. For anyone who attempts to understand Smithson's world without latching onto the cumbersome treadmill of meanings he has attached to it and also without denying its complexity, one of the few paths open for exploration is the limited but important area of function. While one cannot look for specific meanings as ultimately relevant, because Smithson multiplied interpretations to create informational overload, one can localize the individual work's significance by asking how it works as art. Before being a writer, filmmaker, social commentator, and critic, Smithson was a sculptor.

In his art Smithson polarized traditional givens and looked at the resultant positive and negative forces. If Earth art is about a location, a Site, he concerned himself with the negation of place and arrived at the concept of Nonsite—a term that refutes place at the same time that it puns the refutation of vision, that is, nonsight. What Smithson did with sight, he also did with space. Traditionally sculpture is about space—real, three-dimensional space. One of the great obstacles facing sculptors in the twentieth century has been to create significant three-dimensional forms. The problem has been almost insurmountable because advances in physics exploded traditional notions of material reality, and innovations in art, beginning with Cubism, have emphasized two-dimensionality in painting and the falseness of illusionism. Even the most important sculptors have adhered to frontal, hieratic, and basically two-dimensional orientations. Except in the work of Giacometti, who admitted the overwhelming force of space in his attenuated figures, and of Calder, who opted for dynamics over blocky substance, sculpture has been mainly a two-dimensional scheme for three dimensions. In the 1960s, however, a revolution in form was instigated by Minimalists Donald Judd, Robert Morris, Sol LeWitt, and Carl Andre who elected to create pieces that hovered between sculpture and objects. In *Column* (1961–73), Robert Morris set up a test case for examining real space unidealized by overtones of mythic presence and theatrics. He created a sculpture as close to an object as possible so that the absolute reality of its space would become apparent. In the early sixties, Tony Smith solved many of modern sculpture's problems by creating crystalline shapes that departed obliquely from the then repressively frontal orientation of sculpture and that consequently oscillated be-

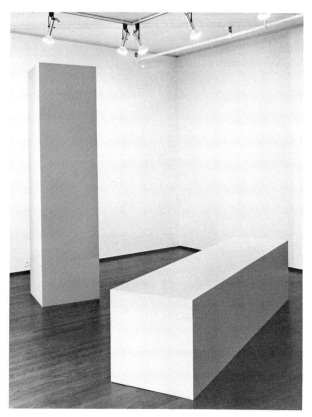

Robert Morris, *Column*, 1961–73; aluminum; 2 columns, each 8 x 2 x 2′. Anonymous collection. Photograph courtesy Leo Castelli Gallery.

tween machined presence and dynamic object. But curiously, the pieces by Smith which were most favored at the time tended to be those that were the most poignantly inert and objectlike, particularly works such as *Die* (1962) which appeared to be part of the new venture toward unidealized objecthood.

Within this context Robert Smithson began working. Not wanting to be simply a maker of objects, he veered away from the Minimalists. Not wishing to make basically two-dimensional translations of paintings and drawings, he refused to follow the lead of such a sculptor as the then universally acclaimed David Smith. The only viable option was shown by the work of Tony Smith. Like Tony Smith, Smithson took the idea of crystals as an organizing principle. As he studied crystals, Smithson became fascinated with their structure and symmetry. Then he found that one can map crystals, and so he turned from crystals to mapping. And at this point he became involved with the possibilities of turning maps into three-dimensional objects. He succeeded in creating three-dimensional, disjunctive maps in 1968, when he originated the Sites and Nonsites. Furthermore he joined together in these works his interests in sculpture, crystal-

lography, mapping, drawing, perception, and landscape. No doubt a catalyst for the Nonsites was Tony Smith's famous description of the nonspace apparent to him while driving along the New Jersey Turnpike at night:

> When I was teaching at Cooper Union in the first year or two of the fifties, someone told me how I could get onto the unfinished New Jersey Turnpike. I took three students and drove from somewhere in the Meadows to New Brunswick. It was a dark night and there were no lights or shoulder markers, lines, railings, or anything at all except the dark pavement moving through the landscape of the flats, rimmed by hills in the distance, but punctuated by stacks, towers, fumes, and colored lights. This drive was a revealing experience. The road and much of the landscape was artificial, and yet it couldn't be called a work of art. On the other hand, it did something for me that art had never done. At first, I didn't know what it was, but its effect was to liberate me from many of the views I had had about art. It seemed that there had been a reality there that had not had any expression in art.
>
> The experience on the road was something mapped out but not socially recognized. I thought to myself, it ought to be clear that's the end of art. Most painting looks pretty pictorial after that. There is no way you can frame it, you just have to experience it. Later I discovered some abandoned airstrips in Europe—abandoned works, Surrealist landscapes, something that had nothing to do with any function, created worlds without tradition. Artificial landscape without cultural precedent began to dawn on me. There is a drill ground in Nuremberg, large enough to accommodate two million men. The entire field is enclosed with high embankments and towers. The concrete approach is three sixteen-inch steps, one above the other, stretching for a mile or so.[5]

This description started Smithson thinking about the ways that twentieth-century man conceives of space, and led him to formulate a new paradigm for sculptural space.

For all his originality Smithson owes an enormous debt to Tony Smith, who chose to look at sculpture in radically different ways. Smith did not consider his sculpture to be objects that activate space but rather voids that displace the solidity of space: in Smithson's terms they are Nonsites. Smith's attitude toward space was influenced by the Japanese sensibility, particularly the idea of space as solid. But his thinking did not appear at all exotic or foreign to Smithson who found it crucial to his formulation of the voids at the center of modern life. When Smith wrote of his sculptures that

[5] Samuel Wagstaff, Jr., "Talking with Tony Smith," *Artforum* 5, no. 4 (December 1966): 19.

they are black and probably malignant. The social or-
ganism can assimilate them only in areas which it has
abandoned, its waste areas, against its unfinished backs
and sides, places oriented away from the focus of its well-
being, unrecognized danger spots, excavations and un-
guarded roofs,[6]

he laid down fundamental attitudes for a new subaes-
thetic terrain that Smithson developed in his
Sites/Nonsites and later in his land reclamation projects.
Even though Smithson's sculpture assumes a very differ-
ent form from that of Tony Smith, the generative ideas
giving rise to that form are dependent on Smith's think-
ing about space, form, and the desperate feeling of alien-
ation that is part of modern man's existence.

With his dialectical turn of mind, Smithson considered
that if sculpture is about space, then it should also be
concerned with space's counterpart, nonspace. The most
important spaces of the twentieth century are nonspaces,
immediate surroundings that fail to impinge themselves
on the modern consciousness—like suburban tract
houses, those patchworks of status symbols that point
away from themselves and toward their referents, that
become a nowhere and nothing because they are always
signs or containers for something else. Searching for the
nonspace elsewhere in the everyday world, Smithson
found that pristine white art galleries and museums are
"canceled" places, as are also super highways and the
strips of fast food chains, gasoline stations, and shopping
centers that are repeated endlessly into an ever present
nowhere. One of the most profound nonspaces that
Smithson discovered is the movie house, where people
become unaware of their present space as they drift into
vicariousness, into what Smithson termed "cinematic
atopias." In Smithson's art the space/nonspace dialectic
is carried out in works such as *Leaning Strata* where
two-dimensional abstract systems for plotting space
meet, then are absurdly reified in three dimensions to
become a conflated, illogical spatial system. The profile
of this early sculpture is determined by the abutment of
two logical but irreconcilable systems for conceiving
space—cartography and perspective. The sculpture thus
formed is a statement of rationality carried to the ex-
treme, or irrationality. Nonspace too is the subject of the
Nonsites, which appear to dispense with their own state
of being as they cast reflections back to the nonapparent
Site. Smithson's proposed land reclamation projects of
the 1970s bring him in contact with another nonspace:

the strip mine. What, after all, are strip mines but
scalped mountains, voids testifying to the act of remov-
ing, negatives left after the positive ore has been scraped
off? The concern with space and nonspace even appears
in Smithson's writing, particularly in those turgid pas-
sages—so dense in their syllables and so convoluted in
their arrangement—that appear to connote a most impor-
tant meaning and yet are devoid of any clear-cut signifi-
cance. While the prose occupies space, literally, it al-
lows for little interpretative space: Like some of Vito
Acconci's early poems consisting of nonsequiturs that
adhere to the page and do not allow clear-cut understand-
ing, Smithson's writings occupy the nonspace of the
page and resiliently defy easy explication. In "Incidents
of Mirror-Travel in the Yucatan" (1969) Smithson cre-
ated a slightly different type of prose nonspace: one of
subject matter. The essay refers to no longer existent
mirror displacements and thus becomes itself a Nonsite.

*The Science Fiction Fiction and
the Art of the Absolute Nothing*

Smithson approached traditionally serious science fic-
tion realms and pricked them with holes to release their
mysterious afflatus, their quasi-religious sacrosanctity.
In their place he created an art that marries the prosaic
with the astounding, that links, as in *The Spiral Jetty*
film, prehistoric monsters with modern bulldozers and
giant caterpillars, and seizes upon entropy as a uniting
faculty for generating an air of unsentimental, objective,
and inexorable hopelessness. In Smithson's hands en-
tropy comes close to determinism but is not quite so log-
ical. Entropy conflates rational structures to the point
that they become like the proverbial monstrous robot, an
absurd manifestation of man's rationality often coming
into conflict with itself, especially with its narrow pro-
gramed form of logic.

Like much science fiction, Smithson's work is pro-
phetic even though it does not present forewarnings of
an eventual doomsday. His art is not about the future, it
is about the present and concerns the hopelessness of un-
derstanding life through systems, the absurdity of ortho-
dox forms of rationality, and the meaninglessness of life
and art when viewed from a universal vantage point.
This futility is aptly underscored in such a work as *Non-
site, Oberhausen, Germany*, in which steel bins are fab-
ricated to hold the waste by-products accumulated in
making them.

Instead of perpetuating in his art the fiction of hope
and progress, Smithson, especially in such works as
"The Monuments of Passaic" essay and *The Spiral Jetty*

[6]*Tony Smith: Two Exhibitions of Sculpture* (Hartford: Wordsworth
Atheneum, 1966), catalogue to the exhibitions held in Hartford, No-
vember 8–December 31, 1966, and in Philadelphia at the Institute of
Contemporary Art, University of Pennsylvania, November 22, 1966–
January 6, 1967, n.p.

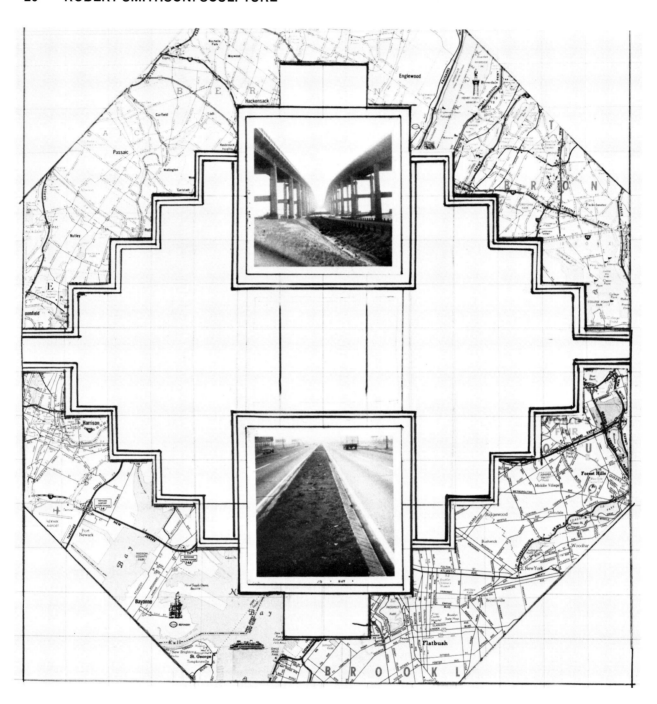

New Jersey, New York with 2 Photos, 1967; collage, maps, photographs, ink, pencil; 22 x 17¼". Collection Estate of Robert Smithson, Courtesy John Weber Gallery. Photograph by Nathan Rabin.

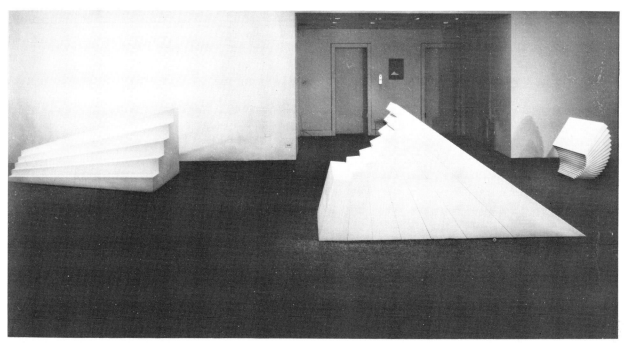

Installation view, Dwan Gallery, New York, March 2–27, 1968. From left to right: *Pointless Vanishing Point, Leaning Strata, Shift*. Photograph by Virginia Dwan, Courtesy Dwan Gallery, Inc.

film, creates a realm in which the distant past and ultimate future are self-canceling reflections of each other, forming a continuous desert of differentiated, undifferentiated, and dedifferentiated matter. In Smithson's art the prehistoric (whether it be earth as in the Nonsites or references to the pre-Olympian Greek god "Chronos" [*sic*] as in "Incidents of Mirror-Travel in the Yucatan") collides with the modern, and both come against an almost self-generating, definitely anthropomorphic intelligence, frequently in the essays an off-stage narrator, who is indebted to Robbe-Grillet's fiction. Together they represent various types of specialization. All three are caught in a framework that is both diachronic and synchronic; all are hopelessly intertwined in a never changing yet ever varying now; all ultimately are interlocked, yet separated and deflected. All contain the possibility of all meaning and consequently of absolutely no meaning because each truth is separate and incompatible with other truths. Examples of these kinds of truths appear to be knowingly parodied by Smithson who assumes the role of the art historian in his 1972 essay on the *Spiral Jetty* and finds spirals in such far-ranging places as salt crystals, helicopter propellers, and Van Gogh's ear. Somehow these various interpretations should congeal into one meaning, but they don't; they remain separate. These partial truths are important, however, because they point the viewer in the direction of Truth, while admitting their inability to deal with it directly.

Dialogue with the American Landscape

In the 1830s Thomas Cole, Hudson River School painter, often exhibited in such works as *Schroon Mountain* a great nostalgia about the present. Reared in England, familiar with the devastation already wrought on the landscape there by the Industrial Revolution, he looked at the still virginal American landscape with an eye to seizing hold of its primordial grandeur. He often captured the uniqueness of the landscape, its epic sweep and still untamed qualities, all of which he combined in *Schroon Mountain* into one scene to show changes of season, weather, and time of day. In his work he synthesized natural conditions that were soon to pass as man disturbed the delicate balance of nature, cut down trees, built settlements and factories, and polluted the environment.

Robert Smithson, resting on a New Jersey rock pile in 1968, surveyed the results of the Industrial Revolution evidenced by an abandoned quarry. He attempted to bring the ravaged landscape into his art. No longer looking for a primordial grandeur, for a startlingly beautiful landscape, as was Cole, Smithson immersed himself in the no longer useful fringes of the industrial world—abandoned rock quarries, tailings ponds, sludge heaps, idle tar pools, and retired oil rigs.

Smithson was interested in the American tradition of landscape painting in general and in Cole's work in par-

Thomas Cole, *Schroon Mountain*, 1838; oil on canvas; 39⅜ x 63″. The Cleveland Museum of Art, The Hinman B. Hurlbut Collection. Photograph courtesy The Cleveland Museum of Art.

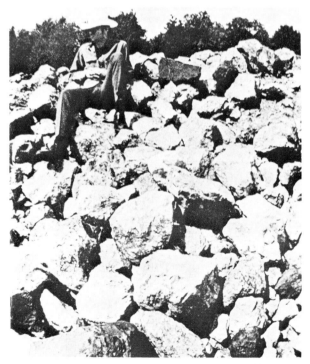

Robert Smithson sitting on a rock pile in New Jersey, 1968. Photograph courtesy Estate of Robert Smithson.

ticular, and his view of the landscape is an unidealized twentieth-century pendant to Cole's. Rather than looking for the most spectacular and enlarging on it in an almost Cecil B. DeMille fashion, as Cole did, Smithson accepted the conditions that were; he deliberately underplayed; and he sought out the prosaic along the wayside which he scrutinized until it became amazingly unfamiliar.

When visiting Italy, Thomas Cole became fascinated with the passage of time, to which he paid tribute in his imposing series *The Course of Empire*. The concept of passing time also framed his allegorical *Voyage of Life*.

Like Cole, Smithson was concerned with time. Having visited Rome briefly, he wanted to create a modern update of the Eternal City, and he found it in such suburban places as Passaic, New Jersey, where he was born. Suburbias are prepared ruins, twentieth-century-style conversions of weathered temples; they become eternal not through antiquity and endurance but through ubiquity. "A Tour of the Monuments of Passaic, New Jersey," a narrative work of art presented in the form of an essay in *Artforum* (December 1967), describes Smithson's day in the town; it shows the eternal to be always present, to be anywhere as long as it is nowhere in par-

ticular. Smithson's mundane eternity is suburbia and the "strip," places of rambling sameness with no one focus, places the artist pinpointed when he repeated Pascal's statement that "nature is an infinite sphere, whose center is everywhere and whose circumference is nowhere." Quoting Nabokov at another time, he said, "The future is but the obsolete in reverse." All Passaic is obsolete; it is a present already past, already used up. This eternal city, like Rome, has visible evidences of time withstood in the form of monuments. But the monuments—an early steel bridge with wooden walkways, a pumping derrick, great smoking pipes—are characteristically un-idealized. And those of a smaller scale are also worthy of note. "Along the Passaic River banks," Smithson wrote,

> were many minor monuments such as concrete abutments that supported the shoulders of a new highway in the process of being built. River Drive was in part bulldozed and in part intact. It was hard to tell the new highway from the old road; they were both confounded into a unitary chaos. Since it was Saturday, many machines were not working, and this caused them to resemble prehistoric creatures trapped in the mud, or, better, extinct machines—mechanical dinosaurs stripped of their skin. On the edge of this prehistoric Machine Age were pre- and post–World War II suburban houses. The houses mirrored themselves into colorlessness.

"Passaic Center," he recalled later in the essay, "loomed like a dull adjective. . . . Actually, Passaic Center was no center—" he admitted, "it was instead a typical abyss or an ordinary void. What a great place for a gallery!"

Both Thomas Cole and Robert Smithson were influenced by eighteenth-century aesthetic categories: Cole with the sublime; Smithson with its less dramatic descendant, the picturesque. While the sublime deals with the strongest aesthetic emotion one is capable of feeling, and indicates that one is caught up in an environment, the picturesque (a term originating in art) suggests ways that the world has been aestheticized, and implies some distance between the viewer and the work. Smithson is the great rediscoverer of the picturesque; he looked for ways to understand devastated industrial areas, to take hold of them in aesthetic terms, and he found a ready-made concept in the picturesque, which deals primarily with change, and which assumes an aesthetic distance between viewer and landscape. In Cole's art of the 1820s and 1830s all sublime paraphernalia, occurring earlier in European art—splintered trees reflecting the uncontrollability of nature coupled with strong dark and light effects, broken irregular shapes, and awesome scale—is given a believable American form. Smithson took a less

heroic stance when he consciously employed the picturesque, emphasizing particularly its casual unevenness and its down-home rusticity. He was also intrigued with the picturesque's emphasis on contrast and transition. The picturesque landscape is a dialectical landscape. In *Partially Buried Woodshed* (Kent, Ohio, January 1970) Smithson created a picturesque situation when he ordered loads of dirt piled on a rustic vacated woodshed until the building started to give way. After creating the piece, he donated it to Kent State University with specific instructions that "the entire work of art is subject to weathering [which] should be considered part of the work." In light of this piece it is interesting to consider that aging rural thatched cottages situated at the end of curving lanes frequently characterize the picturesque, while the awesomeness of an already ruined cathedral is used to illustrate the sublime. Although he tended to romanticize the prosaic and cultivate the ordinary, Smithson deliberately minimized potentialities for the sublime in his art. He chose unfrequented places like the Pine Barrens and Bayonne's Line of Wreckage in New Jersey, because they are commonly considered unspectacular.

His Sites, then, are frequently unmemorable post-industrial places that bear the burden of change; often they are still in transition. And his Nonsites exude a feeling of uneasy containment, as if sandboxes were required to carry the burden of a despoiled landscape. The lack of ease, the feeling that something is missing in the gallery piece, is deliberate. Smithson wanted to show that art in the gallery is a diminution of a far more interesting activity—going to actual locations. The work of art in his hands becomes not so much a pictorialization of an idea—though he does use the realism of geology, namely mapping and ore sampling—as it is the residue of an activity. His Nonsites are also anticlimatic. The ore is dumb and inert: its relation to the Site is analogous to those surprisingly mundane rock samples brought back from the moon.

While Smithson's Sites and Earthworks deal with the picturesque, his Nonsites are mainly concerned with manifesting meaning through ideas commonly associated with the materials used. For example, in *A Nonsite, Pine Barrens, New Jersey*, the gallery piece comprises a land marker or three-dimensional map consisting of actual sand from the rarely used government landing strip and a two-dimensional map that helped to locate the Site. In this sculpture he makes a tacit reference both to the sandbox analogy he used to explain entropy and to the actual sandbox in Passaic that he proclaimed a monument.[7] And in *Asphalt Lump* (1969) Smithson allowed

[7] See "The Monuments of Passaic," in this volume.

the unaltered material itself to connote gravity and inert-ness. The idea of using elements of the real world in a work of art is common to art of the last three decades. The approach itself was innovated much earlier by the Cubists—when newspaper was represented on a table, Picasso collaged a bit of *Le Journal* to the surface of his work. Jasper Johns carried the idea to an extreme when he painted *Flag* (1955), throwing in doubt whether he was creating a painting or an object, making a representation or a presentation. Many American artists since the 1950s have attempted to make their symbols as literal as Johns's flags. They have feared nineteenth-century sentiments as they have also been distrustful of a subject that is not an inherent component of the materials manifesting it. Subject matter and meanings should not be an overlay, many artists have felt; if they are, the work will be an illustration. Artists such as Smithson, Robert Rauschenberg, Andy Warhol, Robert Morris, Donald Judd, and Carl Andre in the past two decades have tried not to illustrate, and they have refrained from dealing with awesome ideas like the sublime. Though they avoid literary overlay, modern vanguard artists have continued to subscribe to metaphorical meanings. The main limitation they have set is that the meanings must be an inherent part of the material.

Exemplary of this literalism is Smithson's Site, Nonsite, and Mirror Trail that he created in 1969 for "Earth Art," the first museum exhibition of its kind, held at Cornell University. For this work, the artist selected the Cayuga Rock Salt Company mine in nearby Lansing as his Site, the University museum's gallery as his Nonsite, and a series of points designated on a map between the two for his Mirror Trail.

The entire piece was called *Mirror Displacement (Cayuga Salt Mine Project)*, and there are a number of types of displacements involved. First there is a displacement, pure and simple, from one place to another when rock salt is carried from the mine to the gallery. Then there is a displacement of often oblique and blurred images by the mirrors. Further, the artist created an interesting inversion of another form of displacement found in his other Nonsites. Instead of constructing a rigid metal bin to hold amorphous material, he used rigid mirrors in the center of the various sculptures and allowed amorphous rock salt to lie along the periphery. The placement of rocks of salt admittedly appears random; but on the molecular (nonvisual) level, each grain of salt is highly structured since it is in a crystalline state. Moreover the glass making up the mirrors, which looks regular, is ac-

tually irregular in its molecular composition. Glass is noncrystalline; it is a congealed liquid in an inert state, and on the molecular level it is amorphous. Since he did study crystallography, Smithson may well have been conscious of all these meanings. Terming the *Project* a Nonsite is ironic, then, since the visual appearance of the piece is overturned once the elements are considered in terms of their molecular structure. The piece itself presents an ongoing dialectic between sight and nonsight which reinforces that other dialectic, between Site and Nonsite. The ideas presented in *Mirror Displacement (Cayuga Salt Mine Project)* are not a literary overlay; they are manifested by the materials comprising the piece. Smithson could thus convey meaning without resorting to illusionism. In this work, moreover, he literalized two traditional aspects of the work of art—its purity and its ability to reflect the world—by finding materials capable of constituting these ideas: salt, which is chemically pure as it comes out of the ground, and mirrors, which displace and reflect aspects of the external world.

Smithson was concerned with the picturesque while Thomas Cole was fascinated with the sublime. Randomness and change were important aesthetic considerations for Smithson. Unlike the Hudson River landscapist who preserved, with an aim at achieving the greatest effect, something very precious that eventually did disappear, the Earth artist was a confirmed realist—one might almost say scientific realist—who accepted the nineteenth-century artist's intimations of a dreaded future. But Smithson went further than Cole; he accepted change without making moral judgments, and he viewed the present as an already past tense.

Although Smithson was concerned with the picturesque, he was not limited to it. Rather than adhering to any one school of thought he opted for a method—the method of dialectics—which he used for a precarious, fluctuating synthesis. Creating an art in which dialectics are structured but not resolved, he erected antitheses such as Site/Nonsite, space/nonspace, and seeing/nonseeing. His importance lay in his realization that if art is about vision, it can also be about blindness, and he made works that hinged on these opposites, keeping them viable options for formulating and understanding art. In Smithson's terms, even nonunderstanding was worthy of study. Contrary to custom, in Smithson's art limits cannot be clearly established, and muddled issues are not to be clarified because their indeterminate lack of focus is an essential distinguishing characteristic.

BREAKING CIRCLES: THE POLITICS OF PREHISTORY

Lucy R. Lippard

The two aspects of Smithson's art that most interest me appear to be contradictory, though he managed to make of them a workable "dialectic." These are, on one hand, his preoccupation with nature, geological time, ruins and prehistoric monuments and landscapes, and on the other, the skeptical politics that informed his expansive notions of public art. After "digging through the histories," Smithson admitted "a tendency toward a primordial consciousness. . . . our future tends to be prehistoric."[1] However, his work is distinguished from that of more nostalgic "primitivists" by its avant-garde attachment to the "ugly"—to swamps, industrial wastelands, barren ravished landscapes—and by his commitment to the practical rehabilitation of land through an original socioaesthetic vision. Thus Smithson's interest in the prehistoric can be seen as a symptom of political pessimism amid the ruins of the "new world" at the same time that it can be seen "dialectically," as an act of faith in new roles and powers for artists in this ruined world.

I have already used the word "dialectic" twice. It is ubiquitous in writings by and about Smithson—a handy and much overworked term, radically flavored but safely synthetic. Yet his use of it disavowed the easy balance and the happy ending: "Dialectics is not only the ideational formula of thesis-antithesis-synthesis forever sealed in the mind, but an ongoing development," he said. His other favorite word was entropy: "a condition that's moving toward a gradual equilibrium"; or, as he quoted Wylie Sypher, "Entropy is evolution in reverse." Smithson loved the notion of chaos—"the

constant confusion between man and nature." A similar confusion can be made of these two words. Their relationship is at the core of his art's unresolved contradictions. Entropy, though transformative by nature, is heading for energy drain or "nullification"; it is associated with negativity and death. Dialectics, on the other hand, has a positive connotation of increased energy, the critical tension through which life asserts itself. The way they could end up in the same place may be what fascinated Smithson, and perhaps that place was the timelessness Ad Reinhardt also saw at the end of the tunnel. Smithson saw entropy as "a mask for a lot of other issues, a mask that conceals a whole set of complete breakdowns and fractures," including those besetting America in the late 1960s. He saw "no hope for logic," said "nothing is more corruptible than the truth," and called his own work "a quiet catastrophe of mind and matter."

These attitudes, and the scope of his ideas, allowed him a rhetorical freedom that often angered and provoked those of us (all of us) who argued with him. During the last eight years or so that he was in the art world, Smithson was unavoidable in and integral to its inner and outer workings—a thorn in the communal flesh who took over where Reinhardt had left off.[2] He began to write in 1964/65 and later quoted Giacometti: "It's hard for me to shut up. It's the delirium that comes from the impossibility of really accomplishing anything." Certainly he was describing his own fascinating mixture of prose and polemic when he wrote about language "covering" rather than "discovering": "In the illusory babels of language an artist might advance specifically to get lost, and to intoxicate himself in dizzying syntaxes, seeking odd intersections of meaning, strange corridors of his-

[1] Unless otherwise indicated, all quotations from the artist are taken from *The Writings of Robert Smithson*, ed. Nancy Holt (New York: New York University Press, 1979), and from a 1969 interview with Patsy Norvell not included there, published in Lippard, *Six Years: The Dematerialization of the Art Object* (New York: Praeger, 1973), pp. 87–90. Now and then I have included phrases of my own from the two-part obituary of Smithson I wrote for *Studio International*, October–November 1973.

[2] Reinhardt's "tautologies" influenced Smithson despite their persistent abstraction. Both men were great talkers and spent a lot of time in the artists' bars fending off popular opinion; both were bitingly humorous critics of the art scene; and both are still badly missed.

tory, unexpected echoes, unknown humors, or voids of knowledge . . . but this quest is risky, full of bottomless fictions and endless architectures and counterarchitectures." At a time when most critical writing was reasonable, dry, spare, and superior in tone, this damp avalanche of querulous contradictions opened up a flood of new possibilities.

Smithson never fully resolved the puzzles he enjoyed setting himself. Dialectic or no dialectic, the three-dimensional counterparts of his extraordinary "Smithsonian" of ideas did not always measure up to his intangible visions and his descriptions of them. Yet now that he is no longer around to argue with (and this essay is in a sense a continuation of my arguments with Smithson), that seems less problematic. There is no question that he has become the only well-known artist I can use as a model for what I think artists should have been doing for the last decade. Had he not been first and foremost a sculptor, neither his writings nor his ideas would have been half so important. They were totally embedded in the physical sense of time, space, and matter, and this is what gave them their unique power. Smithson was, as he claimed to be, a "materialist": "My work is impure; it is clogged with matter. I'm for a weighty, ponderous art," he wrote in the midst of a trend against "the precious object" and toward "dematerialization." He saw his writing "more as material to put together than as a kind of analytical searchlight. . . . I would construct my articles the way I would construct my work."

Contemporary criticism did not please Smithson any more than it did most artists: "Critical boundaries tend to isolate the art object into a metaphysical void, independent from external relationships such as land, labor, and class," he complained about the prevalent formalism. In frustration, he, with Don Judd, Robert Morris, Ad Reinhardt, Dan Graham, and Sol LeWitt, produced the best art writing of the 1960s. Smithson in particular incorporated the real world: "In the Marxian sense of dialectics, all thought is subject to Nature. Nature is not subject to our systems. . . . Dialectics could be viewed as the relationship between the shell and the ocean. Art critics and artists have for a long time considered the shell without the context of the ocean."

This statement, of course, paraphrases the Left's classic argument against art for art's sake. But Smithson gave it a special and very concrete existence. Though subject to slow change, his three large-scale Earthworks were all basically single images (in one case paired). They could therefore be relegated to the category of "objects" in the landscape, particularly once their inaccessibility led them to be photographed as such. The art audience for the most part has experienced the *Spiral Jetty* (under water for several years now), *Amarillo Ramp*, and *Broken Circle/Spiral Hill* as pictures rather than as actual sensuous experiences. (*Asphalt Rundown* too remains for me a single image of frozen motion.) The small-scale and temporary outdoor mirror pieces, also known primarily as photographic records, suggest more powerfully the infinity of the actual experience, and one can more easily sense that *Partially Buried Woodshed* involves both inside and outside spaces. It was the Sites/Nonsites, however, that were Smithson's major *innovations*, in part because they took into consideration the Earthworks' lack of accessibility and, with maps and rocks, provided a physical rather than a pictorial memory.

The Site/Nonsite juxtapositions offered a highly original way of seeing places both as art and as independent from art systems, and they have deeply affected the concept of art outdoors. They established the connections between the "center" (the gallery where dirt and rocks were, sometimes coyly, piled or boxed) and the "fringes" (maps which could be read as "everywhere else" but referred to specific "discarded systems" invisible to most viewers): "My interest in the site was really a return to the origins of material, sort of a dematerialization of refined matter . . . a sort of rhythm between containment and suffering."

The major psychological impetus of Smithson's "dialectic" seemed to be the tensions of escape from such "centers." His circles were almost always broken to provide a way out. Yet the Sites/Nonsites recalled his awareness that "no matter how far out you go, you are always thrown back on your point of origin. You are confronted with an extending horizon; it can extend onward and onward, but then you suddenly find the horizon is closing in all around you, so that you have this kind of dilating effect. In other words, there is no escape from limits. . . . All legitimate art deals with limits. Fraudulent art feels it has no limits. The trick is to locate these elusive limits." While Smithson's favored *images* (derived from natural forms) were more or less compact crescents, circles, spirals, and confined meanders, his favored *visual ideas* were mirrors and the horizon: mirrors canceling out each other and nature by reflections, and the horizon appearing to be an edge, but receding into infinity as one tries to approach it.[3] Both provide *illusions of finality*.

[3] In 1969, for a show in Seattle, according to Smithson's instructions, I executed four hundred square snapshots of horizons—"empty, plain, vacant, common, vacuous, ordinary, dull, level beaches, unoccupied uninhabited deserted fields, scanty lots, houseless, typical, average, void, sandbars, remote lakes, distant, etc." These were hung in an appropriately horizontal grid. "A horizon is something other than

The political ramifications of the Site/Nonsite idea for public art are potentially vast. While Smithson acknowledged that most people wouldn't visit the "fringes," he emphasized the importance of knowing they were there. This raises the problem of "audience," which he never confronted head-on, though he thought of the Earthworks as "collaborative" art and loved the idea of workers on the *Spiral Jetty* bringing their families to picnic near the site, transforming it, in fact, into a park. His notion of Earthworks was far more complex than the academic one of "drawing on the earth," or using dirt as "a new sculptural material," but he was too much of a realist to swallow the utopian idea that Earthworks would change the world and "get art out of the gallery." For all his railing against "cultural confinement," Smithson knew that at this point in history artists were not going to escape from the art world because there was no place else to go.[4] "Confined process is no process at all; it would be better to disclose the confinement rather than make illusions of freedom," he said. "The only way things would be better would be if isolation were discouraged and cooperation was more of a factor." He could also indulge in arrogance (he saw "no place" for Larry Poons's and Frank Stella's "isolated" works) and wishful thinking (he did not see his Earthworks as "collectible. They're supported through the cooperation of different groups that have no commodity fetish").

Smithson's art was public, then, not in the sense that it entertained or responded to any particular non-art audience (though it vaguely aspired to do so). It was public art in its drive to communicate the ideas he made physical about the nature of nature, of land use, history, time, and civilization. The exception was *Broken Circle/Spiral Hill*, just outside Emmen, Holland, executed in 1971 under the auspices of the Sonsbeek outdoor art exhibition. It is the only land reclamation piece Smithson was to make, and it was popular with its audience—the townspeople who voted to maintain it indefinitely. It was built in an abandoned quarry in an area atypically unpopulated for Holland, combining a "backwater site" with easy access from town. Far more complex than either *Spiral Jetty* or *Amarillo Ramp*, *Broken Circle/Spiral Hill* is emblematic of Smithson's political and aesthetic concerns, integrating an ecologically aware public art and the imagery of a "prehistoric future."

The circle itself is a double, or mirrored, or

positive/negative semicircle made half of land and half of water, half jetty and half canal. Its shape is defined by the one arm embracing a section of green lake and the other cut into yellow sand with the bank as the 140-foot diameter. The hill on top of the bank is dark brown, its coiling ascent marked by a spiral of white sand. Smithson saw the piece and the exhibition as "a direction away from the centralized museum into something more social and less esthetic. I would say mainly in Europe one would have to work in a quarry or in a mining area, because everything is so cultivated in terms of the Church or aristocracy." He had the form in mind before he saw the site, which was perfect for it: "The quarry itself was surrounded by a whole series of broken landscapes, there were pasture lands, mining operations and a red cliff—it was a kind of sunken site," which could be viewed from the hill on a high bank.

When Gregoire Müller asked him if this aerial view didn't make the piece into an "object," Smithson replied it didn't: "What you have there are really many different scale changes. Speaking in terms of cinema, you have close, medium and long views. Scale becomes a matter of interchangeable distances. If you are immersed in a flood you can drown, so it is wiser to perceive it from a distance. Yet, on the other hand, it is worth something to be swept away from time to time." This flood imagery came not only from his own "oceanic" worldview, but also from associations with Holland's history and the fact that the piece was constructed by building a dike and flooding the inner circle. As he was working, "it began to function as a kind of microcosm for this natural catastrophe"—a flood that had happened in Holland in 1951.

The "accidental center" of *Broken Circle/Spiral Hill* is a huge boulder that turned out to be too expensive to move out of the way. Smithson disliked the way its intrusion focused the piece, "blotted the circumference"—"a cyclopean dilemma" impossible to escape "just as the earth cannot escape the sun." It became "a dark spot of exasperation, a geological gangrene on the sandy expanse. Apprehensions of the shadowy point spread through my memory of the work." Even after the piece was completed, he thought he might return to Holland and bury the boulder in the center or move it outside the circumference. But eventually it was left as "a kind of glacial 'heart of darkness'—a warning from the Ice Age," which in fact significantly expands the associative levels of the work.

For instance, it ties the circle/spiral to geological and prehistoric phenomena. Such rocks are rare in Holland, existing only along a glacial moraine that runs on a diagonal line through the country. In the Bronze Age they

a horizon," he wrote. "It is closedness in openness, it is an enchanted region where down is up. Space can be approached but time is far away."

[4] And for all his rebelliousness, he had every intention of keeping a *pied à terre* in the gallery system, where he enjoyed a very good personal and professional relationship with his dealer/patron Virginia Dwan, and, later, with John Weber.

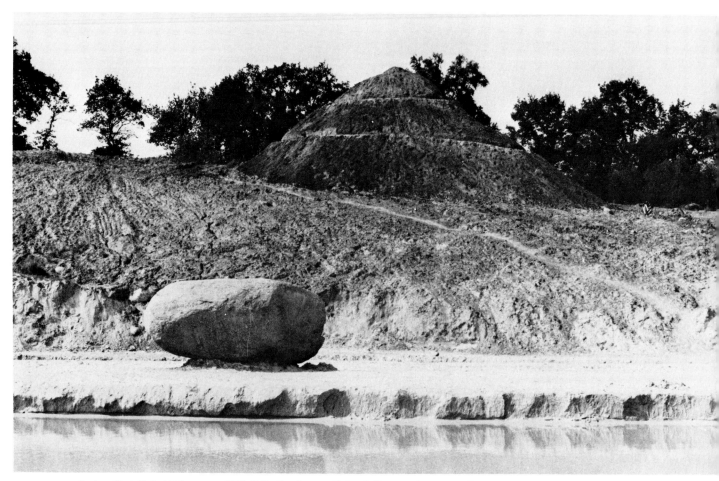

Broken Circle/Spiral Hill, summer 1971. Collection Emmen, Holland. Photograph courtesy Estate of Robert Smithson.

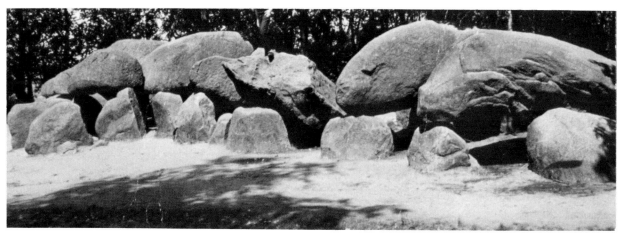

Hun's Bed—Holland postcard. Courtesy Estate of Robert Smithson.

were used to make huge dolmens or passage tombs, once covered with earth mounds, their stone skeletons now exposed on the flat landscape like lurking mastodons. Smithson passed such a "Hun's Bed" each day on his way from town to his site and it became very important to him. He planned a film in which the *Hunebeden* were to appear with the rocks' surfaces connecting these ancient monuments to his own *Broken Circle/Spiral Hill*. He "had in mind shooting a boulder of a Hun's Bed and then zooming into the rock so that you only see the surface, and then pulling back so as to see the rock surface of my boulder. There would be a forward zoom and a backward zoom that would link up the two boulders in a kind of cinematic parallel that would cover vast stretches of time."

It is appropriate that this piece, with its content specifically tied to ancient sites, was made in Europe, where innumerable and often unnoticed prehistoric monuments are virtually underfoot, and where the layers of human-made nature are so much more obvious than in America. *Broken Circle/Spiral Hill* is Smithson's most literary sculpture—perhaps also a tribute to a culture in which myth, history, and geological time are so fruitfully merged. The *Spiral Hill* rises like the tower of Babel over the *Broken Circle*, vertical where the circle is horizontal and counterclockwise (winding back into the past) where the circle reads clockwise (moving into the future).[5] Given ancient mythologies, for instance, the boulder can be seen as a seed or egg (Smithson's notion of burying it has a ritual flavor). It gives a bone, or hard core, to the soft flesh of the earth, and will be there long after the piece itself has disappeared—perhaps another reason for the artist's ambivalence (unfair competition from nature).

As Smithson disliked centers, he also disliked cycles: "I think things just change from one situation to the next, there's really no return." Geologist David Leveson has written that while circles "embody the excitement of motion together with the security of going nowhere," the spiral is "a conceptual configuration."[6] It is also the form taken by a destructive or overpowering nature—the form of the whirlpool and the tornado. And it is an ancient symbol of growth, fertility, and healing, associated in many cultures with woman, with breasts, eyes, and mounds, with water and with snakes. Water is a major factor of change in all of Smithson's Earthworks and many of his projects; because of his writings it suggests

ancient seas and vanished continents as well as the origins of life. The snake is the only vertebrate whose movements reproduce the pattern of water. With Christianity, this matriarchal emblem became the epitome of paganism and was banished to caves and association with evil forces (and, later, to Freudian sexual interpretations). Saint Patrick may have rid Ireland of snakes in his cleanup campaign for the new religion, but the ancient spiral cut in the rock of the great passage grave at Newgrange remained, to be penetrated by a beam of light only at midwinter sunrise. Smithson was aware of all these prehistoric monuments, including the great Serpent Mound in Ohio, which impressively combines the spiral and the meander. He collected snakes as a boy and, according to Dale McConathy, "forever after he saw himself as reptilian, cold and earthbound"[7] (which could also have been an unconscious part of his rebellion against Catholicism). The serpentine form is ubiquitous in his work. The uroboric broken circle and the dynamic spiral were simply more intense versions of the "wandering," "labyrinthine," "forking," "branching," "floating," and "flowing" images in his sketches and sculptures. "Nature does not proceed in a straight line," he said. "It is rather a sprawling development. Nature is never finished."

For all his fondness for entropy and impasse and his antipathy to any "spiritual" interpretations of the highly spiritualized forms he chose to use, Smithson's art was always linear and always on the brink of renewed motion. Chaos isn't linear. Only in his writings (and perhaps the films and film scripts) did he achieve that centerless "morass" he sought and did not want to find: "As long as art is thought of as creation, it will be the same old story. Here we go again, creating objects, creating systems, building a better tomorrow. I posit there is no tomorrow, nothing but a gap, a yawning gap. That seems sort of tragic, but what immediately relieves it is irony, which gives you a sense of humor. It is that cosmic sense of humor that makes it all tolerable. Everything just vanishes. The Sites are receding into the Nonsites and the Nonsites are receding back to the Sites." Yet in response to Charles Reich's trendy declaration (in *The Greening of America*) that the "hard questions" of politics and economics were "insignificant, even irrelevant," Smithson replied that on the contrary "these 'hard questions' are going to have to be faced—even by artists."

Smithson's politics seemed a product less of his own situation in life or of any deep social concern for others than of native curiosity: "I'm just interested in exploring

[5] Will Insley suggests that all Smithson's spirals are counterclockwise and all circles clockwise, though I don't know how you tell with the circles except for their resemblances to clocks. (See his article in *Arts*, May 1978.)

[6] David Leveson, *A Sense of the Earth* (Garden City, N.Y.: Doubleday/Anchor, 1972), p. 41.

[7] Dale McConathy, "Keeping Time: Some Notes on Reinhardt, Smithson and Simonds," *Artscanada*, June 1975.

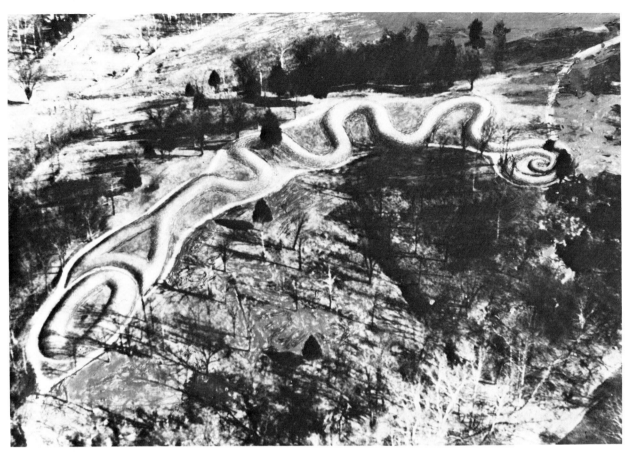

Serpent Mound, Adams County, Ohio (Hopewell Culture). Photograph courtesy Ohio Historical Society.

the apparatus I'm being threaded through, you know."
He felt it was "silly for artists to try to overcome" the
whole system "because they will just be absorbed.
. . . If there really was an alternative, consciously
thought, then artists might do works which are radical,
but they are unconscious about why they are doing them.
. . . Their purity is the opiate, the reward that they get.
While the external value structure is ripping them off, at
the same time they are telling them how pure they are. I
mean religion functioned that way too." In 1969/70, a
number of artists were talking like this and endless dis-
cussions took place in the bars and in meetings of the
AWC (Art Workers' Coalition) meetings that Smithson
infrequently and inactively attended. We were all just
coming to understand the way the art world, or the cap-
italist system, can buy, devour, and use for its own ends
whatever comes within its reach, like the proverbial
monster in the cave; and how art out of its reach tends
not to be called art.

Smithson was too much of a pragmatist to join in the
orgies of rage and desperation in which some of us were
passionately involved. He watched the AWC as a de-
tached bystander, too aware of our powerlessness to join
in, and amused by the spectacle of all of us "idealists"
scrapping with each other. He was probably as politi-
cally confused about the role of the artist as the rest of
us, but he also probably enjoyed it more, since chaos
moving toward entropy was his natural element. He
brought to our common dilemma an ironic mixture of
Marxism and anarchy that applied directly to his own art
and ideas: "Art should not be considered merely as a lux-
ury, but should work within the processes of actual pro-
duction and reclamation. We should begin to develop an
art education based on relationships to specific sites.
How we *see* things and places is not a secondary con-
cern, but primary." Such statements were significant not
for their uniqueness, but because of their incorporation
into the mainstream of an art practice that had hitherto
ignored them; Smithson presented them as art itself,
which allowed them to pass. By applying his analysis of
"space control" to life as well as to art, he exposed so-
cial implications that had previously been buried in aes-
thetics.

The Sites/Nonsites illuminated the contemporary art-

ist's basic problem—that of cooptation. How far can you stretch from the center without being snapped back again? In one wonderful diatribe, Smithson saw the "Establishment" as "a deranged mind that appears to be a mental City of Death . . . a political dream world . . . a nightmare from which I am trying to awake" by pitting a "sedimentation of words" against the "maze-like patterns" and "brainless slogans" of the bureaucracy. When *Artforum* published its 1970 symposium on art and politics (which I recommend in retrospect for its agglomerate of sandstone and gems), Smithson contributed in characteristically diluvial prose:

> The artist does not have to *will* a response to the "deepening political crisis in America." Sooner or later the artist is implicated or devoured by politics without even trying. My "position" is one of *sinking* into an awareness of global squalor and futility. The rat of politics always gnaws at the cheese of art. The trap is set. If there's an original curse, then politics has something to do with it. Direct political action becomes a matter of trying to pick poison out of boiling stew. The pain of this experience accelerates a need for more and more actions. "Actions speak louder than words."[8] Conscience-stricken, the artist wants to stop the massive hurricane of carnage, to separate the liberating revolution from the repressive war machine. Of course, he sides with the revolution, then he discovers that real revolution means violence too. . . . Artists always feel sympathy for victims. Yet, politics thrives on cruel sacrifices. . . . why are so many artists now attracted to the dangerous world of politics? Perhaps, at the bottom, artists like everybody else yearn for that unbearable situation that politics lead to: the threat of pain, the horror of annihilation, that would end in calm and peace.[9]

His was clearly a personal viewpoint; others felt they were politically involved because if everybody weren't involved nothing would ever change. The rest of his statement sailed off into an apocalyptic science-fictional vision of the dire results of involvement. Yet politics was a fine metaphor for the formless cloud Smithson gloomily eulogized in his writings. "I'm interested in the politics of the Triassic period," he told Philip Leider humorously.[10]

In the intervening decade, the politics of nature have become increasingly urgent. I can just hear Smithson on the absurdities of the current energy crisis. He had already predicted the evangelical popularization of ecol-

ogy: "All those sins. And here's 2000 coming so near. Sins everywhere. The dead river with its black oil slime. The crucified river instead of the crucified man. When do you think they'll start burning polluters at the stake?"[11] He had it in for the earnest utopian ecologists because in 1969 they had persuaded the powers that be to veto his projected transformation of the Miami Islet in the Strait of Georgia with one hundred tons of glass—to convert "an ugly pumice island" into "a thing of beauty subtly reflecting the light off the water."[12] Another Vancouver project was for an *Island of the Dismantled Building*, to be capped by concrete sections of a demolished building transported from the city. Nineteenth-century geologists saw the mountains as ruins of the earth's crust, and today the ruin seems an ideal political symbol. Smithson's best-known ruin—*Partially Buried Woodshed* at Kent State in 1970—became a specific social monument after the event. It eerily predicted the massacre of youth by a militarized society, which the piece originally implied only in a general sense.

In accordance with his notion of "de-architecturization," Smithson commented acidly on the quality of city planning: "Buildings don't fall into ruin after they are built, but rather rise into ruin *before* they are built." He equated waste and luxury and chance: "It seems that when one is talking about preserving the environment or conserving energy or recycling, one inevitably gets to the question of waste and I would postulate actually that waste and enjoyment are in a sense coupled." He used as an example the fact that Kennecott was planning to "reclaim" the gigantic Bingham Pit in Utah by refilling it—which would not only take some thirty years, but would entail destroying a mountain to fill up the hole. When he said "utility and art don't mix," one has to assume that he saw his own reclamation projects as useless except in the important sense that he also saw the potential for art to "become a physical resource that mediates between the ecologist and the industrialist. The Peabody Coal, Atlantic Richfield, Garland Coal and Mining, Pacific Power and Light, and Consolidated Coal companies must become aware of art and nature, or else they will leave pollution and ruin in their wake." He saw the present reclamation laws "dealing with a general dream or an ideal world long gone." He was bemused by the artificial separation made between art and nature, man and nature—such as the aesthetic distinctions drawn between visually similar cliffs made by "nature" and by strip mines: "New York itself is natural like the Grand

[8] Here he might have been recalling one of Reinhardt's anti–Abstract Expressionist jokes: "actions speak louder than voids."

[9] *Artforum*, September 1970.

[10] Quoted in Philip Leider, "How I Spent My Summer Vacation, or, Art and Politics in Nevada, Berkeley, San Francisco and Utah," *Artforum*, September 1970.

[11] Ibid.

[12] *The New York Times*, March 1, 1970; this is an atypical quote, since Smithson did not usually evoke the beauty/ugliness dichotomy in such a conventional manner.

Granite Crystal, 1972; pencil; 18 x 24½". Collection Estate of Robert Smithson, Courtesy John Weber Gallery. Photograph by Nathan Rabin.

Canyon. We have to develop a different sense of nature . . . that includes man. . . . As an artist it is sort of interesting to take on the persona of a geologic agent where man actually becomes part of that process rather than overcoming it.''

Smithson would have agreed with Ian McHarg's envisioned society of ''Naturalists'' which makes no divisions between the natural and social sciences and is obsessed with a need to understand nature, including humankind. The Naturalists understand meaningful form, but they use the term ''fitness'' instead of ''art'' because it embraces natural as well as artificial creativity.[13] He once described a city in terms of crystalline networks; he liked Mesa Verde, where art and necessity appeared as one, or ambiguous prehistoric sites in Europe and America where time had blurred or destroyed

[13] Ian McHarg, *Design with Nature* (New York: Doubleday/Natural History Press, 1969).

the boundaries between human-made and natural, order and disorder. Yet his attitude toward the land was basically antiromantic (or his romanticism took the form of an acute distaste for other people's romanticism). He avoided ''scenery'' and dismissed ''beauty spots'' as ''nature with class.''

This attitude could be disorienting for your standard romantic; I remember pointing out to him the ''lovely view'' in coastal Maine in 1972; he could not have been less interested. What he liked was underfoot—a rocky conglomeration of many different kinds and strata of rock that could be read like the pages of a history book—the *substance* of nature rather than its ''looks.'' The roots of this attitude can be found in Smithson's long-standing interest in crystallography, in natural geometry. For instance, a didactic 1972 project (unexecuted) shows a huge chunk of granite protruding from a granite cliff like an illustration in a science primer: See the rock; see

what the rock is made of; see how it breaks along its fissures—the specific contained by the general.

In both art and politics, Smithson saw *abstraction* as the enemy. He equated it with two other prime evils—spiritualism and idealism. "Abstraction essentially is what rules capitalism. Abstraction is what separates production from work." He applied this basic Marxist principle of alienation to site art and land use: "I find a lot of artists completely confused. . . . They don't really know what they're doing there [at the site]. They're imposing an abstraction rather than drawing out an aspect or cultivating something in terms of the ecological situation." Similarly: "When the miner loses consciousness of what he is doing through the abstractions of technology he cannot cope with his own inherent nature or external nature."

Today we may be in the midst of what Max Horkheimer has called a periodic "revolt of nature" against what Paul Shepard has called "the profoundly anti-naturalistic separation of spirit and nature in the Judaeo-Christian religions."[14] There are times when too vast an overview can be an impediment to social action; Smithson had his own version of the "distancing" that was so much a part of the aesthetics of the 1960s—Brechtian at its best and Greenbergian at its worst. Artists' current obsession with the distant past may be in part a rebellion against the planned obsolescence from which art, like all other products, suffers in this society. Yet it is also crucial to avoid the notion of a return to some "natural" Golden Age that ignores modern social questions.

Shepard, in whose important book *Man in the Landscape* Smithson found many of his ideas corroborated and extended, perceived that "the final shaping of our attitude toward the earth is determined by our understanding of gender." David Leveson has compared mapping—"the expert tracing of contours"—to lovemaking; "land that is not mapped is not possessed."[15] Smithson's mapping of Sites for Nonsite exposure is a different approach to the same impulse. He envisioned "the possibility of a direct organic manipulation of the land devoid of violence and 'macho' aggression. . . . The farmer's or miner's treatment of the land depends on how aware he is of himself as nature; after all, sex isn't all a series of rapes." At the same time he made fun of the "ecological Oedipus complex" with which "every penetration of 'Mother Earth'" projected "the incest taboo onto nature."

However, the very connections Smithson made in his work and writings imply a certain regard for prenatal bliss; the meandering lines are umbilical cords leading back through the labyrinthine past into the "primal ooze" of "prima materia" to the womblike "underground" into which he was always "submerging," "sinking," and "falling"—words that consciously suggested sexual experiences and that were embodied in such pieces as the 1970 *Glue Pour*, the 1969 *Quicksand Map*, and the projected *Cinema Cavern*. In another sense, his commitment to low-profile, "lowdown" sites might also be seen as a kind of class nostalgia, an identification with the "underdog," a "downward mobility" similar to that Germano Celant must have had in mind when he called Italian process art *arte povera*. And on yet another level, all that submerging could be seen as part of Smithson's struggle to divest himself of the "facade of Catholicism" with which he was raised, as well as "this lurking pagan religious anthropomorphism" which similarly attracted and repelled him. However iconoclastic he became intellectually, Smithson remained aware of the Jungian "archetypal gut situation" based on "primordial needs and the unconscious depths," while continuing to disdain ecstatic merging or "rising" that might be associated with "spiritualism."

Shepard says that "the alternative to a chaotic world is not necessarily a disciplined one," and writes about the need to preserve all of nature—not just the pretty parts, citing "the swamp, the fertile muck," and its "uroboric nature." Smithson saw gardens and parks and museums as pictorialized, idealized, artificial, finished—"graveyards above ground—congealed memories of the past that act as a pretext for reality. This causes acute anxiety among artists, in so far as they challenge, compete and fight for the spoiled ideals of lost situations." No one at the time, however, was competing with him for "the more infernal regions—slag heaps, strip mines and polluted rivers. Because of the great tendency toward idealism, both pure and abstract, society is confused as to what to do with such places. Nobody wants to go on a vacation to a garbage dump. Our land ethic, especially in that never-never land called the 'art world' has become clouded with abstractions and concepts."

Smithson was a great admirer of Frederick Law Olmsted, who was praised by a contemporary as the producer of "great works which answer the needs and give expression to the life of our immense and miscellaneous democracy."[16] But despite his provocative writings about parks and his perception of the park itself as the major form of public art, Smithson never worked in the

[14]Paul Shepard, *Man in the Landscape* (New York: Ballantine Books, 1967); this book was obviously a very important source for Smithson.

[15]Leveson, p. 71.

[16]Charles Eliot Norton on Olmsted, quoted in Smithson's "Frederick Law Olmsted and the Dialectical Landscape" (see note 1, above).

city.[17] Perhaps it had too much life of its own. He liked to operate in the gap between the utilitarian lives of a place, preferring the modest blankness of "a small quarry, a burnt-out field, a sand bank, a remote island" to a highly populated urban area. "The real estate in towns is too expensive," he explained, "so that it's practical, actually, to go out to wasteland areas whether they're natural or manmade and reconvert those into situations. The Salt Lake piece [*Spiral Jetty*] is right near a disused oil drilling operation and the whole northern part of the lake is completely useless. I'm interested in bringing a landscape with low profile up, rather than bringing one with a high profile down."

What he wanted most, he never got—a chance to make rehabilitative public art in these "disrupted areas" on a truly grand scale, commensurate with the damage done by the industries. Smithson spent his last years traveling the United States trying to persuade strip miners and other corporate despoilers of the earth to let him resurrect it. He bought an island of his own in Maine and planned a meandering canal and jetty for it, but spent most of his energy pleading his broader cause and even-

tually decided not to use the island because it was too "scenic." He was alternately gloomy, bitter, and hopeful. Just before his death it seemed he might actually get to transform a huge devastated mining site in Creede, Colorado. He made drawings for a *Tailing Pond* labeled "25 years, 9 million tons, Diameter 2000′ " and even bought stock in the company. There were the usual delays. Impatient to begin replacing old values, he took on the privately sponsored *Amarillo Ramp* and fell from the air to the earth while photographing it, like some twentieth-century Icarus.

The greatest tragedy of Smithson's early death is not merely that there will be less "good art" in the world, but that he was virtually the only important artist in his aesthetic generation to be vitally concerned with the fate of the earth and fully aware of the artist's political responsibility to it. Perhaps the best indication of the social importance of his work is a geologist's description of the geologist's (rather than the artist's) task: "To interpret the earth to society . . . to bridge the gap between pattern and process." Or, as René Dubos put it: "The geologist cannot escape dedication to history, and this makes him the epitome of western man, whose tragic sense of life comes from his awareness that he is not absolute and final."[18]

[17]In the last few months of his life, however, he did express an interest to Charles Simonds (then making a small park on the Lower East Side himself) in finding a vacant lot to work in; he had previously had a few other ideas for cities which were never executed.

[18]Leveson; René Dubos in preface to Leveson, p. 11.

SITES / NONSITES

Lawrence Alloway

"In June, 1968, . . . I visited the slate quarries in Bangor-Pen Argyl, Pennsylvania," Smithson wrote. "Banks of suspended slate hung over a greenish-blue pond at the bottom of a deep quarry. All boundaries and distinctions lost their meaning in this ocean of slate and collapsed all notions of gestalt unity. I collected a canvas bag full of slate chips for a small Non-Site."[1] This is Smithson's record of the origin of an early Nonsite.

Before creating the Sites/Nonsites of 1968 Smithson made a series of field trips and excursions, documented in a photo album now in the possession of Nancy Holt.[2] In December 1966 Smithson, Holt, and Robert Morris went to Great Notch Quarry, near Paterson, New Jersey, a trip recorded by twelve photographs of fence-climbing in bleak landscapes. In April 1967 a two-day "site selection trip" to the Pine Barrens and Atlantic City was undertaken by Smithson, Holt, Morris, Virginia Dwan, and Carl Andre. The photographic record consists of twenty-four photographs of shots of smokestacks, slag heaps, piled objects, overpasses, and sand pits. In October Smithson made "Passaic Trip 1" on his own; there are twenty-four Instamatic photos of this trip, six of which were used to illustrate his essay "The Monuments of Passaic" published in the December 1967 issue of *Artforum*. The initiative for these trips seems to have been Smithson's, and it was he who subsequently used the locations and itineraries in his art. The Pine Barrens, Franklin Mineral Dumps, Bayonne, and Edgewater are among the New Jersey sites that provide the points of departure for his first Nonsites. These works deal with the convergence of topographical and geological infor-

mation. This was a method of work extendable to other places, such as California, Connecticut, New York, Pennsylvania, and West Germany, but the New Jersey base is significant.

Smithson's attitude to New Jersey bears on his formulation of the Site/Nonsite relationship. He grew up there and was acquainted with it from the inside, as child, adolescent, citizen; he also knew it from the outside, from Manhattan, and as an artist. He had a faculty for not discarding anything that happened to him: he did not develop by rejections—or, in the case of artists, by reduction—but by accretion. He knew all about New Jersey's folkloric incompatibility with artists, but still scheduled the state as his subject matter. The earth samples, maps, and photographs of the Nonsites are site-specific to points in New Jersey. Smithson thought of New Jersey as in some ways the California of the Northeast. What does it mean to be Californian? Over and above suntans and orange groves, the word refers to the horizontal spread of suburban services, in ways that dispense with traditional urban concentricity. In place of ordered zones one faces an endless landscape in transition that includes monotony and dilapidation; these are assimilated in Smithson's wide-angled view. In "The Crystal Land," recording a trip with Donald Judd, he reflected on New Jersey suburbia:

> Most of the houses are painted petal pink, frosted mint, buttercup, fudge, rose, beige, antique green, Cape Cod brown, lilac, and so on. The highways crisscross through the towns and become man-made geological networks of concrete. In fact, the entire landscape has a mineral presence. From the shiny chrome diners to glass windows of shopping centers, a sense of the crystalline prevails.[3]

To compare a Site with a Nonsite would seem to confer priority on the Site; by comparison a Nonsite must be

[1] "A Sedimentation of the Mind: Earth Projects," in *The Writings of Robert Smithson*, ed. Nancy Holt (New York: New York University Press, 1979), pp. 89–90 (hereafter cited as *Writings*).

[2] There is additional material in the Ludwig Collection, Aachen, and in Lucy Lippard's "chronology" of the period 1966–1972 in *Six Years: The Dematerialization of the Art Object* (New York: Praeger, 1973).

[3] "The Crystal Land," in *Writings*, p. 19.

Robert Morris and Robert Smithson climbing fence into "No Trespassing" area, Great Notch Quarry, New Jersey, December 1966. Photographs and composite by Nancy Holt.

Robert Smithson, Nancy Holt, and Carl Andre, New Jersey, April 1967. Photograph by Virginia Dwan.

secondary or even dysfunctional. In an interview Smithson made this point: "What you are really confronted with in a Nonsite is the absence of the Site . . . a very ponderous, weighty absence."[4] However, the relation of Nonsite to Site is also like that of language to the world: it is a signifier and the Site is that which is signified. It is not the referent but the language system which is in the foreground. Smithson is haunted by the reality of words. "The nonsite exists as a kind of deep three-dimensional abstract map that points to a specific site on the surface of the earth. And that's designated by a kind of mapping procedure. And these places are not destinations; they're kind of backwaters or fringe areas."[5]

Smithson's interest in cartography was deep-rooted and included, he recalled, childhood access to detailed charts which he used to plan extensive family vacations. We can distinguish between maps of unknown places and maps of visited terrain. The maps of unknown places are assumed to be real, whereas maps of known places can be seen to be false or incomplete, porous (letting information slip through a comparatively coarse scale). That Smithson accepted both the temporarily true and the proven false maps is suggested by his appreciation of

[4] Robert Smithson, "Fragments of an Interview with P. A. Norvell, April, 1969," in Lippard, *Six Years*, p. 88.
[5] Paul Cummings, "Interview with Robert Smithson for the Archives of American Art/Smithsonian Institution," in *Writings*, p. 155.

Lewis Carroll's maps. He cites both the blank map in *The Hunting of the Snark*, "a map they could all understand," and the cartographic monster in *Sylvie and Bruno* which had a scale of a mile to a mile.[6] Smithson's version of the blank map of Carroll was the series of disappearing continents: Atlantis, Lemuria, and Gondwanaland.

The concept of the Site/Nonsite was presented in *Artforum*, September 1968, in Smithson's article "A Sedimentation of the Mind: Earth Projects" and elaborated in "Dialectic of Site and Nonsite" the following year.[7] In 1972 Smithson referred to the text in a footnote to "The Spiral Jetty."[8] The footnote includes the following list of the properties associated with the two states:

Site	*Nonsite*
1. Open Limits	Closed Limits
2. A Series of Points	An Array of Matter
3. Outer Coordinates	Inner Coordinates
4. Subtraction	Addition
5. Indeterminate Certainty	Determinate Uncertainty
6. Scattered Information	Contained Information
7. Reflection	Mirror
8. Edge	Center
9. Some Place (physical)	No Place (abstract)
10. Many	One

These pairs are a revealing diagram of Smithson's habits of thought, which were speculative but enclosed, systematic but ambience-responsive. To link the pairs of attributes is to get caught up in a dizzy parade of oppositions that end up in complicity with one another. The Nonsites themselves, usually clusters of earth samples, geometric containers, and photographic imagery, have the distinctness of emblems in which visual and verbal levels of discourse are coordinated but not fused. The emblem book, popular in the sixteenth and seventeenth centuries in Europe, joined allegorical images with explanatory poems to make a moral point. Literary historians have not managed to attend equally to both channels and something similar has happened in the interpretation of the Nonsites. They are often reproduced as single objects, that is to say, with the sculptural section isolated from the rest.

In 1976 Elizabeth Wilde and Kristina Heinemann consulted Smithson's Nonsites.[9] Each piece was studied for

Lewis Carroll, *The Hunting of the Snark* Map, 1876. Photograph by Jon Reis, Courtesy Herbert F. Johnson Museum of Art, Cornell University, Ithaca, New York.

orientation to the Sites and supplemented by discussion with Nancy Holt and Smithson's gallery. Wilde and Heinemann compiled an itinerary and drove to New Jersey, following the implicit command of the Nonsites to convert their information into "the real thing." They had difficulty in locating the Sites at first, but as one of the women noted, "I was no longer concerned at being wrong or lost," and they persisted. At the Palisades, Edgewater, there was "a slick high-rise apartment complex overlooking Smithson's original site." At Line of Wreckage, Bayonne: "The site now looks like a set from Antonioni's statement on the environmental crisis, *Red Desert*." What can we conclude from this dissolution of Sites? Is the Site/Nonsite relationship becoming that of Nonsite/Nonsite? In 1972 I visited the Sites with Smithson, and I remember that he appreciated the transformations that were apparent even then: it was the changes of the place rather than its stable features for which he looked. At Bayonne he was unsure which part of the landfill, now occupied by warehouses, was close to the

[6] "A Museum of Language in the Vicinity of Art," in *Writings*, p. 77.

[7] In Gerry Schum, ed., *Land Art* (Berlin: Fernsehgalerie, 1969), n.p.

[8] First published in Gyorgy Kepes, ed., *Art of the Environment* (New York: Braziller, 1972); *Writings*, pp. 109–16.

[9] Elizabeth Wilde and Kristina Heinemann, "An Investigation of Robert Smithson's Early Sites/Non-Sites (1967–68)," unpublished paper prepared for seminar at Columbia University, 1976.

point from which he had taken his original sample of fill. ("Original sample": the words collide in a Smithsonian way, as they strain our categories of the authentic and the ordinary, the representative.)

In "A Sedimentation of the Mind" Smithson explicitly aligns geological change with the process of thought. Thus landscape is an analogue of the human condition, or at least of our communications. The Nonsites exemplify rhetorical fragility by their separate parts and stretched coordinates.

Smithson's skepticism about the reliability of human communication had nothing to do with disappointed expectation. It amounted to a view of the world, the description of a state, not a complaint: he acknowledged complexity and contradiction as a working condition. In this way he differs from both Michael Heizer and Dennis Oppenheim who have no ideas corresponding to his tolerance of complexity and entropy. His taste for indeterminate spaces and his freedom from the need to arrest his Sites at a preferred point in time express a point of view that is antihierarchical. His doubt about the seamlessness of systems also relates to his taste in science fiction. His library included books by Brian Aldiss, J. G. Ballard, Damon Knight, Keith Laumer, Clark Ashton Smith, Jack Vance, and H. G. Wells;[10] his use of John Taine in the soundtrack of the movie *The Spiral Jetty* and his borrowing of the term "Earthworks" from a science fiction novel by Aldiss are well known. His taste for science fiction included *The Man from Planet X*, a B movie of 1953 directed by Edgar G. Ulmer. The movie's incomplete illusion troubled me: my taste was for more expensive films and also for mainline pro-technological science fiction, which had no place in Smithson's library. What he liked about *The Man from Planet X*, and other movies of the genre, was its artificiality, the fact that its conventions could be seen falling apart as one watched the actor in an alien suit totter about the diminutive, foggy set.

When Smithson moved into the landscape itself and began to shape specific Sites, he seems to depart from the Site/Nonsite relationship. The big Earthworks are site-specific, consisting solely of materials from the spot and designed according to the given lay of the land. However, the dyad was not forgotten when he embraced the full scale of the world, as exemplified by the landscapes of Utah or Texas. The *Spiral Jetty* that lies in the sullen waters of the Great Salt Lake off Rozel Point is accompanied by a film on this Earthwork conceived and made by the artist concurrently. More people have seen the film than the sculpture, and the film has information that does not inhere in the Site. The first part follows the

form of a task-fulfillment documentary, like, say, Joris Ivins's *Earth*. The artist paces out the spiral in the shallow red water, succeeded by earth-moving equipment that swipes up rocks and rubble on the shore and edges them out into the lake, building a causeway. The naturalistic celebration of technology at the service of the artist's will is shown in a clear, expository style, with two diversions. First the machines are compared to prehistoric animals and, second, maps of ancient fictional geographies compound the direct informational level. The last third of the film, with the jetty completed, is photographed almost entirely from a helicopter. Aerial views imply both personal vertigo and solar connections as the sun is reflected from the lake and from between the rings of the spiral. The jetty is opened out into spatial images of ascending magnitude. If the first part of the film is about earth-moving, the second deals with fire (the sun). Thus the film is the equivalent of a Nonsite, part of a network of signs that partially denote the absent Site. It is notable that the film stays away from two of the chief impressions that a visitor to the Site has. There is an incomparable horizontality once you are out on the jetty, as the lake flows to the distant mountains that seem extensions of the concentricity of the landscape rather than limits or edges. And the abandoned oil rigs and ruined shacks that are close by on the shore—characteristic Smithsonian detritus one might think—are almost excluded from the film (they appear in the distance in only one or two shots), perhaps because of their easy elegiac potential.

The film is a text authenticated by originating from the artist and by its evidentiary photographic images. It must, as a document, be more real to most spectators than the inaccessible Site. Smithson protected the sense of the illusiveness of the Site, even after expending tremendous energy on its sculpting. The concept of the Nonsite persisted, even after Smithson had begun the realization of monumental works, as is shown by the mirror displacements, executed between the Nonsites and the Earthworks. Smithson's taste for the interface between illusion and reality was continuous. He inserted mirrors, all the same size, into such primal environments as the jungle and a salt mine. He commented wryly that "if you visit the sites (a doubtful probability) you find nothing but memory-traces, for the mirror displacements were dismantled right after they were photographed. . . . Yucatan is elsewhere."[11]

The inaccessibility of the Sites situated them in a nexus of pilgrimage and rumor. In addition, Smithson developed an ambiguous formality in these works. He emphasized curved forms of high regularity in *Spiral Jetty*,

[10] Unpublished catalogue of Smithson's library compiled by Valentine Tatransky, c. 1974.

[11] See "Incidents of Mirror-Travel in the Yucatan," in this volume.

Broken Circle/Spiral Hill, *Amarillo Ramp*, and in many of his drawings of the seventies, such as *Circular Island*, *Lake Edge Crescents*, and *Wandering Canal and Mounds*. Thus Smithson was using forms that are highly stylized, artist-directed spirals, circles, and meanders, but which possess traditional affinities to landscape. The interlocking half-circles of the trout creek in Yellowstone Park have a comparable mixture of artificiality and belongingness. If I am right, Smithson is maintaining his sense of closed limits and contained information at the center, characteristic of the Nonsite, in the context of open limits, scattered information, and edge characteristic of the Sites.

Smithson regarded entropy as not simply the graph of deterioration, in Norbert Weiner's sense (see *The Human Use of Human Beings*) but as order's multiple states. Thus his appreciation of crumbling strata and sprawling Californias was in no sense camp, but a recognition of time's successive conditions. Consider the film of Connecticut's Merritt Parkway that Smithson talked about making. Driving along it after his death one speculated on what it might have been. Would it have been photographed from a moving car, like the dramatically charged opening sequences of *The Spiral Jetty*? The prose of his 1967 essay "Ultra-Moderne" signals his interest in the colonial—or Georgian—derived ornament of between-the-wars modernist architecture. A fast road system, like the Merritt Parkway, is the indispensable first step toward Californiation. The fact that this innovative system should be characterized architecturally by over- and underpasses with semicolonial detail is "entropic" in Smithson's sense. Two strata are overlaid: fans, medallions, volutes, balusters from the classical past are infiltrating the expedient modern framework of the Parkway. Smithson would not have thought about this merely in terms of the decline of a classic style into popular usage, but would have drawn on the hybrid—colonial modern. As he wrote: "One's mind and the earth are in a constant state of erosion, mental rivers wear away abstract banks, brain waves undermine cliffs of thought, ideas decompose into stones of unknowing, and conceptual crystallizations break apart into deposits of gritty reason."[12]

The Nonsites were associated with Minimal sculpture originally: it is true that Smithson knew Morris, Andre, and Judd and that the bins and trays of the Nonsites have a factory-made look and vernacular simplicity about them, but these facts are not binding on his art. There is a streak of Piranesi in Smithson, both in terms of Piranesi's affective imagery of a ruined Rome and his archaeological curiosity and precision. If Piranesi is in part

[12] "A Sedimentation of the Mind: Earth Projects," in *Writings*, p. 82.

Trout Creek Trademark, Yellowstone Park postcard. Photograph by Jack E. Haynes, Courtesy Haynes Foundation, Bozeman, Montana.

Snapshot by Smithson of The Century Apartments, New York City, used as lead-in for "Ultra-Moderne" (1967). Photograph courtesy Estate of Robert Smithson.

about "the vanity of human wishes," Smithson's Nonsites embody a concern with mischievous knowledge: that is to say, knowledge that has a built-in limit, or twist. It is knowledge that affects the way we see the world, but does not really match its shape. As the partial coordinates between Nonsite and Site become known to the spectator, the void between them opens. Smithson is continually dealing with forms of knowledge, mapping and excerpting, but stresses their provisional nature. This sense of the persistence of contraries at the heart of language and hence of art is uniquely Smithson's: information-stress is an essential aspect of the Site/Nonsite.

ROBERT SMITHSON,
THE *AMARILLO RAMP*

John Coplans

A song of the rolling earth, and of words accordingly,
Were you thinking that those were the words, those upright
lines? those curves, angles, dots?
No, those are not the words, the substantial words are in the
ground and sea,
They are in the air, they are in you.
— Walt Whitman, *A Song of the Rolling Earth*

Robert Smithson was a problem from the beginning. When exhibited in The Jewish Museum's "Primary Structures" exhibition in 1966, his sculpture looked eccentric compared with the prevalent notion of the Minimalist style. Smithson's adoption of the spiral motif contrasted strongly with the inert and self-contained icons of Minimalism—the circle, triangle, rectangle, or square. His spiraled *Mirror Prototype for Aerial Art Project,* 1967, for example, and even bulkier *Gyrostasis* of 1968 apparently relate to nineteenth-century systems of logarithmic expansion, or to organic and crystalline growth, or perhaps even to the spiral as a biophysical symbol of life itself. Not until the building of *Spiral Jetty* in 1970 did Smithson's usage become clearer; the spiral is related to his notions of entropy and irreversibility. A spiral vectors outward and simultaneously shrinks inward—a shape that circuitously defines itself by entwining space without sealing it off. One enters the *Spiral Jetty* backward in time, bearing to the left, counterclockwise, and comes out forward in time, bearing right, clockwise. In 1967 Smithson wrote:

I should now like to prove the irreversibility of eternity by using a *jejeune* experiment for proving entropy. Picture in your mind's eye the sand box divided in half with black sand on one side and white sand on the other. We take a child and have him run hundreds of times clockwise in the box until the sand gets mixed and begins to turn grey; after that we have him run anti-clockwise, but the result will not be the restoration of the original division but a greater degree of greyness and an increase of entropy.

Of course, if we filmed such an experiment we could prove the reversibility of eternity by showing the film backwards, but then sooner or later the film itself would crumble or get lost and enter the state of irreversibility.[1]

Smithson used the spiral as an entity outside the logic of current art. He took giddy pleasure that the viewer coming to the end of the *Spiral Jetty* finds nothing there. This attitude gives his work a different kind of vitality.

It may be difficult for those who live outside New York, especially in Europe, and who have a different sensibility, to appreciate or understand the special kind of force Smithson represented. After 1966, he felt a unique sense of mission, and his personal presence on the New York art scene as writer, filmmaker, theoretician, maker of exhibitions, and finally as a powerful conscience was by no means easy to ignore: he delighted in pushing people to their intellectual limits by verbal and aesthetic challenges.

Beyond this there is the problem of Smithson's Earthworks. However widely known as an image, *Spiral Jetty* is nevertheless extremely inaccessible to firsthand viewing. The same is true of *Amarillo Ramp,* which is sited on a private ranch closed to the public. Despite the hundreds of drawings for incompleted projects, Smithson's body of work is small. His premature death meant the end of his developing range of ideas as well as of the realization of many projects.

After completion of the *Spiral Jetty* in 1970 (funded by Virginia Dwan and Douglas Christmas), patronage became a thorny issue for Smithson, who constantly sought ways and means to continue his work. *Texas Overflow*, conceived in the same year for an abandoned quarry between Fort Worth and Dallas, was to consist of a large circle of white limestone rocks with liquid asphalt

[1] See "The Monuments of Passaic," in this volume.

Robert Smithson and Richard Serra at Great Salt Lake, Utah, 1970. Photograph by Gianfranco Gorgoni/Contact.

poured into the center and overflowing the sides. Though negotiations extended over several years with the Fort Worth Art Center Museum, the money to build the work never materialized. Another project that fell through was *Ring of Sulphur and Asphalt*, to have been constructed near Houston, Texas, of local materials—sulphur and asphalt. The Dutch government financed *Broken Circle/Spiral Hill*, built in 1971 in Emmen, Holland, in a nearly exhausted sand-mining quarry slated to become a recreational center. (The local citizenry was so taken with Smithson's Earthwork that it voted to allocate funds to maintain it permanently, a reaction that affirmed to Smithson the democratic goals of his art.)

Smithson explored several abandoned quarries in Maine, but found them too mellowed by time, too picturesque. He bought a small island off the coast of Maine, but abandoned any idea of using it for the same reasons. He explored the Florida Keys and the Salton Sea in California for sites.

Smithson's overriding concern, especially in the last

two years of his life, was to propagate his art as "a resource that mediates between ecology and industry." He visited several strip mines, and negotiated for Earthworks which he argued would be ways of reclaiming the land in terms of art. He wrote to numerous mining companies, especially those engaged in strip mining, reminding them that "the miner who cuts into the land can either cultivate or devastate it." Through a Wall Street friend, Timothy Collins, he finally contacted a receptive mining company, the Minerals Engineering Company of Denver. They were enthusiastic about his proposal for a "tailings" Earthwork at a mine in Creede, Colorado. At this mine, vast quantities of rock are broken up, subjected to a chemical process to extract the ore, and the residue washed into tailings ponds—a hydraulic system for flushing waste. Since the company required a new pond anyway, and since Smithson's Earthwork would cost very little more, his ideas aroused their interest. In his proposal for *Tailing Pond*, Smithson envisaged a work that would continuously progress over twenty-five years or so. Some nine million tons of tailings would complete the Earthwork, to have been approximately two thousand feet in diameter. Smithson allowed for an overflow if the projected quantity of tailings exceeded expectations by extending the design to accommodate the excess tailings into another half-section. Though sketches for *Tailing Pond* might suggest some similarity in design to the *Amarillo Ramp*, the concept is entirely different. The basic shape of *Tailing Pond*, which also consists of a partial circle, is completely tiered into the surrounding hills, and the remaining half of the circle is held in reserve for the extension. The rocky terrain strongly contrasts with the desert prairie around the *Amarillo Ramp*; moreover, the shape of *Tailing Pond* is scooped and dished, rather than built up on a flat surface.

After two years of site selections, fund raising, and inevitable cancellations, his proposal for the construction of *Tailing Pond* realized at last Smithson's vision of an art that mediated between the industrial/technological processes at work within the landscape. It confirmed his idea that the artist could become a functional worker within society, changing the socioeconomic basis of art by restoring to it an everyday function within society; and making an art that restored to the common man his sense of place in the world.

The *Amarillo Ramp*, however, came into existence by chance. Smithson and his wife, Nancy Holt, visited Creede to work out the final design for *Tailing Pond*, but actual work on the project was delayed for a few more months. All the abortive attempts over the preceding two years to make a piece had left Smithson with a sense of repressed and contained energy that needed un-

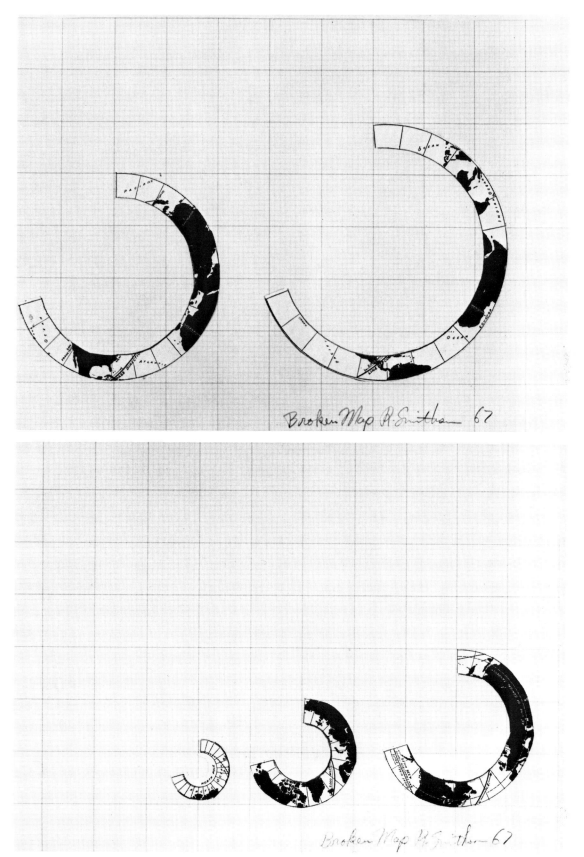

Broken Map, 1967; collage, map on graph paper, pencil; 2 drawings, each 10½ x 8½″. Collection Estate of Robert Smithson, Courtesy John Weber Gallery. Photograph by Nathan Rabin.

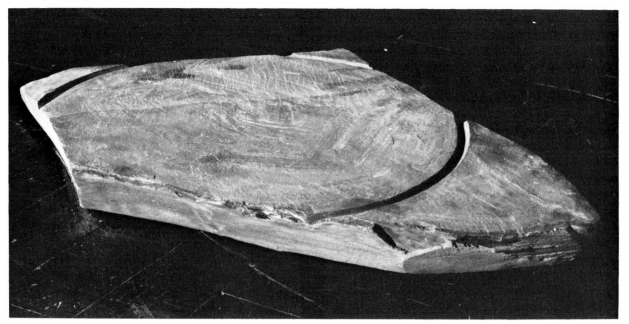

Slate Grind #2, 1973; ground slate drawing; 2 x 25 x 13″. Collection Estate of Robert Smithson, Courtesy John Weber Gallery. Photograph by Walter Russell.

leashing. While passing time in New Mexico, they met a friend, Tony Shafrazi, who told of a ranch with desert lakes he was about to visit in the Texas Panhandle. The thought of desert lakes teased Smithson's imagination to such an extent that he and Holt decided to go along.

The Marsh Ranch is about fifteen miles northwest of Amarillo township, situated near the rim of the Bush Dome, a giant underground cavern deep in the earth, used to store the Western world's readily available supply of helium gas. The rich helium source, found in the Texas gas fields near Amarillo after World War I, was first tapped locally; then as other fields were opened in the Texas Panhandle, Oklahoma, and Kansas, helium gas was piped to the Bush Dome, processed and stored there. Helium is a "noble" gas, one that will not react chemically with other gases or burn, and one crucial to the space program since it is used to maintain pressure in rocket fuel tanks. Other than a small, heavily fenced, and quite anonymous industrial processing unit nearby, there is little evidence of its presence near the ranch. It is typical of the area that until one has probed around, it is hard to grasp the extraordinary evolutionary process the surrounding land has undergone, especially in recent times—a quality that fascinated Smithson.

This part of Texas, east of a line drawn from Amarillo to New Mexico, appears on early maps as the Great American Desert, and the Panhandle (which, in fact, is the northern part of Texas) is still called West Texas, a reminder that geographically it was considered within the arid Western frontier. The Indians have inhabited the

area for thousands of years, beginning with the archaic Plains Indians. Until the last quarter of the nineteenth century, when they were cleared out by the U.S. Cavalry in one of the last actions against Indians, the nomadic Comanches lived there. The area is rich in flint, much prized by the Indians, who sought, worked, and traded it widely. The remains of a pre-Columbian trading kiva exist twelve miles south of the *Amarillo Ramp* on the bank of the Canadian River, and I picked up chips of worked flint all around the bluffs overlooking the *Ramp*, as well as on the rims of the canyon below the Tecovas Lake dam site. The area was considered unsuitable for white settlement until the 1880s, when the railway line was built. The opening of the area for ranching immediately attracted speculative international capital, principally English and Scottish, and settlement of the area by whites began in earnest.

I'm told that when the first ranchers came, the buffalo grass supported a greater number of cattle. It is a natural species of the dry plains east of the Rocky Mountains, a tender protein-rich grass, the food of the great herds of buffalo wandering the prairies, and requires no artificial fertilization. Unlike other ranching operations which must grow feed, the Amarillo ranchers were blessed with a natural food source for their cattle. Continual overgrazing systematically depleted the grass. Now the grass is cropped short and laced with mesquite, yucca, and other noxious weeds that got a toehold from seeds in the droppings of the first cattle driven into the area.

Although at first it appears impossibly desolate, the

Amarillo area is a dynamic center of agribusiness, a central geographic location where cattle, grain, and rail transportation come together. Now, only ninety years after the opening of the Fort Worth and Denver City Railway, what was formerly considered unusable desert has become one of the beef lockers of the world.

The Marsh Ranch straddles a primeval watershed (probably a lake or sea bottom at one time) covered by a red rock of compressed clay. Nowadays, water flows down through this watershed into Tecovas Creek, which feeds into the Canadian River about twelve miles north of the ranch, and then into the Mississippi. At the flood point of the Tecovas Creek, just beyond Tecovas Lake, which is a man-made dam, the action of the water has gouged a deep, twisted rocky canyon.

The dam that forms Tecovas Lake was built in the early sixties. Since then it has been silted some 30 to 40 percent with fine red clay. Before the dam was emptied for the building of *Amarillo Ramp*, the water level was roughly eight feet. The dam is part of a unique irrigation system called the Keyline, the first of its kind built in the Western hemisphere. Pioneered by a visionary Australian, P. A. Yeomans, the system is based upon the local control and development of land and water resources. Large dams can cost enormous sums of money, and the feeder canals and pumping systems necessary to distribute the water can be equally expensive. By contrast, the Keyline system uses every drop of water where it falls. Rain water usually runs off the land faster than the soil can absorb it, and is consequently wasted. Yeomans's plan doctors the land in such a way that the water is conserved as close to the watershed as possible. At the Marsh Ranch the water running down the watershed is dammed, pumped to a ridge eighty feet above, fed through five miles of ditch to a lake, then conducted by gravity downhill, point by point over the surface of the land. The land is plowed to get even coverage from the water. The sparse rainfall of twenty inches a year is utilized to the maximum. I think what interested Smithson was the wonderful simplicity of the system, the manner in which it so economically employs smaller and smaller systems to overcome the aridity of the area.

After Smithson saw Tecovas Lake, he was able to convince Stanley Marsh to let him build an Earthwork. Marsh hired a plane so Smithson could take aerial photographs to chart its position and size. Smithson went up in the plane, photographed the lake, and made some drawings. Later, he and Holt waded into the lake and staked out a piece, but Smithson rejected this plan and began again. A second proposal, for a work about 250 feet in diameter, was dismissed because he felt it displaced too much of the area of the lake. He reduced it to 150 feet. After this third proposal was staked out, Marsh

Robert Smithson in Amarillo, Texas, July 1973. Photograph courtesy Estate of Robert Smithson.

hired the same aircraft to view the staked-out piece from the air. On July 20, 1973, the plane was flying low over the site when it stalled and dived into the ground, killing everyone on board.

Soon after Smithson's death Holt thought that the piece should be built. Shortly after her return to New York, she saw Richard Serra, who had witnessed part of the construction of *Spiral Jetty*. He brought up the subject of finishing *Amarillo Ramp* and volunteered his help. After the funeral, he reminded Holt of his offer,

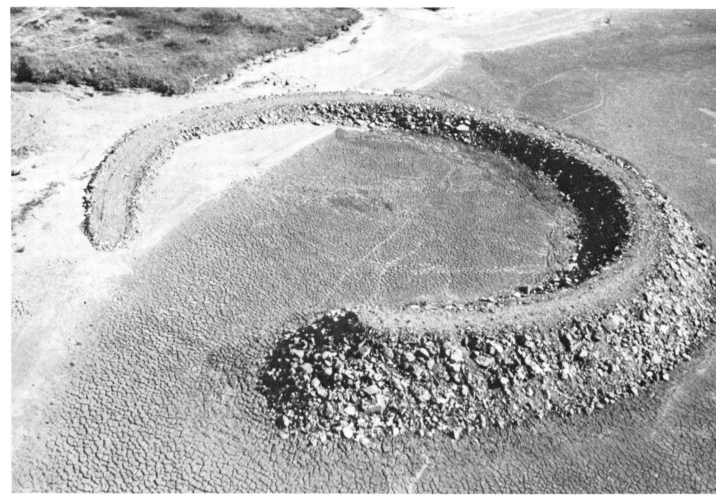

Amarillo Ramp, 1973. Collection Stanley Marsh. Photograph by Gianfranco Gorgoni/Contact.

and she made the decision to return immediately and finish the Earthwork with Serra and Tony Shafrazi.

It took about three weeks for the *Amarillo Ramp* to be built. I know objections will be voiced as to whether it really is a piece by Smithson, and whether during the process of building, Smithson would not have altered his plan. But Holt attended all the initial planning. She worked with him on many of his projects, and Smithson discussed with her the final shape of the *Amarillo Ramp* in great detail, including the use and piling of the rock from the nearby quarry, from which he had decided to draw material. Smithson left specific drawings giving the size, gradation of the slope, and the staked-out shape of the piece in the water. It must be remembered, too, that Smithson never visualized the final design of any work as completely predetermined. The workers who built the *Spiral Jetty* were not just hired hands; they offered their own suggestions as to how the machines and materials

could be employed to realize Smithson's plan. This mode of approach is vital to the anticlassical side of Smithson's temperament.

When Holt, Serra, and Shafrazi arrived in Texas, they found that the water level of Tecovas Lake had risen, and the stakes were almost covered. Their first problem was how to begin to work. They could not find the drain to the dam which they knew existed, even though they searched for hours in the muddy water. To pump the lake dry would have taken three weeks, so they cut the dike and emptied the lake, according to Serra's report, completely changing the place. The mud lay several feet deep, like a quagmire. The lake bed quickly became covered with crabs, crayfish, and sanddabs dying in the sun.

You come across the *Amarillo Ramp* suddenly. You drive across the ranch following a track that meanders according to slight changes in the topography of the

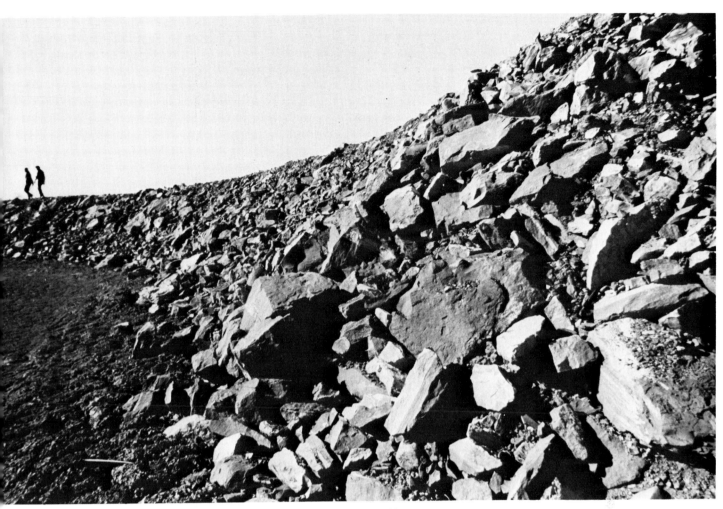

Amarillo Ramp, 1973. Collection Stanley Marsh. Photograph by Gianfranco Gorgoni/Contact.

landscape, which is rolling, yucca-studded prairie. You don't realize that you are on a plateau, about ninety or so vertical feet above the lowest level of the land, until you hit the edge of the bluff that slopes first sharply, and then gently down to Tecovas Lake. There below, beached like something that has drifted in, is the Earthwork. The curve of the shape repeats the rhythm of the edges of the lake and the surrounding low valley. As you walk down the slope toward it, there is a point—about three-quarters of the way down—when the higher part of the ramp slices across the horizon, after which the sides loom up vertically to block the horizon. From the top of the bluff (an upper sighting platform) the Earthwork is planar; it gradually becomes elevational on approach, but you don't really sense or grasp the verticality of the piece until you are close, at the very bottom of the incline and about to climb the ramp.

Seen from above, it is a circle; as you climb, it be-comes an inclined roadway. Walking up the slope of the ramp, you look up valley, far off toward low, flat hills; as you negotiate the curve and reach the topmost part, you look down valley, across the dike, to the land below that gathers into the canyon beyond. The top is also a sighting platform from which to view the whole land-scape 360 degrees. Returning down the Earthwork, you retrace your footsteps, going past your own past, and at the same time you see the makings of the Earthwork, the construction of the construction: the quarry in the nearby hillside from which the rocks were excavated; the road-way to the Earthwork along which they were transported; the tracks of the earth-moving equipment; the tops of wooden stakes with orange-painted tips that delineated the shape still sticking out here and there; and the slope of the ramp shaped by the piled red shale and white cali-che rock. An acute sense of temporality, a chronometric experience of movement and time, pervades one's ex-

perience of the interior of the Earthwork. And something else, too: in walking back and looking down toward the inside, you are intensely aware of the concentric shape that holds its form by compression, heavy rock densely piled and impacted. Stepping off the Earthwork, one has a sense of relief from pressure, stepping back into the normal world's time and space, and even a sense of loss. The piece, then, is not just about centering the viewer in a specific place, but also about elevating and sharpening perception through locomotion. The *Amarillo Ramp* is mute until entered. And it is only later, when you return to the top of the bluff, and look back, that you realize how carefully it has been sited, how on first seeing the Earthwork from above, in plan, everything is revealed by predestination. Once on the bluff again, you are re-minded that even if you think you know the pattern of the world, you still have to move through it to experience life. Thus to think of the *Amarillo Ramp* in traditional terms, as an object or sculpture dislocated from its sur-roundings, is to view it abstractly, to strip it of the exis-tential qualities with which it is endowed.

The *Spiral Jetty* also concerns locomotion, but there are marked differences between the *Jetty* and the *Ramp* in this respect. In the *Spiral Jetty,* I think one of Smith-son's interests lay in the stumbling aspect of walking, forcing one to pay attention to where one is going. I'm told that when he finished the *Spiral Jetty* Smithson ripped up the boulders so that the pathway couldn't be negotiated smoothly. Evidently Smithson wanted to make the locomotion discontinuous—to disrupt it—per-haps because the view across the water is so flat and continuous, and so sublime. On the *Amarillo Ramp* you stop a lot, especially when going up the ramp, to watch how your relationship to the surroundings changes. But in both pieces you become unusually aware of the phys-icality of your body in relationship to its surroundings, of temperature, of the movement of wind, of the sounds of nature, and of how isolated you have been from nature until this moment.

An observation of one of Smithson's heroes, Freder-ick Law Olmsted, comes to mind:

> Beauty, grandeur, impressiveness in any way, from scen-ery, is not often to be found in a few prominent, distin-guishable features, but in the manner and the unobserved materials with which these are connected and combined. Clouds, lights, states of the atmosphere, and circum-stances that we cannot always detect, affect all landscape, and especially landscape in which the vicinity of a body of water is an element.

Smithson never chose sites according to what might be described as norms of beauty. The Great Salt Lake is a somber, moody, dead lake that supports no life within its waters except for the algae giving it its red hue. I think I saw the *Spiral Jetty* under the very best of circum-stances, under romantically sublime conditions. On the day I was there the vast stretch of lake water that filled the horizon for 180 degrees was shot through with the widest range of coloration, from bright pink and blue to gray and black. On the left, near the abandoned drilling wharf, and for some ten or twelve miles out, a storm was raging, with black clouds massed high into the sky, claps of thunder and flashes of lightning, and the surface of the lake in turmoil. Toward the center the storm eased off, but with lower clouds and sheets of rain scudding across the lake surface, almost obliterating from view some islands lying offshore. To the right, a blue sky al-most clear of clouds with a high moon and stars, and on the extreme right, the sun going down in a mass of al-most blinding orange. Where I stood, in the center of the spiral, a warm wind blew offshore, carrying the smell of the flora, and rustling through it, the cries of birds. The scrubby, low hills behind began to flatten and darken against the twilight. The site is a terribly lonely place, cut off and remote, conveying the feeling of being com-pletely shunned by man.

Though equally strong, the feeling of the land around the *Amarillo Ramp* is different. The climate is hot, with little daily variation in temperature, which hovers be-tween 96 and 100 degrees in the summer. But there is a marked dissimilarity in what the land looks like at differ-ent times of the day. The color changes constantly. Be-tween seven and eight o'clock in the morning the shad-ows are heavy and purple, the reflection of the sun off surfaces bright, giving a high contrast to form. At mid-day the land is flattened by the haze of heat and sun. In the afternoon, as the sunlight softens, the whole land be-comes rust covered. Once you are used to the differences in light it is possible to tell the time by the color of the land at a given moment. The land blazes with heat. Local people say that when the Indian hunters traveled, they ran across the land by following the shadows of clouds. It is a very repressed landscape, very primordial, not at all generous, though there is evidence that in prehistoric times the land was lush—the area around the site and farther down in the canyon is littered with pieces of fos-silized trees. The fact that the land has not been worked until recently, and then only for grazing cattle, and that the Indians who inhabited the land were nomadic hunt-ers, has a tendency to obliterate all human effort. The *Amarillo Ramp* seems to be almost engulfed at times by the landscape and the blazing light. I never saw Tecovas Lake filled with water; the dike is now repaired, and when the lake is refilled, the *Amarillo Ramp* looks very

different—holds its own even more in the vastness of the Texas landscape.

Robert Smithson had a heroically romantic attitude toward nature and the industrial processes. He had the ability to accept anything, including ugliness and the pathology of decay, and to make a virtue of these qualities. Impurity, degeneration, and collapse were central to his view of the dialectics of "entropic" change. He understood the process of evolution: improvement is always at the expense of some other quality—it always involves loss of energy. We speak of improvement or evolution when the results appear to benefit man, but one species advances by destroying another; one thing replaces another by progressive default; improvement involves a gradual reordering of the landscape; progress is by degeneration and decay; and man consumes his world with man-centered shapes and processes. This is not to imply that Smithson was unaware of the evils underlying these processes: they may mirror man but man is not the measure of everything. Smithson was a highly cultivated thinker and artist, a visionary, yet an optimistic and practical man, fully aware of the Fall. He was not obsessive in the sense of producing things—an endless series of objects; his art obsession was with the mutual dependency of the parts of our world in maintaining their vital processes.

Smithson had a generous sense of the irony of egotism: by unashamedly being yourself, and by being proud of your uniqueness, you are merely another grain of sand—a part of the general whole. A sense of being your own man is a very American trait, wholly consistent with the Abstract Expressionists and their style. There is no moment in Abstract Expressionism, as there is in Cubism with the early painting of Braque and Picasso, when the artists can be confused. The Abstract Expressionist painters are like a roomful of extreme individualists who resemble each other only in their extremism. Their art is all about "me," but this me includes all of us, and by thoroughly investigating the self one can best understand others. One must appreciate one's weaknesses. This is in extreme contrast, say, to the English attitude, where the culture aims at suppressing differences—educated men speak with a cultivated accent, and to have manners as well as to be cultivated is important. Smithson's attitude was the very opposite: how to open oneself up to the world—cultivation is useful provided it doesn't preclude awareness or action.

Smithson's art is not founded on analytical operations. It does not derive from a closed system clogged by its own fixations and systems of criticism. His art does not

satisfy fixed constructs deduced from theoretical implications structured to a historical notion of a mainstream. His art is open, about the breadth and scale of this country, about being an American. His exemplars were Melville, Whitman, and Pollock, as well as William Carlos Williams, his childhood doctor. Smithson felt that many of his colleagues were too civilized and European, and their art too citified, inbred, and incestuous.

In seeking a less elitist art, more republican in essence, without the overrefinement and the overtones of luxury common to much current art, Smithson was forced into situations outside the then current structure of art itself. He was not against artists making money, but against their accommodation to production, marketing, and sales, which troubled him because it inevitably reeks of compromise and contamination. Art seemed too far from the everyday life of ordinary people, and without a culturally socialized character. Smithson wanted an art free from traditional patronage; he wanted an economically innocent art; and in attempting to move from private to public and industrial patronage, he fully realized he might be exchanging one prison for another.

It's not that Smithson was different from anybody else—more righteous or fastidious. His attitude was formulated out of sheer frustration. Smithson realized that the options were stacked against him, and if an artist has brains, energy, and imagination, then it's necessary to force issues. Nor did he wake up one day with a neatly packaged set of solutions to his problems. As a man boxed in continuously by circumstances the only resource open to him was to take the offensive, and step by step to challenge his peers and the support system, which he did with relish and abrasive humor.

There was much of the transcendentalist to Smithson. I think it finally never really mattered to him who owned his art. Why? Because finally he realized that art, like knowledge, is never owned. It was important to him that the process of getting money to make or in payment for a work of art should not determine what the art should be. It was freedom enough to be able to go down to a ranch, to hire machines to make art out of the easily available material, and to believe that the art he made would be there after any economic and social revolution of the future. Smithson was a pragmatist who realized the necessity of taking risks and took them into account: things falling apart or going through natural changes, the *Spiral Jetty* being inundated by water or landlocked by evaporation. Embracing the positive as well as the destructive potential of nature, Smithson understood that finally it doesn't matter—chance and planning often turn out to be the same.

THE WORKS

Robert Hobbs

1. *The Eliminator*, 1964; steel, mirror, neon; 20 × 20 × 28"

Smithson has clearly described the particular type of nonperception that interested him in this sculpture:

> *The Eliminator* overloads the eye whenever the red neon flashes on, and in so doing diminishes the viewer's memory dependencies or traces. Memory vanishes, while looking at *The Eliminator*. The viewer doesn't know what he is looking at, because he has no surface space to fixate on; thus he becomes aware of the emptiness of his own sight or sees through his sight. Light, mirror reflection, and shadow fabricate the perceptual intake of the eyes. Unreality becomes actual and solid.
>
> *The Eliminator* is a clock that doesn't keep time, but loses it. The intervals between the flashes of neon are "void intervals" or what George Kubler calls, "the rupture between past and future." *The Eliminator* orders negative time as it avoids historical space.[1]

The artist's concept of reality as a void, and nonperception contradictorily enough as part of perception, relies on the following statement by George Kubler in *The Shape of Time:*

> Actuality is when the lighthouse is dark between flashes: it is the instant between past and future: the gap at the poles of the revolving magnetic field, infinitesimally small but ultimately real. It is the interchronic pause when nothing is happening. It is the void between events.[2]

Although *The Eliminator* represents Smithson's only excursion into neon, the piece won him early acclaim as a light artist. The sculpture was featured in the Univer-

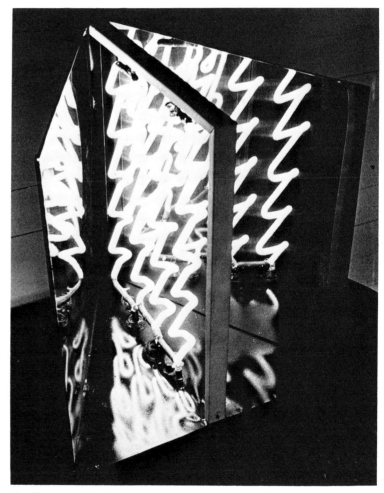

The Eliminator, 1964. Collection Estate of Robert Smithson, Courtesy John Weber Gallery. Photograph by R. Bramms, Courtesy John Weber Gallery.

sity of Pennsylvania Institute of Contemporary Art's exhibition "Current Art" held in 1965. That same year *Life* magazine devoted a section of its May 21 issue to the phenomenon it termed "Neon Art"—a whimsical blend of Pop and Op—and reproduced *The Eliminator*

[1] "The Eliminator," in *The Writings of Robert Smithson*, ed. Nancy Holt (New York: New York University Press, 1979), p. 207 (hereafter cited as *Writings*).

[2] Kubler, *The Shape of Time: Remarks on the History of Things* (New Haven: Yale University Press, 1962), p. 17.

along with the work of nine others included in the exhibition.

Like *Enantiomorphic Chambers*, another mirrored piece that depends upon mirrors' capacity to distort reflected reality, *The Eliminator* is a prescient work. The sculpture is important not only in itself, but also as a key to Smithson's later work. Although the use of neon remains unique, the appearance of cornered reflective surfaces occurs several times in the late sixties when the artist undertook a series of mirror corner pieces in such materials as gravel, rock salt, slate, lace coral, and red sandstone.

2. *Untitled*, 1964/65; steel frame, rose "neon plastic" mirrors; 81 × 35 × 10″

Untitled in blue and rose is one of several crystalline pieces Smithson had fabricated in the mid-sixties. Continuing in the tradition of modern artists such as Robert Rauschenberg, Smithson turned commonly deduced functions of art into literal equivalents: mirrors define art's illusionistic reflective surfaces, while the metal skeleton reiterates the framing device discussed so often in the sixties by adherents of Clement Greenberg's criticism, and the glowing rose-colored "neon plastic" manifests the quality of light long considered a distinction of important artists. Each of the literal equivalents parodies the function it manifests. Even the overall structure of *Untitled* becomes an ironic comment on the then recently proclaimed shaped canvas that supposedly eliminated residual illusionism in favor of the real. If art is concerned with mirroring the world, then Smithson turned his art into a reflective surface that literally does image the world: it mirrors its actual circumstances, making the space around it part of the sculpture.

While employing reflective surfaces was not a new idea in the mid-sixties, Smithson provided a subtle twist on mirrored imagery in *Untitled*. In a working sketch for the piece he noted that in the very center, a "double vanishing point exists as a solid reversal of traditional illusionistic perspective. Infinity without space." The reference to infinity is interesting in light of Picasso's famous remark cited by Alfred Barr in *Fifty Years of Picasso* in which he noted that parallel mirrors reflect each other innumerable times and serve as an image of infinity. Smithson's image of infinity varies from Picasso's: he makes infinity a self-enclosed proposition, a tautology in which his sculpture at its center folds in on itself and reflects abstractly its ability to reflect. By structuring his sculpture so that it incorporates both realistic

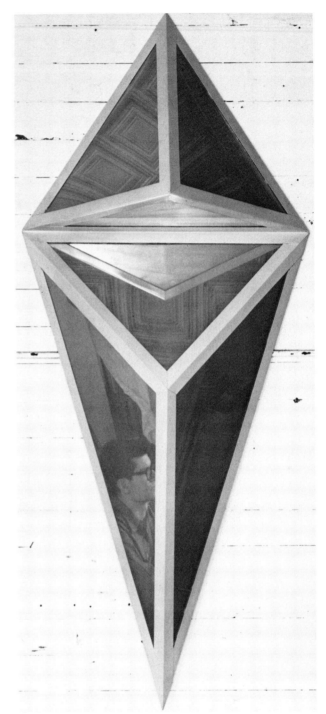

Untitled, 1964/65. Collection Estate of Robert Smithson, Courtesy John Weber Gallery. Photograph courtesy John Weber Gallery.

and abstract types of reflections—elements from the environment as well as the sculpture's ability to mirror itself—he is able to provide a range of visual experiences that ultimately become a philosophic proposition concerning the nature of vision. In relation to his Site/

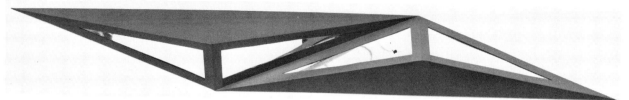

Untitled, 1963/64; steel, mirrorized plastic; 6 x 15 x 100″. Collection Estate of Robert Smithson, Courtesy John Weber Gallery. Photograph by John A. Ferrari.

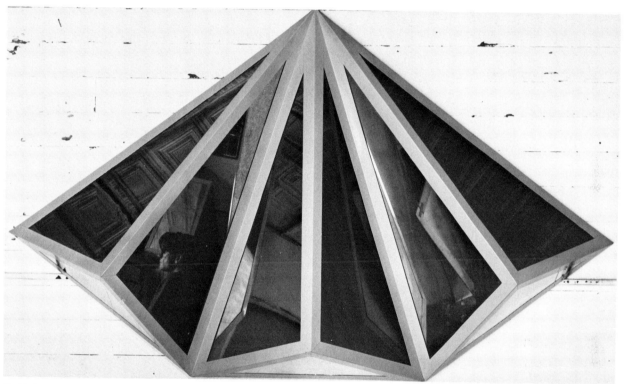

Untitled, 1963/64; steel, mirrorized plastic; 50 x 12 x 18½″. Collection Estate of Robert Smithson, Courtesy John Weber Gallery. Photograph courtesy John Weber Gallery.

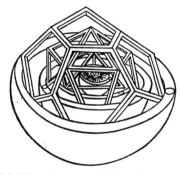

Kepler's model of the universe, consisting of five regular solids fitted together (from Christophorus Leibfried, 1597). Reproduced in the margin of Smithson's "Quasi-Infinities and the Waning of Space" (1966), this drawing suggests a possible cosmological source for the untitled wallpieces of the mid-sixties. Courtesy Estate of Robert Smithson.

Nonsite works of 1968, it is interesting to note that vision in *Untitled* incorporates reflections that are both visible and invisible. In other sculptures belonging to this group, the artist continues the ideas of *Untitled* (blue and rose) as he plays off realistic reflected images with shimmering abstract images of mirrors being mirrored.

3. *Enantiomorphic Chambers*, 1965; steel, mirrors; two chambers, each 34″ square

One of the most important of Smithson's early works, *Enantiomorphic Chambers* combines the artist's interests in perception and crystallography. The term "enantiomorph" refers to either of a pair of crystalline chemi-

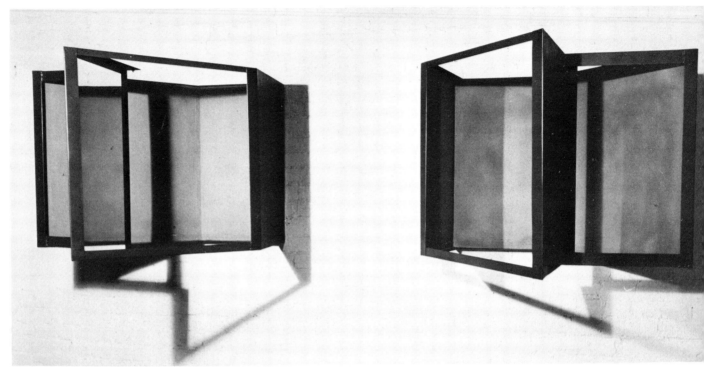

Enantiomorphic Chambers, 1965. Location unknown. Photograph courtesy Estate of Robert Smithson.

Drawing for *Enantiomorphic Chambers*, 1965; pencil and ink; 11¼ x 13½". Collection John Weber. Photograph by John A. Ferrari.

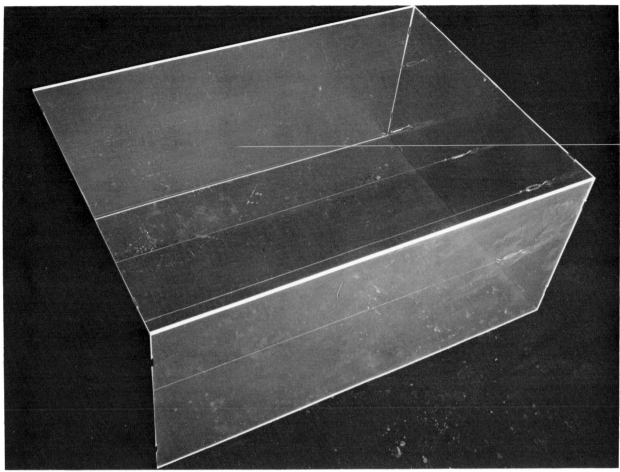

Donald Judd, *Untitled*, 1965; steel and plexiglass; 20 x 48 x 34″. Collection Mr. and Mrs. William C. Agee. Photograph by Rudolph Burckhardt.

cal compounds whose molecular structures have a mirror-image relationship to each other. Literalizing the scientific term in this sculpture, Smithson had steel structures fabricated to hold mirrors at oblique angles. When viewers stand before the mirrors, they see reflections of reflections. Because the mirrors reflect mirror images, vision becomes dispersed. Our usually fused binocular vision is split and disembodied. "The two separate 'pictures' that are usually placed in a stereoscope," Smithson has explained,[3] "have been replaced by two separate mirrors in my *Enantiomorphic Chambers*—thus excluding any fused image. This negates any central vanishing point, and takes one physically to the other side of the double mirrors. It is as though one were being imprisoned by the actual structure of two alien eyes. It is an illusion without an illusion." What the artist has created, then, is a true abstraction of the act of seeing: one's sight is reflected but one is not. As he put it, "To see one's own sight means visible blindness."[4]

In this piece and also in the interpolation, Smithson pokes fun at art's so-called purely visual properties. At the time he created *Enantiomorphic Chambers*, the perceptual act was already canonized in Frank Stella's well-known elliptical statement, "What you see is what you see."[5] Stella was advocating a resolutely visual art that allowed for no extraperceptual properties. Art resides in the formal; anything else, Stella suggests, is just something extra tacked onto the work of art. While Stella was reacting to the Abstract Expressionist cult of the artist's subconscious, Smithson was responding to painters like Stella. He took their statements about the primacy of vision a step further when he created *Enantiomorphic Chambers*. Sight in his sculpture becomes the nonreferential act of seeing instead of the usual unconscious looking at something.

In the history of crystallography, enantiomorphs hold a special position because they relate to living matter,

[3] "Pointless Vanishing Points," in *Writings*, p. 209.

[4] "Interpolation of the Enantiomorphic Chambers," in *Writings*, p. 39.

[5] Lucy R. Lippard, ed., "Questions to Stella and Judd: Interview by Bruce Glaser," in *Minimal Art: A Critical Anthology*, ed. Gregory Battcock (New York: E. P. Dutton, 1968), p. 158.

one characteristic of which is some sort of asymmetry. Unlike living things, which can produce one-handed molecules, crystalline enantiomorphs occur in equal numbers of left- and right-handed molecules. Many scientists feel that the occurrence of asymmetric molecules in nature is most important because of the possible clues they might provide to questions about the origins of life, and believe a way of investigating asymmetry is to study enantiomorphs.

Smithson was aware that the enantiomorphic configuration of some crystals continues to puzzle and intrigue scientists, and he used this left- and right-handed relationship as a metaphor of possibility in *Enantiomorphic Chambers*. Molecular asymmetrical mirroring is restated in this work in an abstract and highly visual manner. With its bipolarity *Enantiomorphic Chambers* contains clues for unraveling the mysteries of art—particularly its reliance on the perceptual and its ability to suggest living presences through static forms.

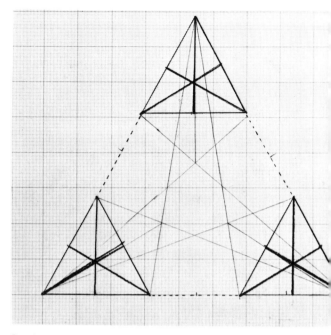

Drawing for *3 Small Vortexes*, 1965; pencil, crayon on graph paper; 10 x 11½". Collection Estate of Robert Smithson, Courtesy John Weber Gallery. Photograph by Nathan Rabin.

4. *Four-Sided Vortex*, 1965; stainless steel, mirrors; 35 × 28 × 28"

When he created *Four-Sided Vortex*, Smithson was fascinated with crystallography. What he was attempting was to base art on a structure different from the organic. Almost always artists and critics have held the quality of a living presence—philosopher Susanne Langer terms it "virtual presence"—to be an absolute standard for judging art. Paralleling Minimalists like Donald Judd, who also tried to avoid the organic, Smithson wished to turn away from an art that was based on man as both subject and viewer, and he found an alternative in crystallography.

Smithson defined crystallography in an essay written on Donald Judd for the Philadelphia Institute of Contemporary Art's catalogue *7 Sculptors*, an essay written the same year he created *Four-Sided Vortex*. "If we define an abstract crystal," he hypothesized, "as a solid bounded by symmetrically grouped surfaces, which have definite relationships to a set of imaginary lines called axes, then we have a clue to the structure of Judd's 'pink plexiglass box.' "[6] Crystals with their orderly arrangement of planes about axes exemplify static symmetry and accordingly look fixed or stationary.

Although Smithson had his geometric sculptures fabricated locally by Arco Steel, Inc., and Milgo Industrial

Four-Sided Vortex (side view), 1965. Collection Estate of Robert Smithson, Courtesy John Weber Gallery. Photograph by Walter Russell.

[6] "Donald Judd," in *Writings*, p. 22.

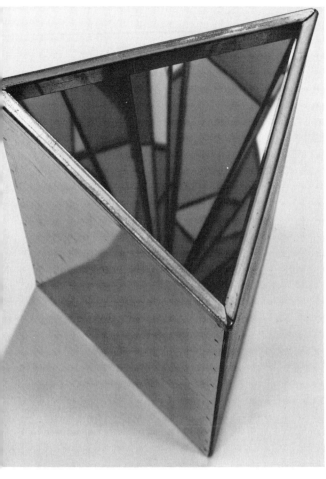

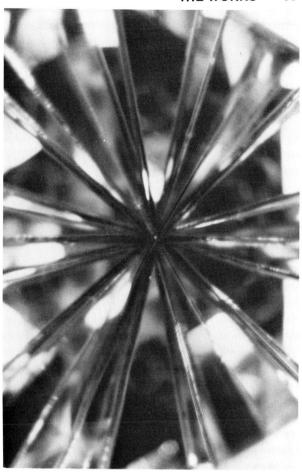

Mirror/Vortex (one of 3 three-sided vortexes), 1965; stainless steel, mirrored glass; each side 16¾ x 9″. Collection Sol LeWitt. Photograph by E. Irving Blomstrann, Courtesy Wadsworth Atheneum, Hartford.

Three-Sided Vortex (inside view), 1965/66; stainless steel and mirrors; each side 34½ x 28¼″. Collection Ace Gallery. Photograph courtesy Ace Gallery.

Corporation, giving them the look of inertness, he frequently relied on the mathematical proportions exhibited by life: dynamic symmetry as defined by Jay Hambidge. Often lauded by teachers at the Art Students League where Smithson studied in the late fifties, Hambidge's *Elements of Dynamic Symmetry* aims to discover a mathematical basis for all living things. Finding static symmetry an instinctive, almost a primitive, means of computing art and not an accurate mathematical understanding of the proportional relationships of living forms, Hambidge carefully analyzes classical Greek art and discovers an eloquent mathematics at work which is true of life, a system founded on geometric progressions and root rectangles, on relations between areas as opposed to mere sets of proportions dependent on linear modules. The distinct advantage of dynamic symmetry is its ability to suggest life and movement. Dynamic symmetry, according to Hambidge, is based on the study of the human skeleton, though he does admit, "The five

regular solids, the cube, the tetrahedron, the octahedron, the icosahedron and the dodecahedron furnish abstract geometrical material for study."

In *Four-Sided Vortex* Smithson pierces a cube with an intersecting mirrored pyramid using forms indicative of crystallography and also recalling the Euclidean solids that Hambidge mentions as worthy of study for dynamic symmetry. One should not view Smithson, however, as a mathematical analyzer of the universe in terms of dynamic symmetry. According to Nancy Holt, his mathematical interests were limited and most of his calculations rudimentary. Rather than attempting to realize a cosmology that could be structured in mathematical relationships, Smithson played on the absurd look of rationality. In the essay "Entropy and the New Monuments," published in 1966, only a year after designing *Four-Sided Vortex,* Smithson links together Lewis Carroll, the fourth dimension, laughter, and crystalline structure. The ordinary laugh is cubic and the chuckle is

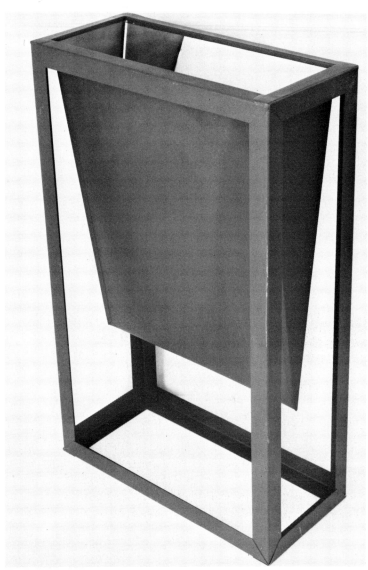

Untitled, 1965; steel, mirrorized plastic; 35½ x 22½ x 10½". Collection Estate of Robert Smithson, Courtesy John Weber Gallery. Photograph by John A. Ferrari.

a triangle or a pyramid, he tells the reader, thus making a work like *Four-Sided Vortex* "solid-state hilarity" or a laughing chuckle.[7] In case viewers of the new art might mistake the artist's original intent as without humor, Smithson concludes his essay by reminding readers to be wary of the physiognomic fallacy: "Math is dislocated by the artists in a personal way, so that it becomes 'Manneristic' or separated from its original meaning. . . . This synthetic math is reflected in Duchamp's 'measured' pieces of fallen threads, *Three Standard Stoppages,* Judd's sequential structured surfaces, Valledor's 'fourth dimensional' color vectors, Grosvenor's hyper-

volumes in hyperspace, and di Suvero's demolitions of space-time."[8]

The use of the word "vortex" in the title of this sculpture appropriately calls to mind the irrational rationality that concerned Smithson. A vortex, a whirlpool or eddy, also a whirling or circular motion forming a vacuum in the center, is indicated in this reductive sculpture that contains a mirrored and negative pyramidal shape. The chuckle is internalized in cubic laughter, and Lewis Carroll's fourth-dimensional realm beyond the Looking Glass is reiterated in the radiating mirrored images that form a vortex within the sculpture. On a drawing of 1964 Smithson noted his intent to make a mirrored vortex which he described as "a well of triangular mirrors— any object may be placed in here—it reveals all kinds of delicate polyhedra, symmetrical networks all held together by fragile 'angles, joints, corners' etc. Put a circle in—you get an upside down pyramid. In the words of Jorge Luis Borges, I have set out 'to design that ungraspable architecture.' "

The ideas developed in *Four-Sided Vortex* were of great importance to Smithson. He created two four-sided vortexes in the sixties and also two groups of three three-sided ones that enclosed negative shapes making up tetrahedrons. One group has black mirrorized plastic that contrasts with the regular mirrors of the others. Another small set was intended as a wall piece. In 1967 Smithson pointed out an important historic precedent in the use of tetrahedrons. Following the lead of Tony Smith, an important proponent of tetrahedral forms in sculpture, Smithson recalled the work of Alexander Graham Bell, who "designed kites based on tetragonal units, that on an esthetic level resemble the satellites such as the SECOR. His units were prefabricated, standardized and crystalline, not unlike Buckminster Fuller's inventions. He also built a pyramid-shaped outdoor observation station that reminds one of the art of Robert Morris. . . . From inside his solid tetrahedron Bell surveyed his 'flight' projects—the tetragonal lattice-kites. A grid connection was established by him between ground and air through this crystalline system. The solid mirrored the lattice. The site was joined to the sky in a structural equation."[9] In this quotation Smithson established a relationship between his mirrored negative tetrahedrons in space and those by Bell. When he mentioned that the outdoor observation station mirrors the floating kites, he established a dialectic that leads to the Site/Nonsite structure of his early Earth art.

[7] "Entropy and the New Monuments," in *Writings*, p. 18.

[8] Ibid.
[9] "Towards the Development of an Air Terminal Site," in *Writings*, pp. 43–44.

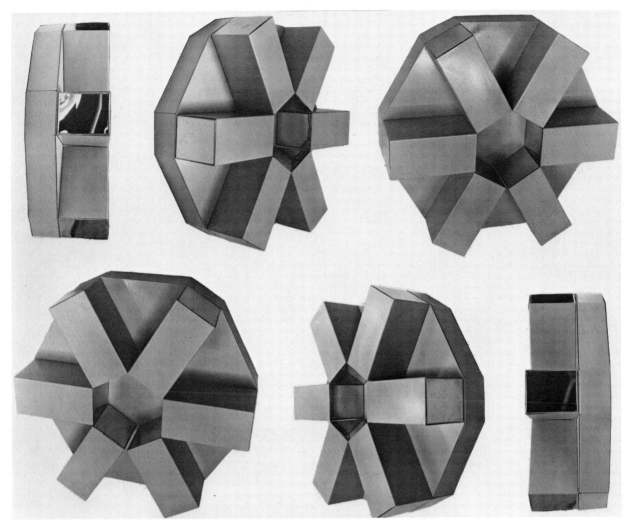

The Cryosphere, 1966. Collection Estate of Robert Smithson, Courtesy John Weber Gallery. Photograph by Gretchen Lambert, Courtesy John Weber Gallery.

5. *The Cryosphere,* 1966; steel with chrome inserts; 6 units, each 17 × 17 × 6″

In an interview with Paul Cummings conducted the summer of 1972 for the Archives of American Art, Robert Smithson recalled that the six hexagonal units making up *Cryosphere* "were linked up somehow in my mind with a notion of ice crystals."[10] Ice crystals, also hexagonal in shape, represent the most stable means for retaining water and the state containing the least amount of energy. In fact, the energy is reduced to such a point that ice can be regarded as water's entropic state. The idea of ice crystals and low temperatures is appropriate to the cool green sculptures in terms of both their color and their inertness. If Minimal art was considered cool art,

then Smithson punned the hip term "cool" by making sculpture that manifested a low-temperature crystalline form indicative of entropy.

For the catalogue accompanying the 1966 "Primary Structures" exhibition at New York's Jewish Museum[11] in which *Cryosphere* was shown, the artist provided the following detailed statistical analysis:

The Cryosphere

Block Encodement #1
010010010010010010 × 12M = 72(1) + 144(0)

1. 010010010010010010 is the tentative sequence for the placement of the six solid hexagonal modules.
2. Each module has 12 mirror surfaces (12M).
3. 6 modules are visible.

[10] Paul Cummings, "Interview with Robert Smithson for the Archives of American Art/Smithsonian Institution," in *Writings,* p. 153.

[11] "The Cryosphere," in *Writings*, p. 37.

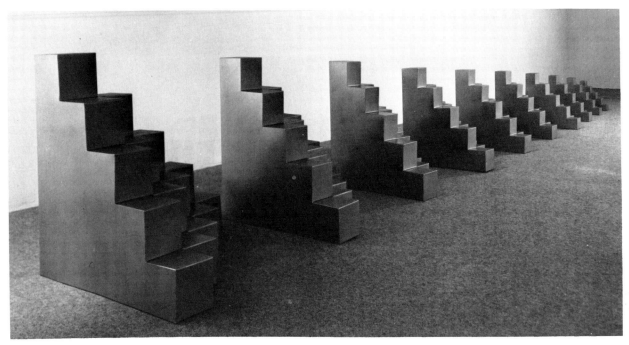

Alogon #2, 1966. Collection Dwan Gallery, Inc. Photograph courtesy Dwan Gallery, Inc.

4. 12 modules are invisible.
5. 72 mirror surfaces are visible.
6. 144 mirror surfaces are invisible.
7. 66⅔% of the entire work is invisible.
8. Invent your sight as you look. Allow your eyes to become an invention.
9. Color by Krylon Inc.

 Surf Green, No. 2002
Pigment . 2.92%
 Titanium Dioxide 100.00%
 Tinting material less than 5.00%
Non-volatile (from vehicle) 9.08%
 Cellulose Nitrate, Coconut Oil
 Modified Alkyd, Phthalate Esters
 Plasticizer, GL-358 Phenolic Resin
 Penetrant
 Volatile . 48.00%
 Ketones, Esters, Alcohols,
 Aromatic Hydrocarbons
 Propellent . 40.00%
 Halogenated Hydrocarbons 100.00%

6. *Alogon #2,* 1966; steel; ten units with square surfaces: 12½″3, 15″3, 17½″3, 20″3, 22½″3, 25″3, 27½″3, 30″3, 32½″3, 35″3

In 1966 Smithson designed three groups of stepped pieces that he named *Alogon.* In each of the works, he created a distinct contrapuntal mathematical system with the linear equation ordering each individual unit and the quadratic equation that the units manifest as a group. Individually the parts appear static, while the group looks dynamic because of the illusion of a sweeping arc. Although both equational systems are entirely logical and consistent in themselves, they contradict each other, creating an interesting and not readily apparent tension between the static consecutive grouping that looks dynamic and the dynamic arrangement of rectangles that appear static. Thus the intended misalliance of two logical systems creates an alogical situation.

As Smithson later wrote of the *Spiral Jetty,* "Ambiguities are admitted rather than rejected, contradictions are increased rather than decreased—the *alogos* undermines the *logos.*" [12] When asked about possible underlying mathematical structures in his work, he related that "the title *Alogon* . . . comes from the Greek word which refers to the unnameable, and irrational number. There was always a sense of ordering, but I couldn't really call it mathematical notation. There was a consciousness of geometry that I worked from in a kind of intuitive way. But it wasn't really in any way notational." [13]

Since the term "alogon" appears to be a clear refutation of "Logos," it is worth mentioning that Logos in ancient Greek philosophy referred to the reason that is the controlling principle in the universe; also it was used

[12] "The Spiral Jetty," in *Writings,* p. 113.
[13] Cummings, "Interview with Robert Smithson . . . ," in *Writings,* p. 153.

Dan Graham, *Row Housing Project, Bayonne, New Jersey*, 1968. Reproduced in Smithson's "A Museum of Language in the Vicinity of Art" (1968). Collection and courtesy Estate of Robert Smithson.

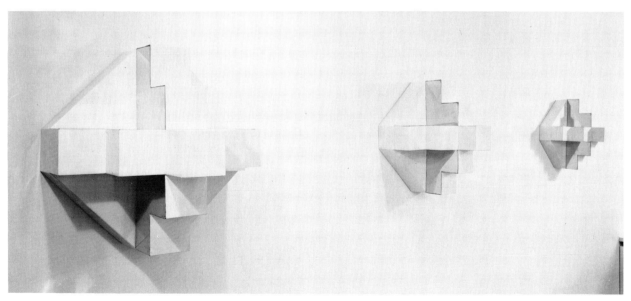

Untitled, 1966; metal; 18¾ x 18½ x 14⅞". Collection Dwan Gallery, Inc. Photograph courtesy John Weber Gallery.

Plan for Hanging Alogon #3, 1966/67; pencil; 18¾ x 24″. Collection Estate of Robert Smithson, Courtesy John Weber Gallery. Photograph by Nathan Rabin.

to define the divine wisdom manifest in creation. Since Smithson did not regard mathematics and solid geometry as sacrosanct, and since he agreed with one of his favorite authors, T. E. Hulme, who wrote that "unity is made in the world by drawing squares over it. . . . The square includes cinders—always cinders. No unity of laws, but merely of the sorting machine,"[14] it seems the "alogos" of *Alogon* is to be taken literally in terms of the underlying conflicting logic of the structure and metaphorically in terms of Smithson's insights into the illogical and absurd nature of existence.

Thus to read *Alogon* as a geometric realization of the apparent logical ordering of the universe which is, in actuality, a refutation of logic is consistent with the artist's

[14] T. E. Hulme, "Cinders: A Sketch of a New Weltanschauung," in *Speculations: Essays on Humanism and the Philosophy of Art*, ed. Herbert Read (New York: Harcourt, Brace & Co., 1924), p. 223.

attitudes. This reading is confirmed by a quotation of Smithson's chosen for inclusion in the catalogue accompanying the exhibition "American Sculpture of the Sixties," an important summation of major trends, organized by Maurice Tuchman for the Los Angeles County Museum of Art in 1967. The piece was selected from Smithson's seminal "Entropy and the New Monuments," originally published in *Artforum* in June 1966. The extract is crucial to all of Smithson's art and of particular interest in relation to the *Alogons*:

Many architectural concepts found in science-fiction have nothing to do with science or fiction, instead they suggest a new kind of monumentality which has much in common with the aims of some of today's artists. I am thinking in particular of Donald Judd, Robert Morris, Sol LeWitt, Dan Flavin, and of certain artists in the "Park Place Group." The artists who build structured canvases

Alogon #1 (as originally installed), 1966; painted stainless steel; 7 units, square surfaces 3, 3½, 4, 4½, 5, 5½, 6″, overall 35½ x 73 x 35½″. Collection Whitney Museum of American Art, New York, Gift of the Howard and Jean Lipman Foundation, Inc. Photograph by George Roos, Courtesy Estate of Robert Smithson.

and "wall-size" paintings, such as Will Insley, Peter Hutchinson and Frank Stella are more indirectly related. The chrome and plastic fabricators such as Paul Thek, Craig Kauffman, and Larry Bell are also relevant. The works of many of these artists celebrate what Flavin calls "inactive history" or what the physicist calls "entropy" or "energy-drain." They bring to mind the Ice Age rather than the Golden Age, and would most likely confirm Vladimir Nabokov's observation that, "The future is but the obsolete in reverse." In a rather roundabout way, many of the artists have provided a visible analog for the Second Law of Thermodynamics, which extrapolates the range of entropy by telling us energy is more easily lost than obtained, and that in the ultimate future the whole universe will burn out and be transformed into an all-encompassing sameness. . . .

Instead of causing us to remember the past like the old monuments, the new monuments seem to cause us to forget the future. Instead of being made of natural materials, such as marble, granite, or other kinds of rock, the new monuments are made of artificial materials, plastic, chrome, and electric light. They are not built for the ages, but rather against the ages. They are involved in a systematic reduction of time down to fractions of seconds, rather than in representing the long spaces of centuries. Both past and future are placed into an objective present. This kind of time has little or no space; it is stationary and without movement, it is going nowhere, it is anti-Newtonian, as well as being instant, and is against the wheels of the time-clock. . . .

This kind of nullification has re-created Kasimir Male-

vich's "non-objective world," where there are no more "likenesses of reality, no idealistic images, nothing but a desert!" But for many of today's artists this "desert" is a "City of the Future" made of null structures and surfaces. This "City" performs no natural function, it simply exists between mind and matter, detached from both, representing neither. It is, in fact, devoid of all classical ideals of space and process. It is brought into focus by a strict condition of perception, rather than by any expressive or emotive means. Perception as a deprivation of action and reaction brings to the mind the desolate, but exquisite, surface-structures of the empty "box" or "lattice." As action decreases, the clarity of such surface-structures increases. This is evident in art when all representations of action pass into oblivion. At this stage, lethargy is elevated to the most glorious magnitude.[15]

The *Alogons,* according to Smithson, are deliberately inert and static; they are testimonies to entropy because they absorb the viewer's active vision and yield nothing in return except their own emptiness. He thought of them as diminishing mirrored reflections made manifest. The sculptures, which appear to recede to a vanishing point, warp real gallery space and make it appear illusionistic. The *Alogons,* those "null structures and surfaces" empty vision of meaning; they dully appear to be logical but in fact conflate logic, rendering it illogical and meaningless. While the subject of the *Alogons* might be the

[15] "Entropy and the New Monuments," in *Writings*, pp. 9–12.

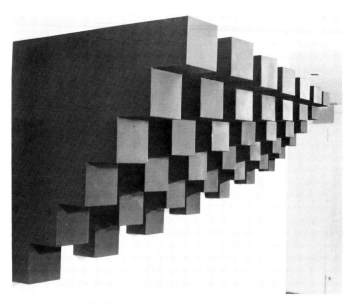

Alogon #1, 1966. Collection Whitney Museum of American Art, New York, Gift of the Howard and Jean Lipman Foundation, Inc. Photograph courtesy Dwan Gallery, Inc.

7. *Plunge*, 1966; steel; 10 units with square surfaces: 14½ to 19″ (½″ increments)

Closely related to the *Alogons, Plunge* incorporates the same conjunction of linear and quadratic equations: the former unifies individual units, the latter serves to organize all the elements into a graduated whole.

Using two alternating equations allowed the artist to create a structure analogous to language—the quadratic could be regarded as synchronic and the linear diachronic. Language was of great concern to Smithson. The same year he designed *Plunge*, he composed *A Heap of Language*, a tautological drawing of a roughly pyramidal shape composed of written words beginning at the top with ''language'' and ending with ''cipher.'' The year after he made *Plunge,* Smithson stressed the physical nature of language in his essay ''Towards the Development of an Air Terminal Site'' (*Artforum,* June 1967). Discussing Alexander Graham Bell's interest in tetragonal systems, he wrote, ''Bell's awareness of the physical properties of language, by way of the telephone, kept him from misunderstanding language and object relationships. Language was transformed by Bell into *linguistic objects*. In this way he avoided the rational categories of art. The impact of 'telephone language' on physical structure remains to be studied. A visual language of modules seems to have emerged from Bell's investigations. Points, lines, areas, or volumes establish the syntax of sites.''[16] In *Plunge,* language's diachronic and synchronic capacities for change are reified, then literalized into a structure that both abstracts and solidifies a basic visual language, perspective. Looking at *Plunge*

[16] ''Towards the Development of an Air Terminal Site,'' in *Writings*, p. 44.

dullness attending entropy, that Smithson can create an image of boredom which is in itself not boring testifies to his power as an artist. He achieves this contradictory feat by establishing a not easily perceived tension between the ponderous repetitiveness of the monotonously increased units and the dynamic arrangement of the overall group.

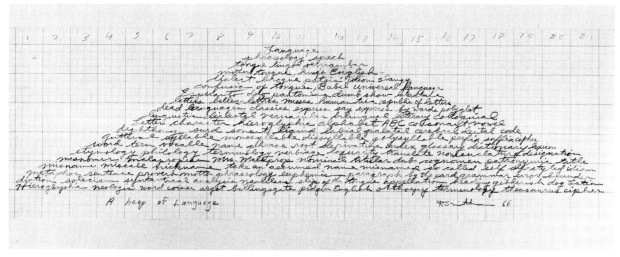

A Heap of Language, 1966; pencil; 6½ x 22″. Collection Estate of Robert Smithson, Courtesy John Weber Gallery. Photograph by Nathan Rabin.

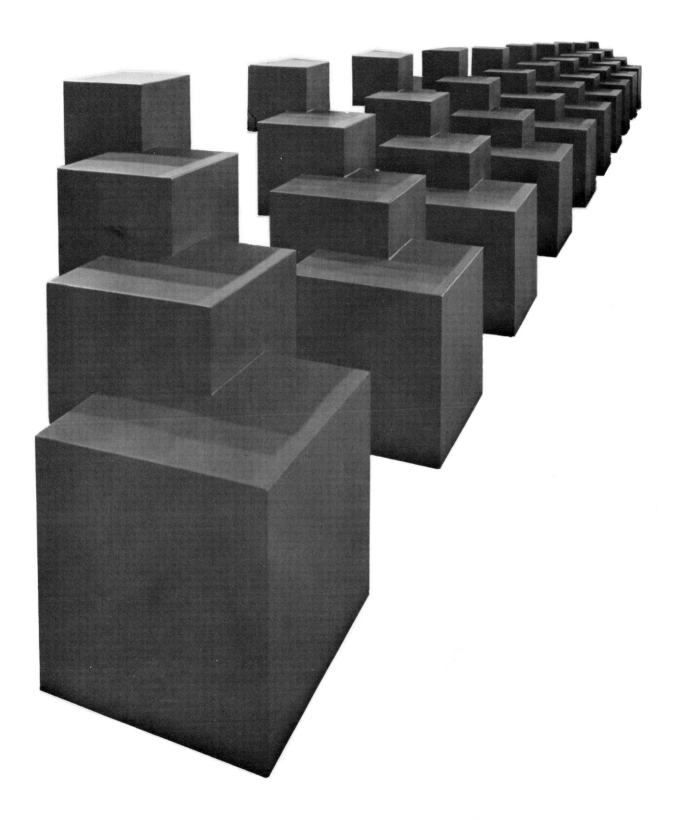

Plunge, 1966. Collection Denver Art Museum, Gift of Kimiko and John Powers. Photograph courtesy Dwan Gallery, Inc.

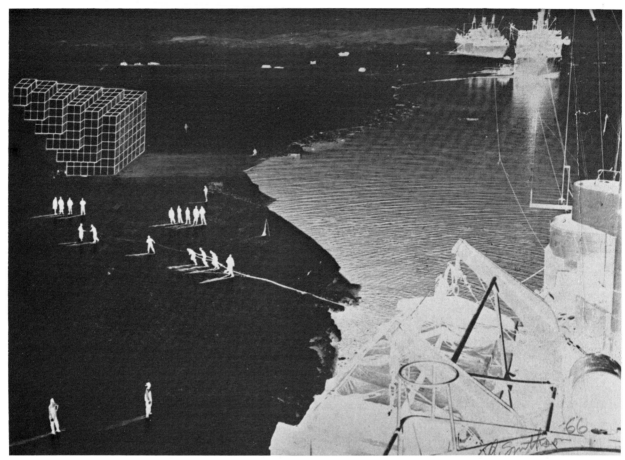

Untitled, 1966; Photostat; 8½ x 12″. Collection Estate of Robert Smithson, Courtesy John Weber Gallery. Photograph by Nathan Rabin.

is equivalent to reading a section of abstracted sign systems. The sculpture appears to be rational, but isn't; it looks as if a single organizing principle has ordered it, but one hasn't; from a certain angle the piece appears to recede far back into space, but it doesn't. The work does, however, provide contradictory statements about both time and space, since time is both diachronic and synchronic, and space is both literal and illusionistic. The dissolution of the commonly perceived space-time continuum suggests a breakdown in the three-dimensional scheme of things and points to a possible fourth dimension, for one must take the plunge into a different dimension in order to perceive the sculpture in its various manifolds.

In addition to the number of conflicting principles at work in this sculpture, there is yet another—crystalline structure. The very makeup of *Plunge* resembles the schematic model for crystals that the French abbé René Just Haüy proposed in the early nineteenth century. The rhombohedral units of Haüy's model emphasize the regularity that is a crystal's essence. At one time crystals

were thought to be transparent materials; Haüy's model, however, made other scientists realize that a definite patterning is the crystal's essential character. The geometric progression organizing the individual elements of *Plunge* endows them with a rationality very similar to that of Haüy's model. When Smithson suggests through linear means a perspectival recession into space, however, he not only confuses the quadratic with the linear—the actual with the illusionistic—but he also puns his efforts to crystallize individual units, that is, to make them clear and regular.

Smithson confirms the crystalline associations of both *Plunge* and the closely associated *Alogons* by creating an imaginary science fiction realm in a photostat of 1966. In this work a huge geometric shape, looking like one element of *Plunge* and also resembling the rhombohedral diagram, rests in the landscape, while off to the side men tug at a large ship. The light is spectral, and the environment is made unfamiliar by the photostat that provides a negative reversal of the world as it is ordinarily seen. The geometric form perched in the middle ground ap-

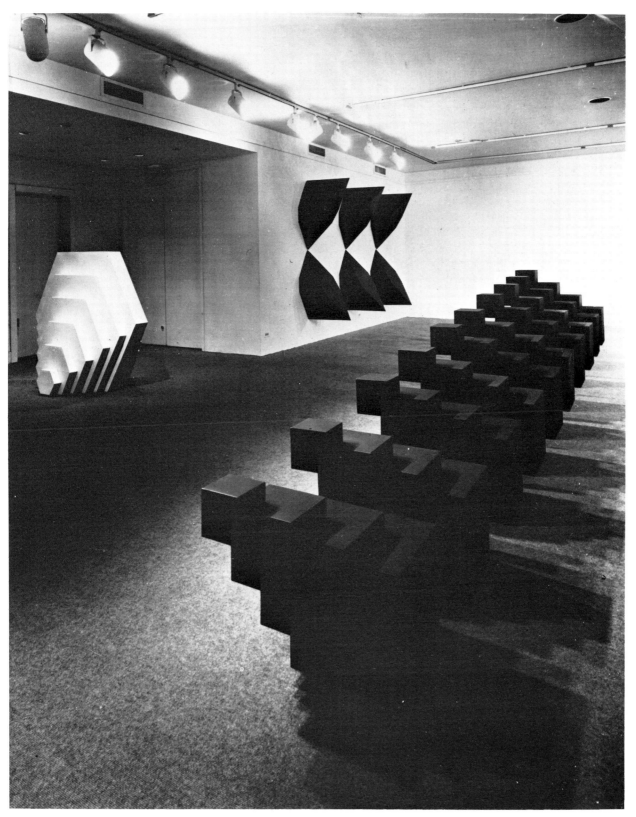

Installation view, Dwan Gallery, New York, December 1966–January 1967. *Plunge* with *Terminal* (left) and *Doubles*. Photograph courtesy Dwan Gallery, Inc.

pears as an absurd and monstrous monument to logic, a clearly drawn solid that is out of kilter with the entire scene. Here the crystalline form denoting clarity and understanding is ironically used to add confusion to an already mysterious realm.

When *Plunge* was first exhibited, Smithson had the piece rotated regularly. Each individual unit was turned 90 degrees so that the work as a whole continued to have a constant axis, and that, though changed, the perspectival view from only one vantage point was maintained. For an exhibition at the Dwan Gallery, *Plunge* was paired with *Alogon #2*. Although the pieces faced each other, they were positioned in reversed ascending and descending order. In this way Smithson played on the three-dimensional perspective that the pieces manifest. If one piece appears to recede into space, the other becomes larger. The artist thus hints at a game of perspective which he then upsets; he makes the gallery space illusionary and then he reaffirms its reality. When he plays with illusion, he establishes the fiction of space pockets, of fourth-dimensional realms where space diminishes and expands. In arranging these works together he also points up the fact that they are "solid-state" illusions: they are sections of paired receding mirror images that supposedly trail off into infinity.

8. *Tar Pool and Gravel Pit*, 1966; proposal for a Philadelphia Earthwork, model destroyed; approximately 3′ square on base 2½′ high

The first proposal for an Earthwork created by Smithson was *Tar Pool and Gravel Pit*, a work with both distinct atavistic overtones and modern art affiliations. Referring back to earlier geological ages, *Tar Pool and Gravel Pit* conjures up the time when giant reptiles and now extinct mammals were encased in tar, as happened to the Rancho-La-Brea group at New York's Museum of Natural History. The piece recalls some specific objects,

Tar Pool and Gravel Pit (model; destroyed), 1966. Photograph courtesy Estate of Robert Smithson.

particularly those early works using asphalt, created by Donald Judd in the early sixties when he was working to rid art of specious illusionism. *Tar Pool and Gravel Pit* also has an early antecedent in the art of Jackson Pollock. It incorporates elements of gravity and ooze and was created on a square platform; thus it provides an interesting counterpart to Pollock's drip paintings which Smithson admired. Indeed, this sculpture could be considered the lugubrious residue of action painting in particular and Abstract Expressionism in general. A final reference for the sculpture can be found in the work of Ad Reinhardt, a friend of Smithson in the sixties renowned for his square black paintings.

Two years after creating this model, Smithson reflected on the analogies between the earth and the brain, evolving a new strategy for symbolizing muddy thinking. In his 1968 *Artforum* essay "A Sedimentation of the Mind: Earth Projects," Smithson describes the making of his early Earthwork. "My own *Tar Pool and Gravel Pit* (1966) proposal," he wrote, "makes one conscious of the primal ooze. A molten substance is poured into a square sink that is surrounded by another square sink of coarse gravel. The tar cools and flattens into a sticky level deposit. This carbonaceous sediment brings to mind a tertiary world of petroleum, asphalts, ozokerite, and bituminous agglomerations."[17]

9. *Proposals for the Dallas–Fort Worth Regional Airport* (Tippetts, Abbett, McCarthy & Stratton, Architects and Engineers), 1966–67

Although Smithson had already proposed *Tar Pool and Gravel Pit* as an outdoor Earthwork for the city of Philadelphia in May 1966 before he was hired in July as an "artist consultant" to the engineering firm of Tippetts, Abbett, McCarthy & Stratton, his contact with the firm, which was making a bid for the Dallas–Fort Worth Regional Airport, was decisive for his Earth art.

During the time he was involved with the project, he originated a number of concepts for Aerial art, that is, art to be made on the ground and viewed from the air. A drawing of 1966 records one of his earliest ideas. Similar to his early quasi-Minimalist forms and also related to *Tar Pool and Gravel Pit* is the proposal for a "Clear Zone," which consists of a series of eleven square asphalt pavements advancing in arithmetic progression from 3 feet to 23 feet, with increments of 2 feet. Each

[17] "A Sedimentation of the Mind: Earth Projects," in *Writings*, pp. 83–84.

PULVERIZATIONS

```
          X              Z              Z              X
 1.   |‾BBBBBBBBBB|TTTTTTTTTT|BBBBBBBBBB‾|
          10'           10'           10'
```

B ■ Bituminous Coal T = Tar (hot, left to cool)

```
          X          Z                      Z          X
 2.   |‾BBBBBBBB|CCCCCCCCCCCCCC|BBBBBBBB‾|
          8'              14'              8'
```

B = Bog Iron Fragments C ■ Cement (dry)

```
          X                    Z  Z                    X
 3.   |‾BBBBBBBBBBBBBB|VV|BBBBBBBBBBBBBB‾|
          14'                2'              14'
```

B ■ Blue Coal V ■ Volcanic Ash

```
          X                    Z  Z                    X
 4.   |‾SSSSSSSSSSSSSS|GG|SSSSSSSSSSSSSS‾|
          14'                2'              14'
```

S = Sandstone Fragments G ■ Glue

```
      X  Z                                        Z    X
 5.   |‾CCC|FFFFFFFFFFFFFFFFFFFFFFFF|CCC‾|
          3'              24'              3'
```

C ■ Coarse Sand F ■ Fine Gravel

Five profiles of foundations (on level ground, 2' deep,
1' below ground, 1' above) shown partitioning contents.

X ■ Outer Foundation Z ■ Inner Foundation

X is always 30' sq., the size of Z is variable.

The widths of X and Z are variable according to
materials used. R. Smithson 66

Pulverizations, 1966; Photostat; 11 x 8½". Collection Estate of Robert Smithson, Courtesy John Weber Gallery. Photograph by Walter Russell.

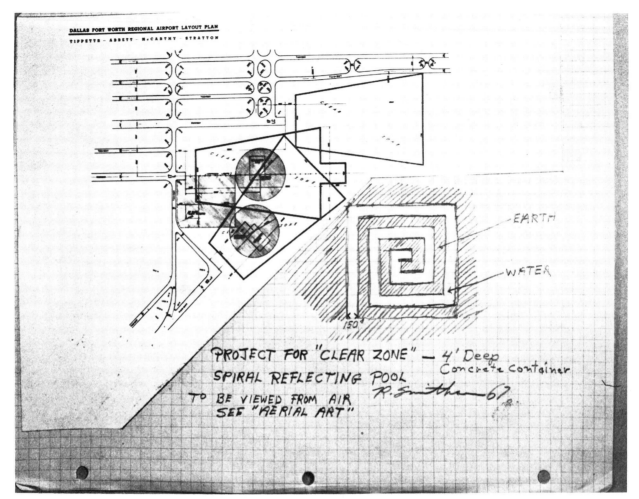

Project for "Clear Zone": Spiral Reflecting Pool, 1967; blueprint with collage and pencil; 11 x 15⅝". Collection Estate of Robert Smithson, Courtesy John Weber Gallery. Photograph courtesy John Weber Gallery.

piece of paving was to be 16 inches in depth with 8 inches above and 8 inches below ground.

The idea of squares is also taken up in another drawing, *Three Earth Windows (under broken glass)* of 1967. In this sketch three sections of clear, broken glass are placed over window grids with stadium lights situated underneath.

While *Earth Windows* continues the mathematical format of *Clear Zone,* other of the Aerial ideas are more organic. A number of drawings are of "wandering earth mounds and gravel paths." One in particular calls for "a web of white gravel paths surrounding water storage tanks." The web is in the form of a spider's net and serves as a conceit for an airport's function, that is, to catch and entrap planes.

When he reflected on Aerial art in an essay for *Studio International* (February–April 1969), Smithson reproduced what one must assume was his final version, as it

is a synthesis of other ideas for the Dallas–Fort Worth project. The concept is titled *Aerial Map—Proposal for Dallas–Fort Worth Regional Airport* (1967); it antecedes later developments on the spiral, particularly *Gyrostasis* (1968) and *Spiral Jetty* (1970). The model illustrated in the essay was made of mirrors, even though the completed outdoor work was to have been of concrete. (A variation on the airport piece calls for a spiral of square asphalt blocks.) Of the final proposal the artist wrote: "A progression of triangular concrete pavements that would result in a spiral effect. This could be built as large as the site would allow, and could be seen from approaching and departing aircraft."[18]

The most immediate effect of the airport proposals was that they caused Smithson to reevaluate his understanding of monumental scale. Whereas he was formerly

[18] "Aerial Art," in *Writings*, p. 93.

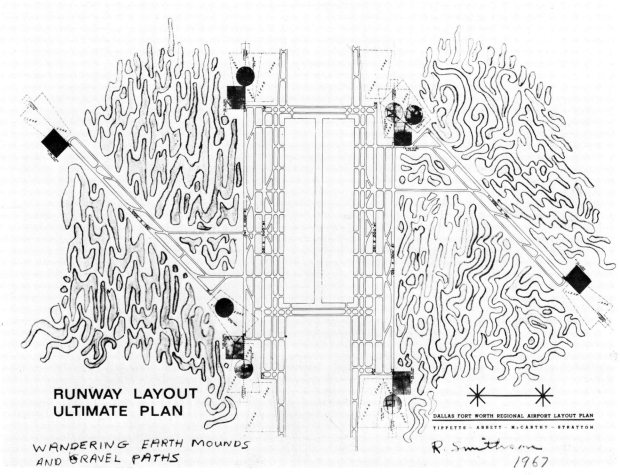

RUNWAY LAYOUT
ULTIMATE PLAN

WANDERING EARTH MOUNDS
AND GRAVEL PATHS

DALLAS FORT WORTH REGIONAL AIRPORT LAYOUT PLAN
TIPPETTS — ABBETT — McCARTHY — STRATTON

R. Smithson
1967

Dallas–Fort Worth Regional Airport Layout Plan: Wandering Earth Mounds and Gravel Paths, 1967; blueprint with collage and pencil; 15½ x 11".
Collection Estate of Robert Smithson, Courtesy John Weber Gallery. Photograph courtesy John Weber Gallery.

attuned to thinking in terms of gallery scale, his whole image of space was enhanced when he came to deal with such gargantuan areas as the proposed landing strips for the airport which were to be 11,000 to 14,000 feet—"or," as the artist remarked, "about the length of Central Park."[19] It is not surprising, then, that he began to view the gallery as a space capable of holding only a few samples from the outdoor locations that increasingly fascinated him, or that he chose to call the gallery pieces "Nonsites" to differentiate them from the "Sites." As he thought about the immense spaces that concerned him, Smithson decided to use the gallery as an important footnote, as a place to bring residues from his journeys and call them art. When he used the name Nonsite he turned the gallery space into an equivalent of moving aircraft and movie theaters—a nowhere place.

Like a movie theater, the gallery attempts to blank itself out, to dissimulate itself into whiteness and austerity so that the work of art—no matter how pared down and minimal in terms of its form—becomes a significant object.

Given Smithson's grounding in the initial plans for the Dallas–Fort Worth Regional Airport, it is not surprising that his first Nonsite involved a landing strip. What is fascinating is that he chose as his Site an airport that is almost the antithesis of the one in Texas: a small, sandy, rarely used government landing strip in the New Jersey Pine Barrens.

Working on the Dallas–Fort Worth Regional Airport caused Smithson to reconsider his early Minimalistic crystalline forms. Concerned with tautologies (as evidenced in his 1966 pyramid of rhetoric, *A Heap of Language*), he began focusing on maps of specific sites and started regarding the sectional divisions on them as abstract shapes that he might make solid. Just as some of

[19] Ibid., p. 92.

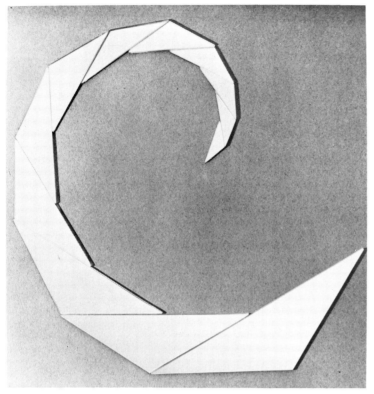

Aerial Map—Proposal for Dallas–Fort Worth Regional Airport, 1967; mirrors; 8 x 50 x 70″. Collection Estate of Robert Smithson, Courtesy John Weber Gallery. Photograph courtesy John Weber Gallery.

his earlier sculptures played with solid geometry, so some of his sculpture made soon after the Texas airport assignment resulted from abstracted mapping that employed degree lines in area maps and lines of latitude and longitude in national and world maps. Sculptures such as *Leaning Strata* and *Gyrostasis* (both of 1968) play on the abstract lines that order maps and become solid cartography. These sculptures represent a midpoint in the development toward three-dimensional relational maps such as *A Nonsite, Pine Barrens, New Jersey*, and mannered perspective studies like a *Nonsite, Franklin, New Jersey*.

10. *Terminal*, 1966; steel; 52½ × 36 × 56½″

Although the word ''terminal'' has several meanings—end, boundary, terminus, relay attached to wire or cable for making connections, and such devices as a teletype writer enabling communication with a computer—the definition Smithson most likely had in mind when he used this word to title a sculpture was a freight or passenger station. At the time *Terminal* was designed,

the artist was considering the possibilities of making what he then termed ''Aerial art.''

In his 1967 *Artforum* essay ''Towards the Development of an Air Terminal Site,'' Smithson considers the meaning of flight in the late twentieth century and compares it with the problem of making art. Both, he suggests, are bogged down by language, by rationalistic details splitting and defining categories to the point that an entropic condition prevails. The artist views present-day ideas of flight as outdated. ''Our whole notion of air-flight,'' he announces, ''is casting off the old meaning of speed through space, and developing a new meaning based on instantaneous time. The aircraft no longer 'represents' a bird or animal (the flying tigers) in an organic way, because the movement of air around the craft is no longer visible. The meaning of airflight has for the most part been conditioned by a rationalism that supposes truths—such as nature, progress, and speed.''[20] In place of the old, no longer useful ideas of speed, with its outmoded forcefulness and concept of movement, the artist suggests a new awareness that takes into consideration the mutual dependence occurring between time and

[20] ''Towards the Development of an Air Terminal Site,'' in *Writings*, p. 41.

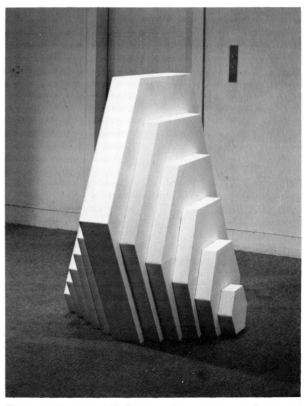

Terminal (side view), 1966. Collection Dwan Gallery, Inc. Photograph courtesy Dwan Gallery, Inc.

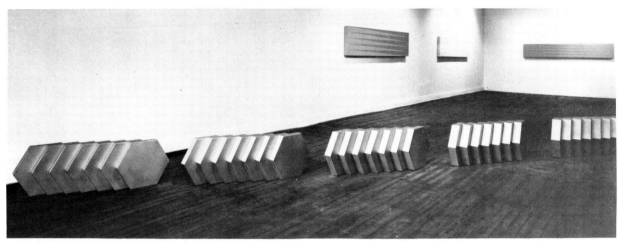

Discontinuous Aggregates, 1966; steel; 5 units, 18 x 54 x 11″, 18½ x 58 x 12″, 19 x 64 x 15″, 19¾ x 66 x 20″, 20 x 70 x 20″. Collection Dwan Gallery, Inc. Photograph courtesy Dwan Gallery, Inc.

space. "The stream-lines of *space* are replaced by a crystalline structure of *time*," he writes enigmatically.[21] Since the crystalline state is very stable and contains little free or available energy, it is an appropriate means for categorizing the new time frozen in immobilized space. Smithson, a little further on in the essay, points out that coordinates gauging land and air masses are crystalline. Also he mentions that the mapping of the planets is akin to establishing the basic axes or coordinates of crystals. So important are crystals with their regularity and their containment of movement within rational coordinates to the new conception of space that the artist even prophesizes that aircraft may assume crystalline patterns and even bear the name of crystals, such as "Rhombohedral T.2; Orthorhombic 60; Tetragonal Terror; Hexagonal Star Dust 49. . . ."[22]

In *Terminal* many of these ideas about the crystalline order of time, the immobilization of space, and the refutation of worn-out concepts of energizing presences are apparent. The sculpture is an enantiomorph composed of pentagonal sections radiating from each side of a central core. The virtual time and space commonly accorded to realistic sculptures is broken down in this work. When looking at *Terminal*, one doesn't feel the sway of immortality that one experiences in a classical Greek or Italian Renaissance sculpture so much as the freezing of both space and time into a new inertness. The illusion of theater, so often used for three-dimensional forms, is likewise evaded in this sculpture; *Terminal* is a terminus, an end zone, a point of stasis. It is a reductive art that is cool to the point of freezing. Built on crystalline ideas, it cloaks itself, turns inward, and as-

[21] Ibid., p. 42.
[22] Ibid., p. 46.

sumes the role of deadpan repetitiveness. *Terminal* could be a new image of space-time coordinates—space frozen and time crystallized to a split second. It also could be a sculptural realization of the new aircraft that doesn't appear to move, but remains calm and immobile.

A drawing of 1966 appears to be related to the sculpture if only in terms of its title and stacked shapes. The drawing indicates thinking about an Earthwork, most likely in conjunction with the Dallas–Fort Worth airport, and suggests that the terminal idea was rooted in concepts Smithson was evolving about flight of the future.

11. *Mirage*, 1967; 9 square mirrors in metal frames; 12 to 36″ (3″ increments)

In the *Mirages*, Smithson plays on differences between reflection and reflector, between so-called illusions and reality. The only work of the series actually to be constructed is the group of nine framed mirrors that graduate in 3-inch increments (12 to 36 inches) from left to right in ascending order and are intended to be hung one inch from the floor. Related to the *Alogons* in terms of their use of arithmetic progression, the mirrors of this *Mirage* indicate a sine qua non for art: the displacement and reflection of reality. Not troubling himself with a laborious working out of mimetic details by painting, drawing, modeling, or carving, Smithson finds a material capable of achieving art's function with little effort. The work involved in making art then amounts to choice, not handicraft, and the meaning of art ceases to be manifested by fictive images. In *Mirage* the illusions are both real and chimerical, as actual, passing reflections appear

Terminal: Plans for Dallas–Fort Worth Regional Airport, 1966; Photostat. Collection Estate of Robert Smithson, Courtesy John Weber Gallery. Photograph courtesy John Weber Gallery.

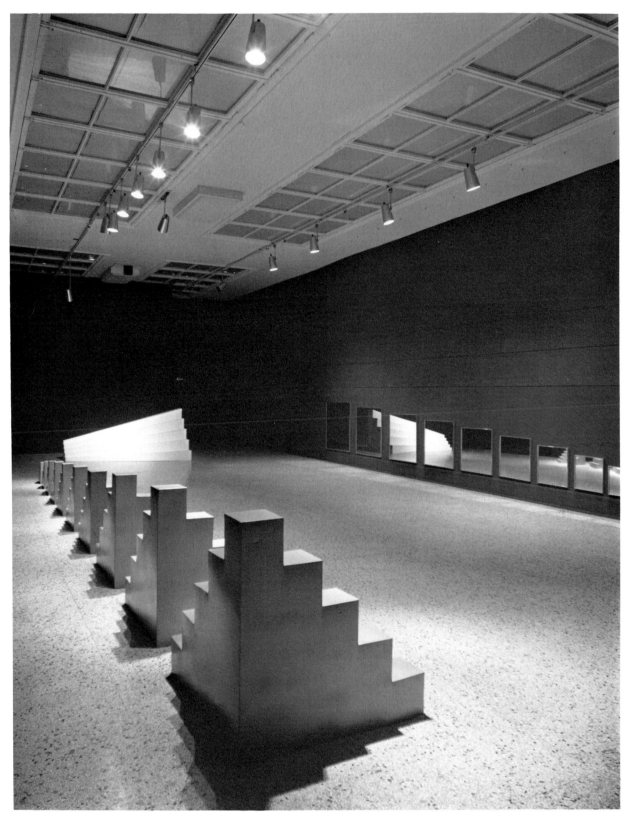

Installation view, Walker Art Center, Minneapolis, 1968. From left to right: *Alogon #2*, *Pointless Vanishing Point*, *Mirage*. Photograph courtesy Walker Art Center.

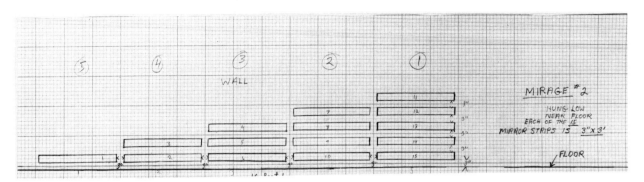

Mirage #2, 1968; pencil on graph paper; 5⅝ x 22″. Collection Estate of Robert Smithson, Courtesy John Weber Gallery. Photograph by Nathan Rabin.

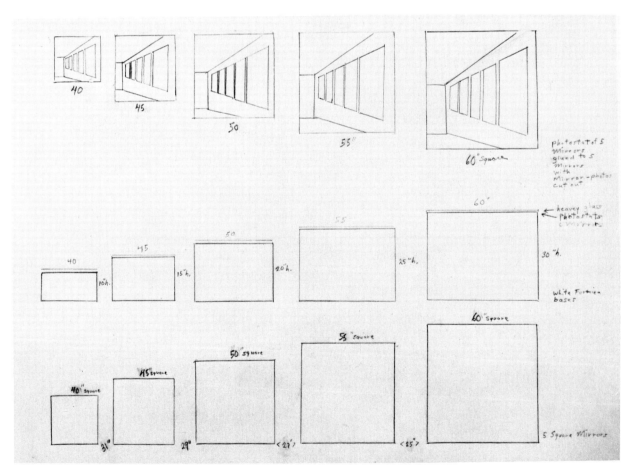

Photostat of 5 Mirrors Glued to 5 Mirrors, 1968; pencil; 18¾ x 23¾″. Collection Estate of Robert Smithson, Courtesy John Weber Gallery. Photograph by Nathan Rabin.

and disappear in the work of art. By graduating and repeating his basic elements, Smithson insures that the unique impressions of individuals will not become the meaning of the work. An underlying rational mathematical order emphasizes the abstract nature of the art and tends to de-emphasize the momentary realism caused by people looking at their feet. If one investigates the piece as a whole, reflectiveness becomes abstract because one cannot encounter all possible mirrored images at any one moment: the inherent function of the mirrors as reflectors of reality prevails.

An elaboration of the *Mirage* theme is explored in a second version that exists only as an undated drawing. Thin strips of mirror 3 inches by 3 feet were to be situated on a wall near floor level. Reflections would be broken up as illusive space worked in conjunction with the solid wall. The entire piece appears to be an early version of an idea that was developed further in 1968 in the Nonsites. In fact, *Mirage #2* resembles an abstract schema for *Nonsite, Oberhausen, Germany*.

The third variation of the *Mirage* theme is proposed in a drawing of 1968 in which mirrors, photostated reflections, and linear perspective are all important forms of illusion. Photostats of five mirrors were to be glued to five mirrors and then cut out to reveal the real mirrors underneath. The photostats were then to be attached to cubes with white plastic sides, becoming elaborate conceits on mirrors and reflectiveness. Although the photostated mirrored cubes were never constructed, ideas germane to this piece were undertaken in several later works. The use of five mirrors receding into the background suggesting perspective in the third version of *Mirage* serves as a source for *A Nonsite, Franklin, New Jersey* (1968), a three-dimensional arrangement of trapezoidal bins suggestive of the schema for linear perspective. In addition, the use of mirrors positioned horizontally to reflect primarily the ceiling of a gallery was the generative idea for *Eight-Part Piece* (making up the 1969 *Rock Salt and Mirror Displacement*), which was composed of horizontal mirrors resting on cones of salt.

In all these works mirrors suggest not so much the actual reflecting of particular circumstances as the function of art as an ongoing means of symbolic displacement. The abstractness of art in these *Mirages* is employed not as a decoration but as a proposition to emphasize an essential nature of art.

12. *Glass Stratum*, 1967; glass; 17¾ × 12 × 84″

In *Ziggurat Mirror, Glass Stratum,* and the *Mirror Strata* (all 1966/67) Smithson experimented with layering mirrors and glass to create simple three-dimensional forms. In *Ziggurat Mirror* the reflective surfaces stand vertically on end, providing a shimmering reflective surface that overlaps itself. The *Mirror Strata* almost cancel out the idea of reflectiveness, however, since only the top and the edges of the stacked piles are visible. In these works an interesting dialectic between shape and illusion

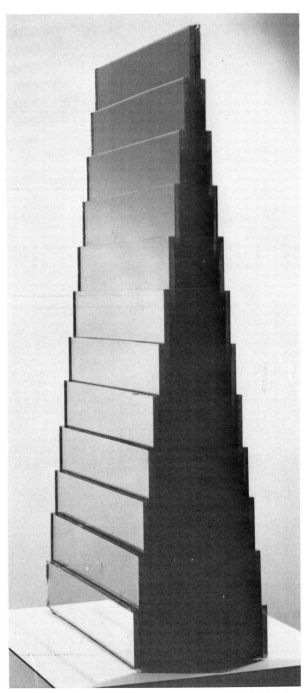

Ziggurat Mirror, 1966; mirrors; 24 x 10 x 5½″. Private collection. Photograph courtesy John Weber Gallery.

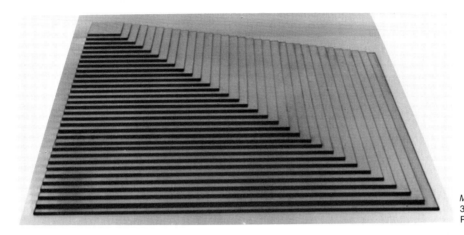

Mirror Stratum, 1966; mirrors; 4 x 35 x 35″. Collection unknown. Photograph by Walter Russell.

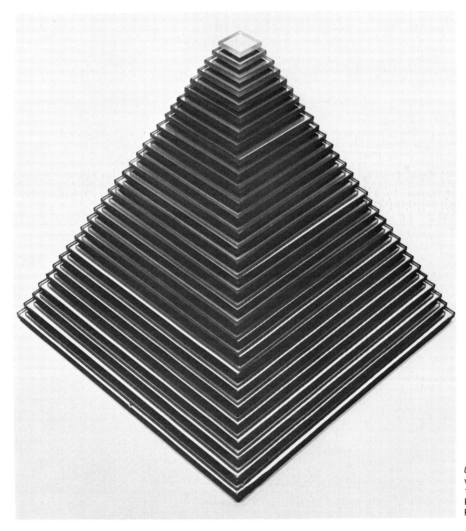

Untitled, 1969; mirror, glass; 2 versions, 5 x 8⅜ x 8⅜″, 7¼ x 12½ x 12⅛″ (editions of 25 each). Published by Multiples, Inc. Photograph courtesy Multiples, Inc.

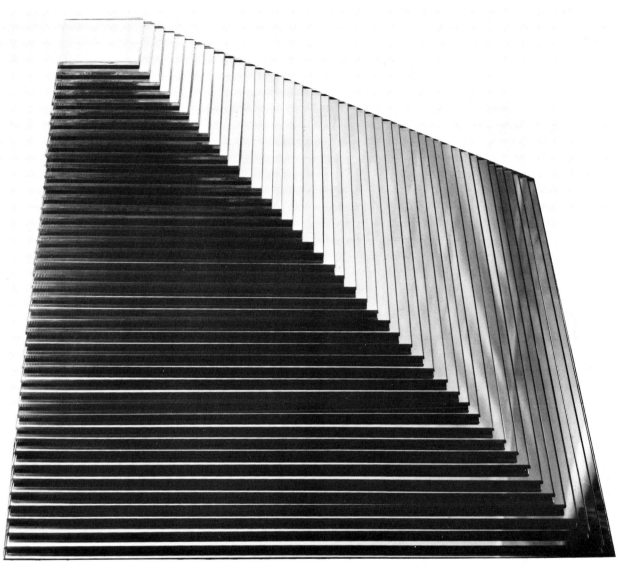

Mirror Stratum, 1966; mirrors; 10¼ x 25½ x 25½″. Collection The Museum of Modern Art, New York. Purchase. Photograph by Walter Russell, Courtesy The Museum of Modern Art, New York.

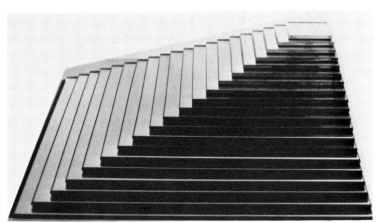

Mirror Stratum, 1966; mirrors; 14 x 14 x 6″. Collection Mr. and Mrs. Eugene Schwartz. Photograph courtesy John Weber Gallery. (Similar piece, 16¾ x 16¾″, in collection of Candace Dwan.)

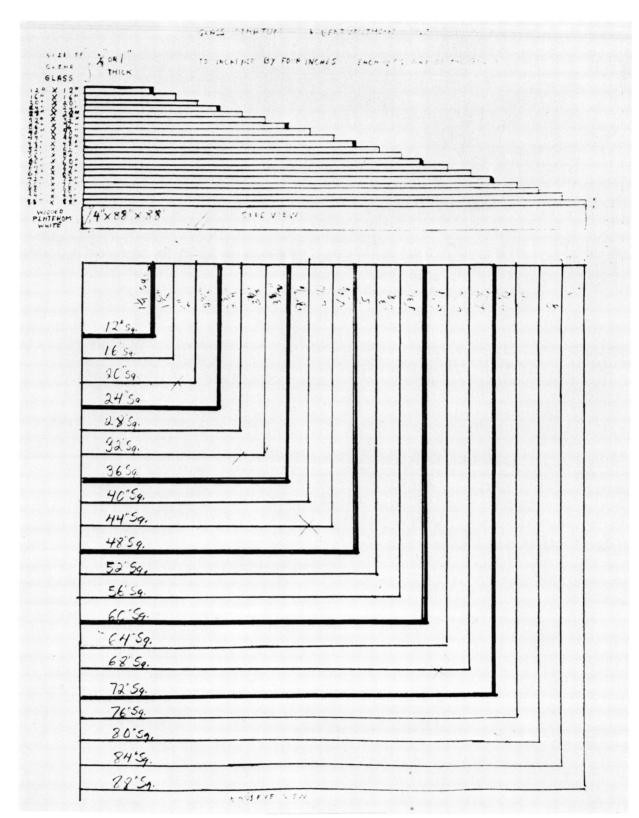

Blueprint for Glass Stratum, 1967; photocopy; 14 x 12″. Collection Estate of Robert Smithson, Courtesy John Weber Gallery. Photograph courtesy John Weber Gallery.

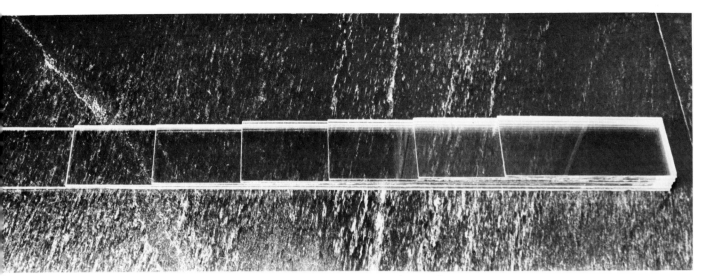

Glass Stratum, 1967; glass; 1½ x 4 x 40″. Collection Candace Dwan. Photograph by Candace Dwan.

is created. If one looks at the piece as sculpture, one minimizes the role the mirrors play; but if one becomes concerned with surface, with the reflectiveness of the piece, one's attention to the sculptural form is diverted.

Smithson's layerings of mirrors and glass are reminiscent of the regular layered planes occurring in such crystals as mica. But even though the visual configurations of these glass sculptures are ordered and rational, the pieces have an underlying nonvisual structure that is disordered and random. Because the sculptures are made of glass—the artist stresses the frozen-liquid nature of this material in the cool green color of *Glass Stratum*—the ordered layering is antithetical to the irregular molecular structure of the material. By using glass, Smithson subverts the presumed order his sculpture exhibits: the rational becomes irrational; systems conflict; and a calm, discreet chaos prevails.

In a 1972 interview with Paul Cummings, Smithson affirmed his interest in crystals during his creation of *Glass Stratum*. "I became more and more interested in the stratifications and the layerings," he told Cummings. "I think it had something to do with the way crystals build up too. I did a series of pieces called *Stratas*. Virginia Dwan's piece called *Glass Strata* [*sic*] is eight feet long by a foot wide, and looks like a glass staircase made out of inch-thick glass; it's very green, very dense and kind of layered up."[23] Smithson was aware of the visual/nonvisual dialectic between appearance and structure in his glass pieces: numerous books on crystallography

in his personal library begin by contrasting the molecular order of glass with that of crystals. In these glass and mirror pieces Smithson establishes a dichotomy between appearance and reality and underscores the concept that clarity and simplicity are often easy surface fictions.

13. *Shift*, 1967; metal; 2 versions (brown and white), both 33 × 30 × 20″

Shift is an early and important manifestation of Smithson's interest in collapsed systems. Smithson made a drawing, concurrent with the *Strata*, in which he played with the concept of perspective systems. He took the schema of one-point perspective, turned it on its side, shifted the orthogonals as one might a deck of cards, and then severed the resulting projection from its point of terminus to create a decontextualized rationality. He had the resultant shape enlarged in three dimensions to create a sculpture that points absurdly to its logical schematic origins. *Shift* is a monument to disconnected logic, to aborted, useless, "entropic" systems. Linear perspective is the traditional means of conceiving space; Smithson ironically literalizes it, making this schematic system a coordinate of real space and thus constructing a sculpture that points to a now nonexistent vanishing point. Traditionally, perspective is a tool for seeing, not a thing to be viewed as an abstract entity. Smithson therefore upsets the traditional means of seeing through perspective when he gives viewers solid perspective that must be looked at.

[23] Cummings, "Interview with Robert Smithson . . . ," in *Writings*, p. 154.

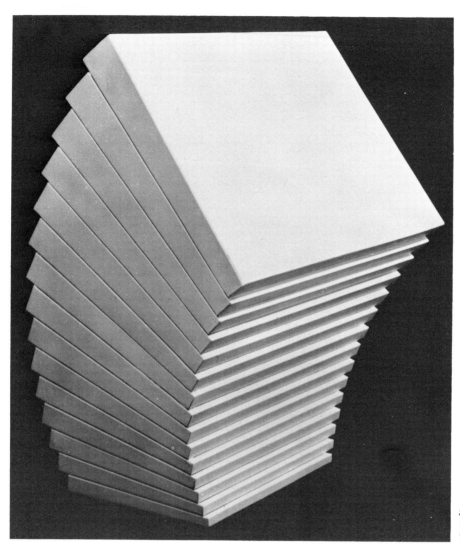

Shift, 1967. Collection Mr. and Mrs. Eugene Schwartz. Photograph by Walter Russell.

14. "A Tour of the Monuments of Passaic, New Jersey," published as "The Monuments of Passaic," in *Artforum* (December 1967)

In "The Monuments of Passaic" Smithson breaks down barriers separating criticism and art from literature and writes an essay that can be termed "narrative art." His "Monuments" piece descends from eighteenth-century travel books that purport to give factual accounts of all major monuments but instead provide a journey in aesthetic sensibility. In the tradition of such essayists as Uvedale Price and William Gilpin, Smithson tours a picturesque landscape, only one wrought not by natural forces, but by the forces of industrialization, urban growth, and suburban sprawl. In the essay Smithson pro-

vides an inversion of the romantic sensibility, both by viewing ruins of the recent past which are not yet immortalized through history and by envisaging ruins that will rise into the future. The point of view chosen is the distancing eye of the camera: "Noonday sunshine cinema-ized the site, turning the bridge and the river into an over-exposed *picture*. Photographing it with my Instamatic 400 was like photographing a photograph." Distance helps to cast the air of unreality on the all too familiar. It enabled Smithson to take great liberties in tone, assuming the disembodied voice of the narrator of many science-fiction tales. It also allowed him to assume an exaggerated rhetorical tone bordering on hyperbole: "If the future is 'out of date' and 'old fashioned,' then I had been in the future. I had been on a planet that had a map of Passaic drawn over it, and a rather imperfect map

at that. . . . I am convinced that the future is lost somewhere in the dumps of the non-historical past; it is in yesterday's newspapers, in the *jejune* advertisements of science-fiction movies, in the false mirror of our rejected dreams.''

The trip taken by the artist from New York to Rutherford and Rutherford to Passaic is a journey in time as well as space. It is a return to his birthplace, Passaic, and his childhood homes, Rutherford and Clifton. The connection between Rutherford and Clifton is Passaic, a town turned into one long main street, a strip that continues for what seems an interminable distance, over four miles, until it becomes Clifton's main street. Passaic is a bridge between Rutherford and Clifton; interestingly, Smithson's first stop is the bridge crossing the Passaic River.

The choice of Passaic as subject for the piece is deliberate. In addition to its importance as Smithson's birthplace, the town has a literary past in William Carlos Williams's *Life along the Passaic River*. Since Dr. Williams's assistant delivered Smithson and Williams himself served as his pediatrician (a fact noted in most of the sculptor's authorized chronologies), Smithson probably knew of Williams's prose poem about the town. Even if he did not know of the book, the subject matter he shares with Williams establishes a connection. Both note the negativity of the landscape as well as the heavy industrialization of the area, and both deal with the town as a ravaged present that almost appears to be part of the past. The most notable coincidence in the representative citing of artifacts by the two writers occurs in the image of pipes gushing forth pollutants into the Passaic River. Smithson names the six pipes he finds *The Fountain Monument*, while Williams more prosaically refers to the single spout he encountered as the jet belonging to the Manhattan Rubber Company. For both, Passaic is a town that struggled to become a flourishing metropolis but ended up an unmemorable suburb of the great megalopolis of northern New Jersey.

At the beginning of the essay Smithson mentions buying the paperback *Earthworks* by Brian W. Aldiss. Although the book receives only a short paragraph a little later in the essay, it provides a most important background for the entire piece. Smithson remarks that the book is "about a soil shortage, and the *Earthworks* referred to the manufacture of artificial soil." The world pictured in this short science-fiction tale is an upside-down inside-out world, something between an ecologist's nightmare of pollutants madly unleashed on the earth and Rachel Carson's vision in *Silent Spring*. Cast in a no-nonsense twenty-second century, the story tells of a deadly depressing apocalypse in which the earth has become an uninhabitable desert. Those who till the land are forced to do so as criminals serving out sentences; they must wear protective suits, and they bear the derogatory name "landsmen." Farmers, by contrast, are powerful. To the free people who live on raised platform cities for protection from pollution, the farmers are but shadowy figures and the landsmen total strangers. "Progress" no longer promises eventual nirvana—it is defined as "only what men do generation after generation," and consequently time is thought to be "an incurable disease." The main character is Knowle Noland (an obvious pun on a man who knows nothing of land), who is engaged at the beginning of the novel in shipping sand around the world. "The sand we got off the Skeleton Coast," he relates, "was mainly quartz grains with gypsum and rock salt also, and traces of rare minerals not worth separating, tourmaline and thorium compounds."[24] These materials are interesting not only because they indicate the desperate state of the earth prophesied in this story, but also because sand, gypsum, and rock salt are the materials used by Smithson in *A Nonsite, Pine Barrens, New Jersey; Death Valley Nonsite;* and *Mirror Displacement (Cayuga Salt Mine Project)*.

Visiting a locale meant only to be seen from a fast-moving automobile, Smithson tours it on foot, slowing down time and perception and allowing himself the opportunity to become familiar with the "nowheresville" twentieth-century suburbia has become. Part of the first generation to experience the pervasiveness of the automobile, the ubiquity of suburbia, and the relief offered by film and television, the artist in this essay changes the basic mode of apprehension of his own generation. Smithson was a significant artist because he was able to make people view the ordinary world in totally new ways. Nowhere is this ability more forcefully presented than in "The Monuments of Passaic." Here monuments are not heroic tributes in the traditional sense. Instead of the Colosseum and Forum of Rome, the Trevi Fountain and Castel Sant' Angelo bridge, the artist finds monuments that neither elevate nor mystify nor awe. They are almost antimonuments: tributes to suburbia, memories of a worn-out, cast-off, "entropic" landscape, they are monuments in miniature, picturesque versions of what in a heroic age might have been sublime concepts.

None of the monuments cited by Smithson are the places in which inhabitants of Passaic take civic pride. In his tour he mentions neither the historic Acquackanonk Landing, an eighteenth-century shipping point for products destined for New York, nor the old brick burial

[24] Brian W. Aldiss, *Earthworks* (New York: Signet, n.d.), p. 10.

vault dating back to 1690, nor even St. Peter and Paul's Russian Orthodox Greek Catholic Church at Monroe and Third streets, said to have been built with money donated by the Czar in 1911. In his eyes New Jersey is the commuter state and the factory state. Grudgingly he might admit that it is also the garden state, but the gardens are of twentieth-century industry and suburbia at the point of exhaustion. The gardens are voids between unnotable nexuses; they are polluted streams, worn parking lots, and unused sandboxes. They are unfocused and certainly not monumental; they are, in short, testimonials to mid-twentieth-century American life.

In a 1972 interview with Gianni Pettena, Smithson summed up his narrative piece on Passaic. "I like landscapes that suggest prehistory," he began. "As an artist it is sort of interesting to take on the persona of a geologic agent where man actually becomes part of that process rather than overcoming it. . . . You just go along with it, and there can be a kind of building that takes place this way. . . . I did an article once, on Passaic, New Jersey, a kind of rotting industrial town where they were building a highway along the river. It was somewhat devastated. In a way, this article that I wrote on Passaic could be conceived of as a kind of appendix to William Carlos Williams's poem 'Paterson.' It comes out of that kind of New Jersey ambience where everything is chewed up. New Jersey like a kind of destroyed California, a derelict California."[25]

THE MONUMENTS OF PASSAIC

Has Passaic replaced Rome as the eternal city?

ROBERT SMITHSON

> He laughed softly. 'I know. There's no way out. Not through the Barrier. Maybe that isn't what I want, after all. But this—this—' He stared at the Monument. 'It seems all wrong sometimes. I just can't explain it. It's the whole city. It makes me feel haywire. Then I get these flashes—'
>
> —Henry Kuttner, *Jesting Pilot*

> . . . today our unsophisticated cameras record in their own way our hastily assembled and painted world.
>
> —Vladimir Nabokov, *Invitation to a Beheading*

On Saturday, September 30, 1967, I went to the Port Authority Building on 41st Street and 8th Avenue. I bought a copy of the *New York Times* and a Signet paperback called *Earthworks* by Brian W. Aldiss. Next I

went to ticket booth 21 and purchased a one-way ticket to Passaic. After that I went up to the upper bus level (platform 173) and boarded the number 30 bus of the Inter-City Transportation Co.

I sat down and opened the *Times*. I glanced over the art section: a "Collectors', Critics', Curators' Choice" at A.M. Sachs Gallery (a letter I got in the mail that morning invited me "to play the game before the show closes October 4th"), Walter Schatzki was selling "Prints, Drawings, Watercolors" at "33⅓% off," Elinor Jenkins, the "Romantic Realist," was showing at Barzansky Galleries, XVIII—XIX Century English Furniture on sale at Parke-Bernet, "New Directions in German Graphics" at Goethe House, and on page 29 was John Canaday's column. He was writing on *Themes and the Usual Variations*. I looked at a blurry reproduction of Samuel F. B. Morse's *Allegorical Landscape* at the top of Canaday's column; the sky was a subtle newsprint grey, and the clouds resembled sensitive stains of sweat reminiscent of a famous Yugoslav watercolorist whose name I have forgotten. A little statue with right arm held high faced a pond (or was it the sea?). "Gothic" buildings in the allegory had a faded look, while an unnecessary tree (or was it a cloud of smoke?) seemed to puff up on the left side of the landscape. Canaday referred to the picture as "standing confidently along with other allegorical representatives of the arts, sciences, and high ideals that universities foster." My eyes stumbled over the newsprint, over such headlines as "Seasonal Upswing," "A Shuffle Service," and "Moving a 1,000 Pound Sculpture Can Be a Fine Work of Art, Too." Other gems of Canaday's dazzled my mind as I passed through Secaucus. "Realistic waxworks of raw meat beset by vermin," (Paul Thek), "Mr. Bush and his colleagues are wasting their time," (Jack Bush), "a book, an apple on a saucer, a rumpled cloth," (Thyra Davidson). Outside the bus window a Howard Johnson's Motor Lodge flew by—a symphony in orange and blue. On page 31 in Big Letters: THE EMERGING POLICE STATE IN AMERICA SPY GOVERNMENT. "In this book you will learn . . . what an Infinity Transmitter is."

The bus turned off Highway 3, down Orient Way in Rutherford.

I read the blurbs and skimmed through *Earthworks*. The first sentence read, "The dead man drifted along in the breeze." It seemed the book was about a soil shortage, and the *Earthworks* referred to the manufacture of artificial soil. The sky over Rutherford was a clear cobalt blue, a perfect Indian summer day, but the sky in *Earthworks* was a "great black and brown shield on which moisture gleamed."

[25] Pettena, "Conversation in Salt Lake City," in *Writings*, p. 187.

The bus passed over the first monument. I pulled the buzzer-cord and got off at the corner of Union Avenue and River Drive. The monument was a bridge over the Passaic River that connected Bergen County with Passaic County. Noonday sunshine cinema-ized the site, turning the bridge and the river into an over-exposed *picture*. Photographing it with my Instamatic 400 was like photographing a photograph. The sun became a monstrous light-bulb that projected a detached series of "stills" through my Instamatic into my eye. When I walked on the bridge, it was as though I was walking on an enormous photograph that was made of wood and steel, and underneath the river existed as an enormous movie film that showed nothing but a continuous blank.

The steel road that passed over the water was in part an open grating flanked by wooden sidewalks, held up by a heavy set of beams, while above, a ramshackle network hung in the air. A rusty sign glared in the sharp atmosphere, making it hard to read. A date flashed in the sunshine . . . 1899 . . . No . . . 1896 . . . maybe (at the bottom of the rust and glare was the name Dean & Westbrook Contractors, N.Y.). I was completely controlled by the Instamatic (or what the rationalists call a camera). The glassy air of New Jersey defined the structural parts of the monument as I took snapshot after snapshot. A barge seemed fixed to the surface of the water as it came toward the bridge, and caused the bridgekeeper to close the gates. From the banks of Passaic I watched the bridge rotate on a central axis in order to allow an inert rectangular shape to pass with its unknown cargo. The Passaic (West) end of the bridge rotated south, while the Rutherford (East) end of the bridge rotated north; such rotations suggested the limited movements of an outmoded world. "North" and "South" hung over the static river in a bi-polar manner. One could refer to this bridge as the "Monument of Dislocated Directions."

Along the Passaic River banks were many minor monuments such as concrete abutments that supported the shoulders of a new highway in the process of being built. River Drive was in part bulldozed and in part intact. It was hard to tell the new highway from the old road; they were both confounded into a unitary chaos. Since it was Saturday, many machines were not working, and this caused them to resemble prehistoric creatures trapped in the mud, or, better, extinct machines—mechanical dinosaurs stripped of their skin. On the edge of this prehistoric Machine Age were pre- and post-World War II suburban houses. The houses mirrored themselves into colorlessness. A group of children were throwing rocks at each other near a ditch. "From now on you're not going to come to our hide-out. And I mean it!" said a little blonde girl who had been hit with a rock.

The Bridge Monument Showing Wooden Sidewalks, 1967; Instamatic snapshot by Robert Smithson. Courtesy Estate of Robert Smithson.

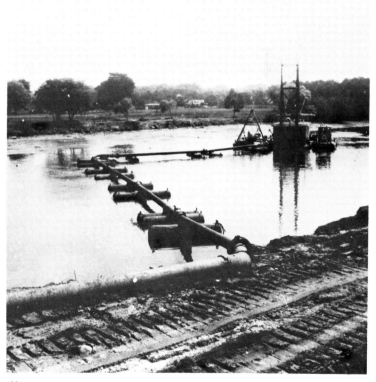

Monument with Pontoons: The Pumping Derrick, 1967; Instamatic snapshot by Robert Smithson. Courtesy Estate of Robert Smithson.

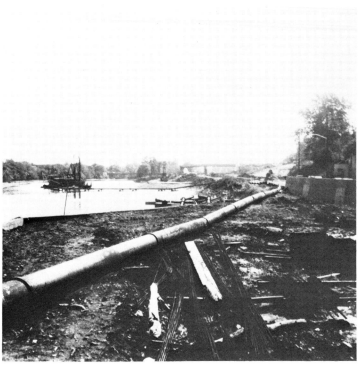

The Great Pipes Monument, 1967; Instamatic snapshot by Robert Smithson. Courtesy Estate of Robert Smithson.

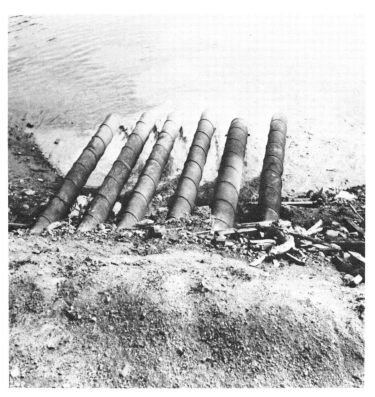

The Fountain Monument—Bird's-Eye View, 1967; Instamatic snapshot by Robert Smithson. Courtesy Estate of Robert Smithson.

As I walked north along what was left of River Drive, I saw a monument in the middle of the river—it was a pumping derrick with a long pipe attached to it. The pipe was supported in part by a set of pontoons, while the rest of it extended about three blocks along the river bank till it disappeared into the earth. One could hear debris rattling in the water that passed through the great pipe.

Nearby, on the river bank, was an artificial crater that contained a pale limpid pond of water, and from the side of the crater protruded six large pipes that gushed the water of the pond into the river. This constituted a monumental fountain that suggested six horizontal smokestacks that seemed to be flooding the river with liquid smoke. The great pipe was in some enigmatic way connected with the infernal fountain. It was as though the pipe was secretly sodomizing some hidden technological orifice, and causing a monstrous sexual organ (the fountain) to have an orgasm. A psychoanalyst might say that the landscape displayed "homosexual tendencies," but I will not draw such a crass anthropomorphic conclusion. I will merely say, "It was there."

Across the river in Rutherford one could hear the faint voice of a P. A. system and the weak cheers of a crowd at a football game. Actually, the landscape was no landscape, but "a particular kind of heliotypy" (Nabokov), a kind of self-destroying postcard world of failed immortality and oppressive grandeur. I had been wandering in a moving picture that I couldn't quite picture, but just as I became perplexed, I saw a green sign that explained everything:

YOUR HIGHWAY TAXES 21
AT WORK

Federal Highway U.S. Dept. of Commerce
Trust Funds Bureau of Public Roads
2,867,000 State Highway Funds
 2,867,000
 New Jersey State Highway Dept.

That zero panorama seemed to contain *ruins in reverse,* that is—all the new construction that would eventually be built. This is the opposite of the "romantic ruin" because the buildings don't *fall* into ruin *after* they are built but rather *rise* into ruin *before* they are built. This anti-romantic *mise-en-scene* suggests the discredited idea of *time* and many other "out of date" things. But the suburbs exist without a rational past and without the "big events" of history. Oh, maybe there are a few statues, a legend, and a couple of curios, but no past—just what passes for a future. A Utopia minus a bottom, a place where the machines are idle, and the sun has turned to glass, and a place where the Passaic Concrete Plant (253 River Drive) does a good business in STONE,

BITUMINOUS, SAND, and CEMENT. Passaic seems full of "holes" compared to New York City, which seems tightly packed and solid, and those holes in a sense are the monumental vacancies that define, without trying, the memory-traces of an abandoned set of futures. Such futures are found in grade B Utopian films, and then imitated by the suburbanite. The windows of City Motors auto sales proclaim the existence of Utopia through 1968 WIDE TRACK PONTIACS—Executive, Bonneville, Tempest, Grand Prix, Firebirds, GTO, Catalina, and LeMans—that visual incantation marked the end of the highway construction.

Next I descended into a set of used car lots. I must say the situation seemed like a change. Was I in a new territory? (An English artist, Michael Baldwin, says, "It could be asked if the country does in fact change—it does not in the sense a traffic light does.") Perhaps I had slipped into a lower stage of futurity—did I leave the real future behind in order to advance into a false future? Yes, I did. Reality was behind me at that point in my suburban Odyssey.

Passaic center loomed like a dull adjective. Each "store" in it was an adjective unto the next, a chain of adjectives disguised as stores. I began to run out of film, and I was getting hungry. Actually, Passaic center was no center—it was instead a typical abyss or an ordinary void. What a great place for a gallery! Or maybe an "outdoor sculpture show" would pep that place up.

At the Golden Coach Diner (11 Central Avenue) I had my lunch, and loaded my Instamatic. I looked at the orange-yellow box of Kodak Verichrome Pan, and read a notice that said:

READ THIS NOTICE:
This film will be replaced if defective in manufacture, labeling, or packaging, even though caused by our negligence or other fault. Except for such replacement, the sale or any subsequent handling of this film is without other warranty or liability.
EASTMAN KODAK COMPANY DO NOT OPEN THIS CARTRIDGE OR YOUR PICTURES MAY BE SPOILED—12 EXPOSURES—SAFETY FILM—ASA 125 22 DIN.

After that I returned to Passaic, or was it the *hereafter*—for all I know that unimaginative suburb could have been a clumsy eternity, a cheap copy of The City of the Immortals. But who am I to entertain such a thought? I walked down a parking lot that covered the old railroad tracks which at one time ran through the middle of Passaic. That monumental parking lot divided the city in half, turning it into a mirror and a reflection—

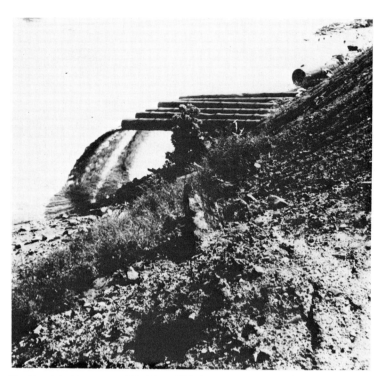

The Fountain Monument: Side View, 1967; Instamatic snapshot by Robert Smithson. Courtesy Estate of Robert Smithson.

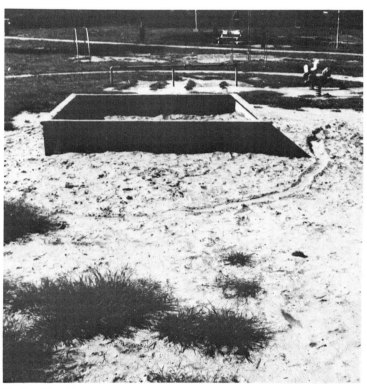

The Sand-Box Monument (also called *The Desert*), 1967; Instamatic snapshot by Robert Smithson. Courtesy Estate of Robert Smithson.

but the mirror kept changing places with the reflection. One never knew what side of the mirror one was on. There was nothing *interesting* or even strange about that flat monument, yet it echoed a kind of cliché idea of infinity; perhaps the "secrets of the universe" are just as pedestrian—not to say dreary. Everything about the site remained wrapped in blandness and littered with shiny cars—one after another they extended into a sunny nebulosity. The indifferent backs of the cars flashed and reflected the stale afternoon sun. I took a few listless, entropic snapshots of that lustrous monument. If the future is "out of date" and "old fashioned," then I had been in the future. I had been on a planet that had a map of Passaic drawn over it, and a rather imperfect map at that. A sidereal map marked up with "lines" the size of streets, and "squares" and "blocks" the size of buildings. At any moment my feet were apt to fall through the cardboard ground. I am convinced that the future is lost somewhere in the dumps of the non-historical past; it is in yesterday's newspapers, in the *jejune* advertisements of science-fiction movies, in the false mirror of our rejected dreams. Time turns metaphors into *things*, and stacks them up in cold rooms, or places them in the celestial playgrounds of the suburbs.

Has Passaic replaced Rome as The Eternal City? If certain cities of the world were placed end to end in a straight line according to size, starting with Rome, where would Passaic be in that impossible progression? Each city would be a three-dimensional mirror that would reflect the next city into existence. The limits of eternity seem to contain such nefarious ideas.

The last monument was a sand box or a model desert. Under the dead light of the Passaic afternoon the desert became a map of infinite disintegration and forgetfulness. This monument of minute particles blazed under a bleakly glowing sun, and suggested the sullen dissolution of entire continents, the drying up of oceans—no longer were there green forests and high mountains—all that existed were millions of grains of sand, a vast deposit of bones and stones pulverized into dust. Every grain of sand was a dead metaphor that equaled timelessness, and to decipher such metaphors would take one through the false mirror of eternity. This sand box somehow doubled as an open grave—a grave that children cheerfully play in.

> . . . *all sense of reality was gone. In its place had come deep-seated illusions, absence of pupillary reaction to light, absence of knee reaction—symptoms all of progressive cerebral meningitis: the blanketing of the brain* . . .
> —*Louis Sullivan, "one of the greatest of all architects," quoted in Michel Butor's* Mobile.

I should now like to prove the irreversibility of eternity by using a *jejune* experiment for proving entropy. Picture in your mind's eye the sand box divided in half with black sand on one side and white sand on the other. We take a child and have him run hundreds of times clockwise in the box until the sand gets mixed and begins to turn grey; after that we have him run anti-clockwise, but the result will not be restoration of the original division but a greater degree of greyness and an increase of entropy.

Of course, if we filmed such an experiment we could prove the reversibility of eternity by showing the film backwards, but then sooner or later the film itself would crumble or get lost and enter the state of irreversibility. Somehow this suggests that the cinema offers an illusive or temporary escape from physical dissolution. The false immortality of the film gives the viewer an illusion of control over eternity—but "the superstars" are fading.

Negative Map Showing Region of the Monuments along the Passaic River, 1967; Photostat. Courtesy Estate of Robert Smithson.

15. *Gyrostasis*, 1968; steel; $73 \times 57 \times 40''$, model $41 \times 30 \times 24''$

Smithson attempted to explain *Gyrostasis* in the following paragraph included in the Hirshhorn Museum and

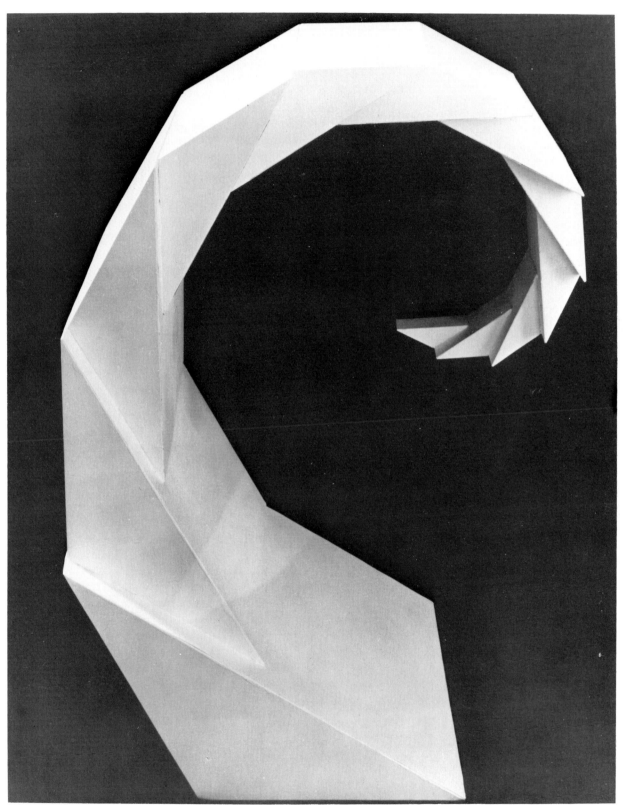

Gyrostasis, 1968. Collection Hirshhorn Museum and Sculpture Garden, Smithsonian Institution. Photograph courtesy Hirshhorn Museum and Sculpture Garden, Smithsonian Institution.

Sculpture Garden permanent collection catalogue (1974):

> The title *Gyrostasis* refers to a branch of physics that deals with rotating bodies, and their tendency to maintain their equilibrium. The work is a standing triangulated spiral. When I made the sculpture I was thinking of mapping procedures that refer to the planet Earth. One could consider it as a crystallized fragment of a gyroscopic rotation, or as an abstract three dimensional map that points to the *Spiral Jetty*, 1970 in the Great Salt Lake, Utah. *Gyrostasis* is relational, and should not be considered as an isolated object.

His first important spiraling form (which foreshadows *Gyrostasis*), *Proposal for Dallas–Fort Worth Regional Airport: Aerial Map* (1967), was a model created in mirrors for a large-scale work to be built in concrete. At the

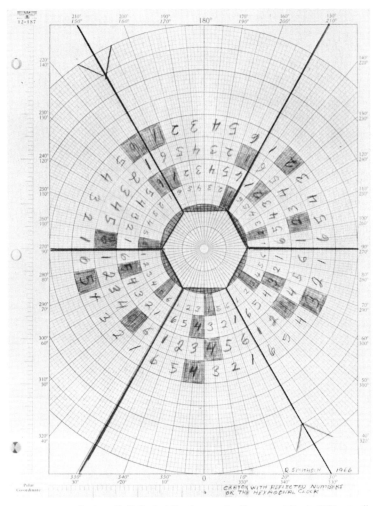

Crater with Reflected Numbers, or the Hexagonal Clock, 1966; pencil, crayon, ink on graph paper; 11 x 8½". Collection Estate of Robert Smithson, Courtesy John Weber Gallery. Photograph by Nathan Rabin.

time Smithson was experimenting with maps, making a number of drawings incorporating abstract cartographic grids. His aim was to create an abstract map, a blank map on the order of Lewis Carroll's,[26] described in *The Hunting of the Snark* and referred to by Smithson in his 1968 essay "A Museum of Language in the Vicinity of Art." Carroll's map contained nothing but the sea, no boundaries of any kind save the border of the map itself. Smithson adopted Carroll's idea, using only portions of the abstract degree lines of cartography in his mirrored model, thus creating a system with no referents, but following only its own rules for measuring distance and scale. Then Smithson elaborated his map drawing in a manner similar to the three-dimensional forms of primitive maps, particularly Eskimo carved wooden charts and relief models and the dried clay maps of northern Mesopotamia (c. 3800 B.C.). From the maps he developed such sculptures as *Gyrostasis*, *Leaning Strata*, and the Nonsites. A transitional piece in this process was the *Aerial Map* for the Dallas–Fort Worth airport project.

The triangular spirals of *Gyrostasis* and *Aerial Map* have a prototype in an alternative design for the regional airport's "Clear Zone": the *Spiral Reflecting Pool* (1967), a 4-foot-deep concrete container for a rectangular spiral 150 feet in width. The importance of this shape resides not only in its foreshadowing *Spiral Jetty* but also in its being a direct reference to a fairly frequent mode of crystal extension—spiral growth from a single rupture, known as screw dislocation.

Several earlier drawings indicate thinking basic to *Gyrostasis*. In 1966 Smithson was concerned with mapmaking procedures. His *Crater with Reflected Numbers, or the Hexagonal Clock* of that year is a drawing on special graph paper detailing polar co-ordinates. Following the guide lines of the map, he divided the 360-degree configuration into six 60-degree intervals, each of which form a corner of a hexagon, which is inscribed in a darkened circle. The circular format of the flattened-out earth's hemisphere is used by the artist in a drawing of 1967. Playing on the idea of the North and South poles, he constructed an "Entropic Pole" that he located in a swamp not far from East Rutherford in Bergen County, New Jersey. A photostat of *Entropic Pole* served as documentation in May 1968 for the second Nonsite, which was constructed at the Walker Art Center under Smithson's written instructions. The piece was later destroyed when the artist saw it. Both *Hexagonal Clock* and *Entropic Pole* serve as sources for *Gyrostasis*, as the plans for the sculpture indicate. Hexagonal forms radiate outward on axis forming a revolving, geometrical foliate

[26] See illustration of Carroll's map in Lawrence Alloway's essay in this volume.

Drawing of a detail of *Gyrostasis*, 1968; pencil on tracing paper; 9½ x 14″. Collection Estate of Robert Smithson, Courtesy John Weber Gallery. Photograph by Nathan Rabin.

pattern of six layers. Twelve tangential triangulated shapes in descending order are selected to form the sculpture that represents an abstraction of cartographic procedures, and to create a network of solid isosceles triangles spiraling around an unidentified void that might well represent an ''entropic pole.''

The sculpture bears a strong relation to *Terminal*; in fact, one might even say that *Gyrostasis* is an inversion of *Terminal*. While *Terminal* contains leaves that converge in a solid core, the elements making up *Gyrostasis* wheel around an empty space. The triangulated sides of *Gyrostasis* are bisections of the sides of a hexagon, while the parts of *Terminal* are gathered around a dominant central hexagon. Inverse or mirror images are not unusual in Smithson's work, which often involves dialectics—especially his Sites/Nonsites, made shortly after these sculptures. The kinship between *Gyrostasis*, *Terminal*, and the Nonsites seems even stronger when one considers that the first Nonsite (*Pine Barrens, New Jersey*) is a hexagon. The piece constitutes a reworking of both cartographic procedures and perspective visions. At the central point of convergence, it becomes both an ''entropic pole'' and a solidification of the traditional vanishing point, testifying to the uselessness of both systems in dealing with actual space.

Entropic Pole, 1967; map; 24 x 18″. Collection Estate of Robert Smithson, Courtesy John Weber Gallery. Photograph by Nathan Rabin.

Gyrostasis is also the result of crystalline ordering. Following the regularity of crystals but not known arrangements of them, the sculpture belongs to the same family of forms as the "pyramidal slabs and flying obelisks" that the artist claims aircraft are already beginning to resemble.[27] Unlike these flying machines, though, *Gyrostasis* is located in the timeless realm of a gallery or museum. The sculpture is immobile; it is time frozen into discrete ascending and spiraling crystals.

In many of his writings the artist reveals his interest in a noncentered and unfocused revolving periphery that relates to *Gyrostasis*. Growing up in New Jersey—realm of the ubiquitous suburb and unending "strip"—made him question the focused, impacted world of Manhattan. He looked for a geography that could serve as a metaphor for the present state of humankind and found it in New Jersey suburbs (such as Passaic), in industrial parks, and in Western deserts. In 1968, the same year he created *Gyrostasis*, he expressed these concerns in a slightly different manner when he discussed "the center and the circumference" in an essay for *Art International*. In the piece he used Ad Reinhardt's cartoon *A Portend of the Artist as a Yhung Mandala* (1955), to discuss the two ideas. "The center of Reinhardt's Joke is empty of monsters," he began, "a circle contains four sets of three squares that descend toward the middle vortex. It is an inversion of Pascal's statement, that 'nature is an infinite sphere, whose center is everywhere and whose circumference is nowhere': instead with Reinhardt we get an Art World that is an infinite sphere, whose circumference is everywhere but whose center is nowhere."[28] With *Gyrostasis* we are given a close parallel, for the sculpture, a spiral related to the golden section and consequently an image of infinite contraction, has no center.

16. *Pointless Vanishing Point*, spring 1968; fiberglass; 40 × 40 × 96"

Pointless Vanishing Point represents a solidification of the orthogonals of traditional linear perspective into stair-stepped lines that terminate before converging. The sculpture presents a no longer useful concept of vision. According to Smithson, it deals with a schema that is no longer believable, an idea frozen in time, just as his sculpture appears frozen or immobilized in space. In this

sculpture, perspective is literalized, made concrete, and rendered useless.

In spring 1968, when Smithson was making arrangements for an exhibition at Minneapolis's Walker Art Center, he contemplated exhibiting a series of *Pointless Vanishing Points* of which the largest is the only piece to have been fabricated. In a letter to Martin Friedman, director of the Walker, Smithson noted his intention: "Each of the five units contains a three-dimensional perspective, and going from right (the largest) to the left (the smallest) one finds a serial 'regress' of perspective." Although the sculpture is painted flat white, originally the pieces were to be painted teal blue with a metallic pearl-essence finish. In the letter Smithson stressed that "the color is an *evanescent* greenish-blue." He noted as a reference J. L. Borges's "Time and J. W. Dunne" in *Other Inquisitions*, and concluded as an afterthought that "perhaps, a better word than metaphysical would be 'intraphysical.'" The term "intraphysical" as opposed to metaphysical suggests that artistic ideas be limited to strictly physical or spatial manifestations. If Smithson had expanded this work, creating five units, he would have established two different vanishing points: one would be set within the limits of each unit; the other would belong to the illusion of recession occurring when the entire group was viewed as a whole.

Although sculptures such as *Pointless Vanishing Point* appear to be Minimalist works, they actually are involved with concepts far removed from Minimalism. Unlike Sol LeWitt and Robert Morris, Smithson was not concerned with reducing sculpture to its essential form. Not a purist, he enjoyed deflecting traditional possibilities and thus making them absurd and impractical. While the works in his Dwan Gallery exhibition of March 1968 might appear to be elaborations on pieces of the early sixties such as Robert Morris's *Column*, they are, in fact, evidence of a very dry sense of humor. Unlike Morris, Smithson did not wish to put viewers in the role of phenomenological investigators; he was not attempting to establish a primacy of experience in which viewers are thrown back on themselves to decide if the austere shapes before them are merely objects or sculptures. The battle between art's supposed "presence" and the object's attributed "inertness" raged earlier in the decade; Smithson did not feel compelled to keep fighting it.

In 1967 and early 1968, Smithson was at a crossroads in his art. He united the crystalline vocabulary of shapes he shared with such Minimalists as Donald Judd with an understanding of the abstract nature of vision. He realized that one sees through schemata or constructs, and that the highly realistic art of Renaissance illusionism

[27] "Towards the Development of an Air Terminal Site," in *Writings*, pp. 45–46.
[28] "A Museum of Language in the Vicinity of Art," in *Writings*, p. 73.

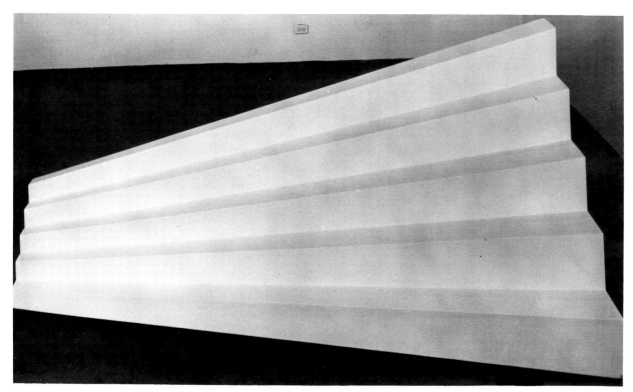

Pointless Vanishing Point, 1968. Collection Dwan Gallery, Inc. Photograph courtesy John Weber Gallery.

was essentially artificial and abstract. *Pointless Vanishing Point* commemorates the abstractness and inertness of this generative body of realistic painting, and it serves as a reminder of an overly specialized system.

In 1968 Smithson might easily have become a Conceptual artist; his quasi-Minimalist forms were already placed at the service of abstract artistic thinking. What prevented him from becoming a Conceptualist was his strong interest in mapping, evidenced in *Leaning Strata*, a work included in the same Dwan exhibition as *Pointless Vanishing Point*. By interpreting mapping as a system of drawing space and a way of rendering it two-dimensionally, the artist revitalized the entire realm of landscape art (both painting and landscape architecture). He incorporated maps into his sculpture as well as actual pieces of the earth (in the form of ore), and his steel bins or containers actualize perspective schemata in three-dimensional terms.

His own exegesis of *Pointless Vanishing Point* provides important clues to both its significance and its relation to other works, such as *Enantiomorphic Chambers*, which are concerned with visual and cerebral aspects of art:

One of the most fugitive concepts in art is perspective—its stupefying dimensions have evaded the "modern" art-

ist ever since Rembrandt spoiled the straight line. With the rise of "naturalism" and "realism" in the arts the artificial factors of perspective were lost in thick brown stews of chiaroscuro. The linear artifices of Euclid were smothered by seas of impasto and replaced with non-Euclidian atomic muddles (Impressionism to mixed media). And in our own times, perspective is swamped by "stains" and puddles of paint. The idea of the universe as a relative pudding is an idea to avoid.

The dual globes that constitute our eyes are the generators of our sense of the third dimension. Each eyeball contains a retina that functions like a photographic plate inside a spheroid camera. Rays of light penetrate the transparent cornea, the pupil, the crystalline lens and the vitreous body until they reach the retina. This process was thought to be reversed in Euclid's Alexandria (300 B.C.), in so far as it was supposed that the rays of light issued directly from the eyes along straight lines until they touched the object they were looking at. The philosopher Hipparchus (160–126 B.C.) compared those visual rays with feeling hands touching the objects. This centrifugal theory of vision seems to have returned to modern times in the guise of "kinaesthetic space" or what is sometimes called "surveyor's space." The eyes do not see this kind of space, but rather they perceive through a mental artifice of directions without determined distances, which in turn gives the illusion of infinite spaces. Natural visual space is not infinite. The surveyor imposes his artificial spaces

on the landscape he is surveying, and in effect produces perspective projections along the elevations he is mapping. In a very non-illusionistic sense he is constructing an illusion around himself because he is dealing directly with literal sense perceptions and turning them into mental conceptions. The binocular focus of our eyes converges on a single object and gives the illusion of oneness, so that we tend to forget the actual stereoscopic structure of our two eyes or what I will call ''enantiomorphic vision'' —that is seeing double.

An awareness of perspective comes into one's mind when one begins to deal directly with the physiological factors of sight as ''a thing-in-itself''. In other words, all of one's attention must be focused on the *camera obscura* of perception as a physical *thing* or *object,* and then translated into a three dimensional illusion, so that one is left with a *non-thing* or a *non-object*. My first physiological awareness of perspective took place when I built the *Enantiomorphic Chambers*. In this work, the vanishing point is split, or the center of convergence is excluded, and the two chambers face each other at oblique angles, which in turn causes a set of three reflections in each of

Diagrammatic view of perspective from Edgar Allan Poe's ''Eureka,'' reproduced in Smithson's ''Quasi-Infinities and the Waning of Space'' (1966). Courtesy Estate of Robert Smithson.

the two obliquely placed mirrors. A symmetrical division into two equal parts is what makes it enantiomorphic; this division also exists in certain crystal structures.

Out of this division of *central perspective* comes what could be called *enantiomorphic perspective*. The only treatise on central perspective was written by Piero della Francesca (1420–1492). Although many artists of that period were interested in perspective, he is the only one to have written a complete description of the methods of central perspective based on Euclid's Xth proposition concerning the intersection of ''visual rays'' on the picture plane. Enantiomorphic perspective differs from central

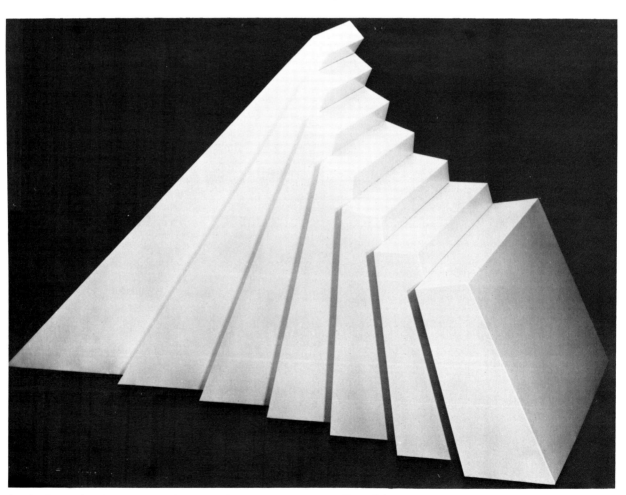

Leaning Strata, 1968. Collection Dwan Gallery, Inc. Photograph courtesy John Weber Gallery.

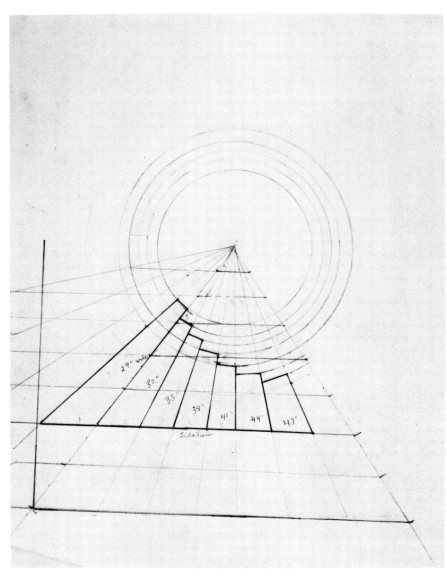

Drawing of *Leaning Strata* (side
view), 1968; pencil and ink.
Collection Estate of Robert
Smithson, Courtesy John Weber
Gallery. Photograph by Nathan
Rabin.

perspective in so far as it is mainly three dimensional and
dualistic in conception, whereas the latter is two dimen-
sional and unitary. Yet, Paolo Uccello (1397–1475) did
do a two-dimensional dualistic perspective grid drawing.
There is a controversy over whether or not Uccello's left
and right converging perspectives are related to binocular
or stereoscopic vision. If one were to build a three dimen-
sional structure from *behind* the two dimensional Uccello
drawing, one would end up with something that would
resemble a *reversed* stereoscopic viewer. One would be
physiologically transported behind the "fused image" of
the *picture plane,* to where the vision diverges. The two
separate "pictures" that are usually placed in a stereo-
scope have been replaced by two separate mirrors in my
Enantiomorphic Chambers—thus excluding any fused
image. This negates any central vanishing point, and takes
one physically to the other side of the double mirrors. It is
as though one were being imprisoned by the actual struc-

ture of two alien eyes. It is an illusion without an illusion.
Consider "Wheatstone's mirror-stereoscope" with A_1B_1
and A_2B_2 pictures replaced with mirrors and you will get
a partial idea of how the *Enantiomorphic Chambers* abol-
ish the central fused image (See *Physiological Optics* by
James P. C. Southall). The double prison of the eyes be-
comes a fact.[29]

17. *Leaning Strata*, 1968; steel; 49½ × 103 × 30″

Among Smithson's early Minimalistic sculptures,
Leaning Strata offers a rare opportunity to study germi-
native ideas since three key preliminary drawings exist.
One drawing, dated 1968, provides a *terminus a quo.*

[29] "Pointless Vanishing Points," in *Writings*, pp. 208–9.

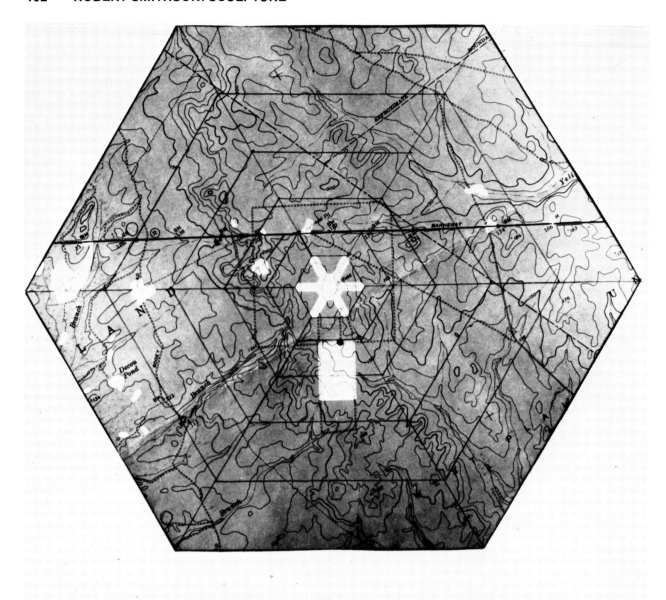

A NONSITE (an indoor earthwork)

31 sub-divisions based on a hexagonal
"airfield" in the Woodmansie Quadrangle -
New Jersey (Topographic) map. Each sub-
division of the Nonsite contains sand
from the site shown on the map. Tours
between the Nonsite and the site are possible.
The red dot on the map is the place where
the sand was collected.

A Nonsite, Pine Barrens, New Jersey, 1968; map Photostat; 12½ x 10½". Collection Dwan Gallery, Inc. Photograph courtesy John Weber Gallery.

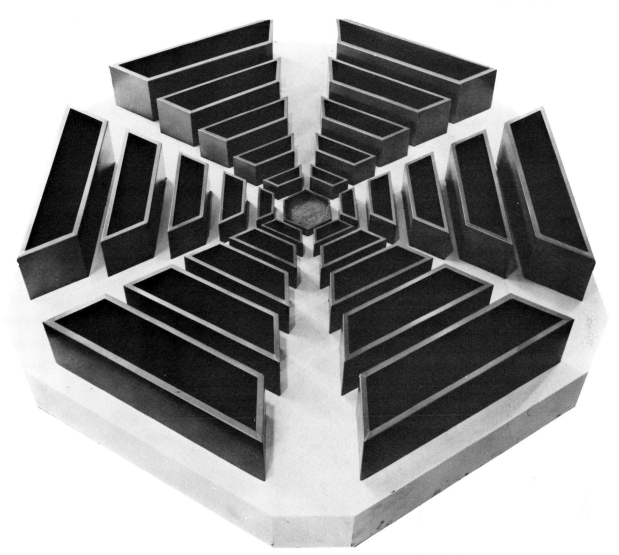

A Nonsite, Pine Barrens, New Jersey, 1968. Collection Dwan Gallery, Inc. Photograph courtesy Dwan Gallery, Inc.

Three concentric circles are drawn with parts of the radius detailed so that *Leaning Strata* appears horizontally oriented. The two other drawings show that this first idea was dropped, perhaps because it too clearly relied on the orientation of *Shift* and *Pointless Vanishing Point.*

Another drawing contains a circle roughly divided along its circumference into 35 sections. (Most likely the artist intended 36 divisions which would provide regular ten-degree intervals.) Radiating from the center of the circle are lines that extend beyond the circumference and terminate on a straight line running perpendicular to them. Notations indicate that Smithson was alternating between seven-inch and three-inch increments. The grid-like configuration at the lower portion of the drawing is initially puzzling.

The puzzle is cleared up, however, in the third drawing which shows a profile view of *Leaning Strata.* The lower grid appears three-dimensional as orthogonals and transversals articulate a diagrammatic view of perspective. The circle appears to be a cartographic configuration similar to Smithson's *Crater with Reflected Numbers, or the Hexagonal Clock* (1966) and *Entropic Pole* (1967), both discussed in the section on *Gyrostasis.* Smithson here again conflates two systems for representing space—perspective and cartography—in an uneasy alliance. The sculpture is another "alogon," a physical manifestation of cognitive dissonance, in which illogicality results from two logical systems coming into conflict with one another.

The title *Leaning Strata* suggests a geologic configuration, a syncline or anticline, perhaps even a portion of a fault. The work, in terms of both its title and its function as a confluence of two spatial systems, foreshadows the Site/Nonsites, also of 1968. In *Leaning Strata* an ab-

surd synthesis is achieved in a dialectic illogically applied. Later, in the Sites/Nonsites, the dialectics are more apparent. In these works, Smithson's sense of humor that delights in the absurdity of our so-called rational world still occurs, but it is not quite so covert, so intent on masking itself in the dead white, austere, mathematical raiment of logic as in *Leaning Strata*.

Leaning Strata probably ought to be compared with the mirror and glass stratas, not because it is similar to them but because it is so different. Unlike the others, *Leaning Strata* does not stand straight or lie horizontally; it is tilted. Moreover, it is opaque, and its very opacity, contrasting as it does with the clear reflectiveness of the mirror pieces and deep unclouded translucence of the glass stratas, indicates a special significance. For *Leaning Strata* is the murky terminus of overlapping, but non-aligned, spatial schemata.

18. *A Nonsite, Pine Barrens, New Jersey,*
winter 1968; aluminum with sand, aerial
photograph/map; 12 × 65½ × 65½″

Accompanying *A Nonsite, Pine Barrens, New Jersey* (the first of Smithson's Nonsites) is the following label:

A NONSITE (an indoor earthwork)

31 sub-divisions based on a hexagonal "airfield" in the Woodmansie Quadrangle—New Jersey (Topographic) map. Each sub-division of the *Nonsite* contains sand from the *site* shown on the map. Tours between the *Nonsite* and the *site* are possible. The red dot on the map is the place where the sand was collected.

In conversation with two other Earth artists, Michael Heizer and Dennis Oppenheim, Smithson clearly outlined the thinking that led to this piece:

I very often travel to a particular area; that's the primary phase. I began in a very primitive way by going from one point to another. I started taking trips to specific sites in 1965: certain sites would appeal to me more—sites that had been in some way disrupted or pulverized. I was really looking for a denaturalization rather than built up scenic beauty. And when you take a trip you need a lot of precise data, so often I would use quadrangle maps; the mapping followed the traveling. The first non-site that I did was at the Pine Barrens in southern New Jersey. This place was in a state of equilibrium, it had a kind of tranquillity and it was discontinuous from the surrounding area because of its stunted pine trees. There was a hexa-

gon airfield there which lent itself very well to the application of certain crystalline structures which had preoccupied me in my earlier work. A crystal can be mapped out, and in fact I think it was crystallography which led me to map-making. Initially I went to the Pine Barrens to set up a system of outdoor pavements but in the process I became interested in the abstract aspects of mapping. At the same time I was working with maps and aerial photography for an architectural company. I had great access to them. So I decided to use the Pine Barrens site as a piece of paper and draw a crystalline structure over the landmass rather than on a 20 × 30 sheet of paper. In this way I was applying my conceptual thinking directly to the disruption of the site over an area of several miles. So you might say my non-site was a three-dimensional map of the site.[30]

When he wrote "A Sedimentation of the Mind: Earth Projects," in 1968, the artist also provided several clues regarding *A Nonsite*. "The map of my *Non-Site #1 (an indoor earthwork)* has six vanishing points that lose themselves in a pre-existent earth mound that is at the center of a hexagonal airfield in the Pine Barrens Plains in South New Jersey," he explains. "Six runways radiate around a central axis. These runways anchor my 31 subdivisions. The actual *Non-Site* is made up of 31 metal containers of painted blue aluminum, each containing sand from the actual *site*."[31] The vanishing points on the map which disappear as they move into the central area are repeated in the Nonsite. There the vanishing point is the area of convergence of the six groupings that descend in size as they approach the central hexagon.

For the second Nonsite (*Franklin, New Jersey*),[32] Smithson took one part of *A Nonsite, Pine Barrens* and

[30] "Discussions with Heizer, Oppenheim, Smithson," in *Writings*, p. 172.
[31] "A Sedimentation of the Mind: Earth Projects," in *Writings*, p. 90.
[32] Usually, *A Nonsite, Franklin, New Jersey* is regarded as the second Nonsite; actually it is the third. The second Nonsite was specially fabricated by the staff of the Walker Art Center, Minneapolis, for "6 Artists, 6 Exhibitions: Bell, Chryssa, Insley, Irwin, Smithson, Whitman" (1968). Consisting of 12 wooden wedges (12 × 41 × 21″ each, diameter 108″), this Nonsite was painted flat white and decorated with mirror strips marking the degree lines. The piece was to be an abstract relief map. On the wall a photostat of *Entropic Pole*—a swamp, located not too far from Passaic, New Jersey, and designated in the plans as "point of no return"—was to be hung as part of the Nonsite. On May 30, Smithson wrote to Friedman about the Nonsite: "We don't need the Nonsite in the Buffalo exhibition, in fact you might as well destroy the one you built." Probably the reason he had this piece destroyed is that it appeared too decorative and abstract and was not a totally satisfactory mirroring of the Site. The piece contained many elements important to Smithson, but they were combined in a way that lacked the rigor and power of the other Nonsites. After *A Nonsite, Pine Barrens, New Jersey, Nonsite #2* appeared a step backward to the Minimalistic pieces that preceded the Nonsites.

enlarged it. When he emphasized one section, he made the perspective arrangement even more ambiguous. Instead of having all lines converge at a central vanishing point, as in *A Nonsite, Pine Barrens*, he abstracted schematic linear perspective in *Franklin Nonsite* so that it points in no particular direction, thus aborting efforts to see through this formula.

On the trip to collect sand for *A Nonsite, Pine Barrens*, Carl Andre, Virginia Dwan, Nancy Holt, Sol LeWitt, Robert Morris, and Mary Peacock accompanied Smithson. Sand was taken from the airfield making up the Site. (The airstrip was used for receiving fire-fighting equipment in an emergency and for routine government use.)

In light of Smithson's previous work with "aerial art" and on the Dallas–Fort Worth Regional Airport, the choice of a desolate, noncommercial airfield in the Pine Barrens appears deliberate. The Pine Barrens airfield could be considered antipodal to the Dallas–Fort Worth airport. Rarely used, composed of sand, the Pine Barrens strip is situated in a sparsely inhabited area that is partially protected by state and federal funds. In contrast, the Texas project represents one of the largest, most modern, and most frequented airports in the world. The desolate field in the Pine Barrens seems an antiquated modernism, signaling a period perhaps not too far in the future when air traffic might be a thing of the past.

The Pine Barrens is an apt choice for a Nonsite. The place befits Smithson's anti-idealist, but romantic aesthetic that concentrates on the forgotten and rarely mentioned outskirts of a thriving metropolitan world, areas that somehow never seem to be quite there, that always appear discarded and unimportant. If this artist chose a preserve as the location for a Nonsite, one could be certain it would not be the Grand Tetons or the Sequoia National Forest. The land he selected is composed of trees that are naturally dwarfed. Other forests can be compared with cities like Manhattan in terms of their height and grandeur; by contrast the Pine Barrens is more like the New Jersey suburbs. Unlike many forests, the Pine Barrens is a retired industrial site. In the eighteenth and nineteenth centuries it was distinguished as a site for the production of glass, charcoal, and bog iron. It was also probably important to Smithson that in the Miocene Age the Pine Barrens was a large body of land in the Atlantic Ocean, while the rest of the area, including large parts of New Jersey, was under water. In other words, the Pine Barrens was a "positive" land mass in the "negative" of the ocean. Now the prehistoric island is a "negative," a large, mostly uninhabited land area in populous New Jersey: it is both a Site and a Nonsite.

Although Smithson started creating Nonsites in 1968,

he did not elucidate their aesthetic until a year later when he published the following statement in Gerry Schum's *Land Art:*

Range of Convergence

The range of convergence between Site and Nonsite consists of a course of hazards, a double path made up of signs, photographs, and maps that belong to both sides of the dialectic at once. Both sides are present and absent at the same time. The land or ground from the Site is placed *in* the art (Nonsite) rather than the art placed *on* the ground. The Nonsite is a container within another container—the room. The plot or yard outside is yet another container. Two-dimensional and three-dimensional things trade places with each other in the range of convergence. Large scale becomes small. Small scale becomes large. A point on a map expands to the size of the land mass. A land mass contracts into a point. Is the Site a reflection of the Nonsite (mirror), or is it the other way around? The rules of this network of signs are discovered as you go along uncertain trails both mental and physical.[33]

19. *A Nonsite, Franklin, New Jersey*, summer 1968; wood, limestone, aerial photographs; 16½ × 82 × 110″

Each of the trapezoidal wood bins making up this Nonsite correlates with an aerial photo-map of the Site from which the ore contained in the bins was taken. Smithson here, as in many Nonsites, punned the importance of vision to art, and also made reference to his negation of it, when he planned the cut-off apex of the cut-out map of Franklin to correspond to an actual dead-end street in the town. The five trapezoidal wood bins form a three-dimensional counterpart to one-point perspective. Seen from one vantage point, the bins actually appear to recede into space, but from the most commonly reproduced point of view—the one shown in the photograph here—the recession is reversed. In a sense the viewer forms the point of terminus, and the result is nonseeing—from the Renaissance point of view. The angle chosen for the photograph accords with Smithson's stated intention in *Enantiomorphic Chambers* to reverse one-point perspective. Ironically in *A Nonsite, Franklin, New Jersey*, as in other Nonsites, what occurs is that the viewer does not see the site (sight); vision is curtailed, made schematic and abstract. Clearly related to this Non-

[33] Statement incorporated as n. 1 to "The Spiral Jetty" (1972), in *Writings*, p. 115. For the bipolar part of the statement, see Alloway's essay, p. 43.

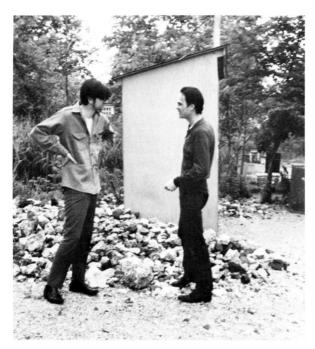

Robert Smithson and Michael Heizer at the Franklin Mineral Dump site, Franklin, New Jersey, June 1968. Photograph by Nancy Holt.

A Nonsite, Franklin, New Jersey, 1968; aerial map. Collection Museum of Contemporary Art, Chicago, Partial gift of Mr. and Mrs. Lewis Manilow, Chicago, Illinois. Photograph courtesy John Weber Gallery.

A NONSITE (FRANKLIN, N.J.)

5 sub-divisions based on the mineral ore deposits in the vicinity of Franklin Furnace Mines as shown on an aerial map (Robinson Aerial Surveys) at a scale of 1 inch = 200 ft. Of the more than 140 minerals found in this site, at least 120 are found in the zinc ore deposits, and nearly 100 are found only in those deposits. The 5 sub-divided parts of the *Nonsite* contains [sic] raw ore from sites 1.A, 2.B, 3.C, 4.D, 5.E—sites are shown on the map. Container sizes in inches are as follows: 12 x (11½ x 20½) x 8, 2. 15 x (20½ x 32½) x 10, 3. 18 x (32½ x 46½) x 12, 4. 21 x (46½ x 63½) x 14, 5. 24 x (63½ x 82½) x 16. The map is three times smaller than the *Nonsite.* Tours to sites are possible. The 5 outdoor sites are not contained by any limiting parts—therefore they are chaotic sites, regions of dispersal, places without a Room—elusive order prevails, the substrata is disrupted (see snapshots of the five shots). The rocks from the 5 sites are homogenized into the *Nonsite.* The entire *Nonsite* and site map in the room are contained within two 70° perspective lines without center point (the center point is at the end of a deadend street some where [sic] in Franklin not shown on map). An unexhibited aerial photo of this point is deposited in a bank-vault. This photo can be seen—a key is available.

R. Smithson 68

site is *Pointless Vanishing Point* of the same year: both ironically comment on perspective as the construct or schema that is seen (rather than seen through), but seen as a futile means of seeing, as an abortive convention.

In a diary of snapshots recording important trips, Nancy Holt has written the date June 14, 1968, when she and Michael Heizer accompanied Smithson to Franklin, New Jersey. In conversation with this author she has reflected that Franklin was important to Smithson for a number of reasons, an important one being that it is one of the few places in the world containing smithsonite, named for Charles Smithson, Robert's putative ancestor who discovered the mineral and who also was instrumental in founding the Smithsonian Institution in Washington, D.C. Among areas of mineral deposits in the world, Franklin is famed for its number of unique ores. The only other place in the world comparable is Langbon, Sweden. At Franklin there are over two hundred minerals, from albite to zoisite. Supposedly forty-two different minerals were discovered there, among them franklinite (named after Benjamin Franklin) and zincite.

Before the rock hunting trip with Holt and Heizer, Smithson visited the mineral deposits around Franklin. The favorite spot was the rock dump at the old Franklin zinc mine, abandoned since the end of World War II but reopened in the sixties for rock hounds who paid a dollar to hunt and chip away. Smithson actually collected other types of ore for the *Franklin Nonsite,* for which he had

originally intended six bins instead of five. In May 1968, he wrote a description of the work:

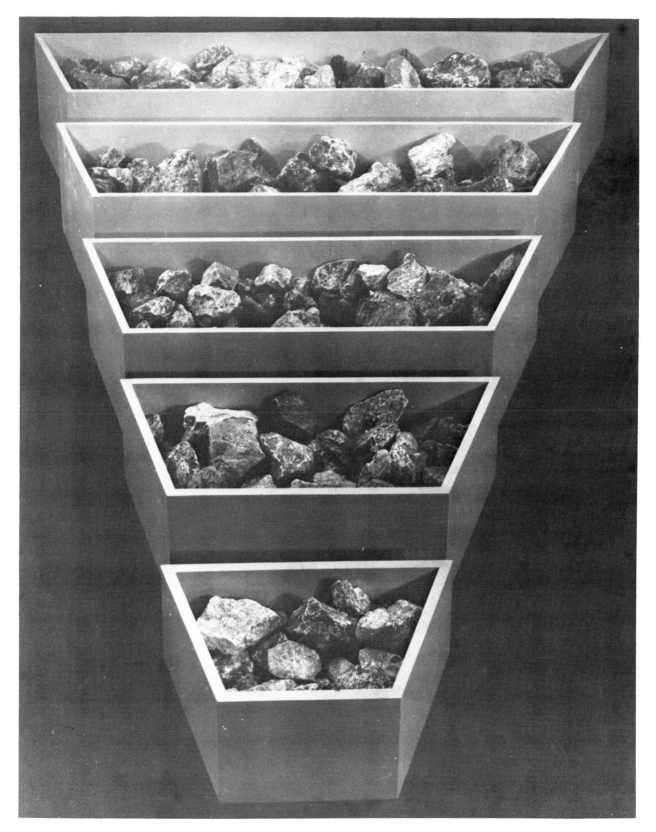

A Nonsite, Franklin, New Jersey, 1968. Collection Museum of Contemporary Art, Chicago. Photograph courtesy Estate of Robert Smithson.

One site upon which the Nonsite is based is the Buckwheat Mineral Dump. It is a site used by rock collectors who hunt for fluorescent minerals. Near the dump is a wide dark room that allows collectors to admire the colors of the minerals under ultraviolet light. (A mercury vapor type lamp gives off energy capable of making minerals respond either by fluorescing or phosphorising.) The dump gets smaller each year as tons of rock are carried away. I chose this site because it has an abundance of broken rock. I needed fragments 2″ to 15″ thick for the six bins of *The Nonsite*. The most common minerals found on the dump are calcite (physical properties: crystal—hexagonal, cleavage—perfect rhombohedral, fracture—conchoidal, glows red) and willemite (physical properties: crystal—hexagonal, cleavage—basal, fracture—uneven to subconchoidal, glows green).[34]

Evidently he originally intended a highly subtle structure. The fluorescent minerals, calcite and willemite, common finds at the Buckwheat Mineral Dump, together formed the potentiality of a complementary color scheme of red and green if viewed under ultraviolet light. They would, in their basic hexagonal structure, reiterate the six bins the artist had originally planned. That the inherent properties of the minerals were unable to be seen under ordinary circumstances echoed the notion of "Nonsite." Smithson's subtly reinforcing microscopic and fluorescent components on a larger scale through a hexagonal structure with six-part divisions reflects an important aspect of twentieth-century life in which the atomic and the subatomic have caused humankind to reevaluate basic assumptions about the world. The idea of a geocentric universe died centuries ago; the anthropocentric world has lasted longer. Only with Smithson's work does a truly nonanthropomorphic art appear—an art that refuses to make man's visual apparatus as well as his sense of time and space a *raison d'être*.

Structurally, Smithson's art is not always what it appears to be on the surface. While the six containers for the initial *Franklin Nonsite* reflect the hexagonal order of the crystals forming the two minerals, the random broken pieces of rock tend to refute any conception of order. Appearances often are deceiving: crystalline order can be found in rocks selected at random. Structure establishes its own criterion, while vision frequently is as accidental as the various views of one-point perspective the artist offers in his final solution. In these pieces he often plays on the dialectic between the visual and the not-so-clearly perceived, on the oscillation between Site and Nonsite.

The decision to reduce the Nonsite from six bins to five may have resulted from a reassessment of *A Nonsite, Pine Barrens, New Jersey* where the sixth bin is the hexagonal terminus at the center. When Smithson mentions in the description accompanying the *Franklin Nonsite* photo-documentation that "the center point is at the end of a deadend street some where in Franklin not shown on map," he may have wished to stress the idea that the vanishing point in perspective is just that—a vanishing point. And since it was not visible, he would make it invisible in his *Nonsite*.

There are precedents for Smithson's playing on the nonvisual, the not-able-to-be-seen. Sol LeWitt's *Box in the Hole* (1968) and Claes Oldenburg's grave dug in Central Park (1967) also comprise this significant area of artistic investigation. Smithson, however, gave the nonvisual a new orientation when he grounded it in the dialectic between the individual piece and its referent. In his work the object is reworked until it constitutes in isolation a way of nonseeing. In Smithson's art, aesthetic apprehension takes precedence over mere looking at an object; it becomes a dialectical experience that takes into consideration thinking as well as looking, and context as well as the isolated object.

Sol LeWitt, *Box in the Hole*, executed at Visser House, Bergeyk, Holland, July 1, 1968; cube of unknown contents cast inside larger cube of concrete and buried in the earth. Photograph courtesy of John Weber Gallery.

[34] Unpublished notes, Smithson papers. Collection Estate of Robert Smithson.

20. *Nonsite "Line of Wreckage," Bayonne, New Jersey*, 1968; aluminum, broken concrete; 59 × 70 × 12½"

On a detailed map of New Jersey that Smithson had enlarged as part of the photo-documentation of the *Nonsite, "Line of Wreckage," Bayonne, New Jersey* is a label "Foul Area." Located in what looks like an industrial wasteland, the "Line of Wreckage" forms a narrow peninsula. Originally an old ship graveyard, the place has been made a fill area. In addition to the rotting hulls and rusting tankards that have been piled along the sinking shoreline, asphalt, concrete, and rubble from wrecked buildings and ripped-up highways have been used to shore up the coast. For the Nonsite container which is spray painted a standard shade of purple, Smithson picked up some rubble consisting of broken concrete coated on one side with asphalt. Evidently he liked the fact that the rubble was twice used: first it formed a road, then later it buttressed the shoreline. In case viewers might not comprehend the desolation of the locale, Smithson framed a number of snapshots that accurately record the wasteland making up this industrial junkheap.

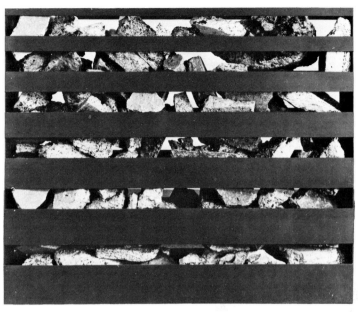

Nonsite "Line of Wreckage," Bayonne, New Jersey, 1968. Milwaukee Art Center Collection, Purchased with National Endowment for the Arts Matching Funds. Photograph courtesy Milwaukee Art Center.

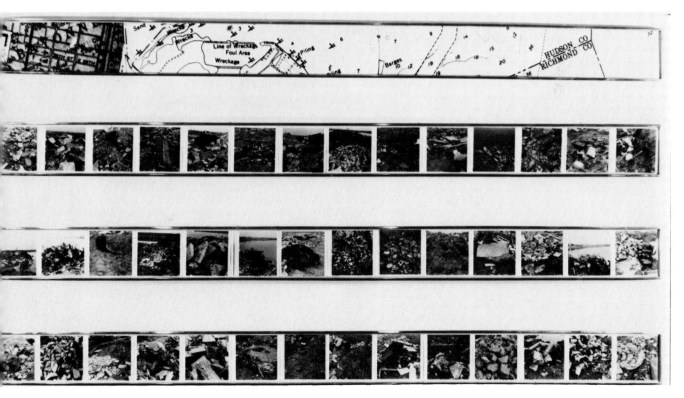

Photodocumentation for *Nonsite "Line of Wreckage," Bayonne, New Jersey,* 1968. Milwaukee Art Center Collection, Purchased with National Endowment for the Arts Matching Funds. Photograph courtesy Milwaukee Art Center.

A NONSITE (THE PALISADES)

The above map shows the site where trap rocks (from
the Swedish word trapp meaning "stairs") for the Nonsite were
collected. The map is 1‑7/16" X 2". The dimensions of the map
are 18 times (approx.) smaller than the width 26" and length
36" of the Nonsite. The Nonsite is 56" high with 2 closed
sides 26" X 56" and two slatted sides 36" X 56" -- there are
eight 8" slats and eight 8" openings. Site-selection was
based on Christopher J. Schuberth's The Geology of New York
City and Environs -- See Trip C, Page 232, "The Ridges". On
the site are the traces of an old trolly system that connected
Palisades Amusement Park with the Edgewater-125th St. Ferry.
The trolly was abolished on August 5, 1938. What was once a
straight track has become a path of rocky crags -- the site
has lost its system. The cliffs on the map are clear cut
contour lines that tell us nothing about the dirt between the
rocks. The amusement park rests on a rock strata known as
"the chilled-zone". Instead of putting a work of art on some
land, some land is put into the work of art. Between the site
and the Nonsite one may lapse into places of little organization
and no direction.

Robert Smithson 68

Documentation for *Nonsite (Palisades, Edgewater, New Jersey)*, 1968; map, typed description; 7⅜ x 9¾". Collection Whitney Museum of American Art, New York, Gift of the Howard and Jean Lipman Foundation, Inc. Photograph by Geoffrey Clements, Courtesy Whitney Museum of American Art.

21. *Nonsite (Palisades, Edgewater, New Jersey)*, 1968; aluminum, trap rock; 56 × 26 × 36"

In addition to the aluminum bin with rubble comprising the *Palisades Nonsite,* Smithson provided the following statement coupled with a map, which he intended to be exhibited as part of the piece:

The above map shows the site where *trap* rocks (from the Swedish word *trapp* meaning "stairs") for the *Nonsite* were collected. The map is 1⁷/₁₆" × 2". The dimensions of

the map are 18 times (approx.) smaller than the width 26" and length 36" of the *Nonsite*. The *Nonsite* is 56" high with 2 closed sides 26" × 56" and two slatted sides 36" × 56"—there are eight 8" slats and six 8" openings. Site-selection was based on Christopher J. Schuberth's *The Geology of New York City and Environs*—See Trip C, Page 232, "The Ridges". On the site are the traces of an old trolly [*sic*] system that connected Palisades Amusement Park with the Edgewater–125th St. Ferry. The trolly was abolished on August 5, 1938. What was once a straight track has become a path of rocky crags—the site has lost its system. The cliffs on the map are clear cut contour lines that tell us nothing about the dirt between

the rocks. The amusement park rests on a rock strata known as "the chilled-zone". Instead of putting a work of art on some land, some land is put into the work of art. Between the site and the *Nonsite,* one may lapse into places of little organization and no direction.

Although the idea of incorporating a description of a work of art into the piece itself was not new, in 1968 it was still novel. Perhaps the earliest statements conceived to be works of art were Marcel Duchamp's well-known notes issued in various forms but best known in his *Green Box.* With the revival of interest in Duchamp's work in the fifties and sixties, the concept of art as information became increasingly important. Significant statements presented as works of art by other artists include Edward Kienholz's proposals and Robert Morris's neo-Dada works such as his tautological *Card File* of 1962. Differing from Duchamp who gave oblique clues to his art, and from Keinholz who used the proposal as a new format for a sketch, as well as from Morris who often made the information self-referential, Smithson in the paragraph cited above wrote essentially a description. His elaboration of the *Palisades Nonsite* can be considered an expanded title, which attempts to elucidate the relationship between Site and Nonsite.

When Smithson created the *Palisades Nonsite,* he was reassessing the then dominant formalist criticism. His rethinking of formalism is articulated in his 1968 essay "A Sedimentation of the Mind: Earth Projects." In this article he takes to task critics such as Michael Fried. Realizing that abstract art, subject to critical whims, becomes almost unrecognizable depending on the context in which it is examined, he hoped to alleviate the problem by providing no-nonsense descriptions of his pieces coupled with maps and snapshots. Even before he made the Nonsites, he varied the artist's usual approach by making the criticism the focus of his activities, as in "The Monuments of Passaic," for example. In that piece his intent was to describe a specific site and make it available to the art world. In a later work, "Incidents of Mirror Travel in the Yucatan" (1969), he intended not to circumscribe but disperse, not to elucidate so much as to dispel any simple desires for clarity. Clarity (he would have added) is attained only at the expense of the true nature of reality. He creates essays that overload information and levels of meaning to the point that possible meanings abound. The work of art might be simple, he infers, but looking at it and understanding it are so complex that seeing art is akin to the fly's view of the world (as he mentions near the conclusion of the essay)—that is, multifaceted, repetitive, and ambiguous.

To say that Smithson annotates *Nonsite (Palisades, Edgewater, New Jersey)* simply to clarify would be to

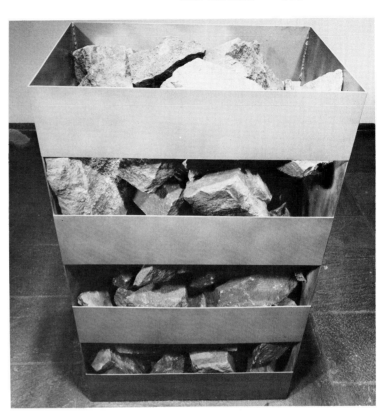

Nonsite (Palisades, Edgewater, New Jersey), 1968. Collection Whitney Museum of American Art, New York, Gift of the Howard and Jean Lipman Foundation, Inc. Photograph by Geoffrey Clements.

misconstrue the situation. While the label does, in fact, articulate the relationship between the Site and the Nonsite, it ultimately serves to point viewers in the direction of a highly complex situation in which they are placed outside the total work of art and are forced to deal with the double reflective void occurring between two places and two ways of looking. When one considers that *Palisades Nonsite* contains traces of an abandoned trolley system, the situation is even more complex, because the location itself is but a reflection of its former self: it is, as Smithson points out, unorganized and directionless.

Even though Smithson was not a formalist, he was an artist concerned with the refinements of his craft. In *Palisades Nonsite,* he wanted to create the effect of tension held in suspension, like an avalanche frozen in time, so he used as few rocks as possible and arranged them precariously with great gaping spaces between them so that they would crest the top of the bin. To stack the rocks in this manner requires patience and skill. Usually several attempts have to be made before the installation of the work is successful. Smithson may have wished to get beyond the preciousness of the artist's own touch in his art, but he nevertheless carefully organized his materials in the *Palisades Nonsite* to insure certain effects.

22. *Mono Lake Nonsite,* 1968; steel, cinders,
map Photostat; container 8 × 40 × 40″,
map 40 × 40″

Michael Heizer, Nancy Holt, and Robert Smithson
traveled to Mono Lake together. They established a base
in Las Vegas first and then moved to Heizer's parents'
cabin in Lake Tahoe while making day tours to local
sites. Nancy Holt has recalled that, among all the trips
taken by Smithson, the one to Mono Lake was especially
important. Smithson was tremendously affected by the
atavistic quality of the landscape, and by the thousands
of flies there, as were Heizer and Holt. (While at Mono
Lake, the three artists collaborated on a Super-8 film
called *Mono Lake.* Although only the two men read the
script which Smithson composed for the soundtrack, all
three shot and appeared in the film. Because the film is
personal, serving mainly to crystallize changes the three
were undergoing, it has remained private and has not
been released for distribution.)

Mono Lake is one of the great inland salt lakes that
fascinated Smithson. Sometimes called the Dead Sea of
America, it is noted for the tufa stalagmites deposited by
the receding lake. Reflecting on this piece that dealt with
an enigmatic, recessional landscape, the artist discussed

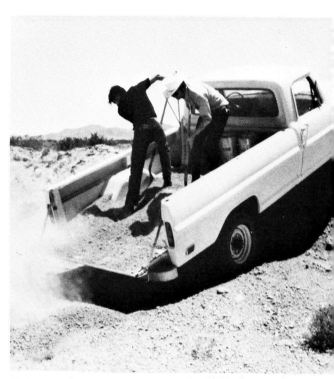

Michael Heizer and Robert Smithson dumping dirt out of a pickup truck near Las Vegas, Nevada, July 13, 1968. Photograph by Nancy Holt.

Documentation for *Mono Lake Nonsite,* 1968; map Photostat, Collection La Jolla Museum of Contemporary Art, La Jolla, California. Photograph courtesy Jan van der Marck.

the framelike map that reiterates the shape of the bins:
"Maps are very elusive things. This map of Mono Lake
is a map that tells you how to get nowhere."[35] The ma-
terial making up the Nonsite is residue framing an inac-
tive volcano: pumice and cinders collected at Black
Point on the shores of Mono Lake. The framelike com-
position of the Nonsite and map points to the parameter
that forms the Site. In Smithson's own words:

> There's a central focus point which is the non-site, the
> site is the unfocussed fringe where your mind loses its
> boundaries and a sense of the oceanic pervades, as it were.
> I like the idea of quiet catastrophes taking place. . . . The
> interesting thing about the site is that, unlike the non-site,
> it throws you out to the fringes. In other words, there's
> nothing to grasp onto except the cinders and there's no
> way of focusing on a particular place. One might even say
> that the place has absconded or been lost. This is a map
> that will take you somewhere, but when you get there you
> won't really know where you are. In a sense the non-site
> is the centre of the system, and the site itself is the fringe
> or the edge.[36]

The terms "Site" and "Nonsite," as mentioned be-
fore, have reference both to place and to vision. Even

[35] "Discussions with Heizer, Oppenheim, Smithson," in *Writings,* p. 176.
[36] Ibid.

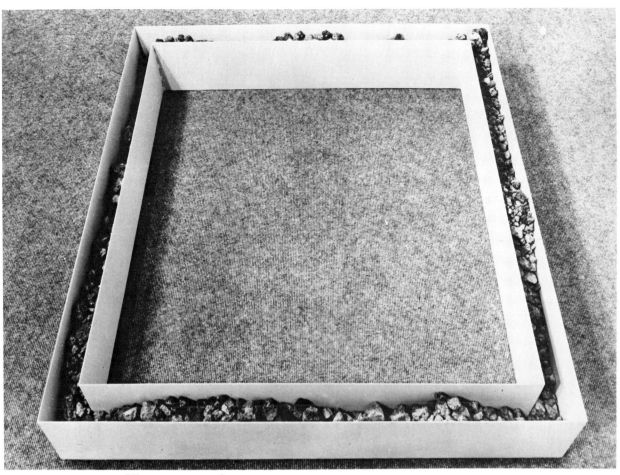

Mono Lake Nonsite, 1968. Collection La Jolla Museum of Contemporary Art, La Jolla, California. Photograph courtesy Jan van der Marck.

though Smithson indicates in the passage above that the Nonsite is a point, it actually is a parameter, a framing device. He says that the Site is the "unfocused fringe," and then he makes the Nonsite into a focused fringe that forms its own frame and nothing else. *Mono Lake Nonsite*'s frame is an ironic realization of a phrase Michael Fried coined in the sixties, "deductive structure," which he used initially to refer to the supposed dominance of the overall governing shape in Frank Stella's paintings. In Smithson's *Mono Lake Nonsite*, the entire piece becomes a framing edge, and the Gestalt vision that Fried discussed is both affirmed and canceled out.

23. *Nonsite, Oberhausen, Germany*, 1968;
 steel, slag, with each bin a map with 5
 photographs; dimensions unknown

When he visited West Germany in 1968, Smithson, predictably, chose not to tour the country's famous his-

toric sites, but focused instead on its highly industrialized areas. Artist Bernard Becher guided him through the heavily built-up Ruhr District. The work resulting from this visit, *Oberhausen Nonsite*, embodies a dialectic between industrially produced steel containers and slag—the waste by-product of the steel-refining process.

The use of slag, an industrial cinder, is an oblique reference to T. E. Hulme's essay "Cinders: A Sketch of a New Weltanschauung," one of Smithson's favorite texts.[37] "Cinders" consists of the edited notes of the evolution of Hulme's personal philosophy over a period of fifteen years. The framing idea of these notes, which are allegorical in form, is that the world has no unity and that nothing can be accurately described in words—even the absolute and truth are cinderlike. Language is a disease, the "*objective* world, a chaos, a cinder-heap," and existence "the general lava flow of cinders." Smithson's *Oberhausen Nonsite* could symbolize an existential statement that accords with Hulme's allegorical terms.

[37] In Hulme, *Speculations*.

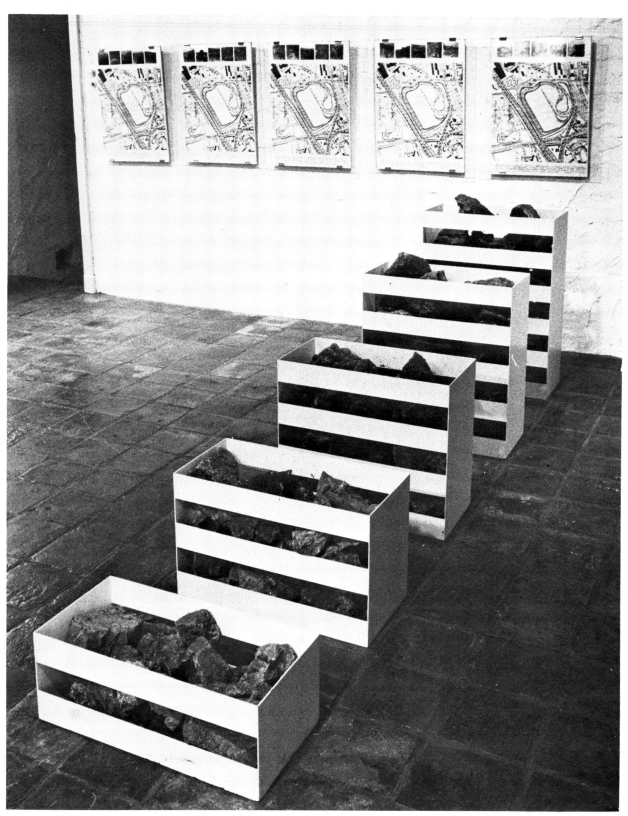

Nonsite, Oberhausen, Germany, 1968; photodocumentation, map of Oberhausen. Private collection. Photograph by Mickery, Courtesy Konrad Fischer Gallery.

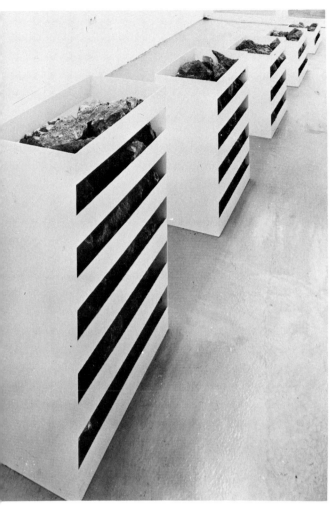

Nonsite, Oberhausen, Germany, 1968. Private collection. Photograph courtesy Konrad Fischer Gallery.

Certainly filling a steel bin with the industrial sludge resulting from steel refining belabors the gratuitous, manifests at best a specious unity, and belies the piece's rationality. In *Oberhausen Nonsite* the underlying premises of mass production are short-circuited.

24. *Nonsite, Site Uncertain*, 1968; steel, cannel coal; 15 × 90 × 90″

"The last nonsite [*Nonsite, Site Uncertain*]," Smithson told Paul Cummings, "actually is one that involves coal and there the site belongs to the Carboniferous Period, so it no longer exists; the site becomes completely buried again. There's no topographical reference. It's a submerged reference based on hypothetical land forma-

tions from the Carboniferous Period. The coal comes from somewhere in the Ohio and Kentucky area, but the site is uncertain. That was the last nonsite; you know, that was the end of that. So I wasn't dealing with the land surfaces at the end."[38] Because the actual place of origin of the ore is unknown and not extant, Smithson included none of the usual documentary information in the form of maps and photographs.

Although *Nonsite, Site Uncertain* is not actually the last Nonsite Smithson made, it neatly concludes the series of Nonsites and provides a link to the land reclamation proposals of the early seventies. The ore making up this piece is coal, and it was to the sites of coal stripmining in Ohio and the Midwest to which Smithson turned his attention when he began to consider the possibilities of reclaiming wastelands through art.

25. *Double Nonsite, California and Nevada*, 1968; steel, obsidian and lava; 12 × 71 × 71″

As its name suggests, *Double Nonsite* contains samples of rock collected from two different locations. For the outside bin Smithson used lava from cinder cones

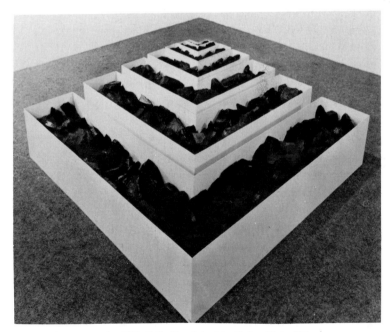

Nonsite, Site Uncertain, 1968. Collection Detroit Institute of Arts, Gift of Helen Charash. Photograph courtesy John Weber Gallery.

[38] Cummings, "Interview with Robert Smithson . . . ," in *Writings*, p. 155.

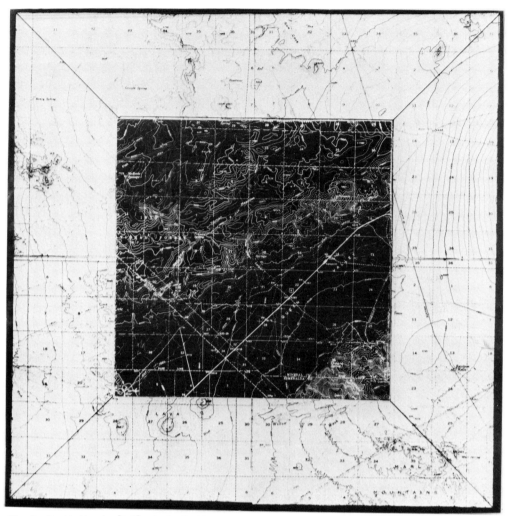

Map for *Double Nonsite, California and Nevada,* 1968. Private collection.
Photograph courtesy John Weber Gallery.

and lava flows found in the Mojave Desert outside Baker-Kelso, California, on the rock-hounding trip he took with Holt and Heizer. For the center bin, obsidian was collected about a week and a half later from a site near Montgomery Pass, Nevada, in Mineral County.

Double Nonsite exhibits a complex interweaving of internal and external relations. Both the inner and outer bins contain products from once active volcanoes. The obsidian filling the inner bin is volcanic glass. The cinders in the outside bins are dross or slag, fragments of lava. By joining these two materials in an inner/outer dialectic, the artist created a Nonsite that reiterates within itself a relationship similar to that of the Site and Nonsite. The black obsidian functions metaphorically as

a black or negative mirror that reflects its point of origin, its Site. But it also serves as a negative within the Nonsite because it does not reflect the point of origin of its paired material, the cinders, even though both types of rock are related by the process of their origin. Similarly, the outward perimeters of *Double Nonsite* contain cinders that point outside the gallery piece but do not reflect the origin of the material in the inner bin.

What Smithson has created in *Double Nonsite* is a double negative doubled once again. One negative exists between each bin and the point of origin of its rock— there being two materials creates a double negative. This double negative is in turn doubled again when one considers that the materials reflect a common volcanic origin

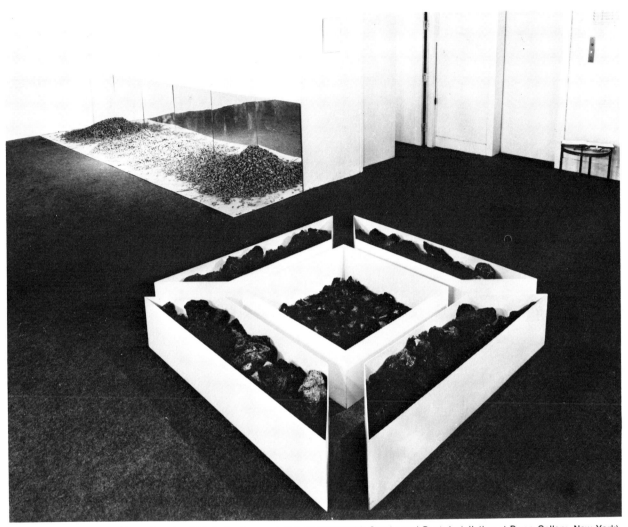

Double Nonsite, California and Nevada, 1968 (in background: *Gravel Mirror with Cracks and Dust;* installation at Dwan Gallery, New York). Private collection. Photograph courtesy John Weber Gallery.

but different locations. They reflect each other, and yet they don't.

26. *Six Stops on a Section*, 1968; Stops: Bergen Hill (gravel), Second Mountain (sandstone), Morris Plains (stones and sand), Mount Hope (rocks and stones), Lafayette (gravel), Dingman's Ferry (slate); steel, stratigraphic maps, and snapshots; each bin 8 × 24 × 8″

The best explication of *Six Stops on a Section* is provided by *Dog Tracks*, a derivative work, taken from the

"First Stop"—Bergen Hill (also known as Laurel Hill), New Jersey. Completed soon after *Six Stops on a Section*, *Dog Tracks* (1969) contains an enlarged photograph displayed on a recessed platform only a few inches above the floor, a Geological Survey map of northern New Jersey featuring iron ore and limestone districts, a detailed map of Laurel Hill, and the following description:

On the site of my "first stop" (Bergen Hill) . . . from *Six Stops on a Section*, I discovered an array of dog tracks around a puddle of water. The distribution of the tracks was indeterminate. Each of these tracks radiated many possible paths leading in all directions, a maze-like network come into view with the help of my camera, which

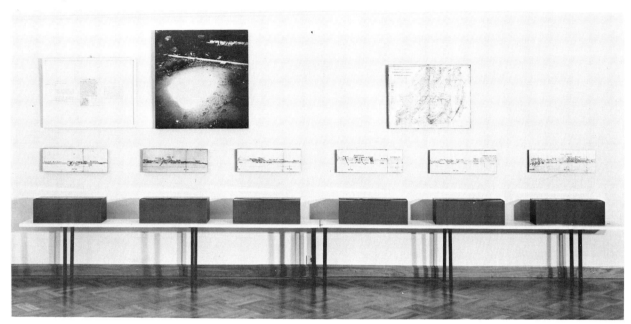

Six Stops on a Section, 1968. Collection Museum of Modern Art, Vienna; Ludwig Collection, Aachen. Photograph by Foto Myr, Courtesy Museum of Modern Art, Vienna. (Incorrectly installed; bins and *Dog Tracks* should be on floor.)

acted as a single point of view from an aerial position. My wife counted 38 paw prints in the 35″ × 35″ photo-blow-up of my snapshot, but many of the prints were obliterated by the overlapping of other print-points rendering a clear view impossible. Visualizing a direct route from any of these tracks would be hazardous, and bound to lead the viewer astray. The "section" of my "Six Stops" is based on a stratagraphic [sic] (sub-surface map) that extends along a line from New York City to Dingman's Ferry on

Dog Tracks, 1969. Collection Museum of Modern Art, Vienna; Ludwig Collection, Aachen. Photograph courtesy John Weber Gallery.

the Delaware River in Pa. Each "stop" is a point where particles of earth were collected and then deposited into containers that follow the cross-section contours of the six mapped sites. The points of collected earth become enormous land masses in the containers. If you consider everything in New York City collapsed to the size of this frame, you will get some notion of the process. A point in the mind, or a paw print in the mud, becomes a world of serial closures and open sequences that overflow the narrow focus of conscious attention.

The type of perceptual experience that interested Smithson on *Six Stops on a Section* is clearly revealed when he writes of the "serial closures" (the Nonsites) and "open sequences" (the Sites themselves that go beyond "the narrow focus of conscious attention"). In *Six Stops* he denied the easily assimilable wholistic configurations of many one-image artists. He was not interested in simplified images that speed up perception to an instantaneous moment in which one recognizes an image even before one knows what it is—as exemplified in Kenneth Noland's "target" paintings, most of Frank Stella's shaped canvases of the sixties, Donald Judd's boxes, and Carl Andre's square floor pieces. Relying on a different perceptual orientation, Smithson went beyond conscious focused vision and moved in another direction. Like the Abstract Expressionists, he chose to emphasize a dispersed image with no internal focus. The only restrictions on randomness in his work are the walls of the bins themselves. They become analogous to the

<u>DOG TRACKS</u>
From the "First Stop" on <u>Six Stops on a Section</u>

On the site of my "first stop" (Bergen Hill)* from
<u>Six Stops on a Section</u>, I discovered an array of dog tracks
around a puddle of water. The distribution of the tracks
was indeterminate. Each of these tracks radiated many possible
paths leading in all directions, a maze-like network come into
view with the help of my camera, which acted as a single
point of view from an aerial position. My wife counted 38
paw prints in the 35"X 35"photo-blow-up of my snapshot, but
many of the prints were obliterated by the overlapping of
other print-points rendering a clear view impossible. Visual-
izing a direct route from any of these tracks would be hazard-
ous, and bound to lead the viewer astray. The "section" of
my "Six Stops" is based on a stratagraphic (sub-surface map)
that extends along a line from New York City to Dingman's
Ferry on the Delaware River in Pa. Each "stop" is a point
where particles of earth were collected and then deposited
into containers that follow the cross-section contours of the
six mapped sites. The points of collected earth become enor-
mous land masses in the containers. If you consider every-
thing in N.Y.C. collapsed to the size of this ~~magazine~~ frame, you
will get some notion of the process. A point in the mind,
or a paw print in the mud, becomes a world of serial closures
and open sequences that overflow the narrow focus of conscious
attention.

Robert Smithson 69

* also called "Laurel Hill" N.J.

Written description for *Dog Tracks*,
1969. Collection Museum of Modern
Art, Vienna; Ludwig Collection,
Aachen. Photograph courtesy John
Weber Gallery.

framing edges of Abstract Expressionist paintings, and
the rocks contained within are similar to the ''overall''
compositions of artists such as Jackson Pollock.

Unlike the Abstract Expressionists, though, Smithson
is not content with a single one-to-one confrontation of
viewer and vertical image. He changes the relationship,
making it both a confrontation and an extension. The
work of art as a vertically oriented object becomes in
Western art another object to contend with—an abstract
anthropomorphic other. A horizontal format is less as-
saulting and more of an extension of the viewer's space,
and this is the orientation Smithson most frequently
chose for his sculpture. Not content with creating art for
visual delectation, Smithson extends the boundaries of

his works. As long as one dwells only on the objects in
the gallery, one is involved in traditional perception. If
the works of art elicit peripheral scanning instead of im-
mediate focused attention, the differences are insignifi-
cant to Smithson because the bounding edges are basi-
cally the same whether they be rectangles, squares,
trapezoids, or circles. Differences of importance to
Smithson are those that go beyond mere objects, concern
the contexts in which art exhibits meaning, and examine
basic modes of apprehension, such as the horizontal ver-
sus the usual vertical means of orientation.

While Smithson's Nonsites do permit traditional gal-
lery viewing, they also multiply the possibilities of un-
derstanding by providing new sets of alternatives for ap-

perception. If "realistic" art has an external referent—say, a person who was the subject of a portrait—there is no traditional way to make that referent more than simply the subject of the art. Smithson, remarkably, provided a means of pulling external reality into a dialectic with the work of art. It is as if he created Alice's Looking-Glass World, then made the "real" world not only a part of the art but also a reflection of the images in the Looking-Glass. In addition, he has enriched peripheral viewing so important to the Abstract Expressionists, by providing a mental counterpart to the visual experience—he disperses thinking between two locations. From scrutinizing the object, the viewer's mind rushes off to the Site and then is lost somewhere in the void between the experienced Nonsite and the only partially understood Site. Vicarious experience, implicit in the Site/Nonsite dialectic, exists, then, only as a frustrating possibility.

Related to *Six Stops on a Section* is a group of photographic "displacements." For these works, the artist had his snapshots of the six Stops enlarged into 30 by 30 inch black-and-white photographs which he took back to the original sites and rephotographed. In conversation with art critic John Perreault, he discussed these photographs that he termed "photo-markers." "My Nonsites," he said, "take the outdoors and bring it inside in containers. This starts a dialectic. These photo-markers do the reverse. I am using the environment to frame something artificial. In the gallery, History frames Time. Here the reverse happens."[39]

The photo-markers have important ramifications for later projects because they suggest (1) that photographs are a type of frozen reflection and (2) that the photographs could be replaced by mirrors that could in turn be photographed, thus eliminating an interim step and providing a more spontaneous displacement of the landscape. That Smithson contemplated using photographic displacements for his *Cayuga Salt Mine Project* (1969), as an existing drawing indicates, demonstrates this connection between the photo-markers and the mirror displacements. Furthermore, establishing this source for the mirror displacements substantiates that their origin does not lie in the work of Robert Morris or Robert Rauschenberg, who also used mirrors in their art.

Dog Tracks is not the only piece that relates to the "First Stop"; *Gravel Mirror with Cracks and Dust*, exhibited in a Nonsite exhibition with *Six Stops on a Section*, contains gravel collected at Bergen Hill. The piece incorporates six pairs of mirrors lined up along the wall and floor with piles of gravel dropped on them with the

[39] John Perreault, "Art: Nonsites in the News," *New York* (February 24, 1969):46.

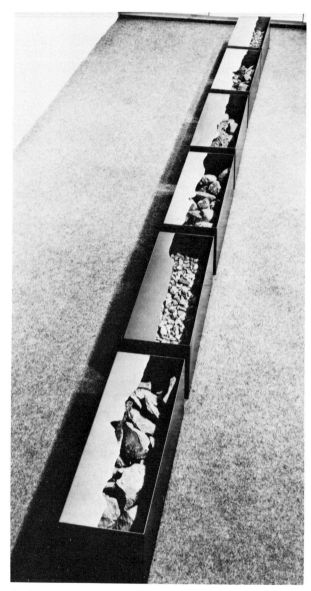

Six Stops on a Section, 1968. Collection Museum of Modern Art, Vienna; Ludwig Collection, Aachen. Photograph courtesy John Weber Gallery.

intent of cracking the glass in several places. Asymmetrical cracks, mirrored, became symmetrical, and thus accidents were incorporated into the very structure of the piece and given authority. The gravel used in the piece was important to Smithson because it was the product of what he termed "de-architecturization," in this case, the disintegration of the foundation of an abandoned hospital.

In addition to *Dog Tracks*, the photographic displacements, and *Gravel Mirror with Cracks and Dust*, Smithson created another piece related to *Six Stops on a Section*, a torn color photograph from the "Second Stop"

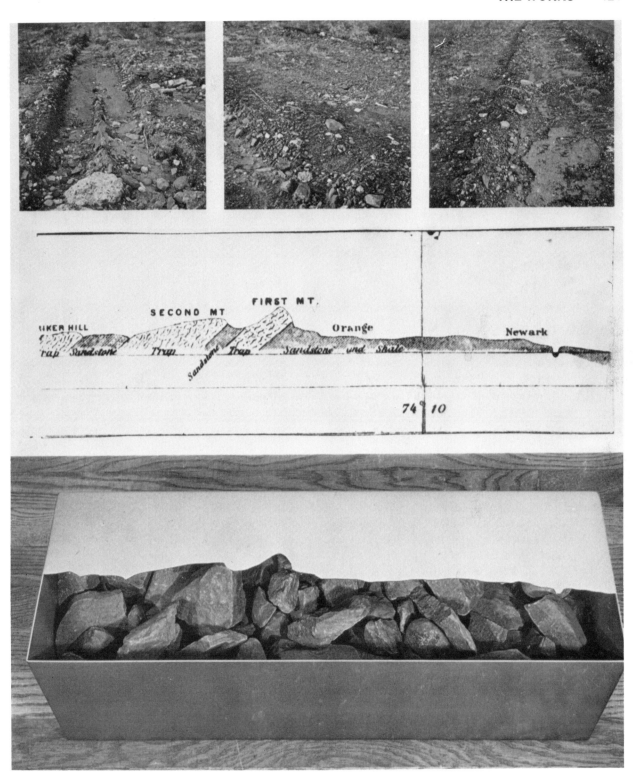

Second Stop from *Six Stops on a Section*, 1968. Photograph by Walter Russell.

Gravel Mirror with Cracks and Dust, 1968 (installation at Dwan Gallery, New York); mirror and gravel; 3 x 18 x 3'. Photograph courtesy John Weber Gallery.

which was distributed by Multiples, Inc., New York, in 1970, along with a group of works by other well-known artists. The photograph, because it was torn, no longer was presentable as a framed object, even though it contained all of its original information. The ripping apart of the blown-up snapshot rendered it useless as an instant record of reality; it became an object rather than a depiction, a puzzle rather than a statement.

Made in 1970, the torn photograph has an obvious connection to the torn maps shot for the *Spiral Jetty* film. In both the film and his 1972 essay on the *Spiral Jetty*, Smithson elaborates on this idea, quoting from Thomas H. Clark and Colin W. Stern's *Geological Evolution of North America*:

> . . . the earth's history seems at times like a story recorded in a book each page of which is torn into small pieces. Many of the pages and some of the pieces of each page are missing.

"I wanted Nancy to shoot the 'earth's history' in one minute," he wrote in the essay. "I wanted to treat the above quote as a 'fact.' We drove out to the Great Notch Quarry in New Jersey, where I found a quarry facing about twenty feet high. I climbed to the top and threw handfuls of ripped-up pages from books and magazines over the edge, while Nancy filmed it. Some ripped pages from an Old Atlas blew across a dried out, cracked mud puddle."[40] Unlike the scraps of maps used for the film, the ripped photograph of the "Second Stop" is a snapshot of a small section of earth blown up to life size. Symbolically, it can be equated with tearing the earth itself, and with Smithson's later sequence in the film, titled "Ripping the Jetty," in which the giant tooth of a plow, ominously resembling a giant phallus, gouges the earth.

27. *Nonsite (Slate from Bangor, Pa.)*,
 summer/fall 1968; wood, slate; $6 \times 40 \times 32''$

As in some other Nonsites, the materials composing *Nonsite (Slate from Bangor, Pa.)* provide meanings in terms of their function: slate in this piece is a broken-up writing surface (that is, slate as blackboard), a now useless covering for roofs (slate shingles), and a metaphor for rigidified mental sludge (muddy thinking metamor-

[40]"The Spiral Jetty," in *Writings*, pp. 114–15.

Edward Ruscha and Mason Williams, Base Side Panel Frame from *Royal Road Test* (glass broken), 1967. Photograph by Patrick Blackwell, Courtesy Estate of Robert Smithson.

phosed into rocks). This last idea is elaborated by Smithson in "A Sedimentation of the Mind: Earth Projects" (1968). In this essay on mind and earth Smithson also describes visiting slate quarries in Pennsylvania:

In June, 1968, my wife, Nancy, Virginia Dwan, Dan Graham and I visited the slate quarries in Bangor-Pen Argyl, Pennsylvania. Banks of suspended slate hung over a greenish-blue pond at the bottom of a deep quarry. All boundaries and distinctions lost their meaning in this ocean of slate and collapsed all notions of gestalt unity. The present fell forward and backward into a tumult of "de-differentiation," to use Anton Ehrenzweig's word for entropy. It was as though one was at the bottom of a petrified sea and gazing on countless stratographic [*sic*] horizons that had fallen into endless directions of steepness. Syncline (downward) and anticline (upward) outcroppings and the asymmetrical cave-ins caused minor swooms and vertigos. The brittleness of the site seemed to swarm around one, causing a sense of displacement. I collected a canvas bag full of slate chips for a small *Non-Site*.

Yet, if art is art it must have limits. How can one contain this "oceanic" site? I have developed the *Non-Site*, which in a physical way contains the disruption of the site.

The container is in a sense a fragment itself, something that could be called a three-dimensional map. Without appeal to "gestalts" or "anti-form," it actually exists as a fragment of a greater fragmentation. It is a three-dimensional *perspective* that has broken away from the whole, while containing the lack of its own containment. There are no mysteries in these vestiges, no traces of an end or a beginning.[41]

Ironically, the artist used as containers for the rock trapezoidal bins whose shape follows the lines of one-point perspective. The embracing and nonfocused experience of the Site and collected rubble (what Smithson called "oceanic") conflicts with the containers in the same way that an illusionistic art dependent on the rules of perspective would conflict with the Earth artist's experience of the Bangor Quarry. (A similar tension is conveyed by a photograph from Edward Ruscha and Mason Williams's *Royal Road Test* which Smithson used to illustrate his "Sedimentation" essay.) Only a leap of the imagination can transcend the ill-suited container and

[41] "A Sedimentation of the Mind: Earth Projects," in *Writings*, pp. 89–90.

The Bangor Quarry. Photograph by Virginia Dwan.

comprehend the far-ringing, fractured, and dispersed environment absorbing Smithson's attention.

28. *Nonsite (Mica from Portland, Connecticut)*, 1968; wood, mica; 5 × 19 × 64¾"

Like *Nonsite (Slate from Bangor, Pa.)* and *A Nonsite, Franklin, New Jersey*, *Mica Nonsite* can be read in terms of the rock's inherent properties. In this piece, mica connotes translucency, structure (layering of thin sheets), and function (as isinglass for windows). The meaning is clearly spelled out by Smithson in a briefly sketched unpublished statement:

Outside of Middletown, Connecticut, in the hills of Portland, are dumps of ore that contain "books" of mica. Micas are composed of silicates of aluminum, with potassium, iron, lithium, magnesium, and hydrogen. Musco-

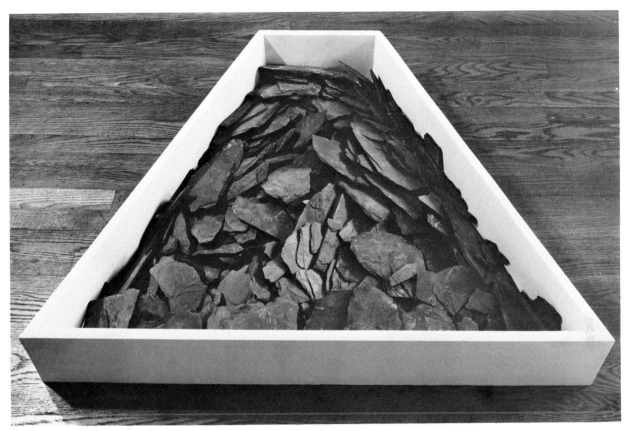

Nonsite (Slate from Bangor, Pa.), 1968. Collection Dwan Gallery, Inc. Photograph by Walter Russell.

vite mica (gets its name from Moscow where it was used for windowpanes) is found in this area. Along the paths that lead to the mineral dumps in Portland, are bits of feldspar and flakes of mica. The flakes flash in the sun like so many shattered mirrors or glass slivers. I met some ''rock hounds'' on the dumps who told me where to find heaps of mica, but they warned me that some of it might be ''rotten.''[42]

What a marvelous symbol the mica is—books of the earth, windowpanes, shattered mirrors, and slivered glass! Mica in the Nonsite serves to underline the futility of art as a true picture/reflection of the world.

Like the mica, like the fractured mirrors mica creates, the container, whose sides are built along the lines of one-point perspective, embodies the concept of nonseeing. Smithson seems to regard the premise of linear per-

spective as specious, not because it reflects or displaces reality so much as because it orders the world to man's viewpoint. When looking at a work of art whose illusionism is based on the rules of perspective, viewers usually accommodate their vision to an ideal point of view near the center of the picture plane from which the illusion is most convincing. There everything appears ordered and carefully reasoned; a rational point of view is substantiated. To reveal the artificiality of this way of looking, Smithson abstracts its elements and makes them three-dimensional so that one can understand that although the rules of perspective apply from one side, they do not work from any of the three remaining sides. In works such as *Mica Nonsite*, then, the title ''Nonsite'' is a pun on the futility of vision based in anthropocentric one-point perspective in the present-day world. The notion of nonvision is also an affirmation of the direction art was taking in the late 1960s away from Clement Greenberg's formalism toward a new contextualism, with a greater emphasis on content that was not solely retinal.

[42] Unpublished notes, Smithson papers. Collection Estate of Robert Smithson.

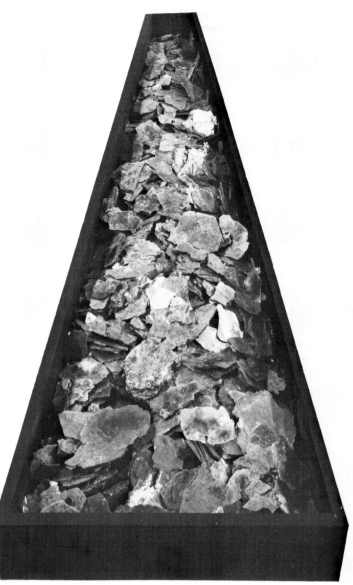

Nonsite (Mica from Portland, Connecticut), 1968. Collection Estate of Robert Smithson, Courtesy John Weber Gallery. Photograph by Walter Russell.

Robert Smithson and Michael Heizer (in foreground), Howard Junker and Stephanie Spinner (in background) at an abandoned mica quarry in Portland, Connecticut, collecting mica for a Nonsite, spring 1968. Photograph by Nancy Holt.

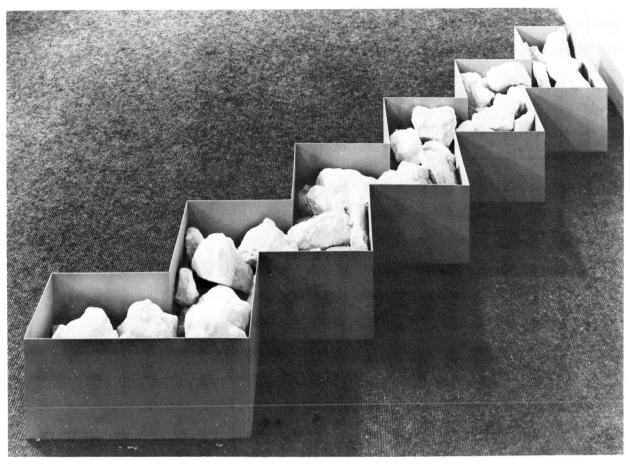

Gypsum Nonsite, Benton, California, 1968. Collection The Art Gallery of Ontario. Photograph courtesy John Weber Gallery.

29. *Gypsum Nonsite, Benton, California*, 1968; steel, gypsum, printed map, photograph; bin 5″ × 3′ × 3′; map 25½ × 27″

To create *Gypsum Nonsite* and the three *Death Valley Nonsites*, Smithson used specially fabricated zigzagged steel bins that had originally been intended for a much larger work that had proved unsatisfactory. The stepped shape of the bins harks back to the collaged map *Untitled (Mer de Canada)* constructed a year before. Particularly important in the collaged map are the intersecting oblique lines of latitude and longitude which provide a rationale for the zigzags of the *Nonsites*.

The material for *Gypsum Nonsite* has a source in Brian W. Aldiss's science-fiction novel *Earthworks*, in which the protagonist navigates a shipment of sand and gypsum. And Smithson's use of Death Valley in the title of the related Nonsites also alludes to Aldiss's book, for not only is Death Valley a specific place, it also suggests the dead, polluted world of the future that was Aldiss's vision.

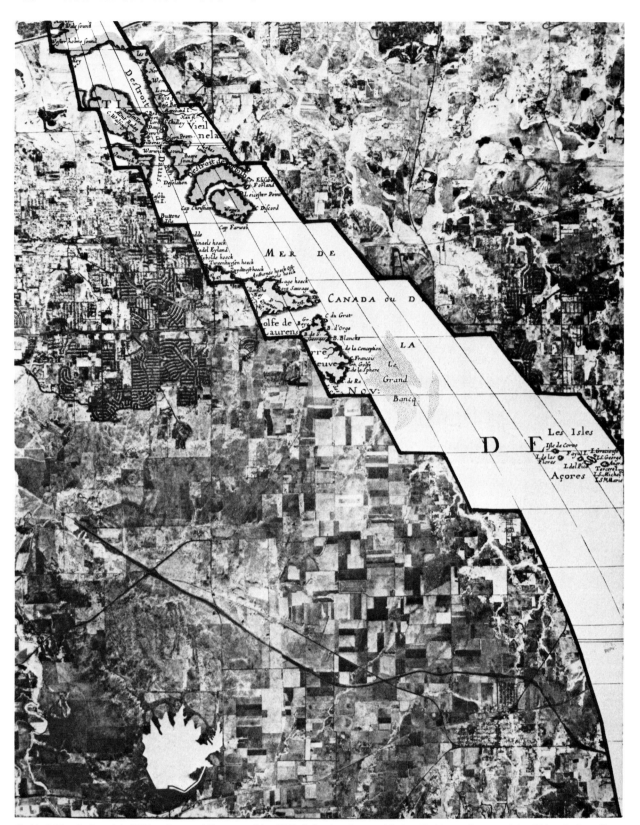

Untitled (*Mer de Canada*), 1967; collage and Photostat; 14 x 10¾". Collection Estate of Robert Smithson, Courtesy John Weber Gallery. Photograph by Nathan Rabin.

(Left) *Untitled*, 1964/65. Collection Estate of Robert Smithson, Courtesy John Weber Gallery. Photograph by John A. Ferrari.

Enantiomorphic Chambers, 1965. Location unknown. Photograph courtesy John Weber Gallery.

(Above) *Glass Stratum*, 1967. Collection Virginia Dwan. Photograph by Jon Reis, Courtesy Herbert F. Johnson Museum of Art, Cornell University, Ithaca, New York.

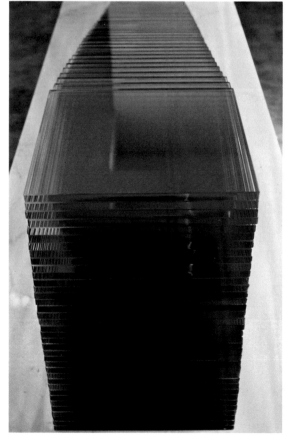

Glass Stratum, 1967. Collection Virginia Dwan. Photograph courtesy Dwan Gallery, Inc.

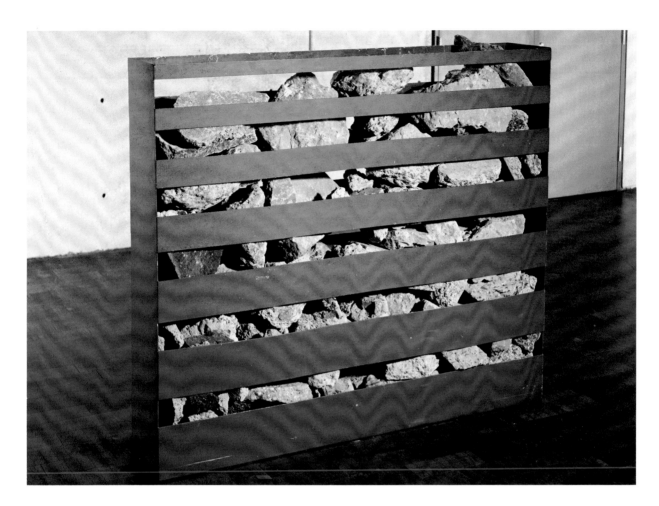

(Above) *Nonsite "Line of Wreckage," Bayonne, New Jersey,* 1968. Milwaukee Art Center Collection, Purchased with National Endowment for the Arts Matching Funds. Photograph courtesy Milwaukee Art Center.

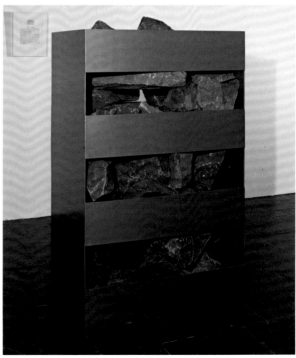

Nonsite (Palisades, Edgewater, New Jersey), 1968. Collection Whitney Museum of American Art, New York, Gift of the Howard and Jean Lipman Foundation, Inc. Photograph by Geoffrey Clements, Courtesy Whitney Museum of American Art, New York.

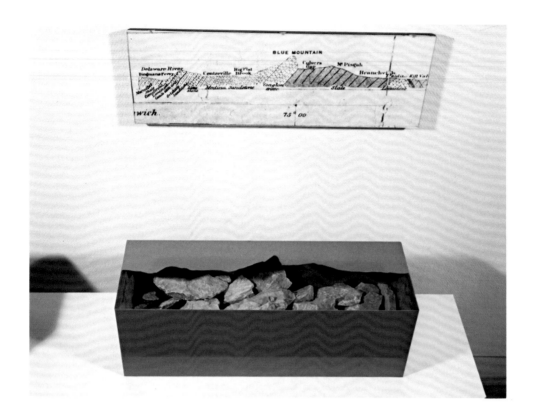

(Above) Sixth Stop from *Six Stops on a Section,* 1968. Collection Museum of Modern Art, Vienna; Ludwig Collection, Aachen. Photograph courtesy Museum of Modern Art, Vienna.

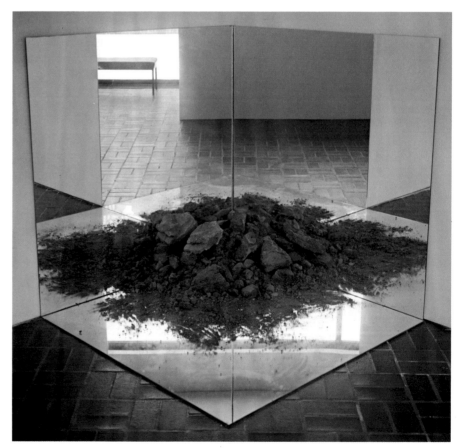

Red Sandstone Corner Piece, 1968. Collection Estate of Robert Smithson, Courtesy John Weber Gallery. Photograph by Steven Sloman.

(Right) *Eight-Part Piece* (*Cayuga Salt Mine Project*), 1969.
Photograph by Yale Joel, *Life* © 1969 Time, Inc.

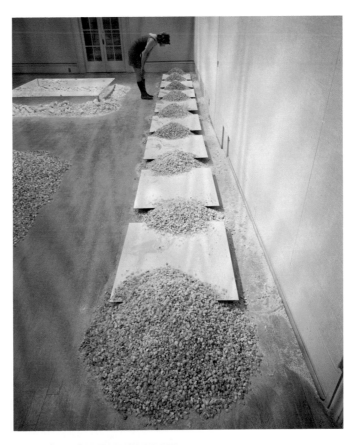

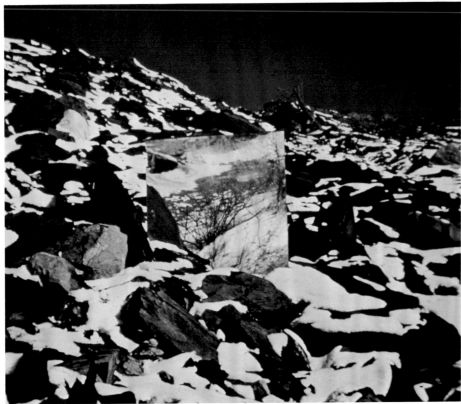

Mirror Trail (*Cayuga Salt Mine Project*), 1969. Photograph by William C. Lipke.

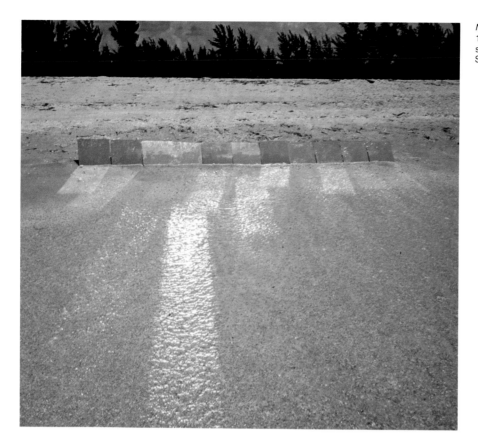

Mirror Shore, Sanibel Island, spring 1969. Photograph by Robert Smithson, Courtesy Estate of Robert Smithson.

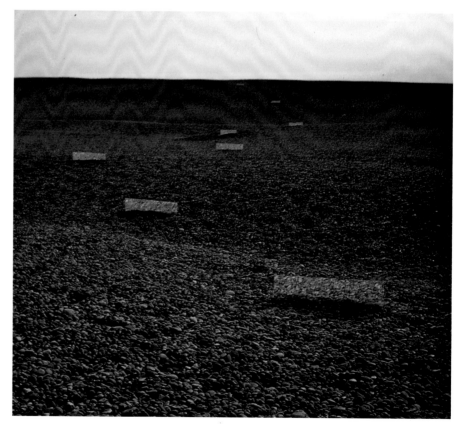

Mirror Displacement, Portland Island, England, September 1969. Photograph by Robert Smithson, Courtesy Estate of Robert Smithson.

First Mirror Displacement

Second Mirror Displacement

Third Mirror Displacement

Fourth Mirror Displacement

Fifth Mirror Displacement

Sixth Mirror Displacement

Seventh Mirror Displacement

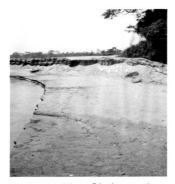

Eighth Mirror Displacement

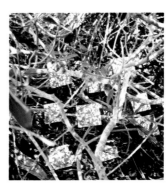

Ninth Mirror Displacement

9 Mirror Displacements from ''Incidents of Mirror-Travel in the Yucatan,'' 1969. Photographs by Robert Smithson, Courtesy Estate of Robert Smithson.

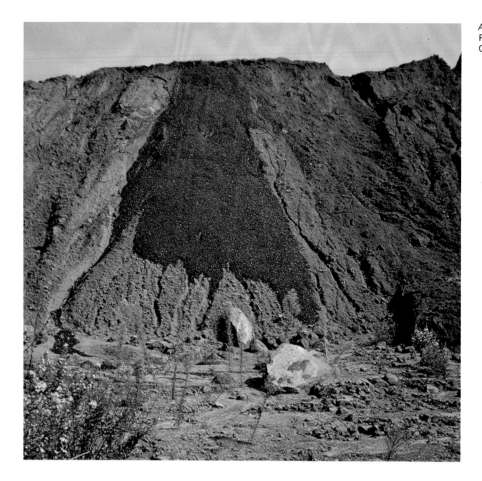

Asphalt Rundown, Rome, Italy, 1969.
Photograph by Robert Smithson,
Courtesy Dwan Gallery, Inc.

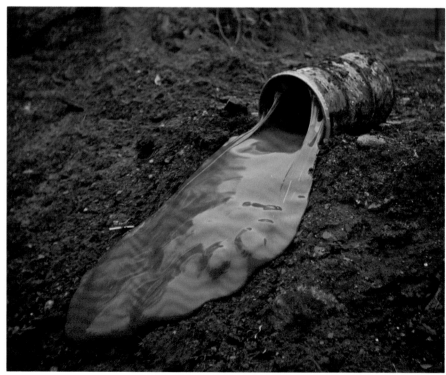

Glue Pour, Vancouver, British Columbia, January 1970. Photograph by
Nancy Holt.

Partially Buried Woodshed, Kent, Ohio, January 1970. Collection Kent State University. Photograph courtesy Estate of Robert Smithson.

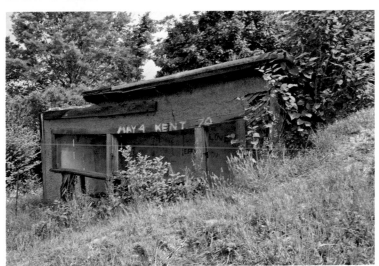

Partially Buried Woodshed eight years later, 1978. Photograph by Nancy Holt.

Partially Buried Woodshed eight years later (interior view), 1978. Photograph by Nancy Holt.

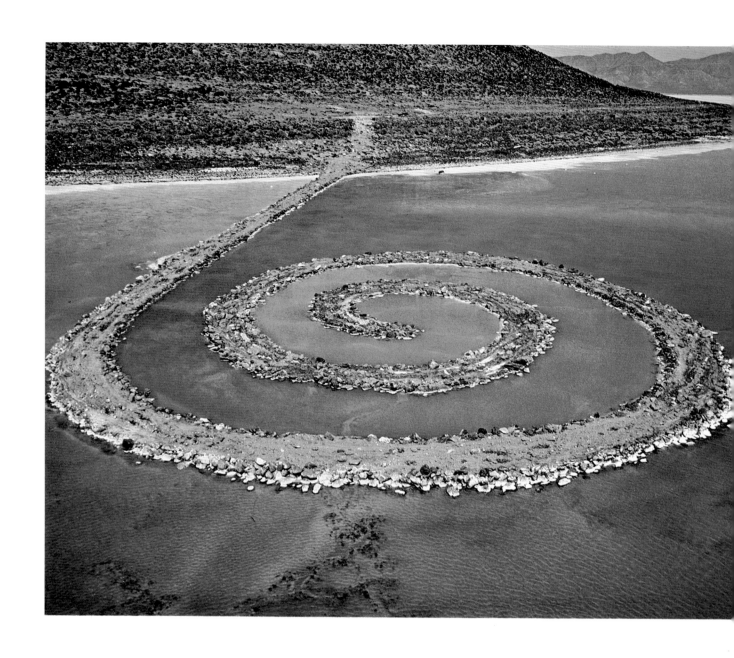

Spiral Jetty, Great Salt Lake, Utah, April 1970. Photograph by Gianfranco Gorgoni/Contact.

Broken Circle, Emmen, Holland, summer 1971. Photograph by Robert Smithson, Courtesy John Weber Gallery.

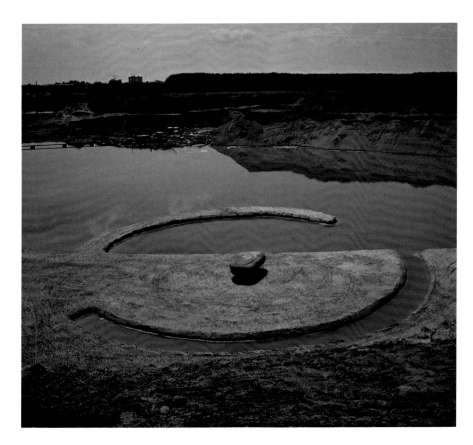

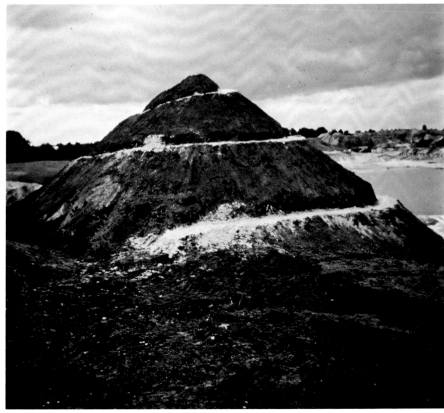

Spiral Hill, Emmen, Holland, summer, 1971. Photograph by Robert Smithson, Courtesy Estate of Robert Smithson.

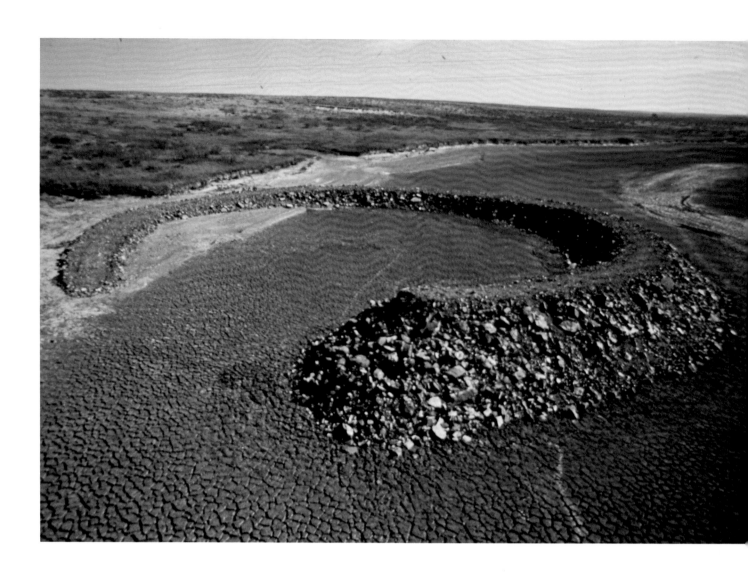

Amarillo Ramp, Texas, 1973. Collection Stanley Marsh. Photograph by Gianfranco Gorgoni/Contact.

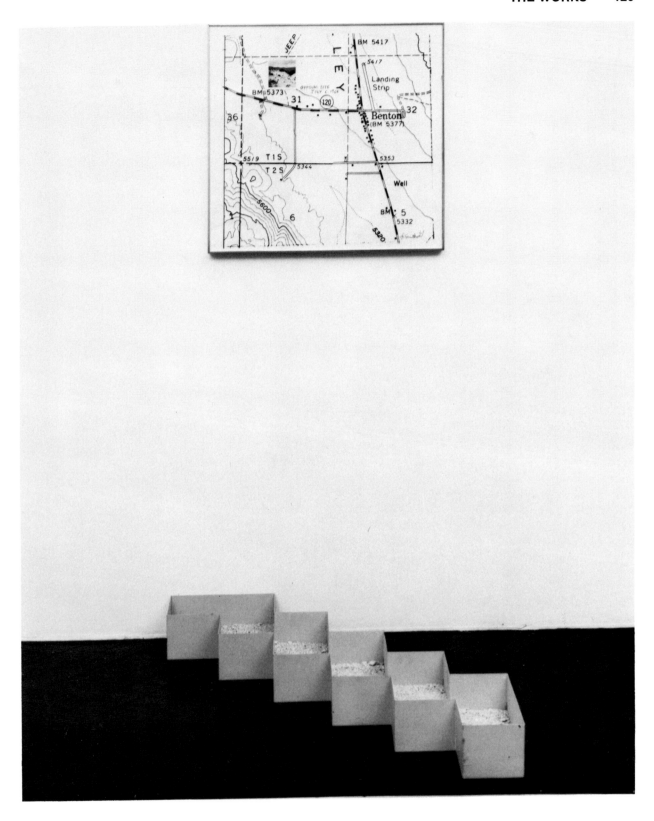

Gypsum Nonsite, Benton, California, 1968. Collection The Art Gallery of Ontario.
Photograph courtesy John Weber Gallery.

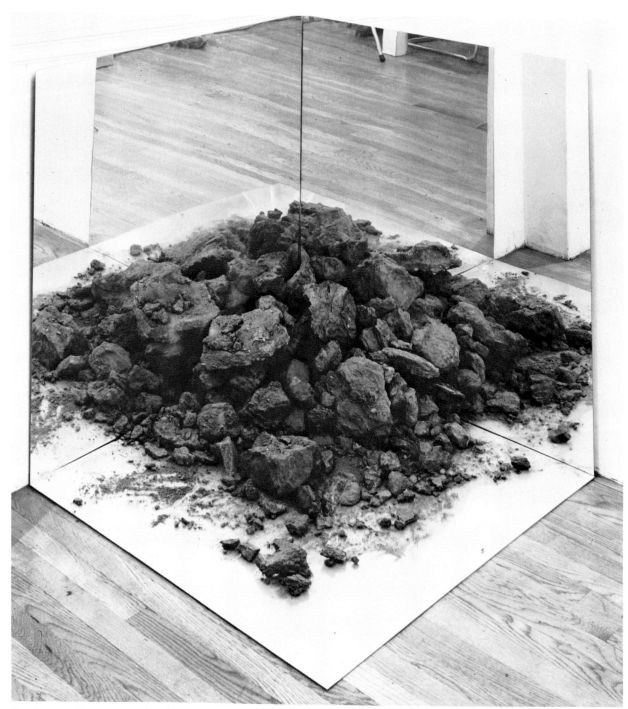

Red Sandstone Corner Piece, 1968. Collection Estate of Robert Smithson, Courtesy John Weber Gallery. Photograph by Peter Moore.

30. *Red Sandstone Corner Piece*, 1968;
mirrors and sandstone from the Sandy
Hook Quarry, New Jersey; mirrors 4 × 4′

Beginning in 1968 Smithson created a series of corner
pieces using gravel, sand, rock, salt, slate, red sand-
stone, and chalk. And he even made mirrored corner
pieces as late as 1971 when he brought back pink lace
coral from Summerland Key, Florida, and used it to
shore up three mirrors.

The corner pieces represent an important elaboration
of Smithson's exploration of mirrors. Usually, as in *Red*

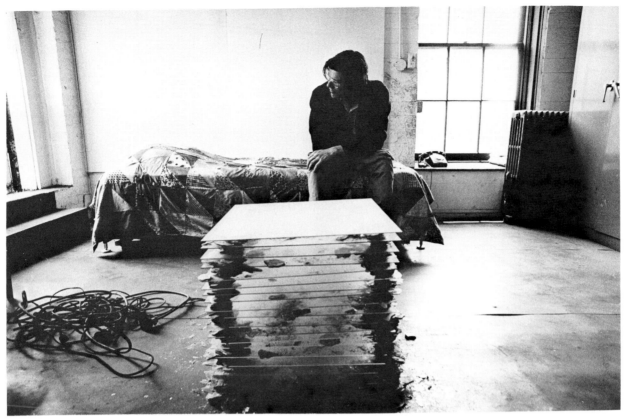

Untitled (Mica and Glass) (destroyed), 1968/69. Photograph by Gianfranco Gorgoni/Contact.

Sandstone Corner Piece, three square mirrors are positioned in a corner, and the rock is loosely piled in the resulting angle. The effect is surprising because the mirrored world extends in three different directions, multiplying by a factor of four the square on the floor as well as the rock, turning it into a symmetrical cone.

31. *Untitled (Mica and Glass)* (destroyed), 1968/69; mica and glass; dimensions unknown

Sometime after he made *Mica Nonsite* of 1968, Smithson disassembled the sculpture to compose this stacked mica and glass piece. Interested in establishing visual structures that are at odds with the basic constituency of his materials, the artist created an alternating layered work with an apparent structural regularity in the glass sheets and a look of randomness in terms of the mica

pieces. Actually appearances are deceiving: glass is not crystalline or regular, and the seemingly irregular mica has an orderly atomic arrangement evidenced by its perfect cleavage. This piece, then, establishes on an atomic level what it contradicts visually, suggesting that an art that deals solely with appearances is apt to be false.

32. *Mirror Wedge (Mirror Span)*, Montclair, New Jersey, 1969 (?); mirror; dimensions unknown

The mirror traverses a narrow rock crevice in the Watchung Mountains near Clifton, where the artist grew up. As a child, he used to bicycle to this spot, which is famed in New Jersey for its uniqueness.

Although there is no way of pinpointing the date of this work, Nancy Holt believes the outdoor displacement to be one of the first mirror pieces. It is possible that *Mirror Wedge* was set up as early as fall 1968.

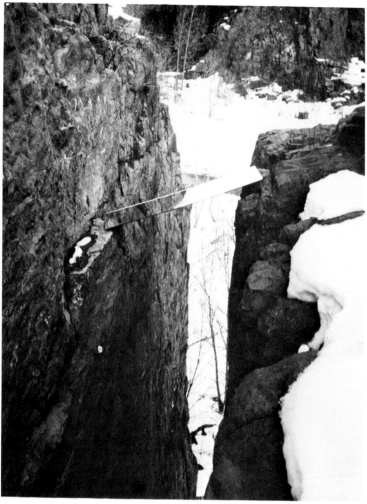

Mirror Wedge (Mirror Span), 1969(?). Photograph courtesy Estate of Robert Smithson.

33. *Mirror Displacement (Cayuga Salt Mine Project)*, implemented February 1969 (begun October 1968); Site/Nonsite, Sub-Site/Sub-Nonsite. *Mirror Trail*, February 1969; mirrors, rock salt, photographs, and fossilized rock

Among all the Sites/Nonsites conceived in 1968, the *Cayuga Salt Mine Project* is by far the most grandiose in conception and the most elaborate in its execution. It was first begun in October 1968 when Smithson visited Ithaca, New York, in anticipation of the "Earth Art" exhibition organized by Thomas W. Leavitt, director of the Andrew Dickson White Museum of Cornell University,

and art critic Willoughby Sharp.[43] During the initial visit, Smithson decided to use the Cayuga Rock Salt Company (now Cargill, Inc.), which is north of the university and half a mile underground.

Smithson's original plans for the Site/Nonsite called for photographs rather than mirrors. The interior of the salt mine was to be photographed, then these pictures were to be placed in the same underground caverns and the interior photographed again. This second series of photographs together with collected samples of rock salt would comprise the gallery piece.

It is difficult to ascertain whether the artist decided that the double photographing would become too involved and confusing, but, in any case, he dispensed with the idea and decided instead to use eight mirrors in the mine. Mirrors provided continuity throughout the different phases of the project and they had the advantage over photographs of maintaining their reflective function even in the gallery, thus giving the piece an episodic and immediate aspect.

When he set up this Site/Nonsite, Smithson decided not only to establish a dialectic between mine and gallery but also to elaborate the scheme with a subset that formed a reversed and criss-crossed version of the first dialectic. The Sub-Site was above ground at the neighboring Cayuga Crushed Rock Company's quarry and the Sub-Nonsite was placed in the basement of the White Museum and consisted of a two-foot-square mirror supported by fossilized rocks from the Sub-Site.

Connecting the Site and Sub-Site to the gallery was a *Mirror Trail* consisting of eight mirrors placed at evenly spaced points that the artist designated on a U.S. Geological Survey map. The artist titled the path with mock formality, "A Mirror Trail with Mirror Displacements from the White Art Museum to the Cayuga Salt Works," thus linking the Site with the Nonsite.

The gallery piece differed significantly from other Nonsites: here the bin/rock relationship is reversed so that the rock salt serves as a "container" for the mirrors. The artist was playing in this piece with differences between appearances and reality: salt appears amorphous but has a regular molecular structure while the glass looks regular but is actually amorphous.

Smithson discussed the piece in a conversation with William C. Lipke, then assistant professor of art history at Cornell University:

[43] After the Earth Art exhibition Smithson left all the material for *Mirror Displacement (Cayuga Salt Mine Project)* at the Andrew Dickson White Museum. In April 1976, with original drawings and installation photographs, Amy Baker, then of the John Weber Gallery, supervised the making of unique reconstructions of the *Cayuga Salt Mine Project* for a one-person exhibition at the gallery.

At present the Tehran Museum of Contemporary Art has purchased *Open Mirror Square*, and the Allan Memorial Art Museum, Oberlin College, has acquired *Slant Piece*.

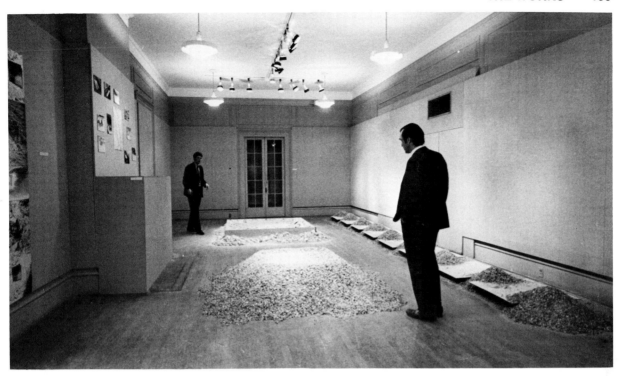

Thomas W. Leavitt, director, Andrew Dickson White Museum of Art, at ''Earth Art'' exhibition, Cornell University, Ithaca, New York. Photograph courtesy Herbert F. Johnson Museum of Art, Cornell University.

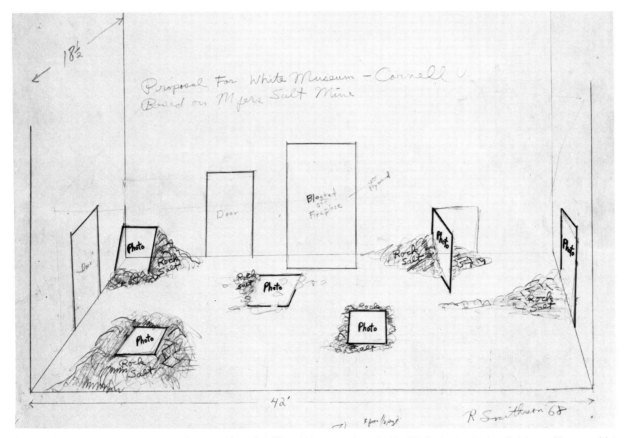

Proposal for White Museum—Cornell U. Based on Myers Salt Mine, 1968; ink and pencil; 22 x 28″. Collection Herbert F. Johnson Museum of Art, Cornell University, Ithaca, New York. Photograph by Nathan Rabin.

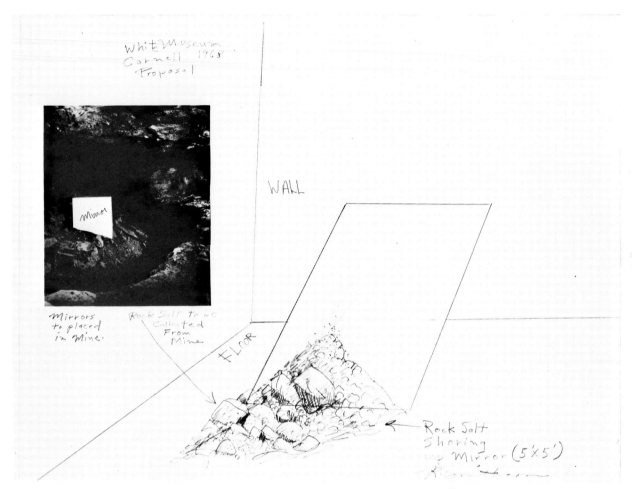

Mirror with Rock Salt (Salt Mine and Museum Proposal), 1968; pencil, pasted photograph, and pasted paper; 17¾ x 24″. Collection The Museum of Modern Art, New York, Gift of Mrs. John de Cuevas. Photograph courtesy The Museum of Modern Art, New York.

This was the first interior underground site that I did, the one in the salt mine. There you have an amorphous room situation, an interior that's completely free. There's no right angles forming a rectilinear thing. So I'm adding the rectilinear focal point that sort of spills over into the fringes of the non-descript amorphousness. Then it's all contained when you shoot the photograph so you have that dialectic in that. On a topographical earth surface you don't have that kind of enclosure. There's a sort of rhythm between containment and scattering. It's a fundamental process that Anton Ehrenzweig has gone into. I think his views are very pertinent in that he talks about this in terms of containment or scattering.

An artist in a sense does not differentiate experience into objects. Everything is a field or maze, and you get that maze, serially, in the salt mine in that one goes from point to point. The seriality bifurcates: some paths go somewhere, some don't. You just follow and what you're left with is like a network or a series of points, and then these points can then be built in conceptual structures.

The non-site situation doesn't look like the mine. It's abstract. The piece I did here utilizes the same dialectic of the site/non-site, except the one controlling element is the mirror which in a sense is deployed differently. There's an element of shoring and supporting and pressures. The material becomes the container. In other non-sites, the container was rigid, the material amorphous. In this case, the container is amorphous, the mirror is the rigid thing. It's a variation on the theme of the dialectic of the site/non-site.

I'm using a mirror because the mirror in a sense is both the physical mirror and the reflection: the mirror as a concept and abstraction; then the mirror as a fact within the mirror of the concept. So that's a departure from the other kind of contained, scattering idea. But still the bi-polar unity between the two places is kept. Here the site/non-site becomes encompassed by mirror as a concept—mirroring, the mirror being a dialectic.

The mirror is a displacement, as an abstraction absorbing, reflecting the site in a very physical way. It's an ad-

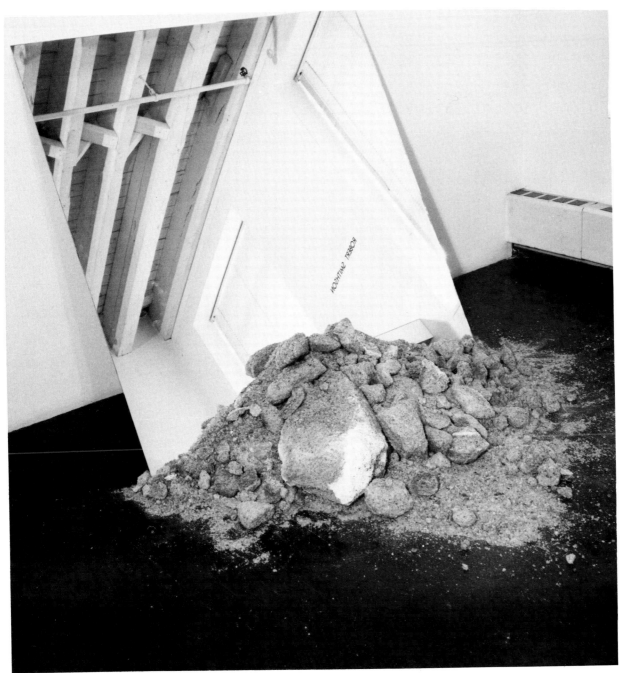

Slant Piece, 1969 (installation at John Weber Gallery, 1976); mirror, rocks, 48 x 60 x 48". Unique reconstruction. Collection Allen Memorial Art Museum, Oberlin, Ohio. Photograph by John A. Ferrari.

dition to the site. But I don't leave the mirrors there. I pick them up. It's slightly different from the site/non-site thing. Still in my mind it hasn't completely disclosed itself. There's still an implicit aspect to it. It's another level of process that I'm exploring. A different method of containment.

The route to the site is very indeterminate. It's important because it's an abyss between the abstraction and the site; a kind of oblivion. You could go there on a highway, but a highway to the site is really an abstraction because you don't really have contact with the earth. A trail is more of a physical thing. These are all variables, indeterminate elements which will attempt to determine the route from the museum to the mine. I'll designate points on a line and stabilize the chaos between the two points. Like stepping stones. If I take somebody on a tour of the site,

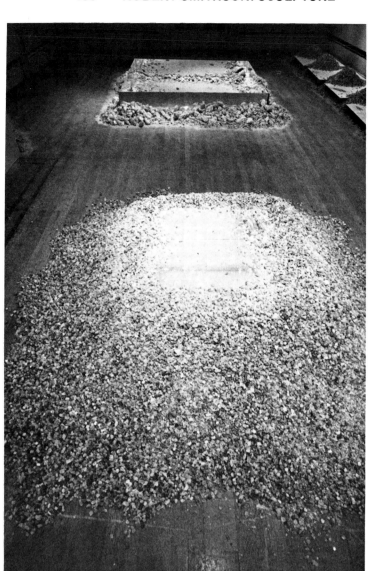

Foreground: *Closed Mirror Square*, 1969; rock salt, mirrors; approximately 22 x 108 x 108″. Background: *Rock Salt and Mirror Square*, 1969; rock salt, mirrors; 10 x 78 x 78″. Photograph courtesy John Weber Gallery.

I just show them where I removed things. Not didactic, but dialectic.

Oblivion to me is a state when you're not conscious of the time or space you are in. You're oblivious to its limitations. Place without meaning, a kind of absent or pointless vanishing point.

There's no order outside the order of the material.

I don't think you can escape the primacy of the rectangle. I always see myself thrown back to the rectangle. That's where my things don't offer any kind of freedom in terms of endless vistas or infinite possibilities. There's no exit, no road to utopia, no great beyond in terms of exhibition space. I see it as an inevitability; of going toward the fringes, towards the broken, the entropic. But even that has limits.

Every single perception is essentially determinate. It isn't a question of form or anti-form. It's a limitation. I'm not all that interested in the problems of form and anti-form, but in limits and how these limits destroy themselves and disappear.

It's not a matter of what I'd like to do, but how things result. There are strict limits, but they never stop until you do.[44]

[44] "Fragments of a Conversation," ed. William C. Lipke, in *Writings*, pp. 168–70.

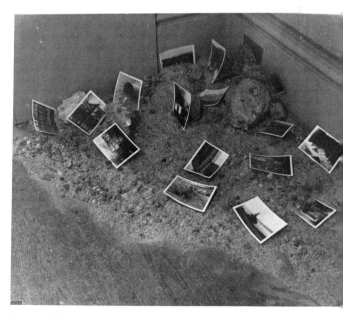

Rock Salt Corner Piece with Photographs, 1969; rock salt, photographs; dimensions variable. Photograph courtesy Herbert F. Johnson Museum of Art, Cornell University, Ithaca, New York.

Installation view, "Earth Art" exhibition, Andrew Dickson White Museum, Cornell University, Ithaca, New York, 1969. Photograph by David Morgan, Courtesy Herbert F. Johnson Museum of Art, Cornell University.

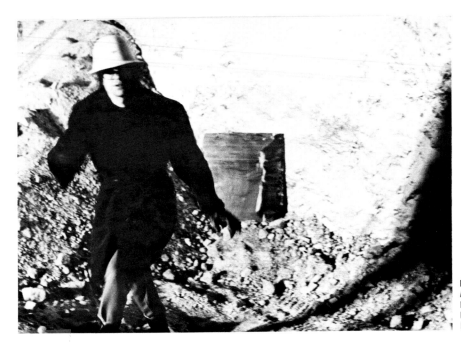

Robert Smithson at Site on the
Mirror Trail between Cayuga Salt
Mine and Andrew Dickson White
Museum, Ithaca, New York, 1969.
Photograph by William C. Lipke.

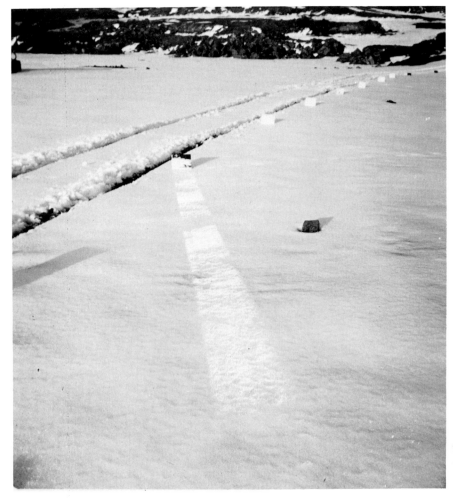

Mirror Trail, New Jersey, Jewish New
Year Poster, 1969. Commissioned by
The Jewish Museum, New York.
Photograph courtesy Estate of
Robert Smithson.

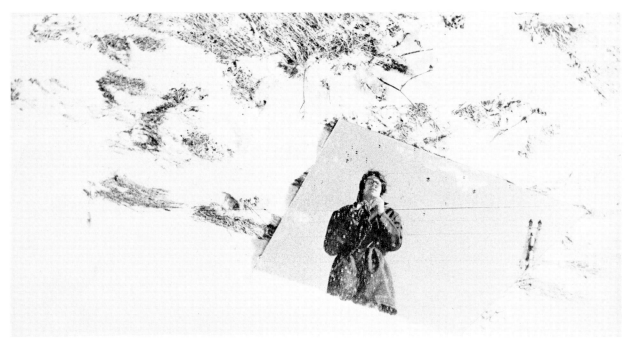

"Smithson displaced" while photographing on the *Mirror Trail* between Cayuga Salt Mine and Andrew Dickson White Museum, Ithaca, New York, 1969. Photograph by William C. Lipke.

34. *Rocks and Mirror Square II*, 1969/71; basalt from northern New Jersey, eight mirrors; 14 × 60 × 60″

In *Rocks and Mirror Square II* Smithson varied the format he originated in the *Cayuga Salt Mine Project* and *Rocks and Mirror Square I* (constructed near Ithaca, New York). The shape of *Square II* repeats the first square; its size, however, has a source in Ad Reinhardt's black paintings which are also 5 feet square. It is possible that Smithson was both honoring and poking fun at his friend: like the black paintings, *Square II* appears to be empty in the center, only a frame.

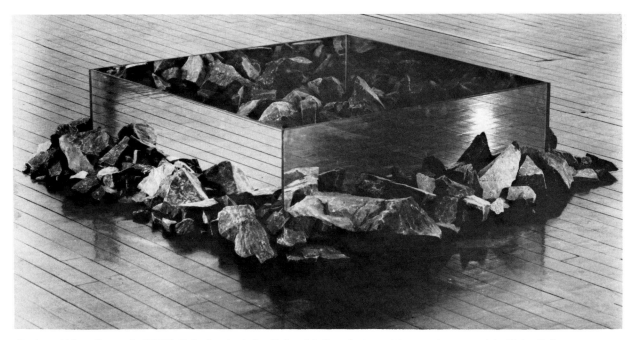

Rocks and Mirror Square II, 1969/71. Collection Australian National Gallery, Canberra. Photograph courtesy John Weber Gallery.

The concept of the framing edge of *Rocks and Mirror Square II* also has other sources. In the 1960s followers of Clement Greenberg hotly debated whether or not internal patterns in shaped canvases, like Frank Stella's, were deduced from an overall shape. Many times in his own criticism, Smithson parodied these formalist concerns. But while he may have castigated the formalists in print, in his work he may have undertaken the goal of making fun of them and establishing something positive in place of their dry, objective-sounding rhetoric. His approach is similar to Reinhardt's in that both artists put forth in their work what they laughingly criticized, creating statements that refute what they also assert.

35. *First Upside-Down Tree*, Alfred, New York, spring 1969; dead tree "planted" upside down; approximately 10′

Curious among Smithson's works are the series of "displaced" dead trees of 1969, which starts with *First Upside-Down Tree* in Alfred, New York. Possibly Smithson's intent in this group of works—if indeed he had a conscious intent—was to indicate the uselessness of the organic. Not only are these trees dead, but they are also upended, or "resurrected," to a new purpose, art. When speaking of art, critics and art historians often use a biological vocabulary: styles have a birth, death, and decay; works of art have a living presence; and artistic ideas germinate and reach fruition. George Kubler, in one of Smithson's favorite books, *The Shape of Time,* holds the biological metaphor suspect and suggests a new mathematical framework based on prime objects and sequences. Following these ideas, Smithson attempts not only to avoid the use of biological terms in his writings, he even undertakes to expunge living references from his art. Although he creates Earthworks—and Earth art should be separated here from its biological counterpart, gardens—he does not intend to provide an image of a fecund universe. His subject is more the "conflation" of time, in which distant pasts collide into distant futures, than it is an unveiling of the yearly burgeoning of nature. Consequently he limits his use of living materials. At this point in his work, when organic elements appear, as in the *Upside-Down Trees,* they are dead—found objects.

If Smithson had uprighted his trees, he might well have been alluding to traditional medieval and Renaissance symbols of Christ, such as the Tree of Life and the Tree of Death. But having suffered an intense religious crisis in the early sixties which left him uninterested in orthodoxies, he never again concerned himself with such iconography. Of course, a connection could be read be-

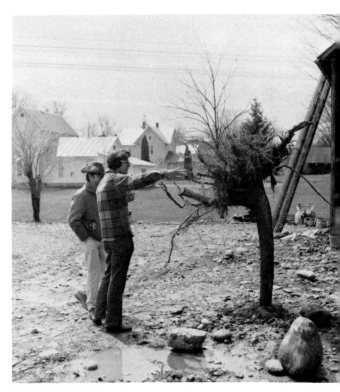

Smithson standing beside *First Upside-Down Tree,* Alfred, New York, 1969. Photograph courtesy Estate of Robert Smithson.

tween the *Upside-Down Trees* and Moslem images of the Prophet's Tree of Bliss in Paradise which grew downward toward earth; but it needs to be emphasized that Smithson's trees are dead, and they are placed in a ludicrous position, turning them into gratuitous objects and, consequently, art.

Smithson also avoided connotations of nature as an explosive force. Even though his *Upside-Down Trees* might at first glance call to mind the splintered limbs and upended trees that were conventions for depicting the Sublime which appear as early as the work of Salvator Rosa, were perpetuated by Dutch artists such as Jacob Ruysdael, and were investigated by nineteenth-century Americans, Smithson was not attempting to create a Sublime art. His *Upside-Down Trees* recall more the familiar and rustic aspects of the picturesque than the drama of the Sublime. There is something ridiculous about the *Upside-Down Trees.* The artist alludes to this playful quality when he writes about the *Third Upside-Down Tree* in "Incidents of Mirror-Travel in the Yucatan" as appropriate art for flies, who see with compound eyes. The meaning of the trees is purposely left ambiguous: they are "riddles" that increase in complexity as they are studied, so that they become compounded into kaleidoscopic images similar to those perceived by flies. And, after all, he asks, "Why should flies be without art?"

36. *The Hypothetical Continent in Stone: Cathaysia*, Alfred, New York (no longer extant) spring 1969; rocks in quicksand (second version: rocks and two dead snakes in quicksand); commissioned by Alfred University as part of project for Smithson and students

Smithson recorded the following information about this disappearing continent in a map drawing of the same year, in which Cathaysia appears as a land mass covering an area that includes the Philippine Islands, the East Indies, and New Guinea:

The Hypothetical Continent of *Cathaysia*
During the lower Carboniferous Period,

Duration 45,000,000 years (from 350 to 305 million years).
Earth map of jumbled rocks to be placed on quicksand.
Clay slope, with quicksand pools, earth map will slowly sink into sand.

Cathaysia, first in the series of "disappearing continents" which includes *Lemuria* and *Gonwanaland,* was a new type of Nonsite. Placed on quicksand, the miniature continent soon disappeared and became a nonvisible testimony to a no longer extant world. The artist, who dealt with nonspace, timelessness, and energy drain, was concerned with creating low-key disappearing works of art.

That Smithson constructed a "disappearing continent" and incorporated snakes into the work is not sur-

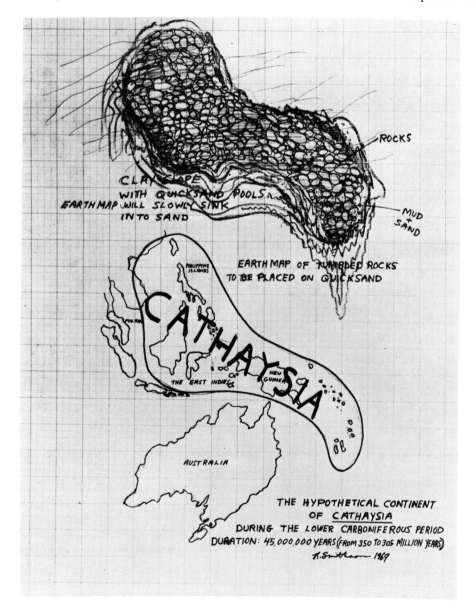

The Hypothetical Continent of Cathaysia, 1969, pencil and pen on graph paper. Photograph courtesy Estate of Robert Smithson.

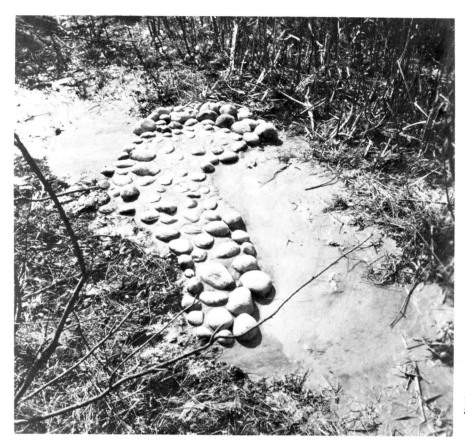

The Hypothetical Continent in
Stone: Cathaysia, Alfred, New York,
1969. Photograph courtesy
Estate of Robert Smithson.

prising given his personal history. As a child he was fascinated by reptiles and even created a home museum of them and of fossils. Throughout his life he continued to be fascinated with reptiles and said that he identified with them. In his work he frequently referred to past eras when reptiles in the form of dinosaurs reigned supreme, and in his early paintings reptilian monsters abound.

The choice of quicksand also has a history in Smithson's art. In the early sixties he made a painting/collage in the Abstract Expressionist vein, entitled *Quicksand*; it was an involved landscape consisting of paint and stapled pieces of paper. The use of quicksand suggests an interesting conversion of Abstract Expressionist themes and attitudes into actual materials and processes. In Abstract Expressionism the work of art frequently is regarded as a palimpsest, and artists often refer to their work as a process of excavation or layering through which they discover who they are. In his *Hypothetic Continent* Smithson layers materials on a background of quicksand, suggesting as he does that the background of art is never inert and stable. If one thinks of the shifting, fractured planes of a de Kooning in relation to Smithson's continent, one can see how the Abstract Expressionist attitude has served as a source for an entirely new art.

Map of Quicksand and Stones with Two Snakes: Cathaysia, Alfred,
New York, 1969. Photograph courtesy Dwan Gallery, Inc.

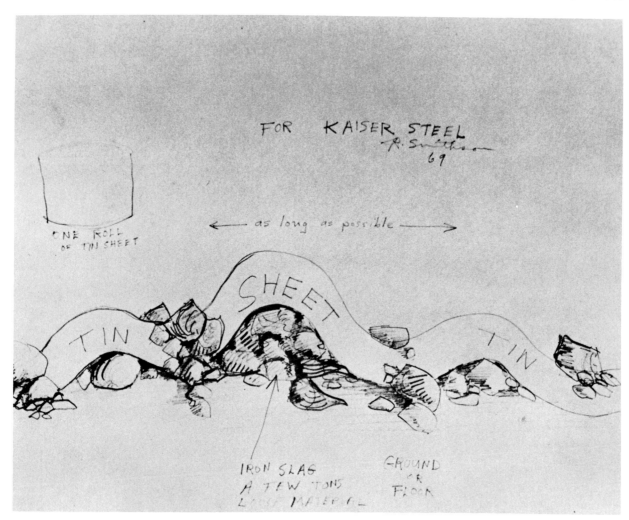

Project for Kaiser Steel, 1969. Collection unknown. Photograph by Ed Cornachio, Courtesy Los Angeles County Museum of Art.

37. Projects for "Art and Technology," Los Angeles County Museum, 1969, exhibition 1971; projects for Kaiser Steel and American Cement Company

Unlike many artists participating in the "Art and Technology" program of the Los Angeles County Museum of Art (1967–71), Smithson did not hold technology as an optimistic promise for art, but felt its only significance could be as a wholly gratuitous enterprise resulting in entropy. While a participant of "A & T," as the program was known, he produced drawings for projects involving two companies, Kaiser Steel and American Cement.

For Kaiser Steel he suggested snaking a sheet of tin (probably galvanized) over and under several tons of iron slag. As in *Nonsite, Oberhausen, Germany*, the smelted material interacts with its slag, illustrating an "entropic"

situation of refinement and consequent energy drain.

His plans for the American Cement Company of Riverside, California, were as pessimistic as his Kaiser Steel project. Avoiding the sophisticated forms of technology—software, video, and invisible occurrences of physical change—which occupied some of the program's artists, Smithson chose an inert material—cement—and investigated its origins by touring a local limestone mine. Following the precedent established only a few months earlier at Cornell, he planned to create works that would exist simultaneously in the mine and at the museum to form a double dialectic. The first part of the dialectic was to consist of minerals—blue calcite and white limestone—spread generously over the floor of an abandoned cavern, preferably a collapsed one. Opposing this hidden spread would be a dispersal of the same materials outside the museum. Related to his piece was a "Dearchitectured Project," a new type of Nonsite, con-

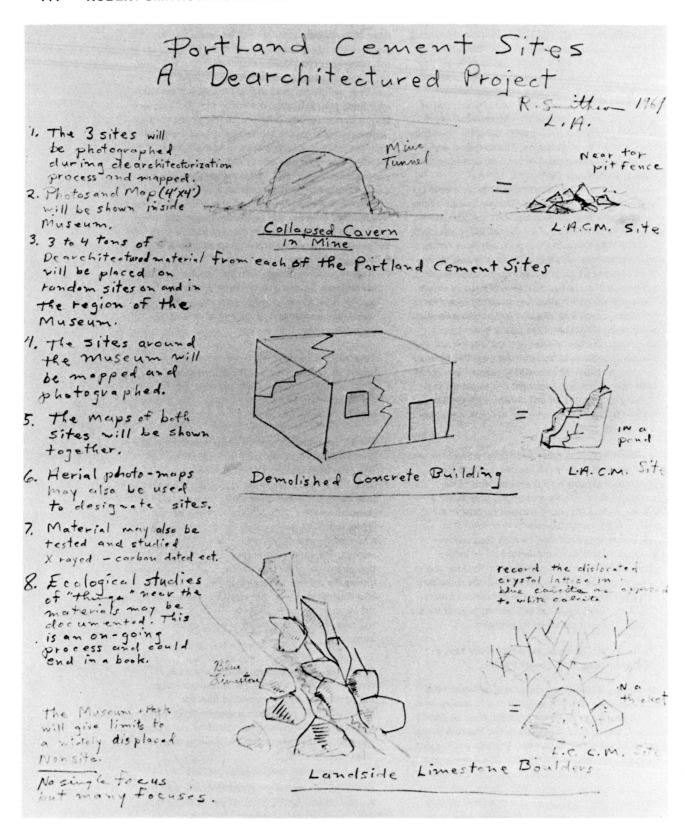

Portland Cement Sites: A Dearchitectured Project, 1969. Collection unknown. Photograph by Ed Cornachio, Courtesy Los Angeles County Museum of Art.

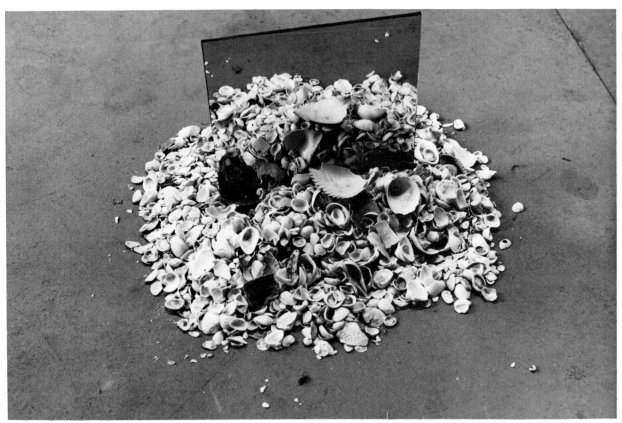

Mirror and Shell, 1969. Collection Keith Sonnier. Photograph by Jene Highstein, Courtesy Keith Sonnier.

sisting of pieces of a demolished concrete building belonging to the cement company which would be distributed in an ''unfocused'' way about the museum's parklike grounds. The idea of dearchitecturing as a creative force has an origin in the work of such Abstract Expressionist artists as Jackson Pollock and Robert Motherwell who regarded their works as a series of destructions.

Although Smithson was unable to implement these projects in California, he did not give up certain principles they dealt with. That same year, 1969, he evolved a way of considering creation and destruction as part of the same ongoing process when he visited the eccentric Hotel Palenque in the Yucatan. The hotel became the subject of a presentation piece in 1972, given to architecture students at the University of Utah. And a year after the proposal of the California project he continued to develop this idea when he initiated the destruction of a building in his *Partially Buried Woodshed* at Kent State University in Kent, Ohio. His ideas about dearchitecturing were elaborated during the 1970s by the late artist-architect Gordon Matta-Clark who, as a student at Cornell University, had assisted Smithson on the *Cayuga Salt Mine Project*. Matta-Clark conducted dissections or cuts on abandoned structures slated for razing.

Neither American Cement nor Kaiser Steel decided to sponsor Smithson's two projects for the ''Art and Technology'' exhibition. Although the projects were not implemented, they represented an important watershed in Smithson's career, for he was beginning to consider the possibilities of removing his art from the gallery network and finding alternative funding through corporate support. He shifted the emphasis of his art, which had in 1968 been carefully balanced between the Site and the Nonsite, and began in 1969 to put more emphasis on outdoor locations. He retained the balance in the projects for the ''Art and Technology'' exhibition, but in his next major work, ''Incidents of Mirror-Travel in the Yucatan,'' he literalized the concept of Nonsite, making it a place of the past apprehensible to viewers only through his essay.

38. *Mirror and Shell*, 1969; square mirror, shells from New Jersey shore; $1 \times 1 \times 2'$

Created in New York, this work was first constructed indoors in the artist's studio. It bears a strong relationship to *The Hypothetical Continent in Shells: Lemuria*, which was built on Sanibel Island, Florida, in the same year.

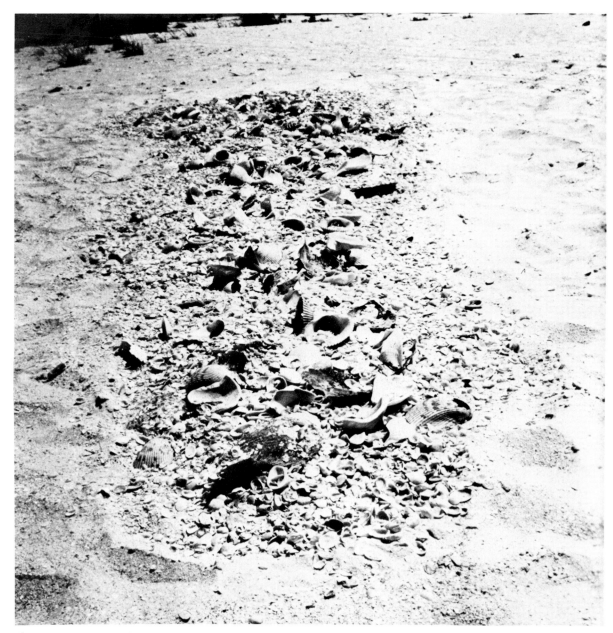

The Hypothetical Continent in Shells: Lemuria, Sanibel Island, Florida, 1969. Photograph by Robert Smithson, Courtesy Estate of Robert Smithson.

39. *The Hypothetical Continent in Shells:*
 Lemuria, Sanibel Island, Florida, 1969;
 shells and sand; dimensions unknown

Sanibel Island, Florida was the site of another hypothetical prehistoric continent. It was an especially fitting location for the sculpture since the island is the legendary site of a prehistoric land bridge to the Yucatan. Traveling with Nancy Holt and Virginia Dwan, Smithson intended to go on to the Yucatan for several weeks where he

hoped to make a piece. (His "Incidents of Mirror-Travel in the Yucatan" resulted from this trip.) The journey then to Sanibel Island and the Yucatan was not simply a trip in distance but also a mythic venture in time.

Another reason why Smithson chose Sanibel Island as the location for a hypothetical continent is that he had gone there as a child and loved the spot and knew that it contained shells in vast numbers and varieties. The *Hypothetical Continent in Shells: Lemuria* is composed of a mass of shells which Smithson placed far enough away

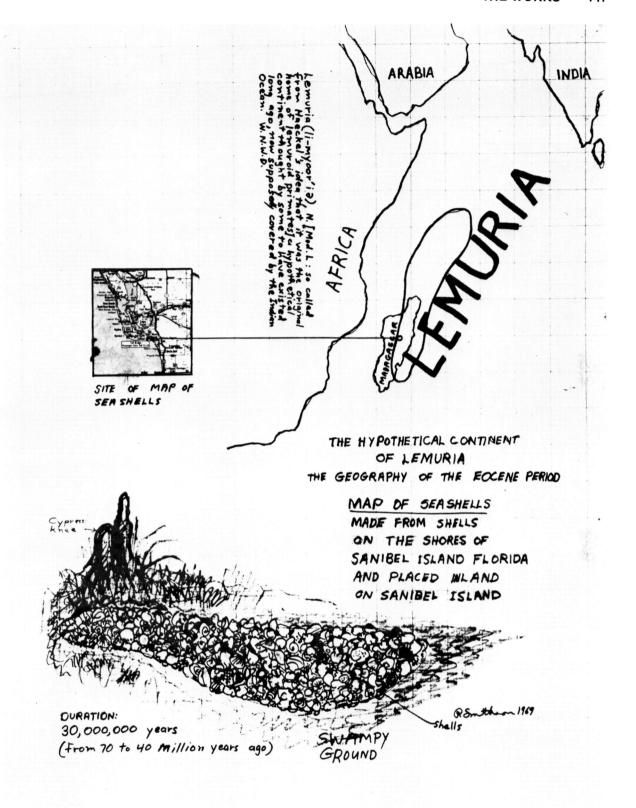

ARABIA

INDIA

LEMURIA

AFRICA

MADAGASCAR

Lemuria ((li-myoor'i?) N.[Mod.L: so called
from Haeckel's idea that it was the original
home of lemuroid primates] a hypothetical
continent thought by some to have existed
long ago, now supposed covered by the Indian
Ocean. W.N.W.D.

SITE OF MAP OF
SEA SHELLS

THE HYPOTHETICAL CONTINENT
OF LEMURIA
THE GEOGRAPHY OF THE EOCENE PERIOD

MAP OF SEASHELLS
MADE FROM SHELLS
ON THE SHORES OF
SANIBEL ISLAND FLORIDA
AND PLACED INLAND
ON SANIBEL ISLAND

Cypress
knee

DURATION:
30,000,000 years
(from 70 to 40 million years ago)

SWAMPY
GROUND

R Smithson 1969
shells

The Hypothetical Continent of Lemuria, 1969; ink, crayon, map; 22 x 17″. Dillard Collection, Weatherspoon Art Gallery, University of North Carolina, Greensboro. Photograph courtesy Weatherspoon Art Gallery.

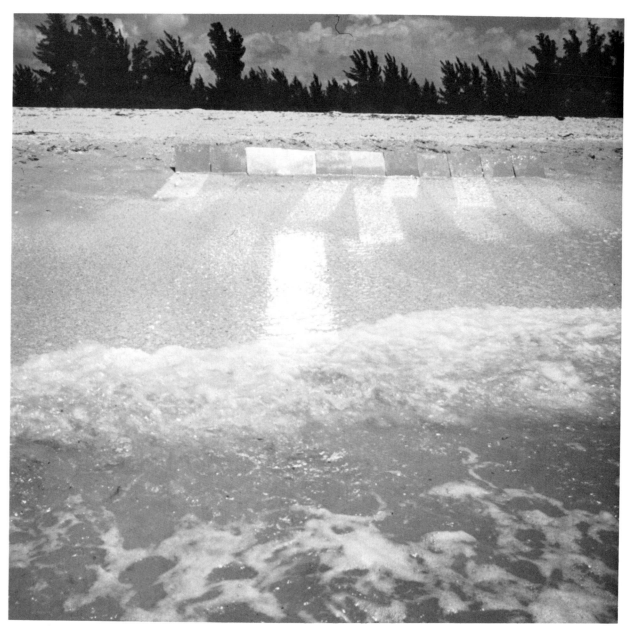

Mirror Shore, Sanibel Island, Florida, 1969. Photograph by Robert Smithson, Courtesy Estate of Robert Smithson.

from the water so that the tide would not wash it away.

Smithson made a collage-and-pencil drawing of the hypothetical continent on which he also mapped its original location and recorded information about it. Lemuria is shown to be near and include part of Madagascar off Africa and south of Arabia and India, and is described in detail:

The Hypothetical Continent of Lemuria
The Geography of the Eocene Period
Map of Seashells
Made from shells

on the shores of
Sanibel Island Florida
and placed inland on Sanibel Island
Duration: 30,000,000 years
(from 70 to 40 million years ago)

Smithson also included a definition of the continent's name: "Lemuria (li-myoor'ia), N. [Mod. L: so called from Haeckel's idea that it was the original home of lemuroid primates] a hypothetical continent thought by some to have existed long ago, now supposedly covered by the Indian Ocean. W.N.W.D.''

40. *Mirror Shore, Sanibel Island*, Florida, 1969,
light reflection on wet sand, 11 mirrors;
dimensions unknown

This mirror displacement at the edge of the water
forms a tropical pendant to the wintery *Mirror Trail* cre-
ated a few months earlier as part of the *Cayuga Salt Mine
Project* and also the Jewish Museum New Year poster
which recorded another *Mirror Trail* in New Jersey. In
one the reflected sun glints across wet sand, in the others
beams of mirrored sunlight radiate on the snow.

41. *Second Upside-Down Tree*, Captiva Island,
Florida, 1969; dead tree "planted" upside
down in sand; dimensions unknown

When Smithson, Nancy Holt, and Virginia Dwan vis-
ited Sanibel Island before their trip to the Yucatan, they
also spent time with Robert Rauschenberg who lives on
nearby Captiva Island in a house bordering the ocean.
While at Rauschenberg's place one day, Smithson
sighted a tree trunk on the shore opposite the island. De-
ciding he wanted to use it for a work of art, he persuaded
Rauschenberg to help him, and together they swam out
to the trunk, floated it ashore, and placed it upside down
on the beach adjoining Rauschenberg's property.

Second Upside-Down Tree, Captiva Island, Florida, 1969. Photograph
courtesy Estate of Robert Smithson.

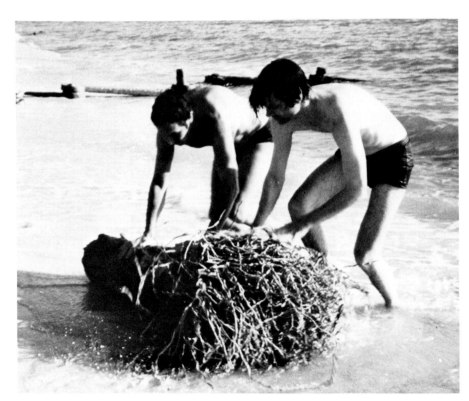

Robert Rauschenberg and Robert
Smithson rolling tree from the
ocean off Captiva Island, Florida,
1969. Photograph by Nancy Holt.

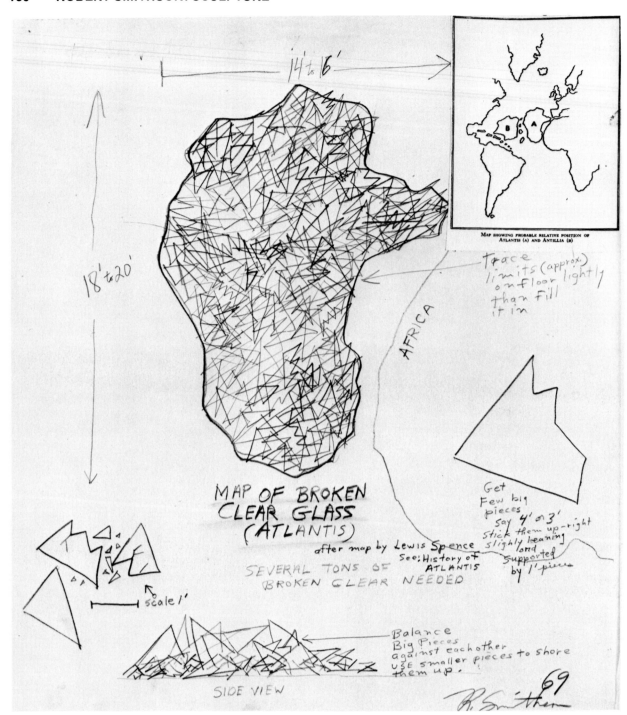

Map of Broken Clear Glass (*Atlantis*), 1969; collage, Photostat, map, pencil; 16¾ x 14". Collection Estate of Robert Smithson, Courtesy John Weber Gallery. Photograph by Nathan Rabin.

42. *The Map of Glass* (*Atlantis*), Loveladies, New Jersey, July 11–31, 1969 (destroyed; reconstructed 1975 at Museum of Contemporary Art, Chicago)

The Map of Glass was commissioned for a group exhibition sponsored by the Long Beach Island Foundation of Arts and Sciences. A 1969 map drawing of the work titled *Map of Broken Clear Glass* (*Atlantis*) shows its location next to Africa, and details specifications:

After map of Lewis Spence
See: History of Atlantis
Several tons of broken clear [glass] needed

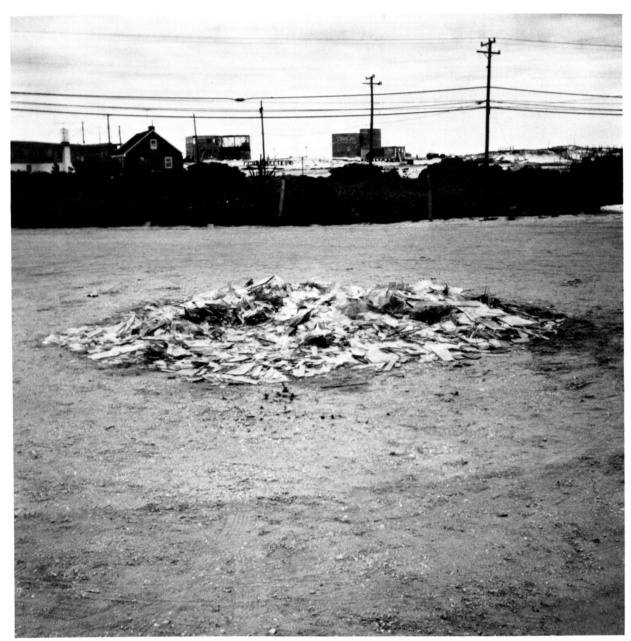

The Map of Glass (Atlantis), Loveladies Island, New Jersey, July 11–31, 1969. Photograph courtesy John Weber Gallery.

Trace limits (approx.) on floor lightly then fill it in
Get few big pieces say 4′ or 3′
stick them upright slightly leaning
and supported by 1′ pieces
Balance big pieces against each other
use smaller pieces to shore them up.

Smithson discussed the possible associations, sources, and visual aspects of this piece in a footnote to his 1969 essay "Incidents of Mirror-Travel in the Yucatan." [45]

[45] See reprint of the essay, which follows.

43. "Incidents of Mirror-Travel in the Yucatan," published in *Artforum* (September 1969)

Among Smithson's most complex works of art is the essay "Incidents of Mirror-Travel in the Yucatan." Straddling traditional boundaries of art history and personal diary, the article becomes a narrative piece. It documents a series of nine mirror displacements; at the same time it assumes the status of art. The artist has often affirmed that writing to him is not a secondary activity but

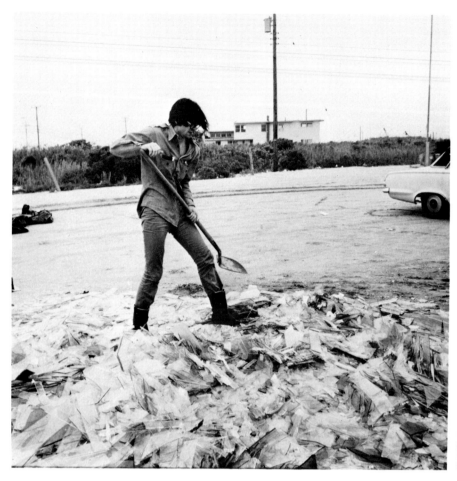

Robert Smithson constructing *The Map of Glass (Atlantis)*, Loveladies, New Jersey, 1969. Photograph courtesy Estate of Robert Smithson.

a primary one. First published in *Artforum,* "Incidents of Mirror-Travel" appears to give a detailed account of no longer extant works of art, but it quickly leaves the mundane world and enters a mythical realm; criticism and art history have become art. The mirror displacements, the supposed art works, disappear and their documentation, in its heightened form, becomes the work of art. Recalling Marcel Duchamp who declared a work of art to be completed by its critical reception, Smithson undertook the task of completing his nine mirror displacements himself by spinning out possible mythic and perceptual meanings.

It is important to note that mirrors are at the core of this piece. Since the time of Plato, mirrors, reflective surfaces, have been a *sine qua non* for works of art. Realizing that works of art in Plato's terms are reflections of material objects that in themselves are but illusive references to the absolute realm of ideas, Smithson created with his mirror displacements fictive illusions that break up and distort the world around them. They are not exactly like the works of art Plato had in mind because they are less lies than imprecise records, which juxtapose

earth and ashes with sky. They become pools of mirrored reflections in the ground and give a corroded, fleeting, and blurred view to the world they indiscriminately reflect. They are not representations and fictions of the external world, for they are incapable of intention; they are more dumb, imprecise reflections, suggesting the difficulty of pure seeing.

Just as mirrors act as rectangles of uncertainty in the Yucatan, the narrative becomes another image of uncertainty in *Artforum.* Presented in a periodical held to be an important mechanism for clarifying the meaning of modern art, Smithson's essay purposely obfuscates and distorts, as it uses the mechanism of writing to reflect the work of art in all its original complexity. Following Alain Robbe-Grillet, who in *For a New Novel* warned against mediating the world by anthropomorphizing it, Smithson does not conventionalize or humanize originality; in fact, he elaborates on the impossibility of ever grasping it in its entirety.

In "Incidents of Mirror-Travel" he creates an enantiomorph of the original mirror displacements when he writes an essay that reflects obliquely the original mirror

images. Just as the displacements confuse earth and sky and produce distorted images of entangled forests, so the narrative piece pulls together the mythic and the mundane into another distortion. By piling image on image and by finding parallels among the mirrors, distortions, visions, ancient gods, and concepts of time, he throws everything into doubt. Readers are both constrained by time and allowed glimpses of timelessness; they see both reflections and supposed reality. Finally the images and their possible mythic ramifications constitute a Tower of Babel; meanings proliferate until they cancel one another out and complexity reigns again. Entropy in terms of information theory is information overload; in "Incidents," with its dizzying inundation of interpretations, entropy is the final outcome.

"Incidents" is part of a dialectic in which art reflects itself, and traditional objects are dispensed with. The artist stresses the unimportance of the objects when he points out that the displacements were dismantled immediately after being photographed and the mirrors stored somewhere in New York. All that remains for the viewer is the problematic mirror of the essay. The essay and the displacements, then, can be regarded as opposing mirrors positioned in much the same way as those of *Enantiomorphic Chambers*—on each side of the void, oblique views of disembodied seeing. No longer holding the central point of view from which all lines of perspective converge on the horizon, the viewer is placed off to the edge, near the periphery of the process—in the void between the mirror displacements of the past and the reverse looking glass of the narrative.

The feeling of loss, displacement, and incomprehension which pervades the essay is confirmed in the name "Yucatan." Although Smithson refers to the first meeting of Mayans and Spaniards in 1517, he does not mention that the word "Yucatan" is a variation of Mayan for "I don't understand." When asked by the Spanish the name of the place, the Mayans responded that they didn't understand the question. Their response, misunderstood by the Spaniards, became the name for the land, and this mutual noncomprehension provides an underlying meaning of Smithson's mirror displacements that are reflections of incomprehensibility.

Several of Smithson's standard vocabulary of shapes and objects are presented in this narrative piece, particularly the road, the map, and the mirror. The road, Highway 261, appears at the beginning of the essay. The artist regards it as "closedness in openness." Cars may traverse it, but no person directly knows or understands it all. Mobility is accomplished, even though the passenger seems to remain still. The road appears less a thing and more an experience—a fundamental experience in

the twentieth century. One travels along a line in space, is drawn out by the road into space; yet the result is not an Earth art drawing in the manner of Michael Heizer or Walter de Maria. The source for the road and also a most important point of departure for Smithson's art is sculptor Tony Smith's well-known car ride along the New Jersey Turnpike.[46] Smith's sentence "the experience on the road was something mapped out but not socially recognized" bears repeating. It could be considered an epigram to much of Smithson's art since it pointed him in the direction of experiences not previously embraced by art. Roads are nonspaces, they are voids separating Smithson's Nonsites from their original Sites. Maps closely parallel roads in "Incidents"; Smithson suggests in the essay that the earth can even be regarded as a map of itself—things in his art are both statements and referents, both objects and signs. Roads, too, can be maps, but they are maps of themselves, flat asphalt tracings in the landscape that are both real and abstract at the same time.

Starting with *Mirror Wedge*, Montclair, New Jersey, continuing with his other mirror displacements, and culminating in the Yucatan piece, the artist situated square and rectangular mirrors in the landscape to displace reality. In all these displacements he created temporary landmarks that he preserved in 35mm slides. The camera captured reflections of mirages on film, thus forming a double mirror or image of timelessness which Smithson equated with the Levi-Strauss statement he chose as an epigraph for his "Incidents" essay.

Smithson abstracts the Platonic assessment of art in terms of mimetic fidelity. He stresses art's ability to mirror and emphasizes its abstract nature as reflector over any images it might happen to capture. His mirrors can be equated with consciousness, the images they reflect with the objects of consciousness. (And he always emphasizes the mirror itself over its fleeting images.) Accordingly, the mirrors in the Yucatan piece always contain some obfuscous information; they always clearly reflect—indiscriminately—whatever comes their way. In other words, mirrors reflect illusions even though they themselves are real. Perhaps the same can be said of art: art has the ability to deceive through reflections, but considered structurally it is an object of consciousness. Art can be a way of conceiving the universal, but it also can be a means of depicting the fictive, accidental, and uncategorical. Smithson, in "Incidents of Mirror-Travel in

[46] Samuel Wagstaff, Jr., "Talking with Tony Smith," *Artforum* 5, no. 4 (December 1966); reprinted in *Minimal Art: A Critical Anthology*, ed. Gregory Battcock (New York: E. P. Dutton, 1968), p. 386. Smithson quoted a passage of this conversation in "A Sedimentation of the Mind: Earth Projects." See extract of the conversation in my "Smithson's Unresolvable Dialectics," in this book.

the Yucatan,'' appears to see the uncatalogued, the terminal moraine of the mind, as a proper subject for art. His realm of ideas constitutes the irrational as well as the rational. One can say Smithson's version of the universal is a realm in which clarity of being is possible but where the ambiguities of man's perception of this being are dominant.

Among contemporary artists, Smithson was not the first to use mirrors although he was the first to create a series of displacements. Robert Morris made notable use of mirrors in his *Untitled*, constructed for his Green Gallery exhibition in 1965. Morris's mirrored cubes differ significantly, however, from Smithson's mirror displacements. While Smithson played on the mirror's capacity to reflect and hence to displace the world, Morris made his cubes out of mirror so that he could deemphasize the otherness often associated with sculpture, debunk the notion of the self-sufficient object, and emphasize the relational aspects of an art that both activates the space around it and is in turn affected by its surroundings. Morris's mirrored boxes are objects for phenomenological study; Smithson's mirrors, in contrast, turn inward.

An even more striking contrast can be found in Italian artist Michelangelo Pistoletto's use of mirrors. Pistoletto, known for his polished reflective surfaces with images of people photographed and painted on them, makes viewers the central focus of his work by combining their reflections with illusionistic figures. Unlike Pistoletto, Smithson does not ingratiate himself with his audience by turning them into art. His art is more complicated because it mirrors itself. In ''Incidents,'' the conjunction of no longer extant mirror displacements and verbal passages makes viewers only examiners of a residue that constantly points away from itself (and them) in the direction of the supposedly primary events.

In the essay ''Incidents,'' as in much of his art, Smithson aimed to create a timeless realm, an almost mythical world that transcends diurnal time/space coordinates. This terrain is suggested by his use of mirrors, cameras, and critical essays that create reflections that refute the here and now and send one scurrying off to some dizzying other world. It is confirmed by Smithson's actual trip to the Yucatan, which was a journey in both real and mythic time. He traveled first to Sanibel Island, Florida, where he created a three-dimensional earth map of the hypothetical continent of Lemuria before he continued on to the Yucatan site of his lost continent of Gondwanaland. This particular itinerary is invested with mythic overtones, since Sanibel Island, according to legend, once formed part of a land bridge to the Yucatan.

The myth that art is capable of reflecting reality is of central importance in Smithson's ''Incidents of Mirror-

Travel in the Yucatan.'' It is a myth that he affirmed and debunked. The work of art is a mirror of reality, but the realities it reflects are other mirrors, other myths.

INCIDENTS OF MIRROR-TRAVEL IN THE YUCATAN

ROBERT SMITHSON

Of the Mayan ideas on the forms of the earth we know little. The Aztec thought the crest of the earth was the top of a huge saurian monster, a kind of crocodile, which was the object of a certain cult. It is probable that Mayan had a similar belief, but it is not impossible that at the same time they considered the world to consist of seven compartments, perhaps stepped as four layers.
—J. Eric S. Thompson, *Maya Hieroglyphic Writing*

The characteristic feature of the savage mind is its timelessness: its object is to grasp the world as both a synchronic and a diachronic totality and the knowledge which it draws therefrom is like that afforded of a room by mirrors fixed on opposite walls, which reflect each other (as well as objects in the intervening space) although without being strictly parallel.
—Claude Levi-Strauss, *The Savage Mind*

Driving away from Merida down Highway 261 one becomes aware of the indifferent horizon. Quite apathetically it rests on the ground devouring everything that looks like something. One is always crossing the horizon, yet it always remains distant. In this line where sky meets earth, objects cease to exist. Since the car was at all times on some leftover horizon, one might say that the car was imprisoned in a line, a line that is in no way linear. The distance seemed to put restrictions on all forward movement, thus bringing the car to a countless series of standstills. How could one advance on the horizon, if it was already present under the wheels? A horizon is something else other than a horizon; it is closedness in openness, it is an enchanted region where down is up. Space can be approached, but time is far away. Time is devoid of objects when one displaces all destinations. The car kept going on the same horizon.

Looking down on the map (it was all there), a tangled network of horizon lines on paper called ''roads,'' some red, some black. Yucatan, Quintana Roo, Campeche, Tabasco, Chiapas and Guatemala congealed into a mass of gaps, points, and little blue threads (called rivers). The map legend contained signs in a neat row: archeological monuments (black), colonial monuments (black), historical site (black), bathing resort (blue), arts and

crafts (green), aquatic sports (blue), national park (green), service station (yellow). On the map of Mexico they were scattered like the droppings of some small animal.

The *Tourist Guide and Directory of Yucatan-Campeche* rested on the car seat. On its cover was a crude drawing depicting the Spaniards meeting the Mayans, in the background was the temple of Chichén Itzá. On the top left-hand corner was printed " 'UY UTAN A KIN PECH' (listen how they talk)—EXCLAIMED THE MAYANS ON HEARING THE SPANISH LANGUAGE," and in the bottom left-hand corner " 'YUCATAN CAMPECHE'—REPEATED THE SPANIARDS WHEN THEY HEARD THESE WORDS." A caption under all this said "Mayan and Spanish First Meeting 1517." In the "Official Guide" to Uxmal, Fig. 28 shows 27 little drawings of "Pottery Found at Uxmal." The shading on each pot consists of countless dots. Interest in such pots began to wane. The steady hiss of the air-conditioner in the rented Dodge Dart might have been the voice of Eecath—the god of thought and wind. Wayward thoughts blew around the car, wind blew over the scrub bushes outside. On the cover of Victor W. Von Hagen's paperback *World of the Maya* it said, "A history of the Mayas and their resplendent civilization that grew out of the jungles and wastelands of Central America." In the rear-view mirror appeared Tezcatlipoca—demiurge of the "smoking-mirror." "All those guide books are of no use," said Tezcatlipoca, "You must travel at random, like the first Mayans, you risk getting lost in the thickets, but that is the only way to make art."

Through the windshield the road stabbed the horizon, causing it to bleed a sunny incandescence. One couldn't help feeling that this was a ride on a knife covered with solar blood. As it cut into the horizon a disruption took place. The tranquil drive became a sacrifice of matter that led to a discontinuous state of being, a world of quiet delirium. Just sitting there brought one into the wound of a terrestrial victim. This peaceful war between the elements is ever present in Mexico—an echo, perhaps, of the Aztec and Mayan human sacrifices.

The First Mirror Displacement:

Somewhere between Uman and Muna is a charred site. The people in this region clear land by burning it out. On this field of ashes (called by the natives a "milpa") twelve mirrors were cantilevered into low mounds of red soil. Each mirror was twelve inches square, and supported from above and below by the scorched earth alone. The distribution of the squares followed the irregular contours on the ground, and they were placed in a random parallel direction. Bits of earth spilled onto the surfaces, thus sabotaging the perfect reflections of the sky. Dirt hung in the sultry sky. Bits of blazing cloud mixed with the ashy mass. The displacement was *in* the ground, not *on* it. Burnt tree stumps spread around the mirrors and vanished into the arid jungles.

The Second Mirror Displacement:

In a suburb of Uxmal, which is to say nowhere, the second displacement was deployed. What appeared to be a shallow quarry was dug into the ground to a depth of about four to five feet, exposing a bright red clay mixed with white limestone fragments. Near a small cliff the twelve mirrors were stuck into clods of earth. It was photographed from the top of the cliff. Again Tezcatlipoca spoke, "That camera is a portable tomb, you must remember that." On this same site, the Great Ice Cap of Gondwanaland was constructed according to a map outline on page 459 of Marshall Kay's and Edwin H. Colbert's *Stratigraphy and Life History*. It was an "earth-map" made of white limestone. A bit of the Carboniferous period is now installed near Uxmal. That great age of calcium carbonate seemed a fitting offering for a land so rich in limestone. Reconstructing a land mass that existed 350 to 305 million years ago on a terrain once controlled by sundry Mayan gods caused a collision in time that left one with a sense of the timeless.

Timelessness is found in the lapsed moments of perception, in the common pause that breaks apart into a sandstorm of pauses. The malady of wanting to "make" is *unmade,* and the malady of wanting to be "able" is disabled. Gondwanaland is a kind of memory, yet it is not a memory, it is but an incognito land mass that has been *unthought* about and turned into a Map of Impasse. You cannot visit Gondwanaland, but you can visit a "map" of it.

The Third Mirror Displacement:

The road went through butterfly swarms. Near Bolonchen de Rejon thousands of yellow, white and black swallowtail butterflies flew past the car in erratic, jerky flight patterns. Several smashed into the car radio aerial and were suspended on it because of the wind pressure. In the side of a heap of crushed limestone the twelve mirrors were cantilevered in the midst of large clusters of butterflies that had landed on the limestone. For brief moments flying butterflies were reflected; they seemed to fly through a sky of gravel. Shadows cast by the mirrors contrasted with those seconds of color. A scale in terms of "time" rather than "space" took place. The mirror itself is not subject to duration, because it is an on-going

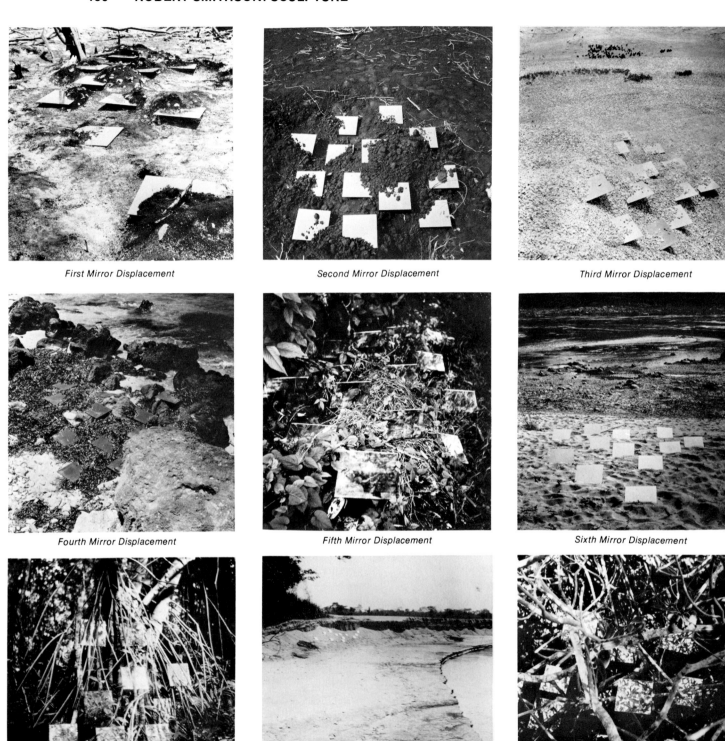

First Mirror Displacement

Second Mirror Displacement

Third Mirror Displacement

Fourth Mirror Displacement

Fifth Mirror Displacement

Sixth Mirror Displacement

Seventh Mirror Displacement

Eighth Mirror Displacement

Ninth Mirror Displacement

9 Mirror Displacements from "Incidents of Mirror-Travel in the Yucatan," 1969. Photographs by Robert Smithson, Courtesy Estate of Robert Smithson.

abstraction that is always available and timeless. The reflections, on the other hand, are fleeting instances that evade measure. Space is the remains, or corpse, of time, it has dimensions. "Objects" are "sham space," the excrement of thought and language. Once you start seeing objects in a positive or negative way you are on the road to derangement. Objects are phantoms of the mind, as false as angels. Itzpaplotl is the Mayan Obsidian Butterfly: ". . . a demonic goddess of unpredictable fate represented as beautiful but with death symbols on her face." (See *The Gods of Mexico* by C. A. Burland.) This relates to the "black obsidian mirror" used by Tezcatlipoca into which he gazed to see the future. "Unpredictable fate" seemed to guide the butterflies over the mirror displacements. This also brings to mind the concave mirrors of the Olmecs found at La Venta, Tabasco State, and researched by Robert Heizer, the archeologist. "The mirrors were masterpieces. Each had been so perfectly ground that when we rotated it the reflection we caught was never distorted in the least. Yet the hematite was so tough that we could not even scratch it with knives of hard Swedish steel. Such mirrors doubtless served equally well to adorn important personages or to kindle ritual fires." (*Gifts for the Jaguar God* by Philip Drucker and Robert F. Heizer, N.G.M., 9/56.) "The Jaguar in the mirror that smokes in the World of the Elements knows the work of Carl Andre," said Tezcatlipoca and Itzpaplotl at the same time in the same voice. "He knows the Future travels *backwards*," they continued. Then they both vanished into the pavement of Highway 261.

The Fourth Mirror Displacement:

South of Campeche, on the way to Champoton, mirrors were set on the beach of the Gulf of Mexico. Jade colored water splashed near the mirrors, which were supported by dry seaweed and eroded rocks, but the reflections abolished the supports, and now words abolish the reflections. The unnameable tonalities of blue that were once square tide pools of sky have vanished into the camera, and now rest in the cemetery of the printed page—*Ancora in Arcadia morte*. A sense of arrested breakdown prevails over the level mirror surfaces and the unlevel ground. "The true fiction eradicates the false reality," said the voiceless voice of Chalchihiuticue—the Surd of the Sea.

The mirror displacement cannot be expressed in rational dimensions. The distances between the twelve mirrors are shadowed disconnections, where measure is dropped and incomputable. Such mirror surfaces cannot be understood by reason. Who can divulge from what part of the sky the blue color came? Who can say how

long the color lasted? Must "blue" mean something? Why do the mirrors display a conspiracy of muteness concerning their very existence? When does a displacement become a misplacement? These are forbidding questions that place comprehension in a predicament. The questions the mirrors ask always fall short of the answers. Mirrors thrive on surds, and generate incapacity. Reflections fall onto the mirrors without logic, and in so doing invalidate every rational assertion. Inexpressible limits are on the other side of the incidents, and they will never be grasped.

The Fifth Mirror Displacement:

At Palenque the lush jungle begins. The palisade, Stone Houses, Fortified Houses, Capital of the People of the Snake or City of Snakes are the names this region has been called. Writing about mirrors brings one into a groundless jungle where words buzz incessantly instead of insects. Here in the heat of reason (nobody knows what that is), one tends to remember and think in lumps. What really makes one listless is ill-founded enthusiasm, say the zeal for "pure color." If colors can be pure and innocent, can they not also be impure and guilty?

In the jungle all light is paralyzed. Particles of color infected the molten reflections on the twelve mirrors, and in so doing, engendered mixtures of darkness and light. Color as an agent of matter filled the reflected illuminations with shadowy tones, pressing the light into dusty material opacity. Flames of light were imprisoned in a jumbled spectrum of greens. Refracting sparks of sunshine seemed smothered under the weight of clouded mixtures—yellow, green, blue, indigo and violet. The word "color" means at its origin to "cover" or "hide." Matter eats up light and "covers" it with a confusion of color. Luminous lines emanate from the edges of the mirrors, yet the surface reflections manifest nothing but shady greens. Deadly greens that devour light. Acrylic and Day-glo are nothing to these raw states of light and color. Real color is risky, not like the tame stuff that comes out of tubes. We all know that there could never be anything like a "color-pathos" or a pathology of color. How could "yellow is yellow" survive as a malarial tautology? Who in their right mind would ever come up with a concept of perceptual petit mal? Nobody could ever believe that certain shades of green are carriers of chromatic fever. The notion that light is suffering from a color-sickness is both repugnant and absurd. That color is worse than eternity is an affront to enlightened criticism. Everybody knows that "pathetic" colors don't exist. Yet, it is that very lack of "existence" that is so deep, profound and terrible. There is no chromatic scale down there because all colors are present spawning ag-

glutinations out of agglutinations. It is the incoherent mass that breeds color and kills light. The poised mirrors seemed to buckle slightly over the uncertain ground. Disjointed square streaks and smudges hovered close to incomprehensible shadows. Proportion was disconnected and in a condition of suspense. The double allure of the ground and the mirrors brought forth apparitions. Out of green reflections came the networks of Coatlicue, known to the Mayans as the Serpent Lady: Mother Earth. Twistings and windings were frozen in the mirrors. On the outskirts of the ruins of Palenque or in the skirts of Coatlicue, rocks were overturned; first the rock was photographed, then the pit that remained. "Under each rock is an orgy of scale," said Coatlicue, while flashing a green snake from a nearby "killer tree" (parasite vines that smother a tree, till they become the tree). Each pit contained miniature earthworks—tracks and traces of insects and other sundry small creatures. In some beetle dung, cobwebs, and nameless slime. In others cocoons, tiny ant nests and raw roots. If an artist could see the world through the eyes of a caterpillar he might be able to make some fascinating art. Each one of these secret dens was also the entrance to the abyss. Dungeons that dropped away from the eyes into a damp cosmos of fungus and mold—an exhibition of clammy solitude.

The Colloquy of Coatlicue and Chronos
"You don't have to have cows to be a cowboy."
—*Nudie*

Coatlicue: You have no future.
Chronos: And you have no past.
Coatlicue: That doesn't leave us much of a present.
Chronos: Maybe we are doomed to being merely some "light-years" with missing tenses.
Coatlicue: Or two inefficient memories.
Chronos: So this is Palenque.
Coatlicue: Yes; as soon as it was named it ceased to exist.
Chronos: Do you think those overturned rocks exist?
Coatlicue: They exist in the same way that undiscovered moons orbiting an unknown planet exist.
Chronos: How can we talk about what exists, when we hardly exist ourselves?
Coatlicue: You don't have to have existence to exist.

The Sixth Mirror Displacement:
From Ruinas Bonampak to Agua Azul in a single engine airplane with a broken window. Below, the jungle extinguished the ground, and spread the horizon into a smoldering periphery. This perimeter was subject to a double perception by which, on one hand, all escaped to the outside, and on the other, all collapsed inside; no

boundaries could hold this jungle together. A dual catastrophe engulfed one "like a point," yet the airplane continued as though nothing had happened. The eyes were circumscribed by a widening circle of vertiginous foliage, all dimensions at that edge were uprooted and flung outward into green blurs and blue haze. But one just continued smoking and laughing. The match boxes in Mexico are odd, they are "things in themselves." While one enjoys a cigarette, he can look at his yellow box of "Clasicos-De Lujo-La Central." The match company has thoughtfully put a reproduction of Venus De Milo on the front cover, and a changing array of "fine art" on the back cover, such as Pedro Brueghel's *The Blind Leading the Blind*. The sea of leaves below continued to exfoliate and infoliate; it thickened to a great degree. Out of the smoke of a Salem came the voice of Ometecuhtli—the Dual Being, but one could not hear what he had to say because the airplane engine roared too loudly. Down in the lagoons and swamps one could see *infinite, isotropic, three-dimensional* and *homogeneous space* sinking out of sight. Up and down the plane glided, over the inundating colors in the circular jungle. A fugitive seizure of "clear-air turbulence" tossed the plane about and caused mild nausea. The jungle grows only by means of its own negation—art does the same. Inexorably the circle tightened its coils as the plane gyrated over the landing strip. The immense horizon contracted its endless rings. Lower and lower into the vortex of Agua Azul, into the calm infernal center, and into the flaming spiral of Xiuhtecuhtli. Once on the ground another match was struck—the dugouts on the Rio Usumacinta were waiting.

The current of the river carried one swiftly along. Perception was stunned by small whirlpools suddenly bubbling up till they exhausted themselves into minor rapids. No isolated moment on the river, no fixed point, just flickering moments of tumid duration. Iguanas sunning themselves on the incessant shores. Hyperbole touched the bottom of the literal. An excess of green sunk any upward movement. Today, we are afflicted with an inversion of hyperbole—*gravity*. Rivers of Lead. Lakes of Asphalt. Heavy water. Generalized mud. The Caretaker of Dullness—habit—lurks everywhere. Tlazolteotl: Eater of Filth rules. Near a pile of rubble in the river, by what was once one of the Temples of Yaxchilan, the dugout stopped. On a high sandbank the mirrors were placed.

The Seventh Mirror Displacement:
Yaxchilan may not be wasted (or, as good as waste, doomed to wasting) but still building itself out of secrets and shadows. On a multifarious confusion of ruins are

frail huts made of sticks with thatched roofs. The world of the Maya and its cosmography has been deformed and beaten down by the pressure of years. The natives at Yaxchilan are weary because of that long yesterday, that unending calamitous day. They might even be disappointed by the grand nullity of their own past attainments. Shattered recesses with wild growths of creepers and weeds disclosed a broken geometry. Turning the pages of a book on Mayan temples, one is relieved of the futile and stupefying mazes of the tropical density. The load of actual, on-the-spot perception is drained away into banal appreciation. The ghostly photographic remains are sapped memories, a mock reality of decomposition. Pigs run around the tottering masses, and so do tourists. Horizons were submerged and suffocated in an asphyxiation of vanishing points. Archeologists had tried to transport a large stone stele out of the region by floating it on dugouts up the Usumacinta to Agua Azul, but they couldn't get it into an airplane, so they had to take it back to Yaxchilan. There it remains today, collecting moss—a monument to Sisyphus. Near this stele, the mirrors were balanced in a tentacled tree. A giant vegetable squid inverted in the ground. Sunrays filtered into the reflections. The displacement addressed itself to a teeming frontality that made the tree into a jumbled wall full of snarls and tangles. The mirror surfaces being disconnected from each other "destructuralized" any literal logic. Up and down parallels were dislocated into twelve centers of gravity.

A precarious balance existed somewhere between the tree and the dead leaves. The gravity lost itself in a web of possibilities; as one looked more and more possibilities emerged because nothing was certain. Nine of the twelve mirrors in the photograph are plainly visible, two have sunk into shadow. One on the lower right is all but eclipsed. The displacement is divided into five rows. On the site the rows would come and go as the light fell. Countless chromatic patches were wrecked on the mirrors, flakes of sunshine dispersed over the reflecting surfaces and obliterated the square edges, leaving indistinct pulverizations of color on an indeterminate grid. A mirror on the third row jammed between two branches flashed into dematerialization. Other mirrors escaped into visual extinguishment. Bits of reflected jungle retreated from one's perception. Each point of focus spilled into cavities of foliage. Glutinous light submerged vision under a wilderness of unassimilated seeing. Scraps of sight accumulated until the eyes were engulfed by scrambled reflections. What was seen reeled off into indecisive zones. The eyes seemed to look. Were they looking? Perhaps. Other eyes were looking. A Mexican gave the displacement a long, imploring gaze. Even

if you cannot look, others will look for you. Art brings sight to a halt, but that halt has a way of unravelling itself. All the reflections expired into the thickets of Yaxchilan. One must remember that writing on art replaces presence by absence by substituting the abstraction of language for the real thing. There was a friction between the mirrors and the tree, now there is a friction between language and memory. A memory of reflections becomes an absence of absences.

On this site the third upside-down tree was planted. The first is in Alfred, New York State, the second is in Captiva Island, Florida; lines drawn on a map will connect them. Are they totems of rootlessness that relate to one another? Do they mark a dizzy path from one doubtful point to another? Is this a mode of travel that does not in the least try to establish a coherent coming and going between the here and the there? Perhaps they are dislocated "North and South poles" marking peripheral places, polar regions of the mind fixed in mundane matter—poles that have slipped from the geographical moorings of the world's axis. Central points that evade being central. Are they dead roots that haplessly hang off inverted trunks in a vast "no man's land" that drifts toward vacancy? In the riddling zones, nothing is for sure. Nevertheless, flies are attracted to such riddles. Flies would come and go from all over to look at the upside-down trees, and peer at them with their compound eyes. What the fly sees is "something a little worse than a newspaper photograph as it would look to us under a magnifiying glass." (See *Animals Without Backbones*, Ralph Buchsbaum.) The "trees" are dedicated to the flies. Dragonflies, fruit flies, horseflies. They are all welcome to walk on the roots with their sticky, padded feet, in order to get a close look. *Why should flies be without art?*

The Eighth Mirror Displacement:

Against the current of the Usumacinta the dugout headed for the Island of Blue Waters. The island annihilates itself in the presence of the river, both in fact and mind. Small bits of sediment dropped away from the sand flats into the river. Small bits of perception dropped away from the edges of eyesight. Where is the island? The unknowable zero island. Were the mirrors mounted on something that was dropping, draining, eroding, trickling, spilling away? Sight turned away from its own looking. Particles of matter slowly crumbled down the slope that held the mirrors. Tinges, stains, tints, and tones crumbled into the eyes. The eyes became two wastebaskets filled with diverse colors, variegations, ashy hues, blotches and sunburned chromatics. To reconstruct what the eyes see in words, in an "ideal lan-

guage'' is a vain exploit. Why not reconstruct one's inability to see? Let us give passing shape to the unconsolidated views that surround a work of art, and develop a type of ''anti-vision'' or negative seeing. The river shored up clay, loess, and similar matter, that shored up the slope, that shored up the mirrors. The mind shored up thoughts and memories, that shored up points of view, that shored up the swaying glances of the eyes. Sight consisted of knotted reflections bouncing off and on the mirrors and the eyes. Every clear view slipped into its own abstract slump. All viewpoints choked and died on the tepidity of the tropical air. The eyes, being infected by all kinds of nameless tropisms, couldn't see straight. Vision sagged, caved in, and broke apart. Trying to look at the mirrors took the shape of a game of pool under water. All the clear ideas of what had been done melted into perceptual puddles, causing the brain to gurgle thoughts. Walking conditioned sight, and sight conditioned walking, till it seemed only the feet could see. Squinting helped somewhat, yet that didn't keep views from tumbling over each other. The oblique angles of the mirrors disclosed an altitude so remote that bits of ''place'' were cast into a white sky. How could that section of visibility be put together again? Perhaps the eyes should have been screwed up into a sharper focus. But no, the focus was at times cock-eyed, at times myopic, overexposed, or cracked. Oh, for the happy days of pure walls and pure floors! Flatness was nowhere to be found. Walls of collapsed mud, and floors of bleached detritus replaced the flatness of rooms. The eyes crawled over grains, chips, and other jungle obstructions. From the blind side reflections studded the shore—into an anti-vision. Outside this island are other islands of incommensurable dimension. For example, the Land of Mu, built on ''shaky ground'' by Ignatius Donnelly in his book *Atlantis, the Antediluvian World*, 1882, based on an imaginative translation of Mayan script by Diego de Landa.[1] The memory of what is not may be better than the amnesia of what is.

The Ninth Mirror Displacement:

Some ''enantiomorphic'' travel through Villahermosa, Frontera, Cd. del Carmen, past the Laguna de Terminos. Two asymmetrical trails that mirror each other could be called enantiomorphic after those two common enantiomorphs—the right and left hands. Eyes are enantiomorphs. Writing the reflection is supposed to match the physical reality, yet somehow the enantiomorphs don't quite fit together. The right hand is always at variance with the left. Villahermosa on the map is an irregular yellow shape with a star in it. Villahermosa on the earth is an irregular yellow shape with no star in it. Frontera and Cd. del Carmen are white circles with black rings around them. Frontera and Cd. del Carmen on the earth are white circles with no black rings around them. You say nobody was looking when they passed through those cities. You may be right, but then you may be wrong. You are caught in your own enantiomorph.

The double aspect of Quetzalcoatl is less a person than an operation of totemic perception. Quetzalcoatl becomes one half of an enantiomorph (*coatl* means twin) in search of the other half. A mirror looking for its reflection but never quite finding it. The morning star of *Quetzal* is apt to be polarized in the shadowy reflection of the evening star. The journeys of Quetzalcoatl are recorded in Sahagun's *Historia Universal de las Cosas de Nueva Espana*, parts of which are translated into English in *The Gods of Mexico* by C. A. Burland. In Sahagun's Book III, Chapter XIII, ''Which tells of the departure of Quetzalcoatl towards Tlapallan (the place of many colours) and of the things he performed on the way thither.'' Quetzalcoatl rested near a great tree (Quanhtitlan). Quetzalcoatl looked into his ''obsidian mirror'' and said ''Now I become aged.'' ''The name of that place has ever afterwards been Ucuetlatitlan (Beside the Tree of Old Age). Suddenly he seized stones from the path and threw them against the unlucky tree. For many years thereafter the stones remained encrusted in the ancient tree.'' By traveling with Quetzalcoatl one becomes

[1] This is just one of thousands of hypothetical arguments in favor of Atlantis. Conjectural maps that point to this non-existent site fill many unread atlases. It very well could be that the Maya writings that alluded to ''the Old Serpent covered with green feathers, who lies in the Ocean'' was Quetzalcoatl or the Sargasso Sea. Every wayward geographer of Atlantis has his own curious theory, they never seem to be alike. From Plato's *Timaeus* to *Codex Vaticanus A* the documents of the lost island proliferate. On a site in Loveladies, Long Beach Island, New Jersey a map of tons of clear broken glass will follow Mr. Scott-Elliot's map of Atlantis. Other *Maps of Broken Glass* (*Atlantis*) will follow, each with its own odd limits.

Outside in the open air the glass map under the cycles of the sun radiates brightness without electric technology. Light is separable from color and form. It is a shimmering collapse of decreated sharpness, poised on broken points showing the degrees of reflected incandescence. Color is the diminution of light. The cracked transparency of the glass heaps diffuses the daylight of the actual solar source—nothing is fused or connected. The light of exploding magma on the sun is cast on to Atlantis, and ends in a cold luminosity. The heat of the solar rays collides with the spheres of gases that enclose the Earth. Like the glass, the rays are shattered, broken bits of energy, no stronger than moonbeams. A luciferous incest of light particles flashes into a brittle mass. A stagnant blaze sinks into the glassy map of a non-existent island. The sheets of glass leaning against each other allow the sunny flickers to slide down into hidden fractures of splintered shadow. The map is a series of ''upheavals'' and ''collapses''—a strata of unstable fragments is arrested by the friction of stability.

aware of primordial time or final time—The Tree of Rocks. (A memo for a possible "earthwork"—balance slabs of rock in tree limbs.) But if one wishes to be ingenious enough to erase time one requires mirrors, not rocks. A strange thing, this branching mode of travel: one perceives in every past moment a parting of ways, a highway spreads into a bifurcating and trifurcating region of zigzags. Near Sabancuy the last displacement in the cycle was done. In mangrove (also called mangrave) branches and roots mirrors were suspended. There will be those who will say "that's getting close to nature." But what is meant by such "nature" is anything but natural. When the conscious artist perceives "nature" everywhere he starts detecting falsity in the apparent thickets, in the appearance of the real, and in the end he is skeptical about all notions of existence, objects, reality, etc. Art works out of the inexplicable. Contrary to affirmations of nature, art is inclined to semblances and masks, it flourishes on discrepancy. It sustains itself not on differentiation, but dedifferentiation, not on creation but decreation, not on nature but denaturalization, etc. Judgments and opinions in the area of art are doubtful murmurs in mental mud. Only appearances are fertile; they are gateways to the primordial. Every artist owes his existence to such mirages. The ponderous illusions of solidity, the non-existence of things, is what the artist takes for "materials." It is this absence of matter that weighs so heavy on him, causing him to invoke gravity. Actual delirium is devoid of insanity; if insanity existed it would break the spell of productive apathy. Artists are not motivated by a need to communicate; travel over the unfathomable is the only condition.

> Living beings dwell in their expectations rather than in their senses. If they are ever to see what they see, they must first in a manner stop living; they must suspend the will, as Schopenhauer put it; they must photograph the idea that is flying past, veiled in its very swiftness.
>
> —George Santayana, *Scepticism and Animal Faith*

If you visit the sites (a doubtful probability) you find nothing but memory-traces, for the mirror displacements were dismantled right after they were photographed. The mirrors are somewhere in New York. The reflected light has been erased. Remembrances are but numbers on a map, vacant memories constellating the intangible terrains in deleted vicinities. It is the dimension of absence that remains to be found. The expunged color that remains to be seen. The fictive voices of the totems have exhausted their arguments. Yucatan is elsewhere.

44. *Overturned Rock #1*, Uxmal, Yucatan, Mexico (site of *Second Mirror Displacement* of "Incidents of Mirror-Travel in the Yucatan"), 1969

The five *Overturned Rocks* were executed on the trip to Aqua Azuil and Yaxchilan (location of the *Seventh Mirror Displacement*), along the Usumacinta River that divides Guatemala from Mexico. Smithson discusses one of the five displaced rocks in "Incidents of Mirror-Travel in the Yucatan," and in the essay holds a conversation with the mythical Coatlicue, who is "known to the Mayans as the Serpent Lady: Mother Earth." If erected stones in the form of herms are often construed as phallic images, then the *Overturned Rocks*, Smithson seems to imply, are vaginal. *Overturned Rocks* are the opposite of monuments: if vertical monuments represent the masculine attitude, man's attempt at dominance over the earth, these unearthed stones are female evocations of Mother Earth, art by virtue of unveiling rather than of imposition.

As vaginal imagery, the *Rocks* elicit Smithson's dark verbiage. He describes what he finds under the rock: in the "pit" are "beetle dung, . . . nameless slime . . . raw roots"; "these secret dens" are also the "entrance to the abyss," "dungeons . . . a damp cosmos of fungus and mold—an exhibition of clammy solitude." His description suggests that the act of overturning rocks and peering beneath borders on pornography.[47]

The idea for *Overturned Rocks* preceded Smithson's trip to the Yucatan. As early as March 1969 he stated in Seth Siegelaub's *One Month* his intentions to upset stones and to photograph mirrors.

> My project may be one of two possible things, or both things.
> 1. *Overturned Rocks*. I will select a site or network of sites, I don't know where yet, and photograph what is under the rocks. Next I will trace the trail on a map, and show the points where I overturned the rocks.
> 2. *Mirror Trails*. I will select a trail and photograph a mirror on the trail at various indeterminate intervals. The trail will be traced on a map.

In *Overturned Rocks* the artist initiated an idea that became increasingly important to him in the early seventies. When he wrote of the tracks and traces of insects found underneath the rocks, he was dealing with a min-

[47] I am indebted to my editor, Carol Betsch, for this suggestion and for seeing the repugnance revealed in Smithson's language.

Overturned Rock #1 (first phase), Uxmal, Yucatan, Mexico, 1969. Photograph by Robert Smithson, Courtesy Estate of Robert Smithson.

Overturned Rock #1 (second phase), Uxmal, Yucatan, Mexico, 1969. Photograph by Robert Smithson, Courtesy Estate of Robert Smithson.

iature ecosystem teeming with life. Later when he attempted to make art out of humankind's monstrous inversions of this system, he turned to a deadened land raped by strip mining. In the sixties Smithson was content to dwell on existing twentieth-century ruins, to create chimerical pieces such as "Incidents of Mirror-Travel," to make Nonsites (nonmonuments) such as the displaced stones. But in the seventies he ceased focusing on an internal/external dialectic between gallery and location—art as object and environment as space—and turned his energies toward a unification he felt achievable in the landscape in terms of reclamation. Moving even further away from a concept of art as object to one of art as aesthetic attitude, his purpose in conceiving art projects in strip mines was to make these devastated areas available to artistic perception.

Termite Colony, shown at the Castellane Gallery, 1962. Photograph courtesy Estate of Robert Smithson.

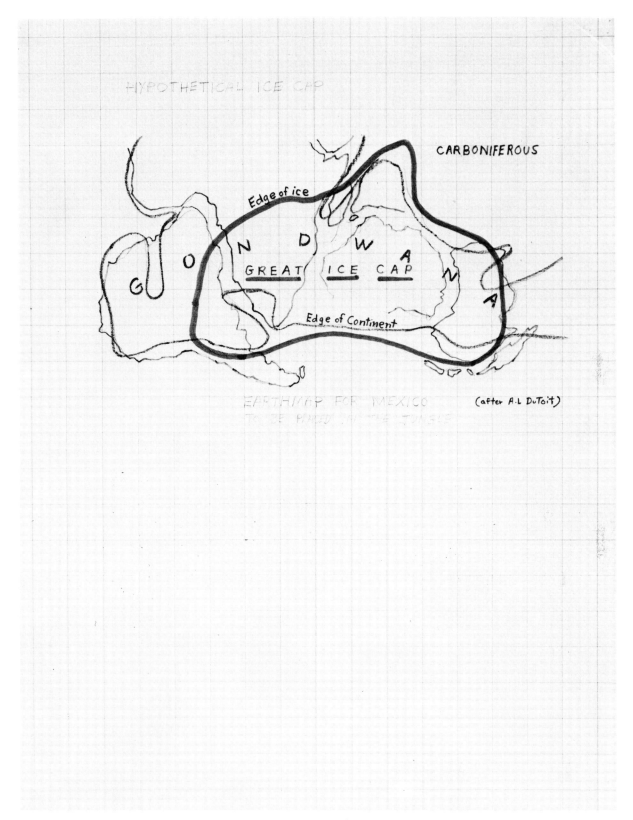

Earth Map for Mexico (*Gondwanaland*), 1969; pencil, crayon, ink; 22 x 17¼". Collection Estate of Robert Smithson, Courtesy John Weber Gallery. Photograph by Nathan Rabin.

Hypothetical Continent of Gondwanaland—Ice Cap, Yucatan, 1969. Photograph by Robert Smithson, Courtesy Estate of Robert Smithson.

45. *Third Upside-Down Tree*, Yaxchilan, Mexico (site of *Seventh Mirror Displacement* of "Incidents of Mirror-Travel in the Yucatan"), 1969

When he "planted" the *Upside-Down Trees*, Smithson created works of art that parody art historians' overriding concerns with sources and influences. The roots in these pieces are exposed; Smithson called the trees "totems of rootlessness." He "resurrects" dead trees, planting them anew so they might "grow downward," leaving their taproots exposed. Because they are dead, they nullify organic time as a way of recording change. Dendrography and carbon-14 dating are useless with such recent monuments as these. Like art, the *Upside-Down Trees* stand as testimonies of their sources, and the trunks become only partially visible reflections of their roots.

46. *Hotel Palenque*, Yucatan, Mexico 1969/72; slides and audiotape, lecture delivered to architecture students at University of Utah

Most tourists to Palenque are concerned with ruins of past civilizations; Smithson, however, was fascinated with the ruins of his own time. When he visited Palenque, he photographed the town's hotel and later used

Third Upside-Down Tree, Yaxchilan, Yucatan, Mexico, 1969. Photograph courtesy Dwan Gallery, Inc.

the slides in a lecture he gave to architecture students. Playing on his audience's expectations to see ruins of great buildings, Smithson presented ruins of an unimportant, run-down hotel that was being torn down in some places and newly built in others. The hotel was not razed at once, he informed the students, but instead it was destroyed slowly, with sensitivity. The lecture was conversational, its organization an extemporaneous exploration of the building, its tone ironic. At first, the students, who had expected a traditional slide lecture, were puz-

zled; they didn't laugh at any of Smithson's jokes. Only after Smithson had talked for twenty minutes did they laugh when they comprehended how he had undermined current architectural premises.

In the lecture Smithson extolled an architecture that defies functionalism. He was drawn particularly to the rooflessness of parts of the hotel and the consequent tropical green interiors, to an empty swimming pool with a suspension bridge over it, and to an inoperative dance floor with its own live Spanish moss.

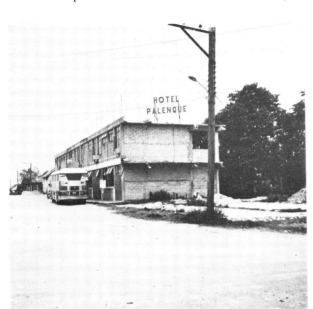

Photograph #1 from *Hotel Palenque,* slide lecture taped 1969. Photograph by Robert Smithson, Courtesy Estate of Robert Smithson.

Photograph #6 from *Hotel Palenque,* slide lecture taped 1969. Photograph by Robert Smithson, Courtesy Estate of Robert Smithson.

Photograph #27 from *Hotel Palenque,* slide lecture taped 1969. Photograph by Robert Smithson, Courtesy Estate of Robert Smithson.

Photograph #12 from *Hotel Palenque,* slide lecture taped 1969. Photograph by Robert Smithson, Courtesy Estate of Robert Smithson.

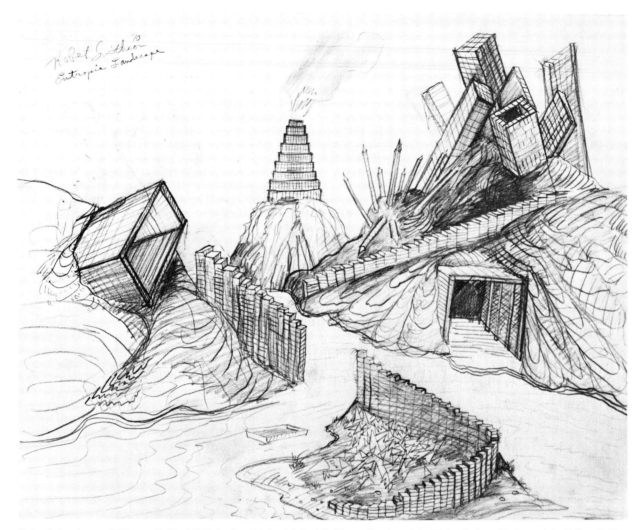

Entropic Landscape, 1970; pencil; 19 x 24". Collection Estate of Robert Smithson, Courtesy John Weber Gallery. Photograph by Nathan Rabin.

47. Nancy Holt and Robert Smithson, *East Coast, West Coast,* 1969; black-and-white videotape with sound; 20 minutes

East Coast, West Coast is an improvisational video-tape made by Smithson and Holt and their friends Joan Jonas and Peter Campus.[48] It was their first venture into the medium. According to Holt, they rented video equipment for the weekend and decided on the spur of the moment to act out stereotypical roles: Smithson plays the part of the "high," hedonistic California artist, and Holt takes the part of the tough New York artist/intellectual. For twenty minutes the two bombard each other, using current jargon, and in the process they reveal the inade-

quacies of both modes. The piece correlates with Smithson's interest in the confining nature of systems, their tendency to limit rather than explain, to disguise more than they reveal.

The same evening the tape was made, they invited friends for an immediate showing. Among the guests were Michael Heizer, Richard Serra, Keith Sonnier, and Jackie Winsor.

A synopsis of the work appears in the Castelli-Sonnabend film/videotape catalogue:

East Coast, West Coast uses the format of a TV talk show. Robert Smithson plays the part of a West Coast artist visiting the East and has a dialogue with Nancy Holt, playing a New York conceptual artist. The two capture the clichés and stereotypes of the divergent attitudes of the art scenes in both places—New Yorkers assuming that

[48] Joan Jonas appears briefly at the beginning of the tape and Peter Campus was the cameraman. Like Smithson and Holt, they were just beginning to work with video.

Nancy Holt and Robert Smithson, image from *East Coast, West Coast*, 1969. Photograph courtesy Castelli-Sonnabend Tapes and Films.

non–New Yorkers are provincial, and Westerners paranoid and defensive about these presumptions. Smithson is laid back and "cooled out," just "out there doing his thing," distrustful of words ("I just use simple words, have simple responses"), having come to art through chrome-plating cars and motorcycles. Anti-intellectual, he asks Holt, "Why don't you stop thinking and start feeling?" Holt, in the role of the over-rational, over-educated artist, criticizes him as a "mystical pragmatist" when he refuses to define his terms. "Definitions are for uptight types," he argues. His fads are all those of the sixties—getting a farm, eating organic food, wanting to go to India, living with the American Indians, meeting "beautiful people." When Holt tries to fit his statements into East Coast systems and critical philosophy, a tension develops between them as he becomes more hostile toward her. "Don't lay your trips on me—that's all your bad psyche." Holt accuses him of not entering a dialogue and of not coming to grips with the philosophy of his attitude: "You're just a closed system and you want to think you're open. . . . You're making a lot of philosophical presumptions." Smithson responds, "I don't need that. I'm

into my own head." Holt counters, "That head has limitations. I hate to tell you. . . . If your mind is so watery that any kind of intellectual resistance seems like a bad trip, I think you should be happy in L.A."[49]

48. *400 Seattle Horizons* (destroyed), September 5–October 5, 1969; Instamatic snapshots; each 3¾ × 3¾"

400 Seattle Horizons was intended as a temporary piece for Lucy R. Lippard's group exhibition "557,087" for the Contemporary Art Council of the Seattle Art Museum, located at the Seattle Art Museum Pavilion. Wanting to create a work that could be constructed by a curator, Smithson sent Lippard the following set of instructions:

[49] Lizzie Borden, *Castelli-Sonnabend Videotapes and Films* 1, no. 1 (November 1974): p. 70.

400 Seattle Horizons (destroyed), 1969. Photograph courtesy Estate of Robert Smithson.

400 square snapshots of Seattle Horizons—should be empty, plain, vacant, surd, common, ordinary blank dull level beaches, unoccupied uninhabited, deserted fields, scanty lots, houseless typical average roads, sand bars, remote lakes, distant timeless sites—use Kodak Instamatic 804. 8 Rows of 50 ganged on wall.

In accordance with his wishes, the snapshots were glued directly to the wall of the Seattle Art Museum Pavilion.

In *400 Seattle Horizons*, one view becomes equivalent to another; all are banal. Unlike some Earth artists, Smithson did not strive to create monuments; he was not a sculptor who was simply using earth as another material. His ideas depended on aspects of the present-day American landscape. In *Horizons* he chose typically twentieth-century views that are the antithesis of picture postcards and the sweeping nineteenth-century panoramas painted by American landscape artists.

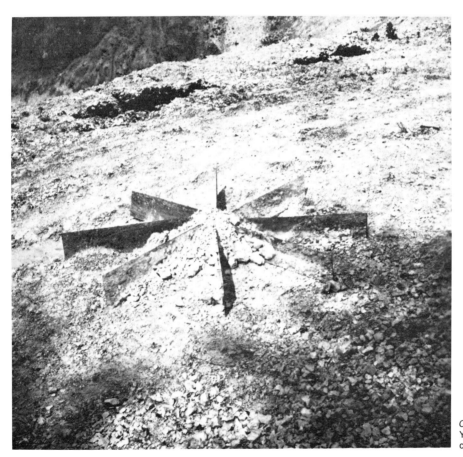

Chalk-Mirror Displacement, Oxted, York, England, 1969. Photograph courtesy John Weber Gallery.

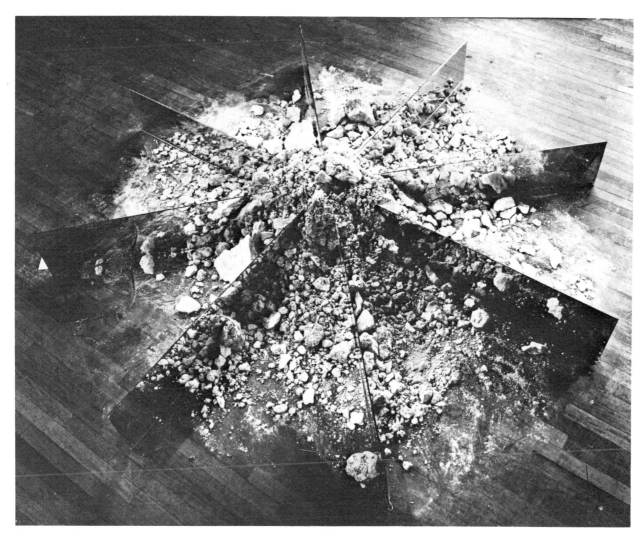

Chalk-Mirror Displacement, Institute of Contemporary Art, London, 1969. Photograph by Robert Smithson, Courtesy Estate of Robert Smithson.

49. *Chalk-Mirror Displacement* (destroyed), September 28–October 27, 1969; mirrors, chalk; 16 mirrors, each 10″ × 5′ (overall 10′)

Chalk-Mirror Displacement was duplicated so that it would appear concurrently at a chalk quarry in Oxted, York, England and also in the gallery of the Institute of Contemporary Art, London, in the exhibition "When Attitudes Become Form."

Two drawings for this piece detail its structure. One sketch, which Smithson rejected, presents two of his preliminary ideas. On one section of the drawing he specifies making a piece 18 feet long and 8 feet wide. On the same sheet of paper he indicates the use of 20 mirrors (10 inches by 5 feet each) placed back to back to make 10 radiating spokes. The drawing labeled "Chalk-Mirror Displacement, made in I.C.A., London 1969" records the finished piece. It comprised 16 mirrors (10 inches by 5 feet each) joined back to back to form a circle with 8 diameter lines, around which was piled chalk in lumps and powder form. According to the drawing, not all the diameter lines were set equidistant from one another. Four were crisscrossed at right angles while the remaining four were set slightly off-center to divide the sections into 50- and 40-degree angles, respectively.

Composed of a circle, a reflective surface, and clumps of white material, *Chalk-Mirror Displacement* uses the same basic vocabulary of shapes that Smithson employed in some of his major Earthworks, particularly *Spiral Jetty* and *Broken Circle*. In both of these pieces, however, the mirrors are replaced with water.

Mirror Displacement, site unknown, England, 1969. Photograph by Robert Smithson, Courtesy Estate of Robert Smithson.

Mirror Displacement, site unknown, England, September 1969. Photograph by Robert Smithson, Courtesy Estate of Robert Smithson.

Robert Smithson in front of a dolmen, England, 1969. Photograph by Nancy Holt.

50. *Mirror Displacement, Portland Island,*
 September 1969; 8 mirrors; dimensions
 unknown

Mirror Displacement, Portland Island is one of a number of mirror pieces Smithson set up while traveling through southern England and Wales after his show at the Institute of Contemporary Art in London. After he created his series of mirror displacements documenting his visits to mines and quarries in England, Nancy Holt has related, Smithson discounted their importance even

though he continued making displacements when he traveled to Europe. Probably the best way to consider the English and Welsh mirror displacements is as isolated sketches for projects the artist was then investigating.

Smithson was fascinated by the ancient dolmens and tarns in England. He and Holt visited Devonshire where they walked to little-known sites; they also traveled to Stonehenge, Weir's Wood, and Tintern Abbey. Smithson was as taken by ancient and medieval ruins as he was by depressed coal-mining districts and industrial sites.

Dead Tree, Düsseldorf (destroyed), 1969. Photograph courtesy Estate of Robert Smithson.

51. *Nonsite—Essen Soil and Mirrors*, October 1969; 12 mirrors; each 3 × 3′

After leaving England in the early fall of 1969 and before going to Rome in October of the same year, Smithson visited Düsseldorf where he was in a group exhibition at the Städtische Kunsthalle. There he exhibited a horizontally placed dead tree which culminated the series of *Upside-Down Trees* planted the same year in New York State, Florida, and the Yucatan. The deliberately absurd *Dead Tree* possibly signaled the death of the organic as well as the removal of art from a basic anthropocentric focus. With its roots and limbs that appeared to mirror each other, it also served as a no longer living enantiomorph and was joined in the show by

Nonsites composed of mirrors "planted" in red Essen soil.

Lined back to back in a long pile of loosely arranged dirt, one Nonsite was a variation on the theme of displacement (both through mirroring and through literally moving the soil). The theme of displacement had occupied the artist in such works as the *Eight-Part Piece* (making up the *Cayuga Salt Mine Project*) and *Mirror Slant in Orange Soil* (created for the London "When Attitudes Become Form" show). The idea explored in Düsseldorf was taken up again early the next year in Vancouver in *Glass Strata with Mulch and Soil.*

While in Düsseldorf, Smithson also continued his outdoor mirror displacements, such as the *Mirror Displacement, Compost Heap* constructed during October 1969.

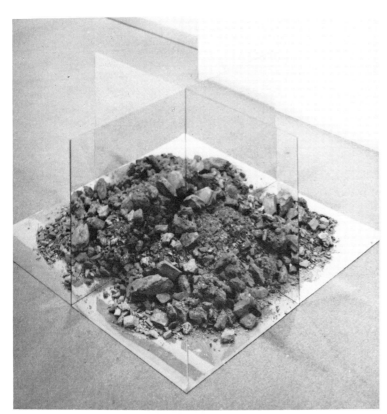

Nonsite—Essen Soil and Mirrors, 1969. Collection unknown. Photograph by Manfred Tischer, Courtesy Estate of Robert Smithson.

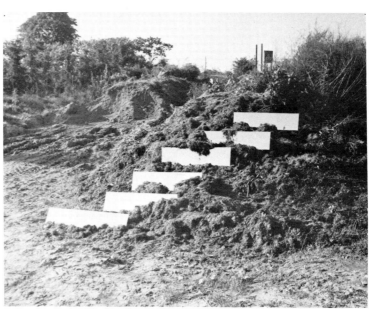

Mirror Displacement on a Compost Heap, Düsseldorf, 1969. Photograph courtesy Estate of Robert Smithson.

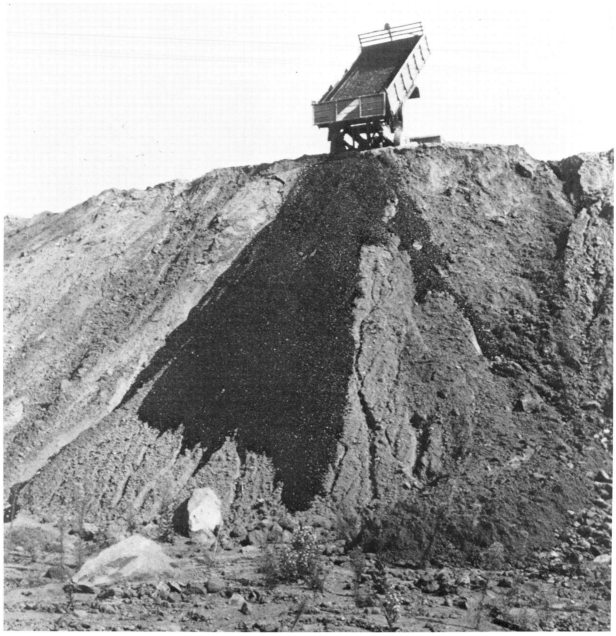

Asphalt Rundown, Rome, Italy, 1969. Photograph by Robert Smithson, Courtesy Estate of Robert Smithson.

52. *Asphalt Rundown*, Rome, Italy, October
 1969

A dump truck released a load of asphalt to flow down an eroded hillside in an abandoned section of a gravel and dirt quarry in Rome. The black viscous material merged with the hillside; along its edge it traced a few of the washed-out gullies, thus freezing erosion. The asphalt was molded by the earth, the *Rundown* became a casting of erosion, and the entire piece a grand tribute to entropy. The deeply lined gullies of the site already manifested a kind of "fluvial entropy" before Smithson en-

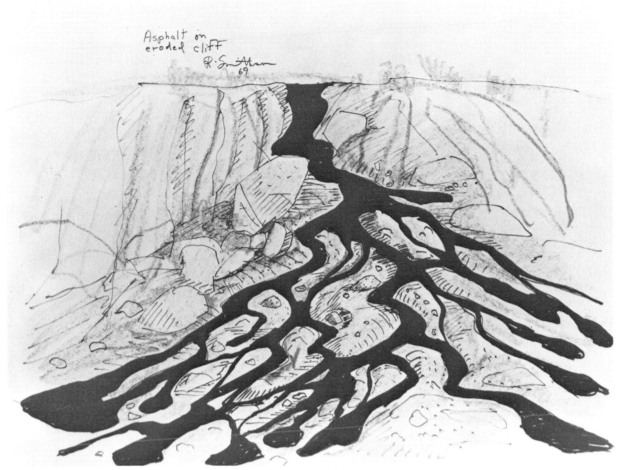

Asphalt on Eroded Cliff, 1969; pencil and ink. Collection Estate of Robert Smithson, Courtesy John Weber Gallery. Photograph courtesy John Weber Gallery.

acted the *Rundown*; now it was reinforced by the asphalt, an overlay of industrial sludge.

Asphalt has special connotations in Smithson's art. To emphasize its importance he made *Asphalt Lump* (shown in Düsseldorf)—which is simply a fragment of the material. A dark, almost black bituminous substance, asphalt is found in natural beds; it is also obtained as a residue in petroleum or coal-tar refining. In early geologic ages, it served as a trap for animals. At the Museum of Natural History in New York—which Smithson frequented since childhood—a display known as the Asphalt Group is located in the Hall of Late Mammals. Trapped and buried in the asphalt of the Tar Pits of Rancho-La-Brea, Los Angeles, California, these now extinct

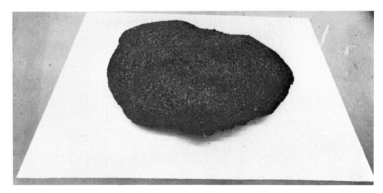

Asphalt Lump, Oberhausen, West Germany, 1969; asphalt; 31 x 39″. Collection F. Klingbeil. Photograph courtesy Konrad Fischer Gallery.

Jackson Pollock, *Number 27*, 1950; oil on canvas; 49 x 106″. Collection Whitney Museum of American Art, New York. Purchase. Photograph by Geoffrey Clements, Courtesy Whitney Museum of American Art.

mammals in the display have been disinterred but remain embedded in asphalt. In *Rundown* Smithson plays on the idea of asphalt as a trap for energy: he makes a tacit suggestion that asphalt highways are the "entropic" tar pits of the present.

The free-flowing movement of this piece has an antecedent in the art of Jackson Pollock. Long an admirer of Pollock's work, Smithson with *Asphalt Rundown* takes the drip beyond the canvas and monumentalizes it in a slow ooze. The large scale of American art, often discussed in reference to Pollock's canvases, is realized in this outdoor "action painting." Directing the action into asphalt, Smithson seems to be commenting on the act of action painting itself: *Asphalt Rundown* literalizes the fact that the resultant work of art is not a tribute to the act, it is an incidence of entropy.

The *Rundown* in Rome was Smithson's first "flow."

In 1969, a particularly fecund year, he considered making a number of flows in mud, muck, and cement. Early in 1970 he made *Glue Pour* in Vancouver, and later that same year he created a series of detailed drawings for *Texas Overflow*.

While *Asphalt Rundown* could have been carried out on any eroded hillside without changing the piece—that is, this hillside has a look of no place special—it gains an additional significance by being sited in Rome, the Eternal City. Two years before the creation of this work the artist wrote "A Tour of the Monuments of Passaic, New Jersey," in which he attempted to define the American version of the Eternal City as a suburb and its commercial strip. He viewed Passaic as a mundane, even boring, image of present-day eternity. "Has Passaic replaced Rome as the Eternal City?" he asks in his essay; *Asphalt Rundown* appears to be his answer.

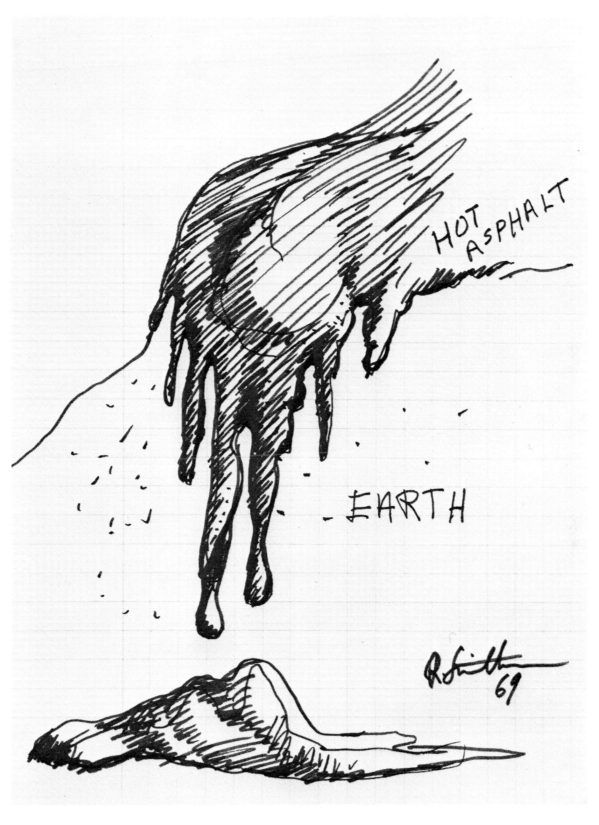

Hot Asphalt—Earth, 1969; black ink on graph paper; 8⅝ x 6⅝". Collection Tony Shafrazi. Photograph by Nathan Rabin.

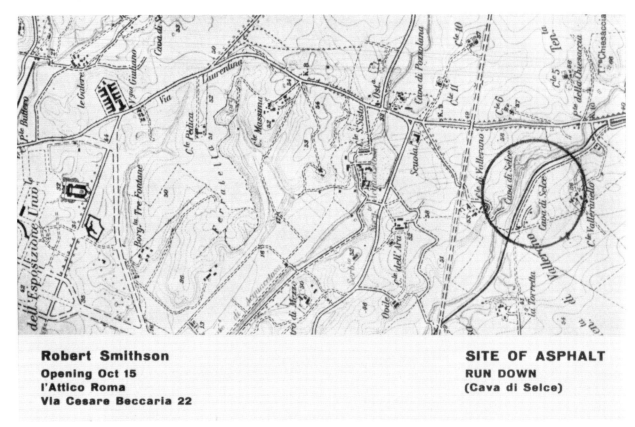

Robert Smithson
Opening Oct 15
l'Attico Roma
Via Cesare Beccaria 22

SITE OF ASPHALT
RUN DOWN
(Cava di Selce)

Site of Asphalt Rundown, commissioned by L'Attico Gallery, Rome, 1969. Photograph courtesy John Weber Gallery.

53. *Mud and Mirrors,* Rome, October 1969

During the time Smithson was creating *Asphalt Rundown,* he had an exhibition in Fabio Sargentini's L'Attico Gallery, Rome. None of the pieces for this exhibition are extant, but a group of drawings provides clues to the ideas Smithson was working with at the time.

Mud, vines, and brambles were combined with mirrors to make some of the works. One drawing, entitled *Mud Flow with Mirrors,* drawn in Rome, calls for twenty mirrors, each 12 inches by 4 feet, placed in a line back to back with mud flowing over them. Another drawing indicates that mirrors were inserted into entangled vines and brambles. A third calls for four mirrors lashed by ropes to a pillar, with bits of sticks and vines placed between the mirrors; the entire ensemble was to be no higher than 3 to 5 feet from the ceiling. As a pendant to this indoor piece, the artist contemplated lashing mirrors to a living tree outdoors.

The last two works which use entangled, organic elements, relate to *Dead Tree,* created for the exhibition at Städtische Kunsthalle, Düsseldorf, which opened just prior to the L'Attico exhibition. Through *Dead Tree* they connect to both the series of Yucatan mirror displacements of spring 1969 and the *Upside-Down Trees* of the same year.

54. *Concrete Pour*, Chicago, November 1969

Concrete Pour was Smithson's contribution to the "Art by Telephone" exhibition of the Chicago Museum of Contemporary Art. All works of art for the exhibition originated, as its title suggests, in the form of ideas communicated by telephone. Preciousness in the form of lovingly hand-crafted objects was to be avoided. (A precedent for the exhibition can be found in Laszlo Moholy-Nagy's "telephone pictures" of 1922.) Taking the place

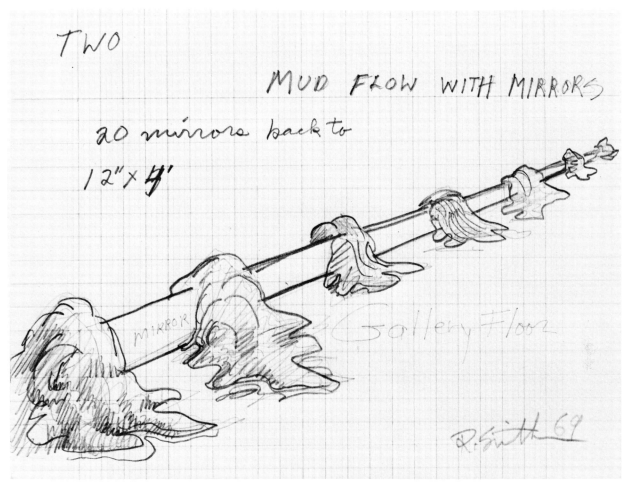

Mud Flow with Mirrors, 1969; pencil; 6¾ x 8¾". Collection Estate of Robert Smithson, Courtesy John Weber Gallery. Photograph by Nathan Rabin.

of craft were industrial and technological projects carried out from verbal directives.

At first Smithson thought to create a live piece. On September 3, 1969, he wrote to Jan van der Marck of the Museum of Contemporary Art: ''Since most people answer the telephone by saying 'hello,' I should like to build a work around that word. Find a bunch of parrots that say 'hello,' put them in a 6 foot square bird cage (use chicken wire and raw wood). Title the work *Hello*.'' In a footnote to the letter he mentioned that the birds could say other things besides ''hello.''

Following the trajectory of ideas he had for gravitational flows and pours, Smithson rethought his submission and directed the museum to find a suitable spot for pouring concrete from a Ready Mixer. When he con-

ceived the work, the artist wished to have concrete poured into Lake Michigan to make a bulwark. The museum staff searched in vain for wealthy patrons who owned property on the north shore of the lake and who were willing to have the work executed on their land. At Smithson's suggestion, they looked for a steep embankment and finally found a location: a ravine where trucks came at the end of each day to discard unused concrete.

Smithson—in keeping with the spirit of the exhibition—did not come to the actual pouring and never saw the piece. A local filmmaker, Jerry Aronson, did, however, shoot a segment of the pour at fast speed so that the developed film could be shown in slow motion.

Ironically, *Concrete Pour* soon merged with the dump and became no longer distinguishable as art.

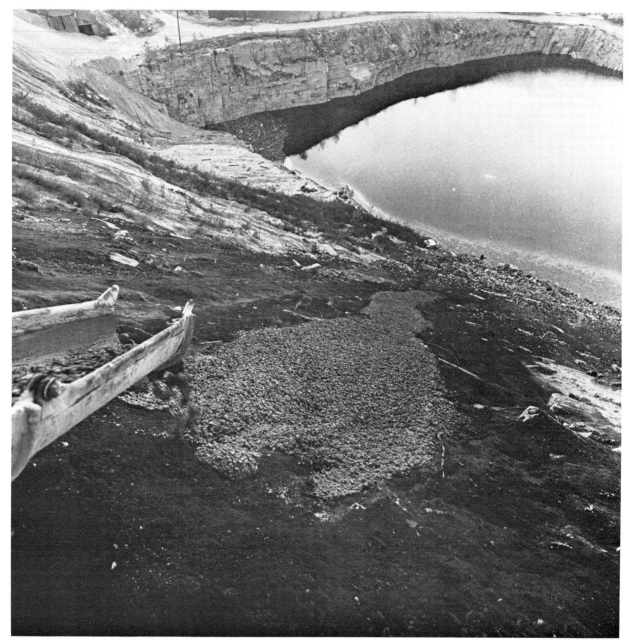

Concrete Pour, Chicago, November 1969. Courtsey Museum of Contemporary Art, Chicago. Photograph courtesy Dwan Gallery, Inc.

55. *Circular Plateau* (never built), 1969

Smithson proposed *Circular Plateau* for the Gemeentemuseum, The Hague. Like *Concrete Pour*, the piece was to be created of concrete: fifteen truckloads of it and over thirty loads of raw earth. Time would also play a part here (as it did in the Chicago *Pour* and the Rome *Rundown*). Smithson intended that "earth will erode from edge leaving concrete spill over."

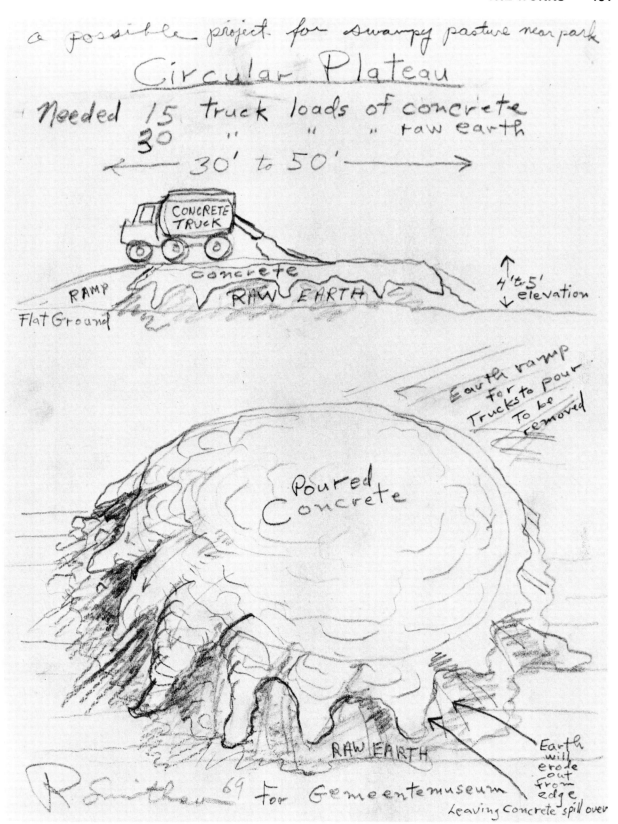

a possible project for swampy pasture near park

Circular Plateau

Needed 15 truck loads of concrete
30 " " " raw earth

← 30' to 50' →

CONCRETE TRUCK

Concrete

RAMP

RAW EARTH

Flat Ground

4' to 5' elevation

Earth ramp for Trucks to pour To be removed

Poured Concrete

RAW EARTH

R Smithson 69 for Gemeentemuseum

Earth will erode out from edge

Leaving concrete spill over

Circular Plateau, 1969; pencil; 11 x 8½″. Collection Estate of Robert Smithson, Courtesy John Weber Gallery. Photograph by Nathan Rabin.

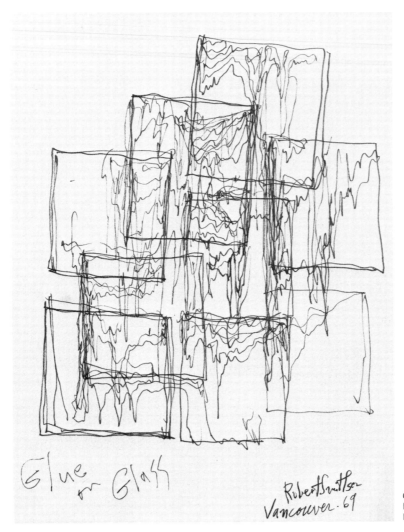

Glue on Glass, 1969; ink; 10 x 8″. Collection Bruce and Barbara Berger. Photograph by Nathan Rabin.

56. *Glue Pour,* Vancouver (destroyed), first planned December 1969, exhibition held January 14–February 8, 1970

Glue Pour was created for "955,000," an exhibition organized by Lucy R. Lippard for the Vancouver Art Gallery. This exhibition was the Vancouver version of "557,087" that Lippard had created for the Seattle Art Museum; the titles refer to the respective populations of the two towns.

There is a drawing for the work which gives the following specifications: "1 to 3 tons of glue. Line up 4 containers next to each other. 500 lb contains 2000 pt. Slight slope." When the *Pour* was enacted, bright orange glue was poured down an eroded dirt slope. Ironically, the glue turned out to be water soluble, and the *Pour* was erased by a few rainfalls.

Apparently Smithson decided on *Glue Pour* only shortly before the exhibition, for the information given in the catalogue does not make reference to the piece and instead designates the alternatives of fifty truckloads of mud, ten of cement, or ten of asphalt. In a drawing included as part of the catalogue card is a truck unloading some dark viscous material, and underneath it the artist's official delegation of choice to the curator whom he instructs to "use one of the above materials."

The pouring, dripping, and staining of paints of varying viscosity has a long and important history in the development of New York art. In his numerous pours and flows of 1969 and 1970, Smithson plays on this New York tradition of emphasizing the inherent properties of the medium, characteristically reinvigorating an outworn convention by broadening its scope, changing its context, and taking it outdoors. Dripping and pouring, decorative contrivances in the late sixties, become in Smith-

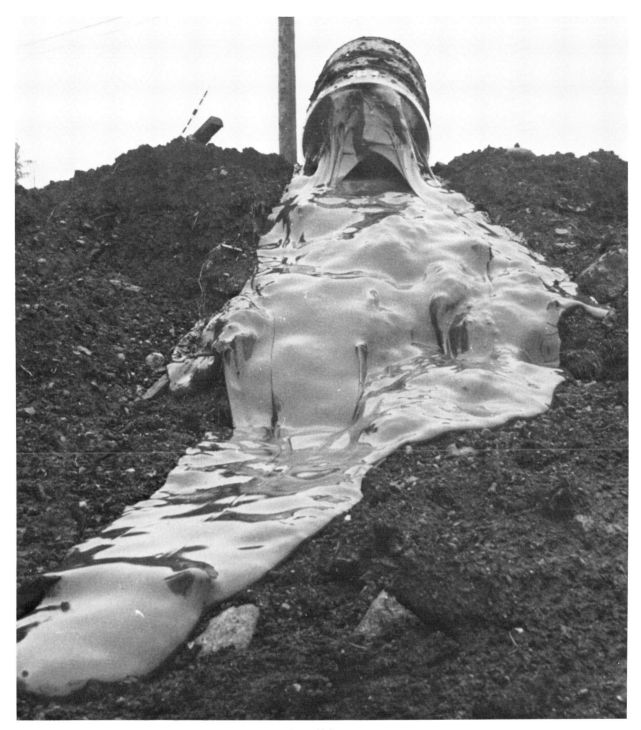

Glue Pour, Vancouver, British Columbia, 1969. Photograph by Nancy Holt.

son's art images of erosion and in his writings symbols for sluggish thinking. For the various pours and flows he used mud, muck, asphalt, concrete, and glue—all highly viscid materials that ooze slowly, almost lugubriously, and resist the easy trickles and soft spongy stains that typify so much New York painting of the sixties. Usually the sites chosen for the flows and pours are eroded hillsides. Sometimes as in *Asphalt Rundown,* Rome, they are abandoned quarries, which are altered until they become the metaphorical tar pits of the industrial age.

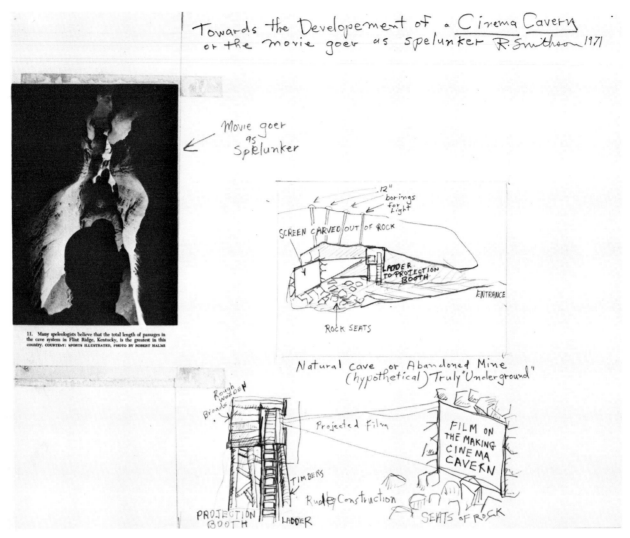

Towards the Development of a "Cinema Cavern," 1971; pencil, photograph, tape; 12⅝ x 15⅝". Collection Estate of Robert Smithson, Courtesy John Weber Gallery. Photograph by Nathan Rabin.

57. *Britannia Beach*, late 1969/70; plans for a film

In December 1969, soon after Smithson arrived in Vancouver to oversee his *Island of Broken Glass Project* and, coincidentally, for Lucy Lippard's "955,000" exhibition, he and Holt traveled north to the Britannia Copper Mines which were scheduled to close within the month. They went down for a day and explored large portions of the caverns. Holt has recalled that the mines were especially Dante-esque, like some great infernal underground.

The caverns generated a number of Smithsonian ideas for artworks. In one section of the mines, there was a long drop from one level to another; Smithson contem-

plated using this cliff for a flow (there is a drawing for the work called *Cavern of Muck*). Another possibility was *Rock Drop* in which a boulder was to be pushed into a dark abyss.

Fascinated by the idea of movie theaters as void dark places where one experiences illusions, Smithson thought of making a real underground film. Britannia Beach was one of a series of mines in different locations that the artist considered for underground cinemas. In "A Cinematic Atopia" (1971) he outlines plans for an underground theater:

What I would like to do is build a cinema in a cave or an abandoned mine, and film the process of its construction. That film would be the only film shown in the cave. The

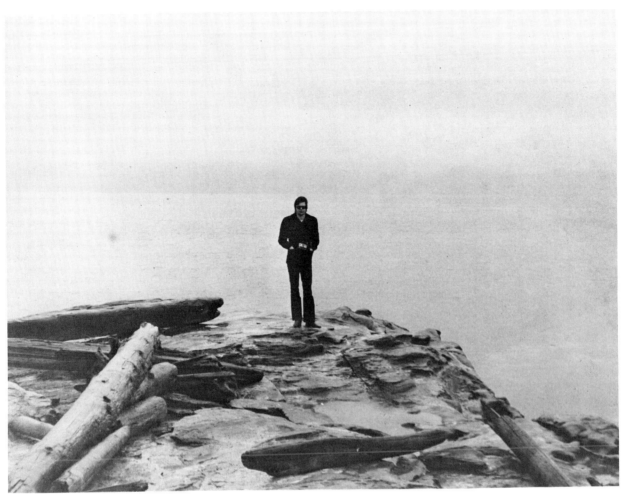

Robert Smithson on Miami Islet, January/February 1970. Photograph courtesy Estate of Robert Smithson.

projection booth would be made out of crude timbers, the screen carved out of a rock wall and painted white, the seats could be boulders. It would be a truly "underground" cinema. This would mean visiting many caves and mines. Once when I was in Vancouver, I visited Britannia Copper Mines with a cameraman intending to make a film, but the project dissolved. The tunnels in the mine were grim and wet. I remember a horizontal tunnel that bored into the side of a mountain. When one was at the end of the tunnel inside the mine, and looked back at the entrance, only a pinpoint of light was visible. One shot I had in mind was to move slowly from the interior of the tunnel towards the entrance and end outside. In the Cayuga Rock Salt Mine under Lake Cayuga in New York State I did manage to get some still shots of mirrors stuck in salt piles, but no film. Yet another ill-fated project involved the American Cement Mines in California—I wanted to film the demolition of a disused cavern. Nothing was done.[50]

[50] "A Cinematic Atopia," in *Writings*, p. 108.

In these underground theaters viewers would vicariously experience the construction of the places in which they actually would be seated. The nonspace of a movie house would be transformed into theater or film space, causing viewers to reassess conventions which dictate that they sit in darkened rooms facing a projected scene.

58. *Vancouver Project: Island of Broken Glass* (later *Island of Broken Concrete*), Miami Islet (never built), January/February 1970

In a footnote to "Incidents of Mirror-Travel in the Yucatan" Smithson predicted that "other *Maps of Broken Glass (Atlantis)* will follow, each with its own odd limits." The first *Broken Glass* map was built at Loveladies, New Jersey. A later development of the Atlantean aspect of the lost continent series was the proposed *Island of*

Broken Glass, Miami Islet, in the waters of the Georgia Strait near Nanaimo.

At the time Smithson intended to build *Island of Broken Glass,* ecological concerns became newsworthy. Two Vancouver newspapers devoted space to his proposal, each taking the opposite editorial stance. The island was only a large barren rock but around it raged a considerable controversy, similar to the battles that were fought by Christo in the mid-seventies when he was building *Running Fence.*

Douglas Christmas, owner of the Ace Gallery in Vancouver and in Venice, California, who was a supporter of the project, discussed the controversy of *Island of Broken Glass* with the author.[51] One hundred tons of green-tinted industrial glass bought in Stockton, California, were to be dumped on the island on February 2. Plans called for a crane to place the glass on the pumice rock that was about one hundred yards long at low tide and half that size at high tide. Then the artist, wearing special logger's boots, would break the glass with a crowbar into pieces ranging from jagged spikes to fine bits. The resulting glass mound would shimmer like emeralds on the dull rock. In a few months the sharper edges of glass would be smoothed down, and in a few centuries the entire glass heap would become sand.

"There was enough glass in the order," Christmas emphasized, "to fill two gondola railway cars." The shipment reached the Canadian border where it was stopped by representatives of the Society for Pollution and Environmental Control who were anxious to keep the glass from entering Canada. Although all necessary legal work for the project had been prepared and Roy Williston, minister of lands and forests, had endorsed the project, as a result of the public outcry the government decided to reverse its decision and prevent the creation of the piece.

The controversy hinged on whether or not this solitary, treeless crag supported wildlife. Conservationists claimed that the island was a nesting ground for cormorants, a refuge for seagulls, and possibly a rest stop for sea lions. Smithson stated that he could find no indication that the islet supported wildlife. Although the two sides held radically differing opinions, both were probably at least partially right in their claims. One Vancouver reporter at the time investigated the rock and decided that while there were some bird droppings, there was no indication that wildlife used the island except infrequently. Ecology, however, had become a topical issue in the late sixties, and consciousness about it was high. The government ruled in favor of the conservationists (many of whom had threatened to sleep on the island to prevent the unloading of the "American beer bottles") and left Smithson in the impossible situation of having to prove beyond question that wildlife would not be hurt by the strata of glass.

Since 1967, when he wrote "The Monuments of Passaic," Smithson had been fascinated with the idea of planned obsolescence—progress in reverse, cities rising to ruin—and he had hoped to symbolize with *Island of Broken Glass* this creation of ultimate ruins. But when he reconsidered the work in light of the ecological issues it raised, Smithson decided that the island of glass might not be such a good idea. He carefully examined his premises and goal and decided that he could create *Island of Broken Concrete* (also called *Island of Dismantled Building*) which would be less threatening but no less viable as a symbol of created obsolescence. Smithson always thought in terms of several possibilities and materials, each with a different symbolic potentiality, and at the time had made drawings for islands of slate and boulders. He could, therefore, easily change *Island of Broken Glass* to *Island of Broken Concrete* without feeling compromised.

Many people, it seems, have regarded the constant pollution of waterways by industrial and human waste and the ravaging of undeveloped areas by strip mining as necessary evils of a populous and highly technologized world. But these same people could not understand why someone would willingly, with no objective of monetary gain, create a ruin. When the *Island* became the subject of a hot debate among concerned environmentalists and art lovers, Smithson may have felt that his statement concerning planned obsolescence had already been made and that he didn't have to pursue the project any further.

When he could not build *Island of Broken Concrete* because of public animosity toward his work, Smithson began to consider the idea of "gratuitous barging," of mobile or action art: why not just tow a barge of broken concrete or broken glass around the Vancouver island? The final work would be more a process than a finished object and the work could be documented with photographs. In the Vancouver barge projects, then, we can see the roots of Smithson's later ideas for *Barge of Sulphur (Panama Canal)* of 1970 and *Juggernaut,* his proposal for the 1971 Boston exhibition "Elements of Art: Earth, Air, Fire, Water."

[51] Telephone conversation between Hobbs and Douglas Christmas, February 1980.

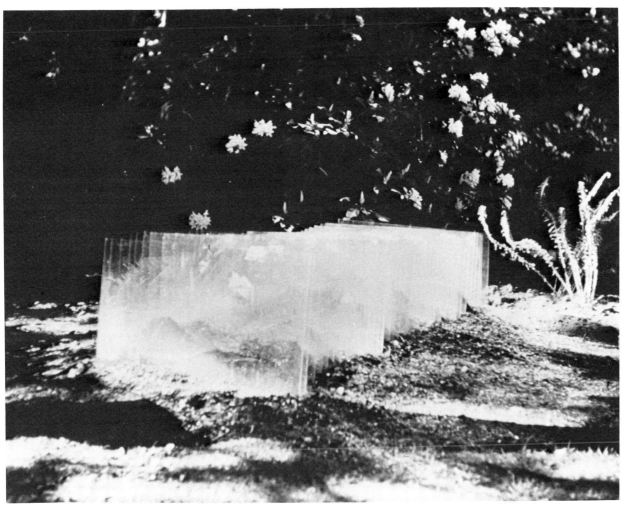

Glass Strata with Mulch and Soil, Vancouver, January/February 1970. Collection Robert Weiss. Photograph courtesy Estate of Robert Smithson.

59. *Glass Strata with Mulch and Soil,* Vancouver, British Columbia, January/February 1970; 18-ounce clear picture glass, set vertically in earth; 32 sheets, each 30″ wide, placed approximately 2″ apart, 12″ to 18″ exposed above ground

Glass Strata with Mulch and Soil was commissioned by Ian Davidson while Smithson was visiting Vancouver. Davidson's property, where the piece was situated, was located near the Georgia Strait, not too far from Miami Islet. Had *Island of Broken Glass* been built, the two works would have been set in dialectic with each other. While the *Island of Broken Glass* was to have glazed over a barren pumice rock incapable of sustaining

life, *Glass Strata with Mulch and Soil* was "planted" in rich earth. Changes in the weather affect the glass which becomes dusty, rain spattered, bedecked with leaves, and iced over, depending on the season.

Glass Strata with Mulch and Soil has several precedents and sources in Smithson's work. The earliest is perhaps *Glass Stratum,* the layered work of 1967. A mirror and sand piece was constructed in summer 1969 for the London Institute of Contemporary Arts exhibition "When Attitudes Become Form: Live in Your Head." *Mirror Displacement on a Compost Heap,* Düsseldorf, of October 1969, also can be considered a source, but perhaps the most obvious forerunner is *Mirror and Shelly Sand* (1969) shown at the Art Institute of Chicago's 69th American Exhibition in January 1970. Two drawings reveal Smithson's train of thought before mak-

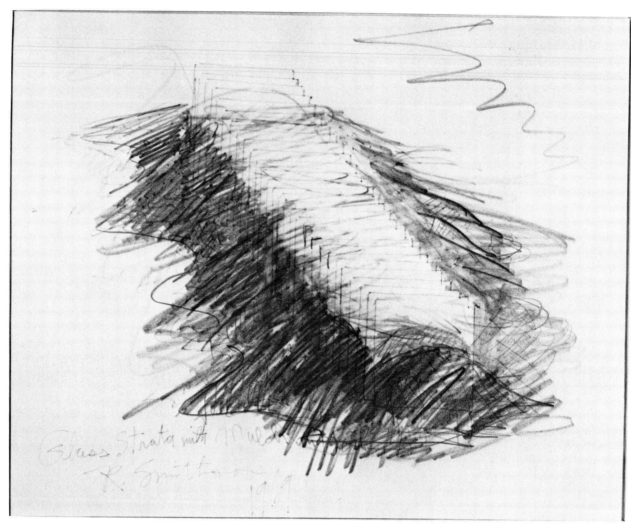

Drawing for *Glass Strata with Mulch and Soil,* 1969; pencil. Collection unknown. Photograph courtesy Estate of Robert Smithson.

ing the Vancouver piece: *Clear Glass Strata with Asbestos* of c. 1968/69 and *Clear Glass in Earth* of 1969. A now destroyed work that bears some relation is *Untitled (Mica and Glass)* of 1968/69, in which pieces of mica are interspersed between sheets of glass to create a stack of two different kinds of transparent materials, natural and man-made.

60. *Partially Buried Woodshed,* Kent State University, Kent, Ohio, January 1970; one woodshed and twenty truckloads of earth; 18′6″ × 10′2″ × 45′

A creative arts festival, held at Kent State University from January 17 through 23, 1970, featured guests John Ashbery, Allan Kaprow, Robert Smithson, Morton Subotnick, and John Vaccaro. Smithson had agreed to create a mud flow at the end of his week's stay.

For about a year before the Kent State festival, Smithson had been interested in ''flows'' and ''pours.'' Their earliest realizations were *Asphalt Rundown* (Rome) and *Concrete Pour* (Chicago), both of 1969. Just before his Kent State trip, the artist had traveled to Vancouver where he witnessed *Glue Pour*. And while in that area, he journeyed north to the Britannia Copper Mines and made a drawing for an underground flow called *Cavern of Muck*. The idea for that flow may have originated in British Columbia, but also might have occurred to him earlier when he was devising his *Concrete Pour* for the Chicago ''Art by Telephone'' exhibition: on the verso of the drawing for the Chicago *Pour* is a sketch called *Bubbling Boiling Mud*. Another drawing of 1969 may in fact

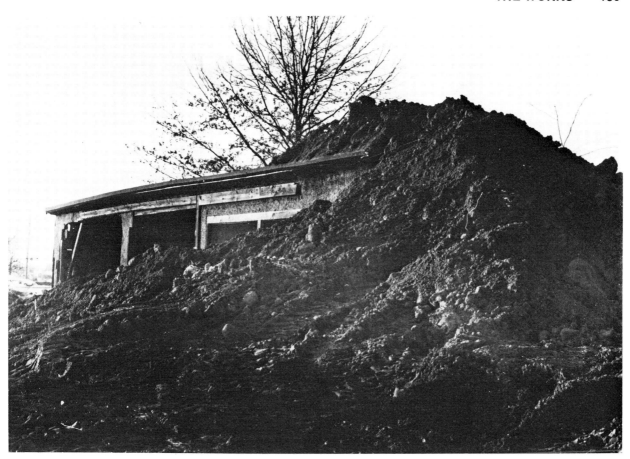

Partially Buried Woodshed, Kent, Ohio, January 1970. Collection Kent State University. Photograph by Robert Smithson, Courtesy Estate of Robert Smithson.

be an alternate proposal for the "Art by Telephone" project: entitled *Mud Flow,* it specifies one thousand tons of yellow mud to flow down an eroded cliff. Smithson had evidently been contemplating a mud flow for several months before going to Kent State.

That the use of mud had symbolic overtones for Smithson is clear from his writings. One of his most famous essays, "A Sedimentation of the Mind: Earth Projects," published in *Artforum* in September 1968, opens with a passage that allies the mind with earth:

The earth's surface and the figments of the mind have a way of disintegrating into discrete regions of art. Various agents, both fictional and real, somehow trade places with each other—one cannot avoid muddy thinking when it comes to earth projects, or what I call "abstract geology." One's mind and the earth are in a constant state of erosion, mental rivers wear away abstract banks, brain waves undermine cliffs of thought, ideas decompose into stones of unknowing, and conceptual crystallizations break apart into deposits of gritty reason. Vast moving faculties occur in this geological miasma, and they move in the most physical way. This movement seems motion-less, yet it crushes the landscape of logic under glacial reveries. This slow flowage makes one conscious of the turbidity of thinking. Slump, debris slides, avalanches all take place within the crackling limits of the brain.[52]

Though the statement is actually in this context an explanation of the forms Smithson used in his Earth projects, it also reveals an early interest in the idea of conjoining mind and mud into a wasteland of sediment, and thus should be considered in exploring his later use of mud and earth. So in the originally proposed Kent State mud pour, the Earth artist could have symbolized indirectly, through his choice of material, his attitude both toward his own art and toward academic thinking without ever having to resort to literary titles or complex explanations.

Because low temperatures prevented mud from flowing, Smithson thought of canceling the project. At the insistence of the students, however, he decided on an-

[52] "A Sedimentation of the Mind: Earth Projects," in *Writings,* p. 82.

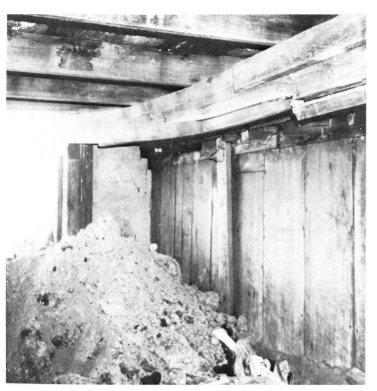

Partially Buried Woodshed (central beam). Photograph by Robert Smithson, Courtesy Estate of Robert Smithson.

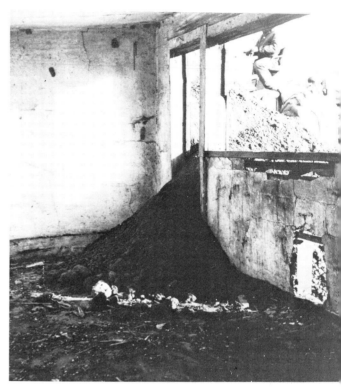

Partially Buried Woodshed (interior detail). Photograph by Robert Smithson, Courtesy Estate of Robert Smithson.

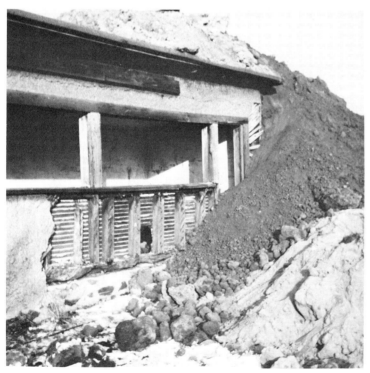

Partially Buried Woodshed (exterior detail). Photograph by Robert Smithson, Courtesy Estate of Robert Smithson.

other course of action. He had thought for some time that he would like to bury a building, so he began looking around the campus for a suitable structure. The woodshed he found had been part of an abandoned farm that belonged to the university. The rustic, ramshackle woodshed stood in sharp contrast to the other buildings in the area, which were for the most part modern concrete structures. It was a makeshift storage for dirt, gravel, and firewood. Smithson decided to leave some firewood in the building, and, on January 22, had earth moved to the area from a construction site elsewhere on campus. Operating a backhoe under Smithson's direction, Rich Helmling, a building contractor, piled twenty loads of earth onto the shed until its central beam cracked. The breaking of the beam was crucial to the piece: to Smithson it symbolized entropy, like the falling of Humpty Dumpty, "a closed system which eventually deteriorates and starts to break apart and there's no way that you can really piece it back together again."[53]

Because the cracking of the interior center beam was crucial to the piece, *Woodshed* is, in formal terms, the first of Smithson's Earthworks to deal with inner and outer space at the same time and thus involves the inte-

[53] "Entropy Made Visible," in *Writings*, p. 189.

rior/exterior dialectic that was to occupy him in his later *Spiral Jetty* museum and *Spiral Jetty*. Sculpture, never a purely formalist endeavor for Smithson, involved ongoing systems, forces and counterforces. The beam's cracking under the weight of the earth communicated directly and forcefully the role of action and gravity in this sculpture. Unlike so much twentieth-century sculpture that plays formalist games with external and internal space, such as Archipenko's and Lipchitz's, Smithson's sculpture is concerned with crushing forces reflected directly in the work, and is coupled with changes occurring over long periods of time.

In "Entropy Made Visible," an interview first published in 1973 in *On Site #4,* the artist commented on the Kent State piece: "At Vestmann Islands," he said, speaking of volcanic eruptions near Iceland, "an entire community was submerged in black ashes. It created a kind of buried house system. It was quite interesting for a while. You might say that provided a temporary kind of buried architecture which reminds me of my own *Partially Buried Woodshed* out in Kent State, Ohio. . . ."[54]

On January 22, the day the work was completed, Smithson decided to donate the work to the university. He signed the following statement:

> I, Robert Smithson, hereby donate the following work of art to Kent U. The work of art is called: *Partially Buried Woodshed.* Measurements of shed: 45′ long, 18′6″ wide, 10′2″ high. Site: On the corner of Rhodes & Summit St. (part of Farm acquisition) an area of 45′ should surround the art. Nothing should be altered in this area. Scattered wood and earth shoring should remain in place. Everything in the shed is part of the art and should not be removed. The entire work of art is subject to weathering which should be considered part of the work. The value of this work is $10,000.00. The work should be considered permanent and be maintained by the Art Dept. according to the above specifications.[55]

On March 28, 1975, the woodshed was set on fire by an arsonist who was never apprehended. Fortunately the right half of the shed remains, and the debris of the burned left-hand side, where firewood was stored, has been removed. In January 1976 Glenn Olds, then president of the university, promised to preserve the building and its immediate environs according to the request in the artist's deed of gift, thereby ending a controversy that had been raging over the future of the *Woodshed.* The controversy centered around the land on which the piece was located. Originally an unimportant spot in the back-

yard of the university, five years later the site adjoined a new gateway, and university administrators, finding the abandoned building unsightly, wished to have it removed. Prominent members of the art world rallied to the defense of the piece, however, and convinced the president that *Partially Buried Woodshed,* one of Smithson's five remaining Earthworks, should not be removed from its original location.

The *Partially Buried Woodshed* has been regarded as a prescient and revolutionary work of art. Only four months after its creation, four students were killed and nine others wounded by National Guardsmen during a campus protest against America's invasion of Cambodia. This subsequent tragedy has for many people eminently politicized the creation and significance of the *Woodshed.* Art critic Phil Leider told Nancy Holt he felt it to be the single most political work of art since Picasso's *Guernica.*[56] Nancy Holt has referred to the piece as "intrinsically political"[57] and indicated that Smithson himself believed it to be "prophetic." All we can say definitely, however, about the politics of the work is that the *Woodshed* is implicitly anti-"Establishment" through its reference to "muddy thinking." (In contrast with Smithson's work, Allan Kaprow's project for Kent State was obvious in its political message: he stuck dollar bills to a tree and titled it *Graft.*)

61. *Spiral Jetty*, Rozel Point, Great Salt Lake, Utah, April 1970; mud, precipitated salt crystals, rocks, water; coil 1500′ long and 15′ wide

In the making of *Spiral Jetty,* 6,650 tons of material were moved, and 292 truck-hours (taking 30 to 60 minutes per load) and 625 man-hours (adding up to more than 10 tons of material per hour) were expended in moving it. Approximately $9,000 (not including the many expenses incurred) was spent on construction of the Earthwork alone by Virginia Dwan of Dwan Gallery, New York, and another $9,000 was provided by Douglas Christmas of Ace Gallery, Vancouver, B.C., and Venice, California, for a film of the work. Later, Smithson traded a number of early works to Dwan and Christmas for the sole ownership of the *Jetty* and film. Currently Nancy Holt maintains the $160 (formerly $100) yearly rental payments on the twenty-year renew-

[54] Ibid., pp. 193–94.
[55] Smithson papers, Collection Estate of Robert Smithson.

[56] Conversation between Hobbs and Nancy Holt, December 14, 1979, New York.
[57] Holt, letter to Alex Guildzen, May 4, 1975.

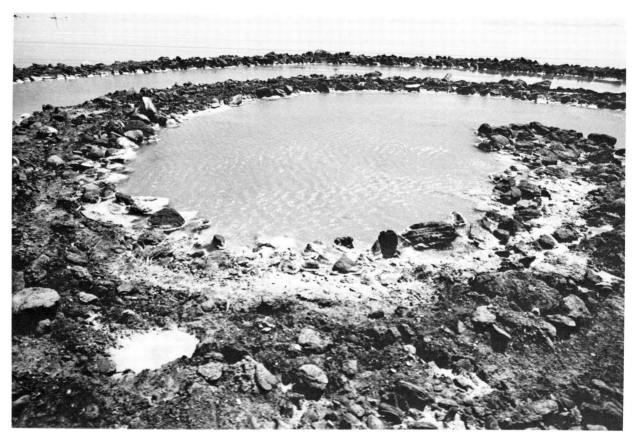

Spiral Jetty, Great Salt Lake, Utah, 1970. Photograph by Gianfranco Gorgoni/Contact.

able lease Smithson negotiated with the Utah Land Board for the ten-acre site at the north end of Great Salt Lake.

Even though *Spiral Jetty* has been more elaborately documented than any other work by Smithson, by both a 35-minute 16mm film (which was originally sold for $300, though $700 would buy the film plus a drawing) and an essay, it still remains his most misunderstood piece. To many people, *Spiral Jetty* is the quintessential heroic gesture in the landscape. If Jackson Pollock created a new standard for scale and boldness by dripping paint on large pieces of canvas laid on the floor, then Smithson established a never before contemplated precedent for monumental art when he created a spiral of mud, salt crystals, rocks, and water—indigenous elements of the landscape. The *Spiral Jetty* appears to many viewers, who have seen only photographs and not the actual site, to be twentieth-century man rivaling the great Pyramids of Egypt, the Serpent Mound in Ohio, and Stonehenge in England. They interpret the *Jetty* as an example of man conquering the wilderness by imposing magnificent—yet gratuitous—marks on the landscape.

What these viewers fail to realize is that building the *Spiral Jetty* is hardly an achievement to compare with such other twentieth-century gestures as making footprints on the moon or creating clones. If *Spiral Jetty* represents a monumental heroic gesture, the gesture is definitely an anachronistic one.

Smithson was aware that the heroics of *Spiral Jetty* were at best passé: in fact he emphasized this aspect. Using massive caterpillars, creaking dump trucks, outmoded machinery that he compared in the film to huge dinosaurs like the Tyrannosaurus Rex, he suggested an already bygone era of building. The *Jetty* was as absurd as the heavy lumbering machinery used to build it. The work was a primitive monument of the passing machine age.

The process of conceptualizing the work began with Smithson's interest in finding an inland body of red saline water. He had heard of such lakes in Bolivia but decided they were too remote. Then he learned that microbacteria give the Great Salt Lake a reddish tinge and decided to investigate. The interest in a red salt lake came first; the idea for the form of the piece came later.

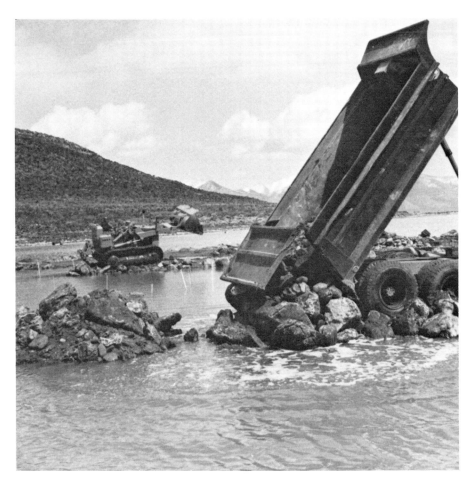

Building the *Spiral Jetty*, Great Salt Lake, Utah. Photograph by Robert Smithson, Courtesy Estate of Robert Smithson.

In the beginning he had thought of making an island; only after he visited the site did he change his mind and consider a spiral. The red salt lake, analogous to blood, became an image of primordial beginnings. Off Rozel Point abandoned oil rigs that seep oil reminded Smithson of asphalt and the tar pits (of the remote past) which embalmed prehistoric life. Nearby is the Golden Spike monument, a ready-made symbol of obsolescence, the commemoration of the joining of the rails of the first transcontinental railroad—a now defunct system and an outmoded concept of progress. The *Spiral Jetty,* located in the lake called "America's Dead Sea," is an image of contracted time: the far distant past (the beginning of life in saline solutions symbolized by the lake) is absorbed in the remote past (symbolized by the destructive forces of the legendary whirlpools in the lake) and the no longer valid optimism of the recent past (symbolized by the Golden Spike monument). All these pasts collide with the futility of the near present (the vacated oil rigging). All appear to be canceled, made useless: all are results of the essential universal force of entropy.

Into this symbolic Utah terrain, Smithson placed the *Spiral Jetty,* an asymmetrical form suggestive of the spiraling salt crystals that periodically encrusted the lake's banks in late summer, suggestive also of crystals, particularly viruses that assume alternately living and crystalline forms, exist at the threshold of life, and provide possible clues to life's origins. J. E. Cirlot's *Dictionary of Symbols,* which Smithson had in his library, describes the symbolic ramifications of the spiral:

A schematic image of the evolution of the universe. It is also a classical form symbolizing the orbit of the moon, and a symbol for growth, related to the Golden Number, arising (so Housay maintains) out of the concept of the rotation of the earth. In the Egyptian system of hieroglyphs the spiral—corresponding to the Hebrew *vau*—denotes cosmic forms in motion, or the relationship between unity and multiplicity. Of especial importance in relation to the spiral are bonds and serpents. The spiral is essentially macrocosmic. The above ideas have been expressed in mythic form as follows: "From out of the unfathomable deeps there arose a circle shaped in spirals. . . . Coiled up within the spirals, lies a snake, a symbol of wisdom and eternity." Now, the spiral can be found in three main

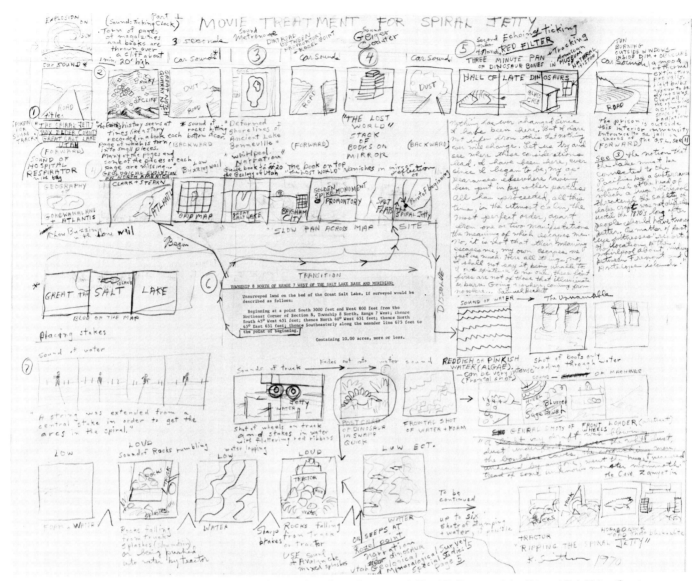

Movie Treatment for Spiral Jetty (first part), 1970; mixed media, collage; 2 parts, each 25 x 29". Photograph by Aida and Bob Mates, Courtesy Gilman Paper Company Collection, New York.

forms: expanding (as in the nebula), contracting (like the whirlwind or whirlpool) or ossified (like the snail's shell). In the first case it is an active sun-symbol, in the second and third cases it is a negative moon-symbol. Nevertheless, most theorists, including Eliade, are agreed that the symbolism of the spiral is fairly complex and of doubtful origin. Its relationship with lunar animals and with water has been provisionally admitted. Going right back to the most ancient traditions, we find the distinction being made between the creative spiral (rising in clockwise direction, and attributed to Pallas Athene) and the destructive spiral like a whirlwind (which twirls round to the left, and is an attribute of Poseidon). As we have seen, the spiral (like the snake or serpent and the Kundalini force of Tantrist doctrine) can also represent the potential centre as in the

example of the spider's web. Be that as it may, the spiral is certainly one of the essential motifs of the symbolism of ornamental art all over the world, either in the simple form of a curve curling up from a given point, or in the shape of scrolls, or sigmas, etc.[58]

Like Cirlot's dictionary, Smithson's essay "The Spiral Jetty" is a compendium of symbols, most of which are applicable to his *Jetty*. Smithson appropriates all possible meanings of the form not only to create a significant work with ancient prototypes, but also to innovate a work in which all meanings are equally relevant, so

[58] J. E. Cirlot, *Dictionary of Symbols* (London: Routledge & Kegan Paul and New York: Philosophical Library, 1962), pp. 305–6.

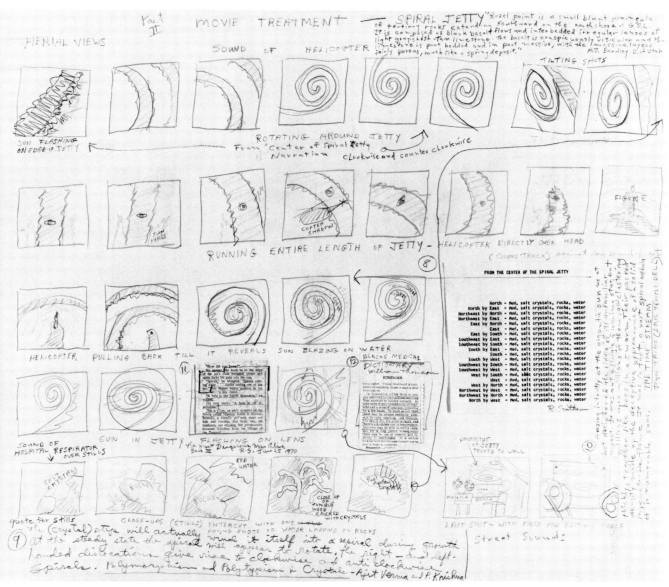

Movie Treatment for Spiral Jetty (second part). Photograph by Aida and Bob Mates, Courtesy Gilman Paper Company Collection, New York.

that no one particular symbolic element dominates—except, of course, the counterclockwise whirl of the *Jetty* itself connoting entropy and destruction.[59]

[59] The symbolic importance of the *Jetty* for Smithson is suggested also by the fact that early in his career, in 1961, he made a painting on cardboard of a red spiral, entitled *Eye of Blood*. In the decade intervening between this small work and the *Spiral Jetty*, Smithson developed his art away from illusionism toward literalism and learned to use materials capable themselves of manifesting symbols so that he could rid his work of literary titles and allusions. In the *Spiral Jetty* essay and film, however, he freely incorporated literary references to create narrative works of art that relate to the Earthwork without being solely dependent on it. When formulating the concept of the *Jetty*, the artist may well have forgotten the small painting since it was an immature work located in a private collection.

Smithson himself became a symbol of entropy when he ran over the counterclockwise coil while being filmed from a helicopter overhead. He was consciously imitating Cary Grant who is chased by a crop-dusting plane in Alfred Hitchcock's *North by Northwest*, and who later climaxes the film in a chase sequence shot on the face of Mount Rushmore, the prototypical great American Earthwork. In the film, Grant becomes a Cold War hero by virtue of accidental circumstances: he is mistaken for the nonexistent agent United States Intelligence created to confuse the Russians. Just as Grant has a nonexistent twin—the fabricated agent—and becomes a replica of himself, Smithson the artist doubles as viewer when he runs along his own *Jetty*.

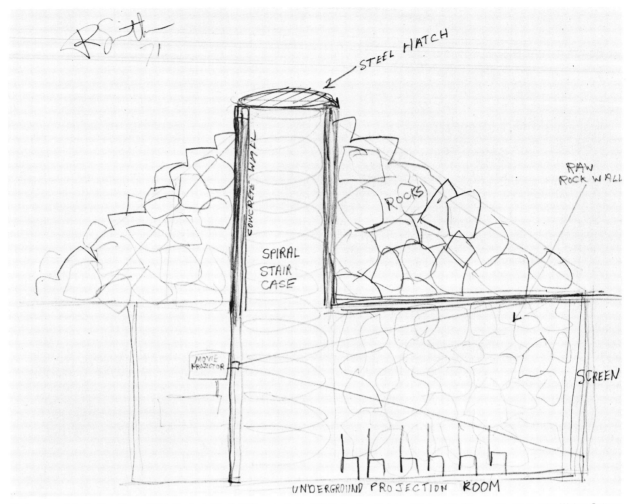

Underground Projection Room (*Utah Museum Plan*), 1971; pencil; 9 x 12″. Collection Estate of Robert Smithson. Courtesy John Weber Gallery. Photograph by Nathan Rabin.

Through the *Spiral Jetty* essay and film Smithson also doubles as art historian and artist. Smithson as artist/filmmaker, appearing at the beginning of both film and essay, remains dry and factual; later becoming the art historian, he finds meaning in everything. Thinking of the spiraling form of the *Jetty,* Smithson as art historian free associates and finds spirals in a number of un-related sources such as Brancusi's description of James Joyce's ear, Pollock's *Eyes in Heat,* aggregating salt crystals, helicopters (from the Greek *helix,* meaning spiral), galaxies and innumerable spirals making up the sun, reels of the film, and the circuity of ending up where his film audience is seated—in a screening room. At the end of both essay and film he overloads the symbolic potentialities to the point of chaos or entropy.

Another facet of Smithson's symbology, a *Spiral Jetty* museum, was originally planned to be built nearby. It was to be a truncated pyramid composed of a rubble of rocks. Situated mostly underground, the museum would

consist of a salt-encrusted subterranean screening room to which one would descend by a spiral staircase. The museum was meant to manifest a nineteenth-century rumor that whirlpools in the Great Salt Lake were connected to subterranean channels leading to the Pacific Ocean.

Since 1972 *Spiral Jetty* has been under water. Although the lake had been gradually receding since the early fifties and reached its lowest point ten years later, the water began to rise again about 1963 and has continued to do so, with slight seasonal fluctuations, for the past two decades. Even though the waters had been rising at a regular rate for the seven years before he built the *Jetty,* Smithson, according to Nancy Holt, expected the lake conditions to remain somewhat steady. She believes he did not anticipate an increase in water level since the lake was higher than it had been for several decades, except for a brief period in the fifties. Once, when asked what he would do if the lake covered the

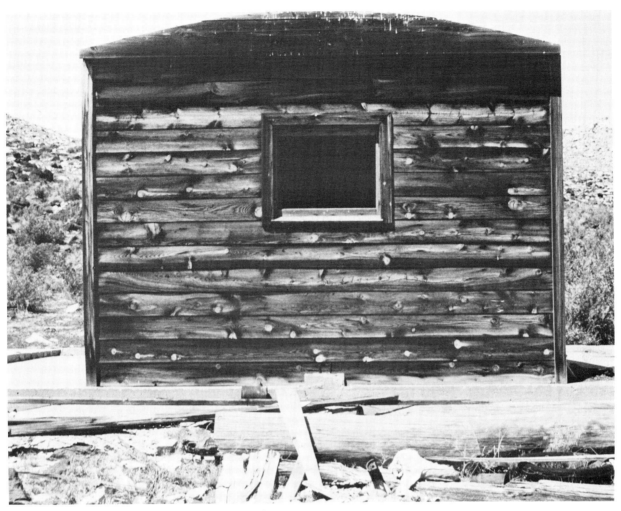

Untitled (Mica Spread), April 1970. Photograph by Nancy Holt.

Jetty, Smithson responded that he would build the piece fifteen feet higher—thus indicating his intention to keep weathering and change within strictly defined limits. After 1972, when the *Jetty* was underwater, he in fact planned to build it higher if the water level of the lake did not recede.

The photographic documentation of the *Spiral Jetty* project involved Smithson in the controversy around defining the difference between documentary evidence and art object. About the time of making the *Jetty* Smithson had been selling photographs of his pieces as works of art (in 1970 he had a color snapshot of the *Second Stop* from *Six Stops on a Section* enlarged, torn, and distributed by Multiples, Inc.). Oversize photographs of the *Jetty* were signed and sold to an Italian collector; Smithson also made three panels of stills from the *Spiral Jetty* film. At that time, Conceptual artists were calling the art object "documentary evidence," although they continued to sell their "evidence"—photographs and printed

matter—in galleries. It may have been in this spirit that Smithson made his photographs available to collectors. When his photographs began to be regarded as the art, he decided not to sell any more, and the casual ambivalent status of gallery pieces that oscillated between being privileged objects and mere referents was again established.

62. *Untitled (Mica Spread),* near *Spiral Jetty,*
Great Salt Lake, Utah, April 1970;
abandoned woodshed

Untitled (Mica Spread) is more an impromptu action than a completed Earthwork. Hardly preplanned, it involved a spontaneous decision on Smithson's part. Investigating an old woodshed located near an abandoned oil derrick not far from *Spiral Jetty,* the artist found bags

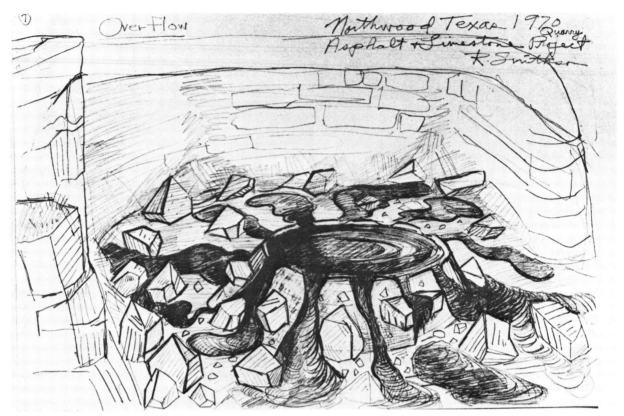

Drawing #7 from Nine Drawings for *Texas Overflow*, 1970; pencil and ink; 12 x 18″. Collection Estate of Robert Smithson, Courtesy John Weber Gallery. Photograph courtesy John Weber Gallery.

of mica. With the help of a few assistants he spread the mica over the floor of the building and on the adjoining concrete slab outside. Nancy Holt, who filmed the sequence for her Super-8 film *Spiral Jetty*, does not remember seeing any indigenous mica near the Great Salt Lake and supposes that the bags were imported years before and left deserted, along with the building. The work has an element of fantasy, a quality of the unreal, which seized all the participants and which Holt managed to capture in her film.

Seeing the bags of mica, Smithson may have thought of his *Nonsite (Mica from Portland, Connecticut)* of 1968 and his reference in unpublished notes from that time to mica as books, mirrors, windows, and glass. When he made *Mica Spread,* he was fascinated with the image of the earth as a giant history book, and probably regarded the mica as a readily available symbolic material to scatter randomly in much the same manner that he and Holt cast torn pages on dried mud flats for his *Spiral Jetty* film.

63. *Texas Overflow,* Northwood Quarry, Texas (never built), 1970; asphalt and limestone

Smithson hoped to build *Texas Overflow* in a roughly semicircular abandoned quarry on land belonging to the Northwood Institute, located between Dallas and Fort Worth, Texas. Using indigenous light-colored limestone, he intended to form a circular basin into which he would have asphalt pumped until it seeped out and flowed beyond the constructed crater. The result would be a modern-day tar pit, a monument both to the abandoned limestone quarry and to the tar pits of the prehistoric age. The contrast between the white limestone formed mainly of the remains of shells and corals and the black asphalt would have recalled the fossilized bones of those now extinct animals preserved in tar.

Smithson made nine drawings for *Texas Overflow*. On numbers 2 and 8 he detailed the process of building the piece, and indicated his intentions to film it. He felt that

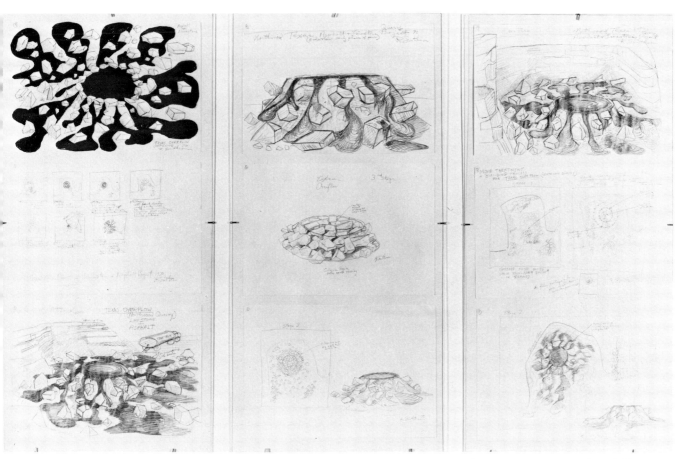

Nine Drawings for *Texas Overflow*, 1970; pencil and ink; each 12 x 18″. Collection Estate of Robert Smithson, Courtesy John Weber Gallery. Photograph by Walter Russell.

the following seven stages were necessary for its completion:

1st stage	remove garbage and weeds
2nd stage	stake out two circles
3rd stage	bulldoze rocks into circles 7′ to 8′ high in center circle tapering to outer circle
4th stage	with front loader cover rocks with earth—center circle should be flat and dishlike[—]rocks on tapering slope should protrude
5th stage	scatter remaining rocks around circular slope
6th stage	pump asphalt into center circle
7th stage	allow asphalt to spread randomly around . . . flat center circle

Plans for the movie treatment of this piece were only tentative and never advanced beyond the initial stage of deciding to film the garbage pile by circling around it once, before posting stakes and taking still photographs of them.

In addition to a limestone and asphalt *Overflow*,

Smithson contemplated using sulphur with asphalt in a second version. He made a drawing in 1970 that carefully noted, ''Earth fill 150 feet and 4 feet deep—asphalt on top and slope with sulphur lumps.''

64. *Barge of Sulphur* (never built), 1970; sulphur lumps from Rosenberg, Texas, to be barged through Panama Canal from east to west

When Smithson could build neither *Island of Broken Glass* nor *Island of Broken Concrete,* he developed the idea of barging materials as a work of art. His concept has a wonderful forthrightness to it: if art is continually transported hither and yon for exhibitions, then why, he may well have asked, not make a new kind of work in which the movement would become the art? Unable to implement his ideas in Vancouver, Smithson attempted

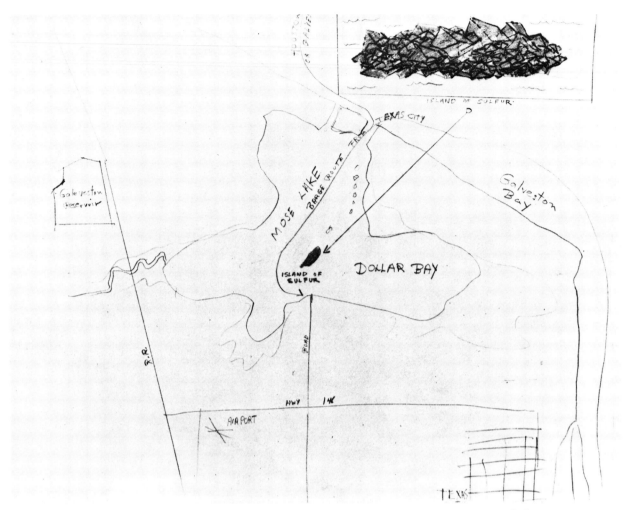

Map—Island of Sulfur, 1970; pencil; 19 x 24″. Collection New York Cultural Center. Photograph courtesy John Weber Gallery.

to persuade Douglas Christmas, owner of Ace Gallery, Vancouver, B.C., and Venice, California, to pay for barging sulphur from Houston to the West Coast through the Panama Canal.

Smithson also conceived in 1970 of a commemoration of this "transportation piece," in a film entitled *Panama Passage*. One section, "Tropical Cargo," calls for a host of surrealistic images: fish were to be stuck in crushed bananas, grapefruit floated in a creek, coconuts were to landslide down a sandy hill, lobsters were to swim in a pool of milk, a rattlesnake was to be milked of venom to the sound of a shaking rattle, pineapples were to be burned on a beach, dead tarantulas were to be buried in applesauce, and feathers were to blow over smashed watermelons.

A variation on the *Barge of Sulphur* which actually may be Smithson's first thinking about the project is a drawing of a *Barge of Broken Glass* going through the Panama Canal. Since the broken glass has obvious affinities with the Vancouver Project's *Island of Broken Glass*, it may well predate the intention to use sulphur.

65. *Floating Island: To Travel around Manhattan Island* (never built), 1970

Perhaps a more whimsical "transportation piece" than his proposed barge of broken concrete or broken glass (Vancouver) is Smithson's idea for a *Floating Is-*

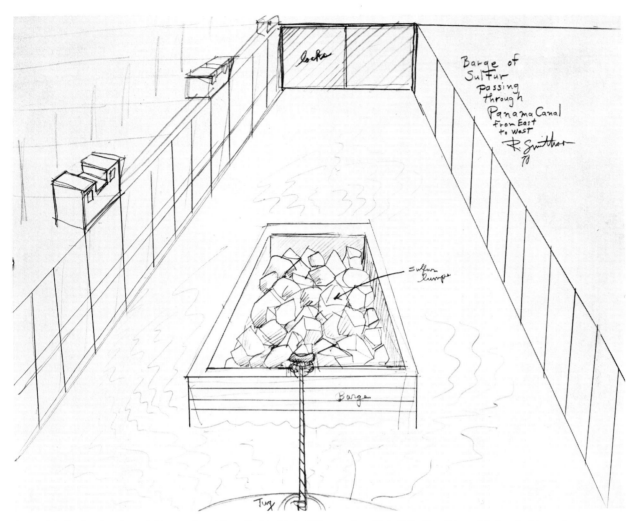

Barge of Sulfur Passing through Panama Canal from East to West, 1970; pencil and ink. Collection Estate of Robert Smithson, Courtesy John Weber Gallery. Photograph courtesy John Weber Gallery.

land, a fantastic project that he actually proposed to Alanna Heiss, director at the Institute for Arts and Urban Resources in New York. His drawing for the project shows that a tugboat was to pull a barge of primordial Manhattan around the island. "Trees common to the New York region," rocks, and bushes were to be set into a traveling landscape not unlike a miniature Central Park in a boat.[60]

The idea of incorporating indigenous plants into an artistic "ecosystem" was first developed by Smithson

and later taken up separately by two New York artists, Alan Sonfist and Michelle Stuart. Smithson's *Floating Island,* however, was conceived in a more ironic spirit than either of these latter projects, both of which emphasized a sense of loss. *Floating Island* would be a sort of ongoing parade, a literal float, tugged around Manhattan like a decorative Circle Liner. Instead of viewing Manhattan from the water, New Yorkers could see a restaged bit of their island as it used to be, floating by them. The past would, then, become the tourist viewing the present—a new twist to the Site/Nonsite dialectic.

[60] I thank my editor, Carol Betsch, for this image.

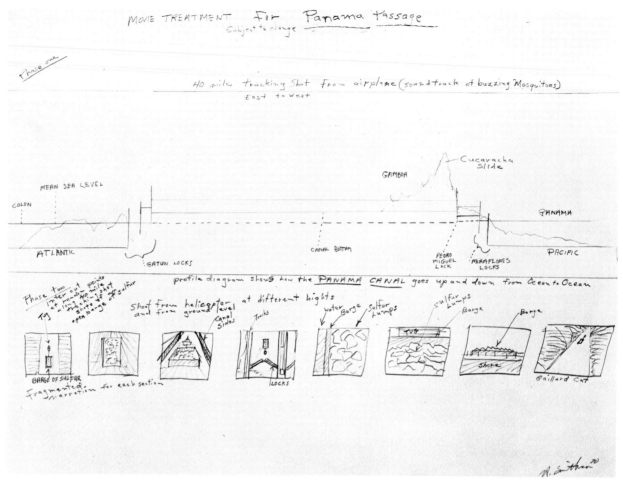

Movie Treatment for "Panama Passage," 1970; pencil and ink; 10 x 24". Collection Estate of Robert Smithson, Courtesy John Weber Gallery. Photograph courtesy John Weber Gallery.

66. *Boston Project: Juggernaut* (never built), 1970

One of Smithson's proposals for the "Elements of Art: Earth, Air, Fire, Water" show at the Boston Museum of Fine Arts (1971) develops his notion of transportation as art. A drawing entitled *Juggernaut* shows a "flat back trailer with heavy rocks and poured concrete" loaded on it (in another drawing Smithson included the definition of a juggernaut: "anything that exacts blind devotion or terrible sacrifice"). It was Smithson's intention that the *Juggernaut* be pulled around the city and parked at different locations.

A mobile monument, the *Juggernaut* develops the idea of moving artworks which Smithson had originated during the thwarting of his Vancouver Project (and has other, obvious connections with his barge carrying broken concrete, as well as the shipping of rocks for the Nonsites). While transporting major artworks is of course not new, large mobile sculptures are novel in Western culture. They recall the bookmobiles common in many cities and actually literalize the elaborate artmobiles that travel around Virginia under the auspices of the Museum of Fine Arts in Richmond. An Eastern source for the Boston Project is the great towering juggernauts that are pulled through the streets of India during special religious festivals. While Smithson's *Juggernaut* would have occasioned a type of parade, it was not dedicated to the sublime feelings elicited by Eastern gods. Instead it is dedicated to entropy and becomes a cortege honoring industrial waste and uselessness.

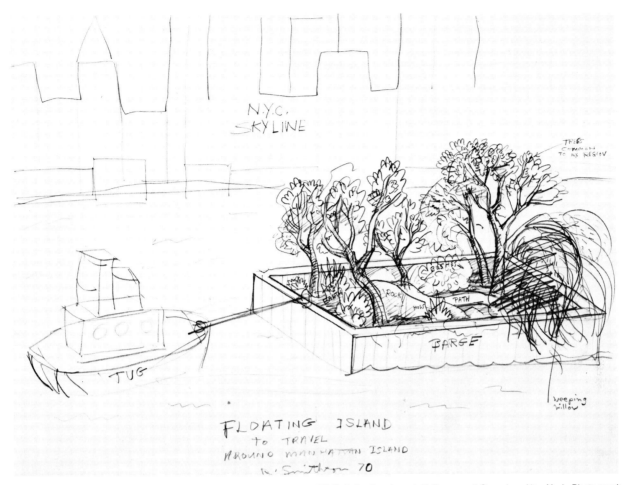

Floating Island: To Travel around Manhattan Island, 1970; pencil; 18⅜ x 23½". Collection Joseph E. Seagram & Sons, Inc., New York. Photograph by Nathan Rabin.

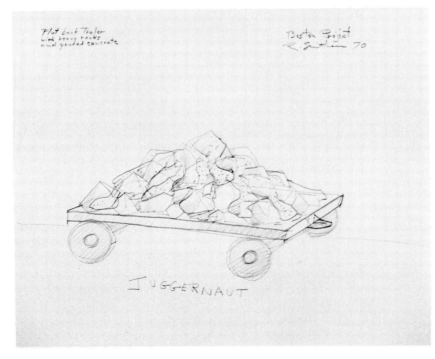

Boston Project: Juggernaut, 1970; pencil; 18⅞ x 24". Collection Estate of Robert Smithson, Courtesy John Weber Gallery. Photograph by Nathan Rabin.

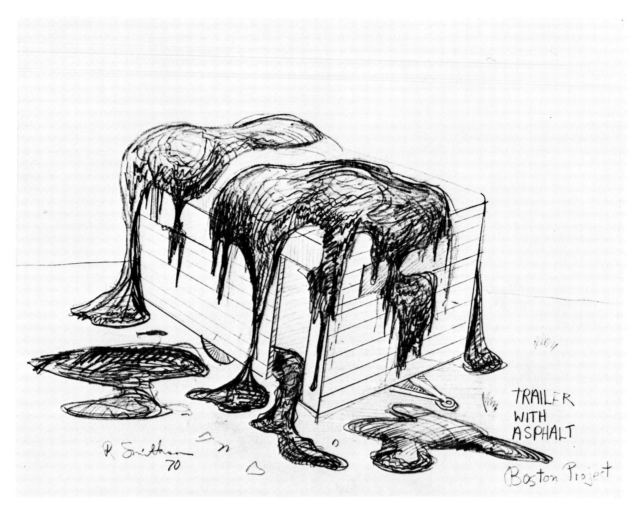

Boston Project: Trailer with Asphalt, 1970; pencil; 19 x 24″. Collection Estate of Robert Smithson, Courtesy John Weber Gallery. Photograph courtesy John Weber Gallery.

67. *Little Fort Island*, *Maine, Projects* (never built), 1971

In 1971 Smithson purchased Little Fort Island, Maine, with the intention of creating an Earthwork of jetties that would unify the two parts of an island split at high tide into the shape of an exclamation point. He considered jetties that were circular, meandering, and interlocking in the figure-8 symbol of infinity. Smithson had bought the island without seeing it, however, and when he did travel to it, he found it so beautiful in its natural state that he decided against tampering with it and abandoned

his idea of creating an Earthwork there. This respect for the natural beauty of this site contrasted with his attitude toward a bare rock, Miami Islet in Vancouver.

When he abandoned the Little Fort Island site, Smithson shifted his interest away from intervening with nature through art to using art as a way of dealing with an industrially ravaged landscape. Although he did later propose a few Earthworks that were more gratuitous creations of beautiful shapes in the landscape, such as his proposals of the early seventies for Moodna River and Creek at Storm King in Mountainville, New York, his most important work developed around the possibility of "reclaiming" the landscape through art.

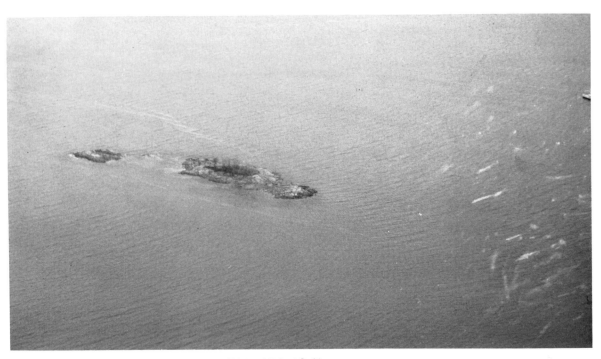

Little Fort Island (aerial view). Photograph courtesy Estate of Robert Smithson.

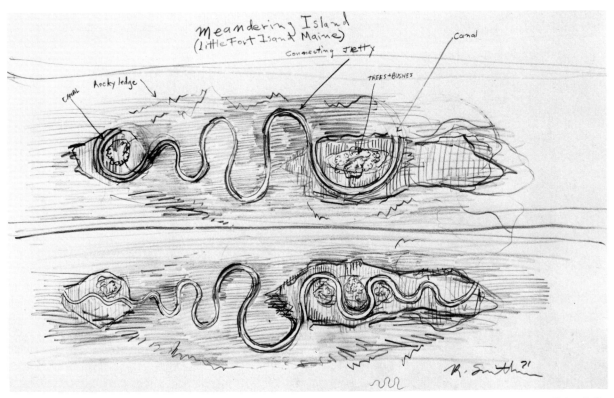

Meandering Island, Little Fort Island, Maine, 1971; pencil; 18¾ x 23⅔". Collection Estate of Robert Smithson, Courtesy John Weber Gallery. Photograph by Nathan Rabin.

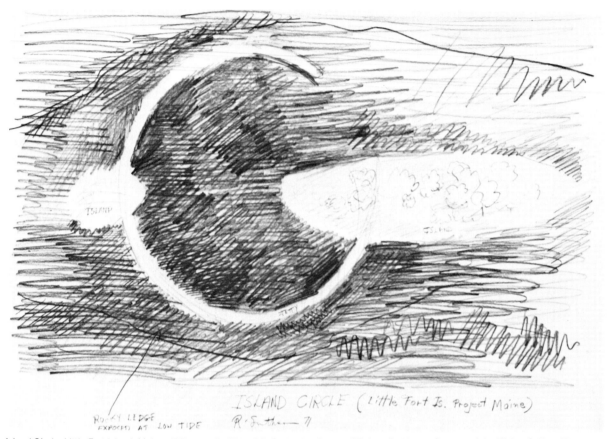

Island Circle, Little Fort Island, Maine, 1971; pencil; 18¾ x 24″. Collection Estate of Robert Smithson, Courtesy John Weber Gallery. Photograph by Nathan Rabin.

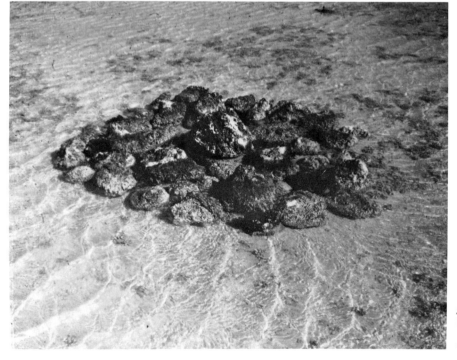

Sunken Island, Summerland Key, Florida, 1971. Photograph by Robert Smithson, Courtesy Estate of Robert Smithson.

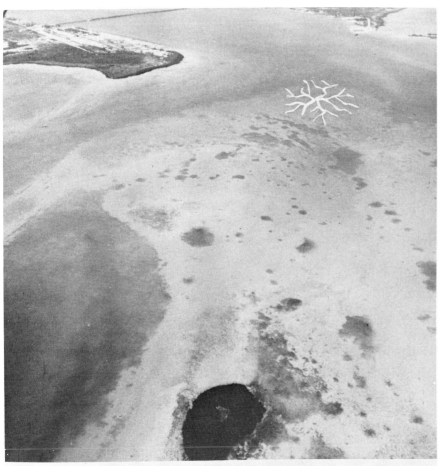

Forking Island

R. Smithson
71

Forking Island, 1971; ink on
photograph; 10 x 8″. Collection
Estate of Robert Smithson,
Courtesy John Weber Gallery.
Photograph by Nathan Rabin.

68. *Mangrove Ring*, *Oolite Island*, and *Sunken Island*, Summerland Key, Florida, 1971

In 1971 Smithson with Nancy Holt made his second extended trip to Florida, this time to investigate the possibility of creating a "forking island" and a maze off one of the Keys. One drawing shows an *Island with Forking Peninsula in Shallow Water* to be constructed of rocks on or near Summerland Key near Key West. Smithson stayed in Florida nearly three weeks, meeting with many people, including a state senator, in hopes of obtaining permission for his project. Unfortunately, *Forking Peninsula* never advanced beyond the planning stage because of problems concerning permission and funds.

While in Florida Smithson did create a series of islands that appear to emphasize the ritual of construction

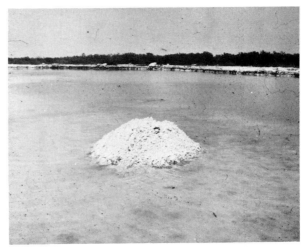

Oolite Island, Summerland Key, Florida, 1971. Photograph by Robert
Smithson, Courtesy Estate of Robert Smithson.

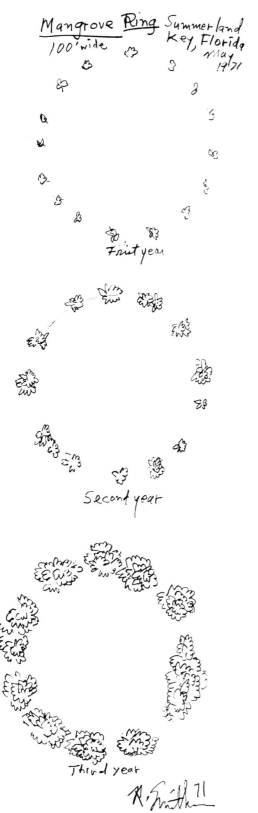

Drawing of *Mangrove Ring*, 1971. Photograph courtesy *Arts Magazine*.

as much as the finished piece. Each is an aggregate of living plants and animals that attract other creatures and sediment, forming through this process an island:

> On Summerland Key, near Key West, I found a shallow lagoon, where I built two 5′ wide islands and planted a 100′ wide ring of mangrove seedlings. One island was made out of white coralline material called "oolite." I got the oolite out into the lagoon on a plastic raft. The *Sunken Island* was made by consolidating rocks from the bottom of the lagoon. The rocks were encrusted with small slimy things, and sponges called "dead man's fingers." This island was mostly underwater. The *Mangrove Ring* was made by planting seedlings into sediment deposits in cracks in the rocky bottom of the lagoon. Mangrove seedlings are supposed to take root almost immediately. There's a story that Alexander the Great stopped his march through Asia to observe mangroves making land. Mangroves are called "island makers" because they catch sediment in their spidery roots."[61]

After the controversy attending his *Island of Broken Glass* in early 1970, it is not surprising that Smithson turned to constructing islands rather than negating them. The Summerland Key islands have a source also in the disappearing continents of 1969, particularly the *Hypothetical Continent in Shells: Lemuria* which had been constructed mostly of seashells on the shores of Sanibel Island during the artist's previous Florida trip.

69. *Broken Circle/Spiral Hill*, Emmen, Holland, summer 1971; *Broken Circle*: green water, white and yellow sand flats; approximately 140′ diameter; canal approximately 12′ wide; depth quarry lake 10 to 15′; *Spiral Hill*: earth, black topsoil, white sand; approximately 75′ at base

When Smithson wrote letters to various mining corporations in 1972 offering his services as artist-consultant, he pointed out that he had previously built two Earthworks combining land reclamation and art: *Spiral Jetty* in the Great Salt Lake, Utah, near an old mining area and *Broken Circle/Spiral Hill* in a sand quarry in Holland. Although the location for *Spiral Jetty* was an abandoned oil production site, Smithson's project was not specifically directed toward land reclamation. The first industrial location that he actually "reclaimed" in the name of art is the site of *Broken Circle/Spiral Hill* in Emmen, Holland.

[61] " '. . . The Earth, Subject to Cataclysms, Is a Cruel Master,' " in *Writings*, p. 185.

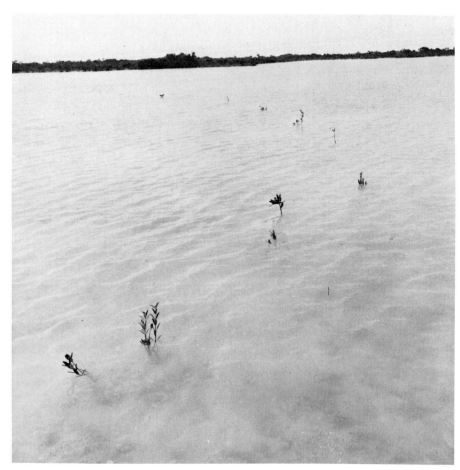

Mangrove Ring, Summerland Key, Florida, 1971. Photograph by Robert Smithson, Courtesy Estate of Robert Smithson.

Originally Smithson had been invited by the Sonsbeek international art exhibition to create a work for a park. But when he visited the country he decided not to site a work in a cultivated landscape because he felt such a piece would become too much a precious object. With the help of Sjouke Zijlstra, a geographer who was also head of the cultural center in Emmen, Smithson found a quarry already slated for reclamation as a recreational site. The uncultivated, disjunctive qualities of the quarry appealed to him; he referred to the place as "a disrupted situation" and "a whole series of broken landscapes." In addition to preferring a location devastated by industry, he was entranced by the varied range of hues in the landscape, and he noted both in conversation and in drawings that the cliffs surrounding the quarry lake were red, the soil grading up from the sand flats was a warm brown loam, the sand yellow and white, and the water green. He constructed *Spiral Hill* of earth and further enriched the spectrum of hues by covering the *Hill* with a few inches of black topsoil before spreading white sand along its edges to form a contrasting spiraling path.

The creation of *Broken Circle/Spiral Hill* depended on accidents occurring over vast ranges of time. The quarry itself, sliced out along the edge of a terminal moraine, is a fortuitous assemblage of chunks of many different terrains picked up and transplanted by glaciers in the last ice age. In recent years the site's function as a sand quarry broke up the landscape even more. When Smithson found the quarry, it had already reached a heterogeneous "entropic" state. Smithson built two images that enforce and heighten this differentiated condition: a broken circle (formed of a jetty and a canal) which is impossible to circumambulate and a hill whose path, spiraling in a counterclockwise direction, forms an ancient symbol of destruction.

The work in Emmen is another of Smithson's continuing investigations of dialectical propositions. *Broken Circle*, flat and light in color, is a centrifugal image, while *Spiral Hill*, three-dimensional and dark, centripetally winds around itself. One work is surrounded by water, the other by earth. The two pieces become antipodes of each other; they create a circularity, an insular quality, as they respond inversely to each other.

A group of drawings of 1970 related to the Emmen

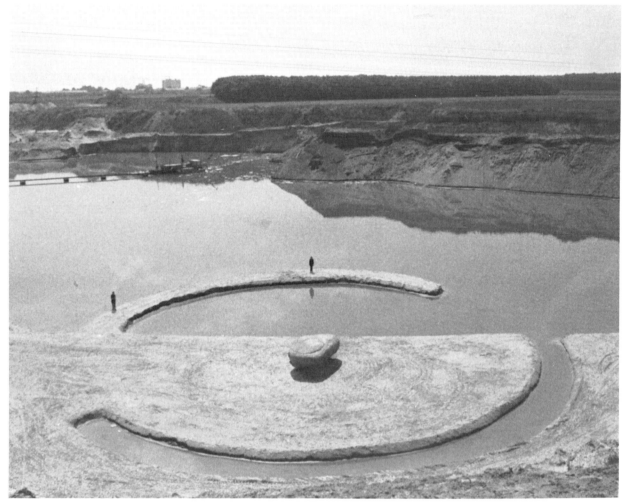

Broken Circle, Emmen, Holland, summer 1971. Photograph courtesy Estate of Robert Smithson.

work reveals Smithson's interest in creating an image of entropy. The drawings show fantastic structures whose source we can trace to Giovanni Battista Piranesi's *Caceri* etchings (1745) of which Smithson owned a facsimile edition. Smithson was fascinated by Piranesi's visionary evocations of Roman ruins, ancient torture chambers, and prisons, and in drawing after drawing pictured macabre sites. The elements that appear to have most intrigued him are an island, a circular hill surmounted by a winding staircase, and sharpened beams. In the drawing *Entropic Landscape* all of these are found, as well as another island supporting a layered burning pyre. And we can see that some of the dramatic images of the *Entropic Landscape* recur almost prosaically in the Emmen project: *Spiral Hill* duplicates the sharp pointed island and *Broken Circle* represents an elaboration of the large round one, while the sharp

threatening beams reappear as the stakes preserving the *Circle*.

Smithson wanted *Broken Circle/Spiral Hill* to be a microcosm of Holland and intended the Earthwork to relate quite specifically to its site. Indicative of the artist's concept of Holland was the dredged half-circle jetty of *Broken Circle*, metaphor for the country's dikes. Smithson wanted to make a film of the work similar to *The Spiral Jetty*, and shot about a half-hour of footage of the sand-dredging and jetty-building operations before his funds ran out. His idea was to obtain film clips of the Holland flood of 1953 and juxtapose them with shots of the breaking of the dike and flooding of the *Broken Circle*, to establish a distinct relationship between the country and the Earthwork.

A boulder near the center of the *Broken Circle* presented the most problematic aspect of the piece. Depos-

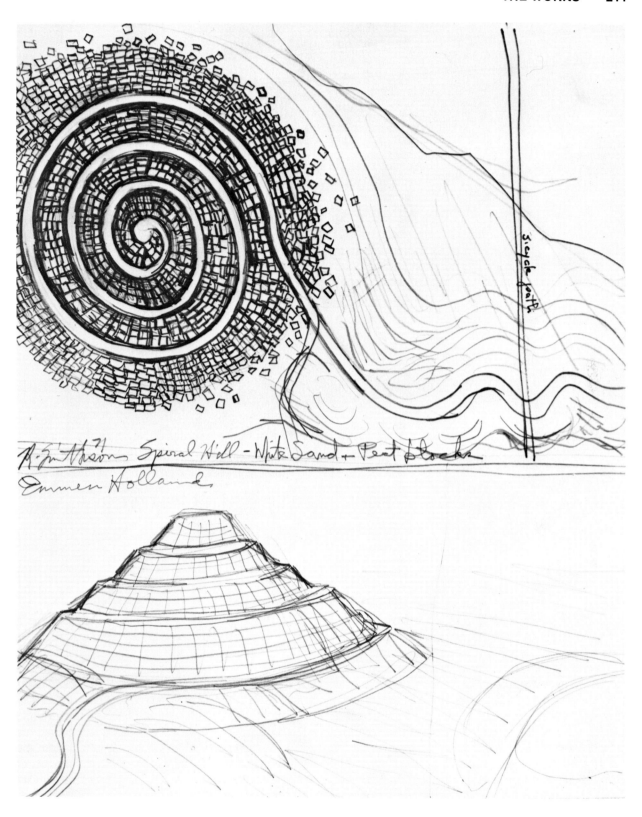

Spiral Hill, Emmen, Holland, summer 1971; pencil and ink; 15⅝ x 12¾". Collection Estate of Robert Smithson, Courtesy John Weber Gallery
Photograph by Nathan Rabin.

Giovanni Battista Piranesi, Plate #7 of *Carceri d'Invenzioni* (*Prison Scenes*), c. 1761; etching; 21¾ x 16¼″. Collection Herbert F. Johnson Museum of Art, Cornell University, Ithaca, New York. Photograph by Jon Reis, Courtesy Herbert F. Johnson Museum of Art.

ited by a glacier, the mammoth rock distressed Smithson. Because it was the same sort of glacial boulder that the ''Hun's beds'' were made of, he equated it with those prehistoric burial chambers found throughout Holland, one of which is located about a third of a mile from the work. He intended to move the boulder out of the circumference of the circle or bury it, but discovered that it was one of the largest rocks of its kind to be found in the country and would take an army—literally the Dutch Army—to transport it. ''I was haunted by the shadowy lump in the middle of my work,'' he recalled. ''Like the

eye of a hurricane it seemed to suggest all kinds of misfortunes. It became a dark spot of exasperation, a geological gangrene on the sandy expanse . . . a blind spot in my mind that blotted the circumference out . . . a kind of glacial 'heart of darkness'—a warning from the Ice Age.''[62] Smithson referred to the boulder as an ''accidental center'' and probably was troubled by the fact that the huge rock provided a focal point to the entire piece and consequently disrupted the dedifferentiated

[62] Ibid., p. 182.

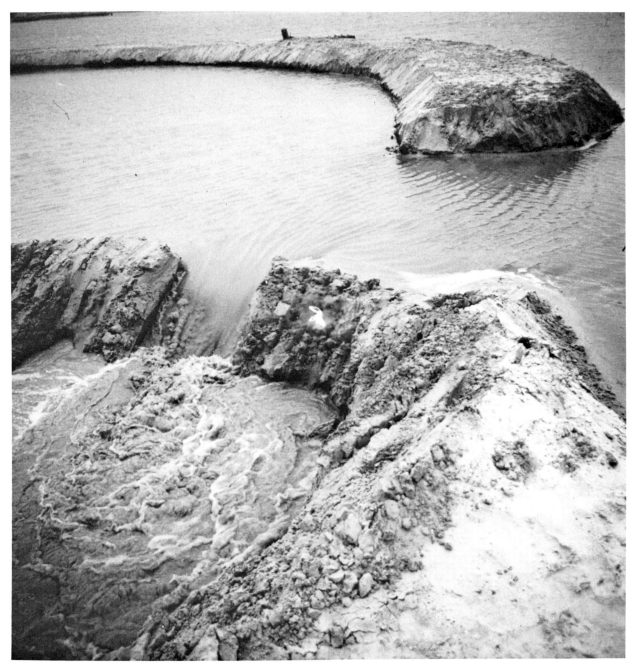

Broken Circle (breaking the dike), summer 1971. Photograph courtesy Estate of Robert Smithson.

quality he was after, as well as the dialectic between spiraling hill and circular peninsula which he hoped to create.

Broken Circle/Spiral Hill was originally commissioned as a temporary outdoor installation. The work proved so appealing to the Dutch, however, that only a few months after it was built the people of Emmen voted to preserve it as a park. (Smithson had always hoped the work would be permanent.) Acting on the vote, Smithson wrote a letter on December 10, 1971, to a Dr. Sanders, detailing measures he wished taken to preserve the piece—although he believed in letting his work be weathered and changed by nature, he wanted those changes to happen to a permanent structure. His first desire was for changes that would allow the filming of the work to be completed:

The temporary restoration would include:
 1. Digging the canal deeper (about 1½ meters in all)
 2. Filling in with sand all eroded areas in the pier
 3. Removing weeds from the hill.
Then later in the spring, the permanent stabilizing and restoring with the wooden stakes can be done.[63]

By 1971 Smithson had evolved a vocabulary of shapes that he contemplated using in one project after another. Studies for segmented circles, scattered islands, radiating quadrants, meanders and sprawls and random forking patterns all abound in his art at this time. One variation for the Emmen piece is a meandering canal. Another early idea consists of eight jetties radiating like spokes

[63] Smithson papers, Collection Estate of Robert Smithson.

from a circular pool comprising a central hub. During the same year that Smithson considered this latter design for Holland, he also contemplated using a variation—with four rather than eight jetties—for the Storm King Art Center, Mountainville, New York. *Moodna Circles,* one of the many designs he created for the Moodna River and Creek at Storm King, is most unusual. Consisting of scattered rocks placed within a ten-foot circle that would create a central shape of disruption in the water, the piece recalls the flooding of the *Broken Circle* which so intrigued him. The plans for all these never realized projects form a compendium of the ideas then important to the artist, and relate to works as diverse as the Little Fort Island, Maine, proposals, *Forking Island* off the Florida Keys, and *Tailing Pond* in Creede, Colorado.

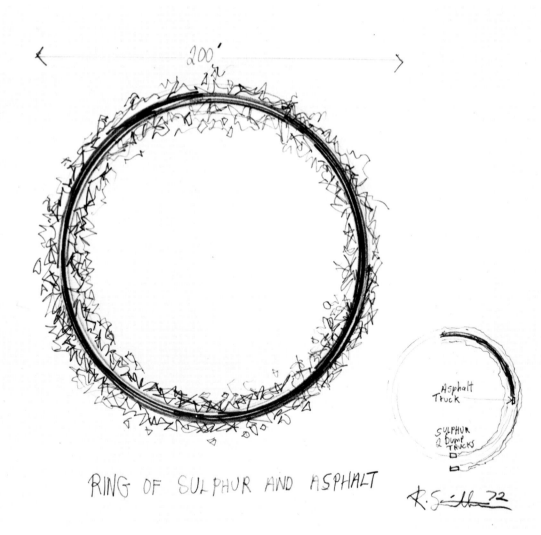

Ring of Sulphur and Asphalt, 1972; pencil; 12⅝ x 16¼". Collection Estate of Robert Smithson, Courtesy John Weber Gallery. Photograph by Nathan Rabin.

70. *Ring of Sulphur and Asphalt*, Texas (never built), 1972

The De Menil Foundation of Houston, Texas, sponsored in 1968 "Visionary Architects: Boulée, Ledoux, Lequeu," an exhibition held at the University of St. Thomas, Houston. Because of the success of this exhibition, the Foundation planned to continue the theme of visionary architecture into the modern period, with an emphasis on Earth artists such as Robert Smithson. Although the second exhibition was never realized, it did give Smithson the opportunity to conceive an appropriate project.

Smithson made several drawings of projects incorporating the huge chunks of bright yellow sulphur he knew to exist in the Houston area. The most elaborate was *Ring of Sulphur and Asphalt* (proposed diameter 200'), which consisted actually of three concentric rings, a central one of asphalt bounded on both sides by those of sulphur. A variation was his idea for a 300-foot-diameter ring of sulphur 15 feet wide to be built on a flat plain.

Smithson's interest in the sulphur at Rosenberg, Texas, near Houston predates plans for the visionary architecture show. In 1970 he planned at Northwood an alternate version of his *Texas Overflow* using sulphur. That same year he dreamed of an *Island of Sulphur* formed by routing barges in the Gulf of Mexico from Texas City to Mose Lake and Dollar Bay. At the same time he also attempted *Barge of Sulphur* which would consist of shipping Texas sulphur through the Panama Canal to California.

An artist whose ideas continually outdistanced opportunities for their realization, Smithson also contemplated a movie treatment of *Ring of Sulphur* (similar to his proposal for a film entitled *Panama Passage*), in which he envisaged taking shots of mining sulphur as well as of the convoy transporting the material to the site. The records for this film are fragmentary but do contain intriguing clues to its intended range, including a proposal for a shot of praying mantises mating.

71. *Lake Edge Crescents—Egypt Valley, Ohio* (*Hanna Coal Reclamation Project*) (never built), October 1972; water, earth, limestone, crown vetch; diameter 750', jetty 4' high, water 5' deep

Smithson started visiting industrial sites and quarries in New Jersey as early as 1960. In 1967 he wrote "The Monuments of Passaic" in which he analyzed ruins of the present, and a year later he began his Nonsites, such as "Line of Wreckage," Bayonne, New Jersey and Oberhausen, Germany, which dealt with industrial fill and waste. He made *Asphalt Rundown*, Rome, in 1969 for an eroded cliff in an abandoned quarry, and situated the *Spiral Jetty* (1970) in one of the United States's great dead saline seas near abandoned oil rigging. Yet he did not then view his art as an effort to reclaim devastated land. Rather, the Earthworks used wasted areas as backdrops for focusing on the theme of entropy. To have made the Earthworks positive contributions to the landscape at the outset would have defeated his original purpose—to focus on the ruins of industry, on the changes modern man is able to make in his environment which equal in scale the upheavals wrought by geologic forces of former ages. Earthworks aimed at reversing this process would have been viewed as affirmations of modern man's ability to control his world, to wipe out the urban blight and industrial decay he has created, and to turn waste areas into simulacra of virginal landscapes. Smithson's early Earthworks were not affirmations of progress, they were nonpartisan records of industrialization which pointed to usually ignored scarred areas.

When he created the *Spiral Jetty*, Smithson hoped to construct a museum near the site in which he would build an "underground cinema," literally, for projecting the *Spiral Jetty* film. At that point he verged on repositing the focus of his Earthworks. The dialectic formerly established between Site and Nonsite still existed, but its range was shortened: the Nonsite was brought into closer proximity with the Site. In works such as *Spiral Jetty*, Smithson, rather than subtracting from the Site, relocated elements of it. The work is not so much a reevaluation of a landscape through art as it is an integration of art with landscape. *Spiral Jetty* is a sculpture in flux which partially renounces its objecthood while it is subject to the changing water level of the lake and the spiraling aggregation of salt crystals that sometimes blanket its edges.

The ideas concerning land reclamation which are incipient, even ambiguous, in *Spiral Jetty* are developed in *Broken Circle/Spiral Hill*, built in 1971 in Emmen, Holland. Because Smithson did not wish to create an object in a park, he looked for uncultivated land that would serve not so much as a frame as an integral part of the Earthwork, and eventually sited the work in an abandoned sand quarry. When the people of Emmen were so pleased with his *Broken Circle/Spiral Hill* that they voted to maintain the work permanently, Smithson began to consider the possibility of altogether avoiding the traditional art network. His next step was to pursue the idea of working with mining firms and quarry owners to "reclaim" land as art.

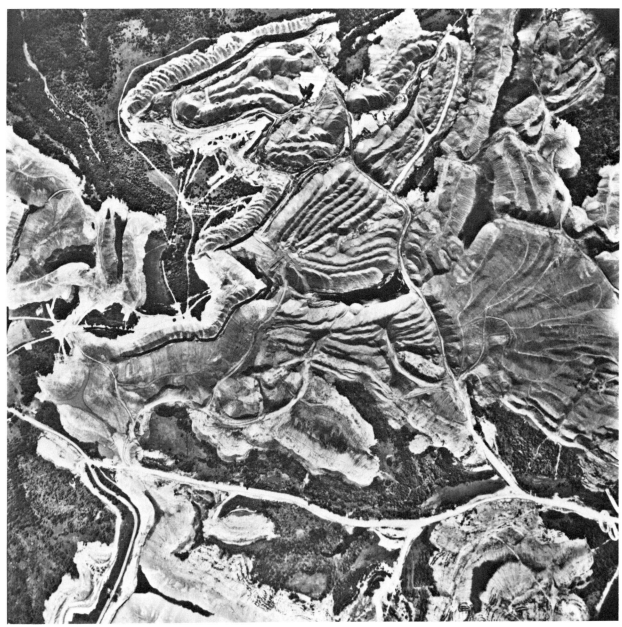

Aerial photograph of a strip mine in Ohio. Photograph courtesy Estate of Robert Smithson.

In 1971, soon after he completed *Broken Circle/Spiral Hill*, Smithson drafted the first reclamation statement calling for the "recycling" of natural resources through Earth art.[64] He maintained that art could mediate between the ecologist and the industrialist, although he did not specify how. He later explained, in numerous letters to corporate heads, that Earthworks could provide a redeeming focus to reclamation projects. Rather than at-

tempting to create images of paradise—an impossible task—corporations could reclaim large portions of land by creating grazing land or recreation areas for skiing and boating and leave the tailings ponds, steep-walled water impoundments, and deep pits to Earth artists who would make them focal points on which people could reflect about devastation—in much the same way that they contemplate natural forces in the Grand Canyon. In a proposal "for the reclamation of a strip mine site in terms of Earth Art" (1972), he elaborated his original

[64]See "Untitled, 1971," in *Writings*, p. 220.

concept. "Art," he wrote, "should not be considered as merely a luxury, but should work within the processes of actual production and reclamation."[65]

The year 1972 was a most important one for Smithson. During that time he worked almost continuously to find commercial support for land reclamation art. Early in that year the impetus for seeking a commission was increased when he was invited by Bertram S. Katz of the Ohio State University College of the Arts to participate in the first International Conference of Visual and Performing Arts in Higher Education (April 2–8, 1973). The invitation was most likely prompted not only by Katz's genuine admiration of Smithson's art but also by the furor then ensuing in the state of Ohio around a strip-mining reclamation bill pending since October 1971 and finally coming to a vote in April 1972.

The Ohio bill represented possibly one of the toughest and most comprehensive attempts to reduce devastation of natural resources by strip mining. According to the bill, miners, after stripping an area, would have to restore the land's original contour. A provision of the bill which was hotly debated required miners to backfill canyonlike high walls because of the acid pollution occurring when embankments of exposed coal come into contact with air. Although the final bill was tough and restrictive, part of its severity was lessened by an amendment that allowed miners to evade the backfilling requirement if they could show a viable use for the strip-mined land (among the possibilities were water-oriented real estate development and recreational area improvement). Senator Harry Armstrong, a Republican from Logan County, Ohio, praised the provisions that restricted the grade of high walls to no more than 35 degrees, and mentioned that he had called in soil and water management experts who stressed both water impoundment and aesthetics over costly backfilling. A month after Armstrong made his statement, Smithson met with the senator about a proposal for land reclamation art.

Recounting his meeting with Armstrong in a letter proposing a land reclamation art project to Ralph Hatch, president of Hanna Coal Company (which had strip mined the Egypt Valley in southeastern Ohio), the artist wrote: "The director of the conference, Professor Katz, contacted Senator Harry Armstrong, and the Senator and I met together last month. The Senator liked my idea, and put me in contact with the Ohio Reclamation Association. On June 6, 7, 8 I toured the Peabody and Hanna Mines with Ed Kohl and Donald Richter in order to find a site for my work. . . . Donald Richter took me to the Egypt Valley," he continued, "the 1000 acre tract that is slated for future recreation use. I felt I could incorporate a work in that site with the help of Hanna Coal as the direct sponsor."[66]

Smithson's letter to Hatch clearly reveals the direction of his thinking during this important time. Aware that in 1972 the cause of the environmentalists was garnering media support, the artist counseled Hatch:

> Even if reclamation is done it lacks the visual impact of the actual operational mining—one tends to focus on the negative visual aspects of the Gem of Egypt [the company's gigantic earth-stripping machine]. A restored woodland is just not visually interesting to the press. An Earth Sculpture, on the other hand, would provide a focus that would have positive visual value, and call attention to the surrounding reclamation process. A park without a visual focus is simply dull, and has no effect on public opinion. Future production uses which involve natural resources (farming, grazing, reforestation) should be combined with a better sense of the visual.[67]

Hanna Coal's "Gem of Egypt" was operated continuously. It was the Tyrannosaurus Rex of power shovels, measuring twenty stories in height, weighing 7,000 tons, and having a bucket capable of holding 130 cubic yards of earth. Smithson mentioned in his letter that he chose Egypt Valley because he believed its scale to be appropriate to his art, and he thus indicated his desire to make monumental work. In the passage quoted above, he reveals that he did not intend Earth art to become a substitute for land reclamation, but rather to remain auxiliary to it—a focal point in the dialectic of devastation/reclamation.

In the letter to Hatch, Smithson asked for a nominal fee for his sculpture. He pointed out that in return for the commission he would provide not only an important and monumental work that could rival the devastation of the Gem of Egypt but also his own press coverage: "Publicity will be international before becoming local," he declared. Even before seeking the commission from Hanna Coal, he made certain that Lawrence Alloway, who was writing a major article on him for publication in *Artforum,* would be willing to include a chronicle of the building of the Egypt Valley piece.

Evidently, the president of Hanna Coal did not respond at once to the letter because Smithson wrote an exasperated note to Katz at the end of the month reporting that he had not heard from Hatch even though the proposal had been mailed two weeks before. Smithson did, however, go ahead with plans for the Egypt Valley

[65] "Proposal, 1972" in *Writings,* p. 221.

[66] Letter to Ralph Hatch, June 10, 1972. Smithson papers, Collection Estate of Robert Smithson.

[67] Ibid.

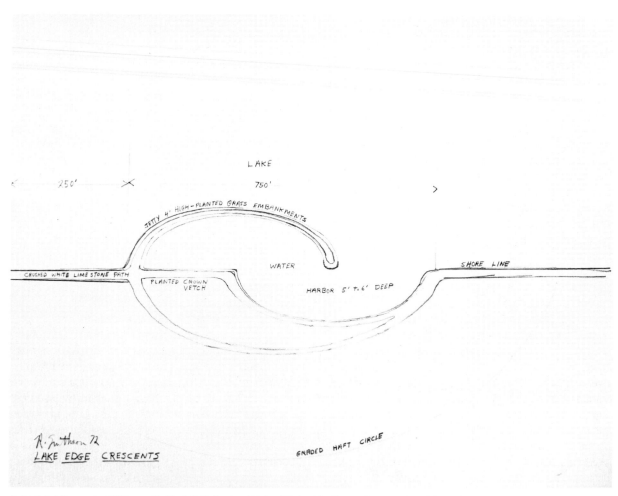

Lake Edge Crescents, 1972; pencil; 19 x 24″. Collection Estate of Robert Smithson, Courtesy John Weber Gallery. Photograph by Nathan Rabin.

project. On October 4, he mailed Hatch two drawings and a letter outlining the materials required: ''I would need the use of 3 dump trucks, 2 draglines and a bulldozer for grading. I would also like to work with the Ohio Reclamation Association on grass planting and path making. The project could be completed in 2 weeks.''[68]

The design for *Lake Edge Crescents—Egypt Valley, Ohio (Hanna Coal Reclamation Project)*, as Smithson preferred to call it, is formal and almost traditional. Smithson chose to create an Earthwork that largely simulates the orientation of landscape architecture. The piece draws on both the precision and the curving jetty of *Broken Circle*. A little over five times as large as that work, however, *Lake Edge Crescents* would have been an extension of the landscape—a park rather than an object in a garden. The materials that Smithson chose for

[68] Letter to Ralph Hatch, October 4, 1972. Smithson papers, Collection Estate of Robert Smithson.

this piece, including limestone and crown vetch, have played an important role in Hanna Coal's activities. The limestone undoubtedly would have come from Hanna's Georgetown, Ohio, operation, which produces the rock in addition to marketing the seed resulting from the company's crown vetch cultivation projects.

Smithson was aware that, of large corporations in the United States, Hanna has had one of the best reputations for consistent and judicious land reclamation. Beginning its operations in eastern Ohio in 1940, Hanna started a year later to reclaim mined land by planting trees (primarily locust) which when mature are used as ceiling timbers in its deep-mining operations. During the late 1960s the company reclaimed more than 2,500 acres a year, and by 1971 it had returned to cultivation and recreation more than 33,000 acres of land it had mined in eastern Ohio. About 15,000 of these reclaimed acres were planted in crown vetch, a native European legume with an intricate root system that can prevent soil erosion

and that thrives in the Ohio climate. First used as a ground cover on Hanna land in 1951, crown vetch, a hardy perennial that radiates a beautiful lavender color in summer and enriches land by returning nitrogen to the soil, was in 1958 discovered to be an excellent pasture for cattle.

Smithson had assembled a file on Hanna Coal which contained the company's public relations brochures recounting the virtues of crown vetch for land reclamation. So his intended use of the legume in *Lake Edge Crescents* should be viewed as a conscious reference to a symbol of successful reclamation procedures properly applied. *Lake Edge Crescents,* situated on the banks of an artificially created lake (most probably a flooded strip-mining site), would have served as a compelling lens through which to view the changes wrought on nature. The sculpture—with its precise design of carefully ordered geometric parts covered in reclamation grass—would have emphasized the delicate balance achieved by man in his attempts to repair his devastation of the land.

Smithson carried over the basic schema of *Lake Edge Crescents—Egypt Valley, Ohio* to two other never-constructed projects: *Lake Crescents—Forest Park South, Illinois* (1972/73), which was to be placed in swampland adjoining a new city, and *Coastal Crescents—Salton Sea Project* (1972). This continuation of the ideas originally evolved for the Egypt Valley project, rather than signifying a poverty of imagination, attests to the artist's pertinacity during a time of repeated disappointments. The reapplication of the *Lake Edge Crescents* design to other terrains is indicative of Smithson's working method. While many of his projects were suited to specific sites, and some, like *Spiral Jetty,* could not be realized in another location without a fundamental loss to the work's significance, other concepts such as the design for *Lake Edge Crescents* were generalized enough that they could accord with vastly different terrains. While the design itself was abstract, the choice of building material—crown vetch in the Egypt Valley, white gravel in the Salton Sea area—became the significant factor in localizing the work.

Most of Smithson's land reclamation proposals did not receive commercial backing (only two, *Lake Crescents—Forest Park South, Illinois* and *Tailing Pond,* Creede, Colorado, received promises of funding), and it is interesting to speculate why mining corporations failed to see the potentials of Earth art for their operations. Economics and public favor were on art's side, but the corporations proved unyielding. Most companies' policy is to provide an ingratiating image of paradise as the result of successful land reclamation—an image of land they often promote as more idyllic and fertile than

the original untouched site was. The public relations pamphlet on Egypt Valley which Smithson had on file should have indicated Hanna's orientation to him. The brochure decrees that the land will be restored to its maximum usefulness—a flourishing area, treed and grassy, providing income from cattle and lumber, recreational lakes, and even ski runs. What it promises is a halcyon retreat, a summer and winter vacationland more glamorous and profitable than nature itself can provide. Smithson might well have asked himself, as the managers of Hanna Coal may have asked themselves: where is the need for Earth art in the recreational paradise Hanna is promising? The corporation may have realized that reclamation art does not entirely gloss over the problems of strip mining, that, in fact, Smithson's work emphasized the changes, establishing and maintaining a dialectic between industrial ravage and bucolic reclamation, acting as a fulcrum to keep in suspension the two opposing states.

When Smithson made his proposal to the president of Hanna Coal, he probably thought he would be successful in having it accepted. On his side he had the important conference on higher education which was to be held at the state university the following year, the possibility of international publicity, and the promised aid of Alloway and *Artforum.* Furthermore, the press was beginning to bear down on strip miners. Less than a week after Smithson sent his proposal to Hatch, in its October 9 issue *Newsweek* ran a major article about the Powder River Basin and Fort Union land formations of Wyoming, Montana, and North Dakota, where the richest deposits of coal ever discovered—plus large amounts of oil and uranium—were located. The mineral and surface-mining rights to these deposits had been bought up largely by Peabody and Consolidation Coal, and plans had been laid for the development of the largest power operation in the world—a 53,000-megawatt complex between Colstrip, Montana, and Gilette, Wyoming. A battle between environmentalists and industrialists was imminent. The issues were inflammable, and George McGovern, speaking in support of the ecological cause, struck sparks when he referred to strip mines as "gaping wounds that never heal." If ever a coal mining corporation would look for positive press concerning land reclamation, it seems that the fall of 1972 would have been the time. The controversy in the West seems to have had the reverse effect, however, and corporations maintained a low profile.

Undaunted when Hanna did not commission *Lake Edge Crescents,* Smithson joined forces with his friend Timothy Collins, then president of Collins Securities Corporation of New York City. Collins, an active mem-

ber of the Friends Council of the Whitney Museum of American Art in the early seventies, had met Smithson in 1972 on a tour taken by the Friends to the artist's studio. Discovering that they shared a common interest in mining and land reclamation, the two had struck up an acquaintance that quickly developed into a close friendship. Collins became an enthusiastic supporter of Smithson's art. He helped Smithson organize a prospectus that included a statement on Earth art and mining reclamation, excerpts from press reports, designs for *Lake Edge Crescents* (retitled *Reclamation Project for Open-pit Mine*), photographs of *Spiral Jetty* and *Broken Circle,* and an in-depth biography of the artist, including a list of his exhibitions and collections, his articles and other writings. In a cover letter Collins emphasized the practicality of Smithson's solutions for land reclamation. The entire packet was sent to approximately fifty heads of industries and mining concerns (many of whom were Collins's friends) during the period from December 1972 to June of the following year. The proposals went to such companies as Kennecott Copper Corporation, Anaconda Company, U.S. Steel, International Minerals and Chemicals, Union Carbide, and Peabody Coal. After the initial siege of letters, Smithson followed up all responses. Peabody Coal, which had received negative press in fall 1972 concerning its mining rights to the Powder River Basin deposits and Fort Union formations, replied to Smithson's land reclamation proposal. Unfortunately, no commission resulted. Evidently Peabody's interest waned after the first response, and Smithson never even submitted a proposal for a specific piece.

On March 1, 1973, the artist had written to W. G. Stockton, vice president of public relations for Peabody Coal, asking for a six-month contract at a modest salary of eight hundred dollars per month. At that point he cared little for money; he wanted only to create his Earthworks. And he also wanted access to the resources of large companies like Peabody—their vast tracts of ravaged land and monstrous earth-moving vehicles. In his letter to Stockton, Smithson attempted to sell his ideas in as realistic and pragmatic a manner as possible; he pointed out how Earth art could advance the company's interests. Not an idealist and certainly not a guardian of the rarefied precious art object, Smithson assumed the tone of one businessman addressing another:

> I would also add that Earth Art as a part of the reclamation process would give the landscape a higher economic value in terms of real estate. Waste land is thus converted into something practical and necessary, as well as becoming good to look at. It would provide the company with a public image which would go far beyond any defensive advertising. This is a kind of art that anybody can understand. Also, if I build an Earth Sculpture in a remote strip mine region, I can make it public, as I have done before by documenting the work with photographs and movies, which then will be exhibited in a museum or a gallery or on television.[69]

The voice he uses to articulate his ideas in these proposal letters is self-assured, the voice of a maker of national icons such as *Spiral Jetty*. No longer is his audience limited to the small insular art network of the East Coast: his field is national and his means for distribution are the mass media. Art may be private and inaccessible to many, but the media are readily available for disseminating news about it. Smithson had employed the media before with success, and he could employ them again. While his language in these letters is geared to his correspondent, the confidence he exudes is his own. Smithson, a man of his time, became increasingly aware that the artistic process had gained another step. No longer were ideas simply generated and executed (for example, sketched and built); in the present-day world they also had to be communicated via mass media.

Aware that an artist must forge into uninvestigated and undeveloped areas, Smithson also realized that artists also must restructure the past to create a tradition sympathetic to their art, or at least emphasize possible sources by making a tradition out of what was previously incipient. Attempting to bridge the long-standing boundaries between sculpture and gardening, Smithson found that he had to expand the domain of landscape architecture. When, in 1972, the Whitney Museum sponsored an exhibition of the work of Frederick Law Olmsted, Smithson discovered his precursor. He compared the nineteenth-century desert in the center of Manhattan which Olmsted turned into Central Park with the strip-mined wastelands he wished to reclaim through his Earthworks. Interested in both Olmsted the man and Olmsted the landscape architect, Smithson found him an important role model because he had managed to create Central Park under almost impossible conditions resulting largely from the self-interest of politicians and businessmen. This artist of political savvy and business acumen also impressed Smithson as the foremost American practitioner of the picturesque.

Olmsted's ties with the eighteenth-century English conception of gardening, particularly with the ideas of Uvedale Price and William Gilpin, are investigated by Smithson in "Frederick Law Olmsted and the Dialectical Landscape," published in *Artforum* in February 1973.

[69] Letter to W. G. Stockton, March 1, 1973. Smithson papers, Collection Estate of Robert Smithson.

In one section of the essay Smithson quotes liberally from Price, noting that "some of our present-day ecologists, who still see nature through eyes conditioned by a one-sided idealism" should look at Price's discourses on the picturesque. The passage Smithson extracts deals with a smooth green hill gouged by a flood. Price describes how time and nature can soften the initial gash in the landscape, giving the effect of picturesqueness. Other locales capable of becoming picturesque, Price notes, are quarries and gravel pits.[70] In Smithson's essay, Olmsted's work is read as a historical basis for Earthworks, and the picturesque a means of establishing an ongoing dialectic between landscape and man-wrought changes. "Dialectics of this type" (that is, those established in the theories of Price, Gilpin, and Olmsted which are rooted in the physical landscape), Smithson asserts, "are a way of seeing things in a manifold of relations, not as isolated objects. Nature for the dialectician is *indifferent* to any formal ideal."[71]

In his essay Smithson denigrates fashionable ecological idealism. He deplored books like Charles Reich's *Greening of America* and was disgruntled by "modern day ecologists with a metaphysical turn of mind [who] still see the operations of industry as Satan's work" and who still lament a lost paradise.[72] The purpose of his essay is realized: Olmsted is rendered a worthy prototype of land reclamation (he is referred to as "America's first 'Earthwork artist' ") and the picturesque—that eighteenth-century aesthetic category that Price located between beauty and sublimity and whose character is variety, intricacy, and partial concealments—serves as an adequate historical framework for Smithson's own ideas concerning the American landscape of the late twentieth century.

The picturesque presents an important alternative to aesthetic categories of the Beautiful and the Sublime. Throughout most of the twentieth century, aesthetic categories, such as "beauty," have been held in low esteem. Beauty, like taste, has been considered an out-of-date standard, more appropriate to a period of orthodoxy and reaction than to one of continual change and experimentation. During the 1940s the Sublime as an aesthetic category was resurrected by a number of New York Abstract Expressionists, notably Robert Motherwell, Barnett Newman, Mark Rothko, and Clifford Still, who were concerned with creating an art that could elicit the strongest aesthetic feeling viewers were capable of experiencing. Sympathetic to a more low-key attitude toward art, Smithson did not attempt to construct sculpture capable of creating sublime reactions, for such an art in the sixties and seventies was melodramatic. Preferring the diminished feelings of his age while also rejecting the awe of terror associated with the Sublime, Smithson found a viable alternative in the tradition of the picturesque. As a framework for Earth art the picturesque had distinct advantages since it had been associated with aspects of nature and gardening: serving to direct the viewer's attention to ongoing changes in the landscape, it was an eminently realistic aesthetic which could be reoriented to the land reclamation projects of interest to Smithson.

72. *Lake Crescents—Forest Park South, Illinois* (never built), 1972/73

Thirty-five miles from Chicago, a city was to be built from scratch by the Park Forest South Development Company. Because the city was surrounded partially by swampland, and because the president of the company was an art collector, Lewis Manilow, the developers decided to employ an Earth artist to reclaim what for them was unusable acreage. Advocated by Manilow and insisted upon by Walter Kelly, a Chicago art dealer, the choice of Smithson for the commission was strongly favored. Smithson was, in fact, still working on this project at the time of his fatal accident.

Lake Crescents represents an elaboration of the the ideas Smithson developed in his *Broken Circle* in Emmen, Holland. The experience of having the people of Emmen mandate his *Circle* a permanent work led Smithson not only to pay more attention to his prospective audiences but also to begin to think of Earthworks as radical variations on the concept of public parks. He began to conceive of his large-scale outdoor land sculptures as recreational areas themselves instead of public monuments placed in parks.

According to his new consciousness of his audience and to his continuing attention to the indigenous materials of his site, Smithson designed an Earthwork that would have become the property of Forest Park South (the town would have paid for its upkeep) and whose essential component was the peat of the bog that comprised the designated site. His basic plan (shown in a drawing of 1972, which, according to Manilow, constitutes a concept for only a portion of the several acres of bog involved) called for digging up the peat and with it forming a graded slope next to the lake that gives the work its title. Along the slope he intended to plant a

[70] "Frederick Law Olmsted and the Dialectical Landscape," in *Writings*, pp. 118–19.
[71] Ibid., p. 119.
[72] Ibid., p. 120.

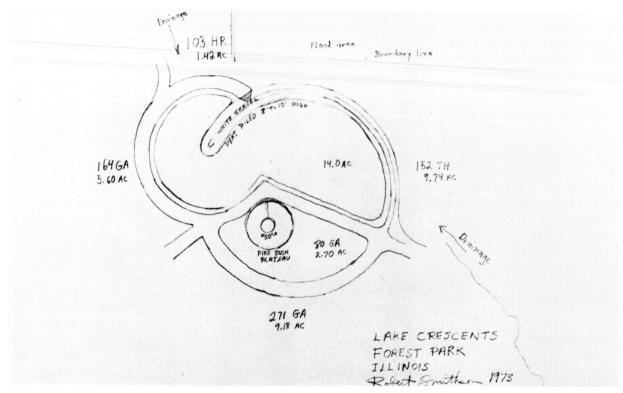

Lake Crescents—Forest Park, Illinois, 1973; pencil; 19 x 24″. Collection Estate of Robert Smithson, Courtesy John Weber Gallery. Photograph courtesy Estate of Robert Smithson.

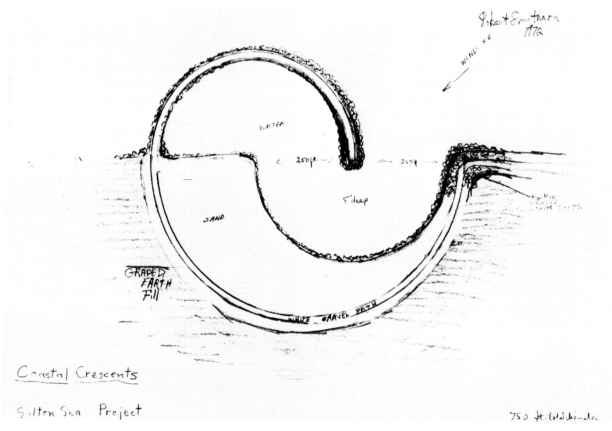

Coastal Crescents—Salton Sea Project, California, 1972; pencil. Collection Roger Davidson. Photograph courtesy John Weber Gallery.

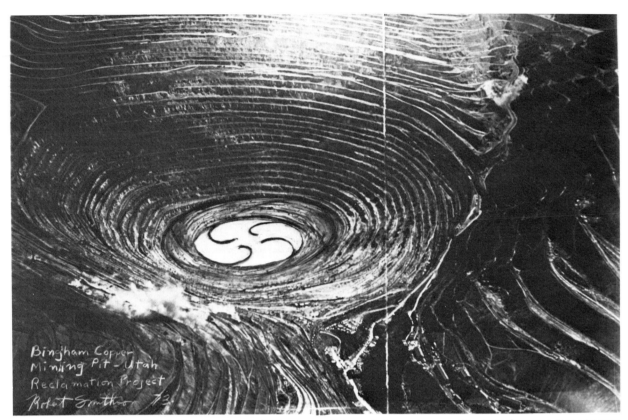

Bingham Copper Mining Pit—Utah Reclamation Project, 1973; wax, pencil, tape, plastic overlay, map; 20 x 30½". Collection Elmer Johnson Photograph by Nathan Rabin.

shrub that would seasonally turn red, giving the site an intense fiery character. The piece, with its cone-shaped hill forming the highest point in the landscape, would have provided a focus the new city lacked. (The work was never constructed, but Forest Park South is now a town of between six and seven thousand residents.)

The design of *Lake Crescents* is very similar to those plans Smithson conceived during the same time for the Egypt Valley, Ohio, strip mine site (*Lake Edge Crescents*) and for *Coastal Crescents—Salton Sea Project*, California (1972), which was to be a circular, comma-shaped jetty, 750 feet in diameter, bordered by sand, a white gravel path, and graded earth fill. These pieces have strikingly similar formats with their component materials rooting each to its specific site. The similarity suggests an abstract dimension in Smithson's work and indicates that, in the seventies, his art was becoming more universal, less tied to the circumstances of location.

73. *Bingham Copper Mining Pit*, Utah (never built), 1973

Two drawings record Smithson's ideas for the Bingham Copper Mine, a three-mile wide gaping hole in Utah, which is one of the richest deposits of copper, molybdenum, and gold in the world. Smithson seemed to have thought that Kennecott Copper Corporation, owner of the mine, was interested in his ideas for land reclamation through art, which his friend Timothy Collins had sent out in an assembled press packet. According to Nancy Holt, Smithson based his optimism in part on a rumor that the federal government was going to force Kennecott to fill its monstrous hole or somehow turn it into a resort area. The company in fact showed no interest in Smithson's proposal. We must assume that Smithson made his drawings early in 1973, before he knew of

the company's negative responses dated January 16 and February 8.

In addition to the rumor that the time was auspicious for a reclamation project at Bingham, the historical importance of the mammoth strip mine may also have appealed to Smithson. The modern copper industry originated at Bingham when, in the beginning of the century, Daniel C. Jackling, an engineer, demonstrated the commercial feasibility of producing copper from low-grade (containing only about 2 percent copper) ore by surface mining and mass-production processing.

Smithson's design calls for a revolving wheel motif at the base of the circular amphitheater of the mine; large portions of the pit would have been left unaltered. The base design would have capped off the terraced pit and gathered the circular forces of the strip cuts into a pattern

that could be viewed alternately as their origin or their centripetal culmination.

If the Bingham Mine had been reclaimed through art, it would have been, in terms of its scale, the Grand Canyon of Earthworks.

74. *Tailing Pond, Creede, Colorado* (never built), 1973

Of all the land reclamation Earthworks that Smithson proposed during the last two years of his life, the one with the greatest probability of being built had he lived was the ambitious *Tailing Pond*, commissioned by Charles Melbye of Minerals Engineering Company,

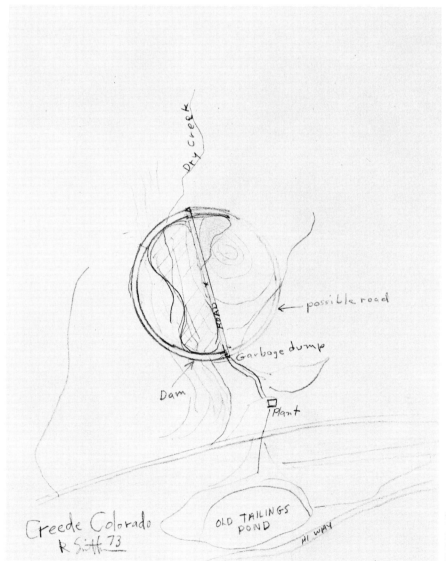

Creede, Colorado (Tailing Pond), 1973; pencil; 12 x 9″. Collection Estate of Robert Smithson, Courtesy John Weber Gallery. Photograph by Nathan Rabin.

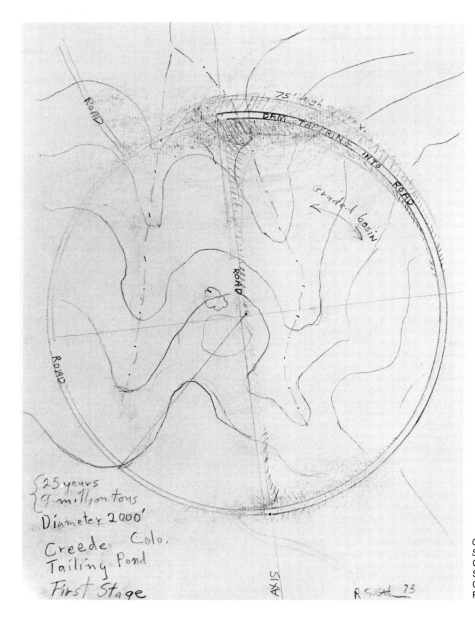

Road

75' high

DAM TAPERING INTO ROAD

Graded basin

ROAD

Road

25 years
9 million tons
Diameter 2000'
Creede Colo.
Tailing Pond
First Stage

AXIS

R Smith 73

Creede, Colo. Tailing Pond First Stage, 1973; pencil; 12 x 9". Collection Estate of Robert Smithson, Courtesy John Weber Gallery. Photograph by Nathan Rabin.

headquartered in Denver, Colorado. Without doubt the major reason why this commission would have been realized is that Smithson's close friend and staunch supporter Timothy Collins, then president of Collins Securities Corporation of New York City and later president of United Mining Corporation, was a major shareholder in Minerals Engineering.

Tailing is the residue or dross separated in the preparation of various ores. Often tailings take the form of a sludge, if a flotation separation process is employed in preparing the ore. Because traces of valuable minerals can be found in the tailings—they remain because a process for their separation has not been invented or is currently economically unfeasible—the sludge is stored in

dry ponds which are readily accessible for resifting. Until circumstances change making future separation a likely venture, tailings are a paradigm of entropy—and their unavailable energy, without doubt, was noted by Smithson.

For *Tailing Pond* the artist suggested creating a dam approximately 75 feet high with a gradual grade that sloped off to one side. The dam would taper into a road and together they would make the pond a circular configuration. Then he intended to bisect the pond with another road. Over the years tailings would be terraced in a series of berms, endowing the work with a dynamic stepped appearance that would be accentuated by the forceful swath of the bisecting road. On a drawing of the proposal

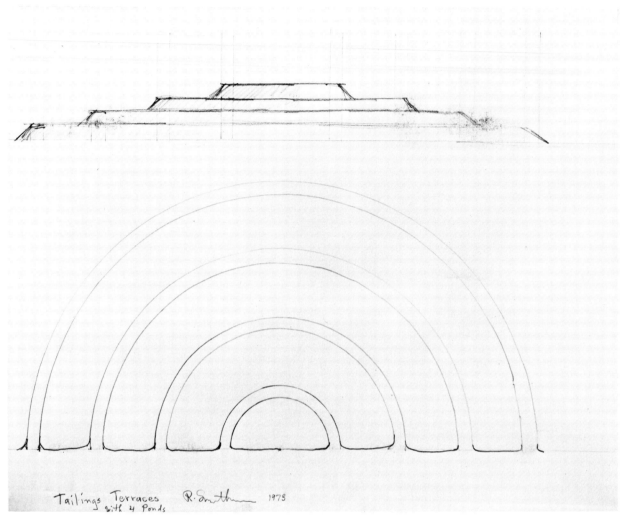

Tailings Terraces with 4 Ponds, 1973; pencil and charcoal; 19 x 24″. Collection Estate of Robert Smithson, Courtesy John Weber Gallery. Photograph by Nathan Rabin.

Smithson indicated the scale he had in mind, noting "25 years, 9 million tons, Diameter 2000′ . . . First Stage."

Before arriving at a solution that Collins has since termed not only feasible but also eminently practical, Smithson considered two alternatives. One labeled the *Garden of Tailings*, presents a design of curving semicircular spokes radiating from a central hub, similar to the project for the Bingham Copper Mine. The other plan accords with Smithson's numerous meander and sprawl designs; it calls for random piles of tailings no more than five feet high to be spread in a circle, and, between the piles, irregular pathways to be provided. His final solution is more architectonic and rigid, and less obviously designed. Composed of austere stepped berms, it resembles the massive Neoclassic renderings of such eighteenth-century architects as Ledoux.

Even after Smithson's death and as late as April 1975, Collins seriously considered having Nancy Holt and Richard Serra commence Smithson's design for *Tailing Pond,* Creede, Colorado, a project taking twenty-five years for completion. On October 2, 1973, Holt wrote to Collins suggesting the possibility of completing the project. "I see it as functional or necessary aesthetics," she emphasized, "not art cut off from society, but rather an integral part of it."[73]

From the point of view of a conservationist, Smithson's sculpture would not represent a substantive practical recycling of the land. Admittedly, his intent in *Tailing Pond* was not a functional one. While he did wish to take art out of its ivory tower and relocate it in the real

[73] Smithson papers, Collection Estate of Robert Smithson.

world, he still wished to make art. Never did he intend to forsake his role as an artist to become an environmentalist. He was creating potent images of a postindustrial world. Using tailings he made a new type of garden, a totally man-made one of industrialization and technology. In works like *Tailing Pond* Smithson was not a moralist bemoaning man's fate in the late twentieth century; neither was he an advocate of irresponsible land use. He was a realist who wished to deal in all his work with actuality, to make art of industrial waste, sludge heaps, tailings, suburbs. In his art he indicates that the present-day world is his raw material, not his creation. He uses industrial waste and largely ignored urban blight as his materials because they provide a potency and contemporaneity unavailable elsewhere. They also have the distinct advantage of being paradigmatic images of entropy. The materials themselves manifest meaning, leaving Smithson free to organize these ready-made signifiers into clearly conceived, articulate compositions. Using these peculiarly modern materials, Smithson created an art that is at times ambivalent, at times ironic, but always inescapably relevant.

Sculptures

Unless otherwise noted, all sculptures Collection Estate of Robert Smithson.

Untitled, 1964; fiberglass, aluminum, electric lamp; 60 x 22 x 16″

Untitled, 1964; metal, neon, electric sockets, plug; 28 x 20 x 18″

Untitled, 1964; painted mirror in wood frame

Untitled, 1964; plastic on wood, aluminum stripping; 48 x 42″

Quick Millions, 1965; plastic, aluminum, glitter; 54 x 56″

Untitled, 1966; wood; 13 x 13 x 12″

Untitled, 1966; wood; 13 x 5 x 34½″

Untitled, 1966; steel

Untitled, 1965/66; painted mirror

Death Valley Nonsite, 1968–71; 64 x 15 x 6½″. Collection Dwan Gallery, Inc.

Pierced Meander, 1973; cardboard, woodsticks; 39 x 16 x 10″

Pierced Spiral, 1973; cardboard spiral with woodsticks; 10 x 20″ in diameter

Untitled, 1973; square cardboard box with woodsticks; 10 x 15 x 15″

Untitled, 1973; cardboard spiral; 26½″ high

Films

Untitled (Mono Lake), 1968; Super-8 film made with Michael Heizer and Nancy Holt. Collection Nancy Holt.

Swamp, 1971; 6-minute 16mm film; made with Nancy Holt. Distributed by Castelli-Sonnabend Videotapes and Films.

CHRONOLOGY

The following chronology revises that compiled by Alan Moore for the catalogue to the exhibition "Robert Smithson: Drawings," held at the New York Cultural Center in association with Fairleigh Dickinson University, April 19–June 16, 1974. Revision made by Peter Chametzky, Robert Hobbs, and Nancy Holt.

1938–44

Robert Irving Smithson, born January 2, in Passaic, New Jersey, to Irving Smithson, at the time an automobile mechanic, who eventually became vice-president of a mortgage loan firm, and Susan Smithson (née Duke). Great-grandfather, English emigré Charles Smithson, and grandfather Samuel did the ornamental plasterwork in the New York City subway system (opened in 1904), in the American Museum of Natural History, in the Metropolitan Museum of Art, and in more than one hundred churches. His maternal grandparents, Alexander and Mary Duke (née Miller) were Slavic Austrian-Hungarians who emigrated to the United States at the end of the nineteenth century, settling in Rutherford, New Jersey, where Alexander was a worker in a bleachery. They had five children, Susan Duke being the youngest. (Alexander died when Susan was eight months old, Mary when she was thirteen years old.)

Robert was the only surviving child; in 1936, two years before his birth, nine-year-old brother Harold died of leukemia. Dr. William Carlos Williams was his pediatrician. Born to a Protestant father and Catholic mother, Smithson became a Catholic. He was encouraged by his aunt, Julia Duke, who remained single and lived with the family throughout Robert's life; she was a second mother to him until her death in 1961.

1945

Draws wall-size dinosaur for the hallway of his school.

1948

Family moves to Clifton, New Jersey, from Rutherford, New Jersey, where they had lived since Robert's birth.

Maintains a museum and zoo constructed for him by his father, in the basement of his home.

Plans routes of annual family vacations to Sanibel Island, Florida, Oregon Caves, northern California, Grand Canyon, Yellowstone Park, among others.

1949

Joins Boy Scout troop 23; becomes an Explorer in 1951 and earns a total of nine merit badges.

Robert Smithson's childhood museum of reptiles, fossils, and artifacts, in the basement of his New Jersey home, c. 1948. Photograph courtesy Estate of Robert Smithson.

1952

Visits naturalist Ross Allen's reptile farm in Florida to buy live reptiles. Plans a career as a naturalist. Allen encourages him and takes him on frog and snake hunts.

Makes frequent visits to the New York Museum of Natural History, where he is fascinated by Charles Knight's hypothetical paintings of dinosaurs.

1953

Again visits Allen's reptile farm in Florida.

In his third year at Clifton High School, wins a scholarship to the Art Students' League and begins to study evenings there for two years with John Groth and others. Meets Dick Bellamy, then of Hansa Gallery, Paul Goodman, Meyer Levin, author of *Compulsion,* and his son, Joe.

Frequents Greenwich Village coffeehouses and the Cedar Bar until it closes in 1963.

1956

Studies at the Brooklyn Museum School as well as Art Students' League while he continues to live in Clifton.

Meets the poet Charles Haseloff. One week after Robert's high school graduation they both join the Army Reserves and are assigned to Special Services. Basic training at Fort Knox, Kentucky. Placed in clerk-typist training, but because he showed little aptitude, made artist-in-residence, doing posters for shows and watercolors of the camp.

1957

Obtains an honorable discharge from the reserves on grounds that continued service will ruin his creativity.

Hitchhikes around the United States and Mexico with Joe Levin and high school friend Danny Donahue. Jailed for vagrancy in Mexicali, Mexico, for a few days.

On returning to New York, lives with poet Allan Brilliant on Park Avenue between 97th and 98th streets; later moves into a loft over a synagogue at 27 Montgomery Street with city planner Phil Israel. Paints Abstract Expressionist canvases. His circle of friends includes the painters Edward Avedisian and Robert Sievert and the poets Richard Baker, who later became a Zen priest, and Charlie Bonjourno.

1958

Hitchhikes again in the United States, this time with Phil Israel; visits Pueblo dwellings in New Mexico, witnesses rain dances there.

Designs cover for the first issue of *Pan,* a poetry magazine edited by Brilliant.

1959

Visits William Carlos Williams in New Jersey with poet Irving Layton.

Works at Wilentz's Eighth Street Bookstore; teaches art at Police Athletic League.

Through a mutual friend becomes reacquainted with Nancy Holt (they had met previously as youngsters in New Jersey).

Donahue killed in Brooklyn motorcycle accident.

Exhibitions
One-man show:
First one-man show of paintings, Artists Gallery, Lexington Avenue, New York, October 17–November 5.

1960

Records visit to quarry in Upper Montclair, New Jersey, in drawing.

Moves to 725 Sixth Avenue in the Chelsea area with Phil Israel. Meets Sol LeWitt, who takes his Montgomery Street loft after seeing notice for it in the Cedar Bar. Throws several parties featuring rock'n'roll music; one of these parties is illustrated in Fred McDarrah's book *The Artist's World* (New York: Dutton, 1961).

Collectors John Streep and George Lester buy many of the early paintings and drawings.

In the fall begins seeing Holt, who had moved to New York from Boston after spending three months in Europe.

1961

Aunt Julia Duke dies, April 24.

Visit to Rome (for show at Galleria George Lester) coincides with introspective period during which Smithson reads books on psychology and religion, and becomes interested in Byzantine art.

Exhibitions
One-man show:
Galleria George Lester, Rome.
Group show:
"New Work by New Artists," Allan Gallery, New York, shows paintings, with Ay-O, Rodger Lapelle, Claes Oldenburg.

1962

Partially withdraws from the art world, draws and reads voluminously, and with Holt attends late-night movies on 42nd Street and many underground films (through 1966).

Exhibitions
One-man show:
Assemblages, Richard Castellane Gallery, New York, March/April and Provincetown, summer.

1963

Moves to 799 Greenwich Street, where he lives until his death.

Marries Nancy Holt. Close friend Charlie Bonjourno dies.

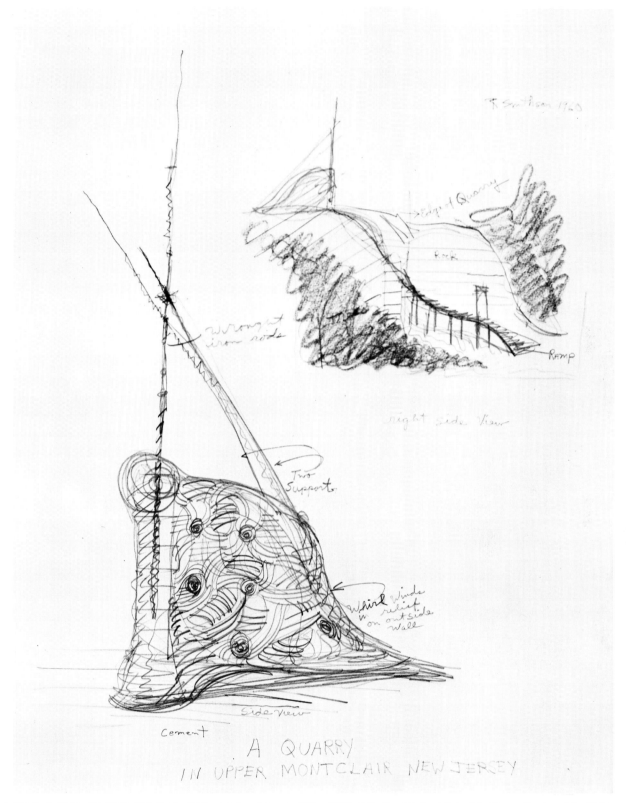

A Quarry in Upper Montclair, New Jersey, 1960; pencil and crayon; 24⅛ x 18⅛". Collection Estate of Robert Smithson, Courtesy John Weber Gallery. Photograph by Nathan Rabin.

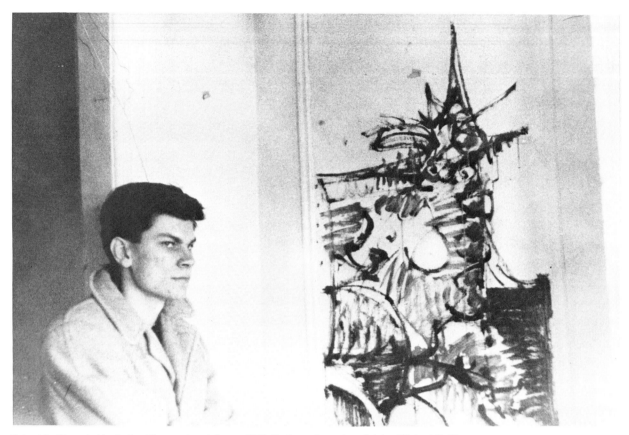

Robert Smithson in his studio with an early painting, c. 1961. Photograph courtesy Estate of Robert Smithson.

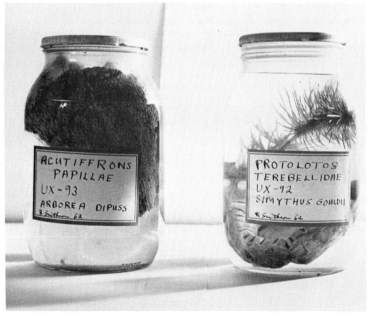

"Biological Specimens" show at the Castellane Gallery, 1962. Photograph courtesy Estate of Robert Smithson.

1964

Begins to write and begins to create what he considers to be his mature work.

Meets Peter Hutchinson.

Major Works of Art
1. *The Eliminator*
2. *Untitled* (purple), 1963/64
3. *Untitled* (yellow and blue)
4. *Untitled* (blue and rose), 1964/65

1965

Brings plastic slab pieces to Dan Graham's John Daniels Gallery; shows in "Plastics" exhibition there. Becomes friendly with Minimal artists showing at Daniels: Dan Flavin, Donald Judd, and Sol LeWitt, and meets artist-writers for *Arts Magazine*. Writes on Judd's work for catalogue of "Seven Sculptors" show at Philadelphia Institute of Contemporary Art.

Meets Carl Andre, Mel Bochner, Clement Greenberg, Eva Hesse, Chuck Hinman, Will Insley, Robert and Sylvia Plimack Mangold, Robert Morris, Brian O'Doherty, Yvonne Rainer, and Ruth Vollmer.

Shows mirror chamber pieces at New York World's Fair, American Express Pavilion.

Exhibitions
Group shows:
"Art '65," American Express Pavilion, New York World's Fair;
"Current Art," Institute of Contemporary Art, University of Pennsylvania, Philadelphia, March 18–May 10;
"Plastics," John Daniels Gallery, New York.

Major Works
1. *Enantiomorphic Chambers*
2. *Four-Sided Vortex*

1966

Begins regular excursions to urban, industrial, and quarry sites in New Jersey, many of which he documents in a photo-journal. Companions on trips from 1966 to 1968 were Andre, Ted Castle, Virginia Dwan, Graham, Michael Heizer, Holt, Joan Jonas, Donald and Julie Finch Judd, Howard Junker, Allan and Von Kaprow, LeWitt, Richard Long, Dale Mc-Conathy, Morris, Claes and Patti Oldenburg, Mary Peacock, John Perreault, and Charles Ross.

Articles published: "The Crystal Land" about a quarry trip with Judd; "Domain of the Great Bear" written with Mel Bochner; "Entropy and the New Monuments"; and "Quasi-Infinities and the Waning of Space."

Becomes friendly with Virginia Dwan; joins Dwan Gallery. Meets Ad Reinhardt, who asks him to help plan "10" show at Dwan Gallery; also meets Lawrence Alloway, Jo Baer, Max Kozloff, Lucy Lippard, and Annette Michelson.

Proposes *Tar Pool and Gravel Pit* as outdoor piece for the City of Philadelphia; it is rejected; shows model at Dwan Gallery.

Speaks at Yale Art Association symposium "Shaping the Environment: The Artist and the City" and as a result is hired as artist-consultant to the architectural firm of Tippetts, Abbett, McCarthy & Stratton which is proposing designs for Dallas–Fort Worth Regional Airport; plans Earthworks on the fringes of the airfield. The firm loses the contract and the works are not built.

Continues to meet with artists at the Daniels Gallery; in evenings frequents Max's Kansas City bar near Union Square with Andre, Bochner, Graham, Hesse, Holt, and LeWitt. (Until the end of his life, Smithson regularly visits Max's and other bars at night. His circle at Max's included over the years many of those friends already mentioned as well as David Diao, Ruth Kligman, Joseph Kosuth, Brigid Polk, Mickey Ruskin, Tony Shafrazi, Larry Weiner, and Ian Wilson and visiting Los Angeles artists John Baldessari, Robert Irwin, and Edward Ruscha.)

Exhibitions
One-man show:
Dwan Gallery, New York, December 1966–January 1967.
Group shows:
"American Abstract Artists, 30th Annual Exhibition, 'Yes-

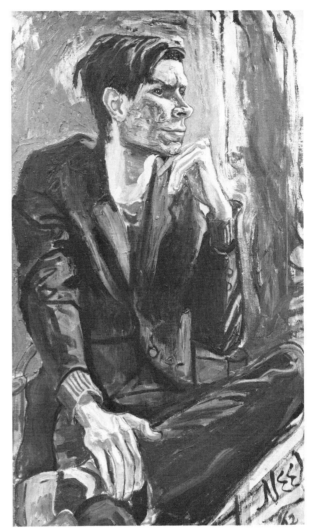

Alice Neel, *Portrait of Robert Smithson*, 1962; oil on canvas; 40 x 24½″. Photograph by Eric Pollitzer, Courtesy Graham Gallery.

terday and Today,'" Riverside Museum, New York, September 25–November 27;
"Art in Process: The Visual Development of a Structure," Finch College Museum of Art, Contemporary Study Wing, New York, May 11–June 30;
"Multiplicity," Institute of Contemporary Art, Boston, April 16–June 5;
"New Dimensions," A. M. Sachs Gallery, New York, with Peter Hutchinson, Donald Judd, Sol LeWitt, May 10–May 28, 1966;
"Pattern Art," Betty Parsons Gallery, New York;
"Primary Structures," The Jewish Museum, New York, April 27–June 12;
"10," Dwan Gallery, New York, October 4–29;
Three-person show, Park Place Gallery, New York, with LeWitt, Leo Valledor;
"20," Park Place Gallery, New York;
"Whitney Sculpture and Prints Annual," Whitney Museum of American Art, New York, December 16, 1966–February 5, 1967.

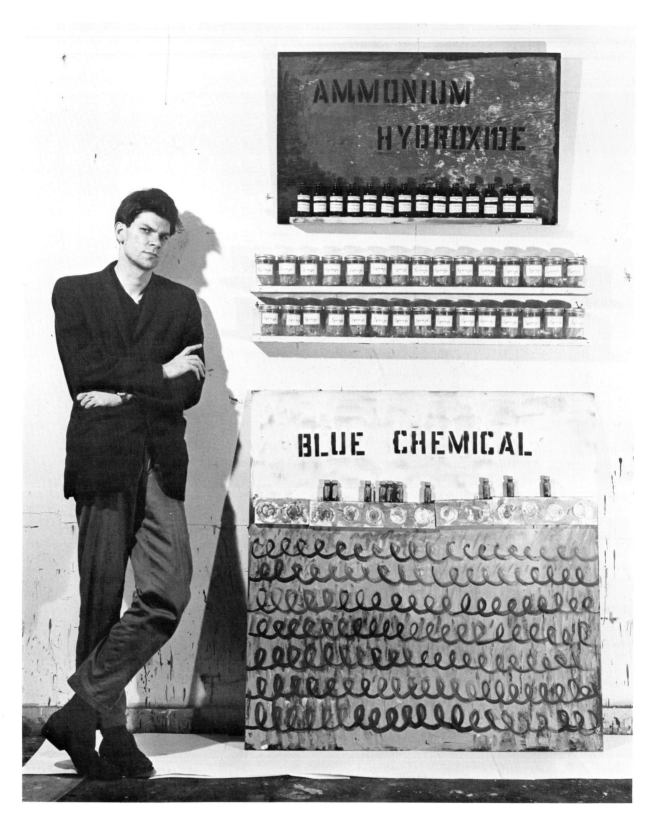

Robert Smithson with works shown at Castellane Gallery, New York, 1962. Photograph courtesy Estate of Robert Smithson.

Fling, 1965; plastic panel on wood, aluminum stripping; 48 x 42″. Collection unknown. Photograph by John A. Ferrari.

Major Works of Art

1. *Cryosphere*
2. *Alogons*
3. *Plunge*
4. *Tar Pool and Gravel Pit,* proposal for Philadelphia
5. Proposals for Dallas–Fort Worth Regional Airport
6. *Terminal*

1967

Meets Philip Leider, Dennis Oppenheim.

Articles published: "Towards the Development of an Air Terminal Site"; "The Monuments of Passaic."

Exhibitions

Group Shows:

"American Sculpture of the Sixties," Los Angeles County Museum of Art, April 28–June 25, Philadelphia Museum of Art, September 15–October 29;

"Art in Series," Finch College Gallery, New York, November 22–January 6, 1968;

"Art on Paper," Weatherspoon Art Gallery, University of North Carolina at Greensboro, October 15–November 22;

"Focus on Light," New Jersey State Museum, Trenton, May 20–September 10;

"Form, Color, Image," Detroit Institute of Arts, April 11–May 21;

"Language to Be Looked at and/or Things to Be Read," Dwan Gallery, New York, June 3–30;

"Monuments, Tombstones, and Trophies," Museum of Contemporary Crafts, New York, March 17–May 14;

"New York Group," Dwan Gallery, New York;

"Scale Models and Drawings," Dwan Gallery, New York;

"10," Dwan Gallery, Los Angeles, May.

Major Works of Art

1. *Mirage*
2. *Glass Stratum*
3. *Shift*
4. "The Monuments of Passaic"

1968

Meets Vito Acconci and Michael Heizer; goes with Heizer to Connecticut, New Jersey, Nevada, and California to gather rocks for Nonsites. Makes a super-8 movie at Mono Lake with Heizer and Holt which in part anticipates the film *The Spiral Jetty*.

Visits slate quarries in Pennsylvania and Civil War battlefields along the East Coast with Dwan, Graham, and Holt.

Travels to Germany; Bernard Becher guides him through Ruhr District, which becomes a Site for a Nonsite.

Articles published: "A Museum of Language in the Vicinity of Art"; "A Sedimentation of the Mind: Earth Projects."

Exhibitions

One-man shows:

Dwan Gallery, New York, March 2–27;

Konrad Fischer Gallery, Düsseldorf, December 20, 1968–January 17, 1969.

Group shows:

"Art of the Real," Aldrich Museum of Contemporary Art, Ridgefield, Connecticut, September 8, Tate Gallery, London;

"Cool Art—1967," Aldrich Museum of Contemporary Art, Ridgefield, Connecticut, January 7–March 17, 1968;

"Directions 1: Options," Milwaukee Art Center, June 22–August 18; Museum of Contemporary Art, Chicago, September 14–October 20;

"Earthworks," Dwan Gallery, New York, October 5–30, with Andre, Heizer, Stephen Kaltenbach, LeWitt, Walter DeMaria, Morris, Oldenburg, Oppenheim;

"International Circulating Exhibition," 1968–1969;

"Kunstmarkt," Köln Kunsthalle, October 1968;

"Language II," Dwan Gallery, New York, May 25–June 22;

"L'Art du Réel," Centre National d'Art Contemporain, Grand Palais, Paris;

"Minimal Art," Haags Gemeentemuseum, The Hague, March 23–May 26;

Allan Kaprow, Claes Oldenburg, and
Robert Smithson on Smithson's
guided tour of the monuments of
Passaic, New Jersey, January 6,
1968. Photograph by Nancy Holt.

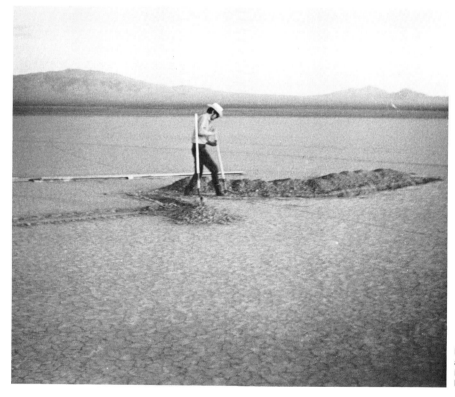

Robert Smithson digging trench for
a work by Michael Heizer in Dry
Lake, near Las Vegas, 1968.
Photograph by Nancy Holt.

Robert Smithson in Aqua Azul, Mexico, on his trip through the jungle with Virginia Dwan and Nancy Holt, 1969. Photograph by Nancy Holt.

"Plus by Minus: Today's Half Century," Albright-Knox Art Gallery, Buffalo, March 3–April 14;

"Prospect '68," Kunsthalle Düsseldorf, September 1968;

"Sculpture Annual," Whitney Museum of American Art, New York, December 17, 1968–February 9, 1969;

"6 Artists 6 Exhibitions," Walker Art Center, Minneapolis, May 12–June 23, Albright-Knox Art Gallery, Buffalo, September 23–October 27.

Major Works of Art
1. *Gyrostasis*
2. *Pointless Vanishing Point*
3. *Leaning Strata*
4. The Nonsites

1969

Meets Bob Fiore, Philip Glass, Dorothea Rockburne, Alan Saret, Richard Serra, Keith Sonnier, Jackie Winsor.

In February, constructs *Mirror Displacement (Cayuga Salt Mine Project)* for "Earth Art," Cornell University, Ithaca, New York. Other participants include Jan Dibbets, Hans Haacke, Neil Jenney, Richard Long, David Medalla, Robert Morris, Dennis Oppenheim, and Günther Uecker.

In spring makes *First Upside-Down Tree* and the disappearing *Hypothetical Continent in Stone: Cathaysia*, at Alfred, New York.

During spring/summer, makes *Second Upside-Down Tree* with Robert Rauschenberg at Captiva Island, Florida, near Sanibel Island and second hypothetical continent of *Gondwanaland*.

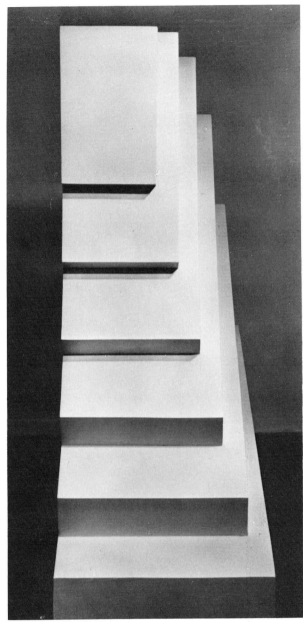

Sinistral Spiral, 1968; plastic; 6 ascending rectangles, total 75½ x 28 x 70". Collection unknown. Photograph courtesy John Weber Gallery.

Article published: "Incidents of Mirror-Travel in the Yucatan."

Begins work on slide-lecture piece, *Hotel Palenque*.

In August designs *400 Seattle Horizons* for the exhibition "557,087."

Makes *East Coast, West Coast* videotape with Holt.

During late September/October takes trip to England with Holt. Builds *Chalk-Mirror Displacement* for Institute of Contemporary Art, London. Visits Stonehenge and other archeological ruins in southern England and Wales. Travels to Europe for exhibitions at Städtische Kunsthalle, Düsseldorf, and

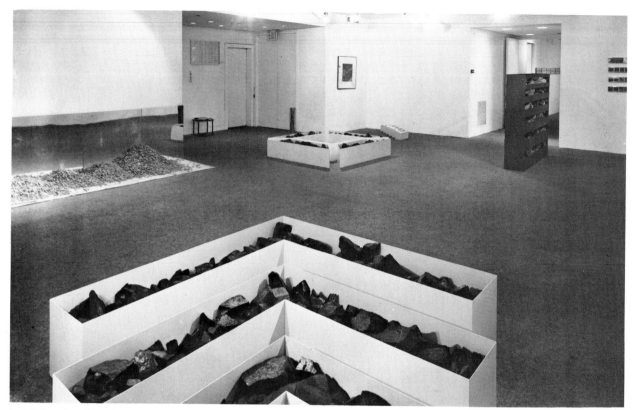

Installation view: Dwan Gallery, New York, 1969. Photograph by Walter Russell, Courtesy John Weber Gallery.

L'Attico Gallery, Rome, where he creates *Asphalt Rundown* in a quarry.

In Vancouver (December 1969–January 1970) attempts to use Miami Islet to make a work; government agrees to lease him an island, then rescinds the agreement because of public outcry that project is ecologically unsound. While in Vancouver meets filmmaker Dennis Wheeler; makes *Glue Pour* for the "955,000" exhibition; and visits the Britannia Copper Mines north of Vancouver.

Exhibitions

One-man shows:
"Nonsites," Dwan Gallery, New York, February 1–27;
Konrad Fischer, Düsseldorf, December 20, 1968–January 17, 1969;
L'Attico, Rome, October 15–November 7.

Group shows:
"Art by Telephone," Museum of Contemporary Art, Chicago, November 1–December 14;
"Art of the Real, USA, 1948–1968," Kunsthaus, Zurich;
"Art on Paper," Weatherspoon Art Gallery, University of North Carolina at Greensboro, November 16–December 19;
"Critics Choice," New York State Council on the Arts,

New York City, studio visits, December 1968–March 1969;
"Between Object and Environment," Institute of Contemporary Art, University of Pennsylvania, Philadelphia, April 2–May 3;
"Catalogue of the Exhibition," Seth Siegelaub, New York, July–September;
"Earth Art," Andrew Dickson White Museum, Cornell University, Ithaca, New York, February 11–March 6;
"555,087," Seattle Art Museum, September 5–October 5;
"Konzeption/Conception," Städtische Museum Leverkusen, West Germany, October;
"Land Art," Fernsehgalerie, Gerry Schum, Hannover. TV broadcast April 15, 10:40 P.M., West German Program I;
"Long Beach Island, New Jersey," Long Beach Island Foundation of the Arts and Sciences;
"Minimal Art," Städtische Kunsthalle, Düsseldorf, January 17–February 23, Akademie der Künste, Berlin, March 23–April 27;
"Prospect '69," Düsseldorf Kunsthalle, Museum of Contemporary Art, Chicago;
"Series Photographs," School of Visual Arts Gallery, New York, December 3, 1968–January 9, 1969;
"Vergorgene Strukturen," Museum Folkwang, Essen, May 9–June 22;

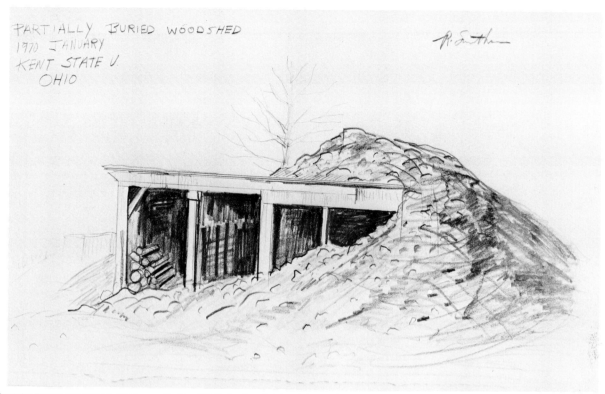

PARTIALLY BURIED WOODSHED
1970 JANUARY
KENT STATE U.
OHIO

R. Smithson

Partially Buried Woodshed, 1970; pencil; 11 x 19″. Collection Estate of Robert Smithson, Courtesy John Weber Gallery. Photograph by Walter Russell.

"When Attitudes Become Form," Bern Kunsthalle, March 22–April 27, Institute of Contemporary Art, London, September 28–October 27;

"One Month," March 1969; Seth Siegelaub, 1100 Madison Avenue, New York, a conceptual art exhibition of 31 artists for 31 days. Smithson's day was March 28.

Major Works of Art
1. *Mirror Wedge*, Montclair, New Jersey
2. *Mirror Displacement (Cayuga Salt Mine Project)*, Ithaca, New York
3. *First, Second, and Third Upside-Down Trees* in Alfred, New York; Captiva Island, Florida; and Yucatan, Mexico
4. *Hypothetical Continents* in stone (Cathaysia, Alfred, New York), shells (Lemuria, Sanibel Island, Florida), glass (Atlantis, Loveladies Island, New Jersey), and rocks (Gondwanaland, Yucatan, Mexico)
5. *The Map of Glass*, Loveladies Island, New Jersey
6. "Incidents of Mirror-Travel in the Yucatan," Mexico
7. *Concrete Pour*, Chicago, Illinois
8. *Asphalt Rundown*, outside Rome, Italy

1970

Builds *Partially Buried Woodshed* at Kent State University, Kent, Ohio, while a participant at creative arts festival which includes John Ashbery, Allan Kaprow, Morton Subotnick, and John Vaccaro (January 17–23).

In Utah in February, leases ten acres in the Great Salt Lake to build *Spiral Jetty*. Spends April constructing the work. Douglas Christmas, Gianfranco Gorgoni, Holt, Jonas, Leider, and Serra visit the *Spiral Jetty* during construction. Meets John Coplans for the first time at *Spiral Jetty*.

At Northwood Institute near Dallas negotiates without success to build *Texas Overflow* in disused white limestone quarry. Also considers project of barging sulphur from Rosenberg, Texas, through the Panama Canal and filming the event.

Makes film *The Spiral Jetty* with assistance of Bob Fiore and Barbara Jarvis. Proposes *Floating Island* to New York Institute for Arts and Urban Resources (rejected) and *Juggernaut* (Boston) for the "Elements of Art: Earth, Air, Fire, Water" exhibition (never built).

Exhibitions
One-man shows:
Dwan Gallery, New York, October 31–November 25;
Ace Gallery, Los Angeles and Vancouver, November–December.
Group shows:
"Against Order: Chance and Art," Institute of Contemporary Art, University of Pennsylvania, Philadelphia, November 14–December 22;
"Artists and Photographs," Multiples Gallery, New York;

"Conceptual Art—Arte Povera—Land Art," Galleria Cevica d'Arte, Moderna, Turin, June 12–July 12;

"Evidence on the Flight of Six Fugitives," Museum of Contemporary Art, Chicago, March 27–May 10;

"Group Show," Dwan Gallery, New York;

"Information," Museum of Modern Art, New York, July 2–September 20;

"955,000," Vancouver Art Gallery, January 14–February 8;

"Recorded Activities," Moore College of Art Gallery, Philadelphia, October 16–November 19;

"Sculpture Annual," Whitney Museum of American Art, New York, December 12, 1970–February 7, 1971;

"69th American Exhibition," Art Institute of Chicago, January 17–February 22;

"3d Salon International de Galeries-Pilotes, Lausanne, Musée Cantonal des Beauxarts, June–October, Musée d'art moderne de la ville de Paris, October–December.

Major Works of Art
1. *Partially Buried Woodshed*
2. *Spiral Jetty* (Earthwork)
3. *The Spiral Jetty* (film)

1971

Makes 16mm film *Swamp* with Holt.

Builds *Broken Circle/Spiral Hill* in Emmen, Holland. Holt shoots film footage on the project for future film (not completed).

Buys Little Fort Island, Maine, for a possible work.

Travels with Holt to Florida Keys to look (without success) for an island to use for a work; both make small works near Summerland Key.

Travels west to look for desert lakes. Visits petroglyphs near Moab, southeastern Utah. Buys acreage in Utah but decides not to build because it is too inaccessible.

Meets architect Robert Bliss, artist/architect Anna Campbell Bliss, and critics Rosalind Krauss and Carter Ratcliff.

Dwan Gallery closes; joins John Weber Gallery.

Exhibitions
Group shows:

"Elements of Art: Earth, Air, Fire, Water," Museum of Fine Arts, Boston, February 1971;

"Nürenberg Biennale," Nurenberg Kunsthalle, April 30–August 1;

"Sonsbeek '71," Park Sonsbeek, Arnhem, The Netherlands, June 19–August 15;

"Art and Technology," Los Angeles County Museum of Art, 1967–1971; Smithson's proposals (made in 1969) for Kaiser Steel and American Cement Company rejected;

"USSF," United States Servicemen's Fund Collection, July.

Major Works of Art
1. *Broken Circle/Spiral Hill*, Emmen, Holland
2. *Mangrove Ring, Sunken Island, Oolite Island*, Summerland Key, Florida

1972

In Houston plans *Ring of Sulphur and Asphalt* and film for possible visionary architecture exhibition proposed by the De Menil Foundation.

Increasingly interested in working with industry; makes numerous proposals to mining companies for reclaiming strip-mined lands through art.

Visits newly acquired island in Maine and decides not to use it because it is too scenic. Visits old granite quarries in Maine and draws proposals for them.

In May, visits Harry Armstrong, Republican senator from Logan County, Ohio, to discuss land reclamation art.

Tours Peabody and Hanna Mines in southeastern Ohio on June 6 to find site for work; contacts Ralph Hatch, president of Hanna Coal Company, about project.

Enters statement of protest as his contribution to the "Documenta 5" exhibition in Germany.

In October, submits proposal *Lake Edge Crescents—Egypt Valley, Ohio* (*Hanna Coal Reclamation Project*) but does not receive commission. Plans variation on Hanna Coal proposal for *Lake Crescents, Forest Park South, Illinois*. Interest in project continues to his death.

Travels with Holt to Salton Sea in California. Investigates possibilities of making an Earthwork there; despite local encouragement, final approval is withheld.

Timothy Collins, art collector and mining investor, in December starts sending Smithson's land reclamation proposals to approximately fifty corporations, including Kennecott Copper Corporation, Anaconda Company, U.S. Steel, International Minerals and Chemicals, Union Carbide, and Peabody Coal. Continues to send proposals until June of the following year.

Exhibitions
Group shows:

"Diagram and Drawings," Rijksmuseum Kröller-Müller, Otterlo, Holland, August 13–September 24;

"Documenta 5," Kassel, West Germany, June 30–October 8;

"Group Show," John Weber Gallery, New York;

"70th American Exhibition," Chicago Art Institute, June 24–August 20 (Smithson received Kohnstamm Award).

Major Works of Art
1. *Hotel Palenque* (slide lecture), University of Utah
2. Proposals for projects that were never built, as follows: Projects for Moodna River and Creek, Storm King Art Center, Mountainville, New York; *Ring of Sulphur and Asphalt*, Houston; *Lake Edge Crescents—Egypt Valley, Ohio* (*Hanna Coal Reclamation Project*)

Robert Smithson (double-exposed through umbrella) with Andy Warhol in Warhol's studio. Photograph by Brigid Polk, Courtesy Estate of Robert Smithson.

1973

Article published, in February: "Frederick Law Olmsted and the Dialectical Landscape."

In March, writes W. G. Stockton, vice-president of public relations, Peabody Coal, asking for a six-month contract to make land-reclamation art.

Participates in First International Conference of Visual and Performing Arts in Higher Education (April 2–8) at Ohio State University College of Arts.

Receives Guggenheim Fellowship.

Father dies, April 13.

Travels to Albuquerque, New Mexico, to lecture. Visits Mesa Verde and other Pueblo sites; witnesses Indian corn dance in town of Old Oraibi with Fiore, Holt, Terry McLuhan, Wheeler.

Makes Earthwork proposal for Kennecott Copper Company's Bingham Copper Mining Pit, Utah.

Travels to Creede, Colorado, where Minerals Engineering Company is interested in his project *Tailing Pond*. Makes drawings for the work but the project is delayed, so he travels to Stanley Marsh's ranch in Amarillo, Texas, with Holt and Tony Shafrazi, where Marsh commissions him to make a work on a site of his choosing.

Stakes out *Amarillo Ramp*. Dies July 20 in a plane crash a few hundred yards from the site while photographing staked-out work. Pilot and photographer are also killed.

Amarillo Ramp built in August according to Smithson's plans by Holt, Serra, and Shafrazi.

Exhibitions
Group shows:

"American Drawings 1963–1973," Whitney Museum of American Art, New York, May 25–July 22;

"Biennial Exhibition," Whitney Museum of American Art, New York, January 10–March 18;

"Group Show," John Weber Gallery, New York, May 20–June 16;

"3D into 2D: Drawing for Sculpture," New York Cultural Center, January 19–March 11;

"Young American Artists: Drawings and Graphics," Gentofte Radhus, Charlottenlund, Denmark, January 24–February 11, Aarhus Kunst Museum, February 18–March 4, Henie-Onstad Kunstsenter, Oslo, March 18–April 15, Hamburger Kunsthalle, Hamburg, April 28–June 11, Moderna Museet, Stockholm, September 15–October 21;

Planned exhibition at Ace Gallery, Venice, California to include *Spiral Palms, Smoke Tree Ring,* and *Coastal Crescents—Salton Sea Project* and exhibition at The Jared Sable Gallery, Toronto, to include *Slate Grinds.*

Major Works of Art
1. Proposals for *Bingham Copper Mining Pit,* Utah, and *Tailing Pond,* Creede, Colorado
2. *Amarillo Ramp* (Earthwork), Amarillo, Texas
3. *Slate Grinds #1–7* (drawings)

BIBLIOGRAPHY

Peter Chametzky

Part I. Articles and statements by Smithson, arranged chronologically

Part II. Published interviews and conversations with Smithson, arranged alphabetically by the last name of Smithson's interlocutor, when known

NOTE: Most items in Parts I and II may be found in *The Writings of Robert Smithson*, edited by Nancy Holt (New York: New York University Press, 1979). This work, when named as a secondary source, is cited as *Writings*.

Part III. Articles, books, and sections of books that deal wholly or in part with Smithson, his work, or exhibitions in which he participated, in which the treatment goes beyond mere description, arranged alphabetically by author and annotated

Part IV. Essays in catalogues of exhibitions in which Smithson participated, arranged alphabetically by author and annotated

Part I. Articles and statements by Smithson

"The Eliminator." 1964. In *The Writings of Robert Smithson*, ed. Nancy Holt, p. 207. New York: New York University Press, 1979.

"Statement: *Quick Millions*." 1964–1965. In *Art '65: Lesser Known and Unknown Painters, Young American Sculptors—East to West*, p. 68. American Express Pavilion Catalogue, New York World's Fair.

"Donald Judd." 1965. In *7 Sculptors*. Philadelphia Institute of Contemporary Art Catalogue. Also in *Writings*, pp. 21–23.

"The Cryosphere." April 1966. In *Primary Structures*. Exhibition Catalogue, Jewish Museum, n.p. Also in *Writings*, p. 37.

"The Crystal Land." May 1966. *Harper's Bazaar*, no. 3054, pp. 72–73. Also in *Writings*, pp. 19–20.

"Entropy and the New Monuments." June 1966. *Artforum* 5, No. 10:26–31. Also in *Writings*, pp. 9–18. And selection in Maurice Tuchman, ed., *American Sculpture of the Sixties*, pp. 51–52. Los Angeles: Los Angeles County Museum of Art, 1967.

"Interpolation of the Enantiomorphic Chambers." 1966. In *Art in Process: The Visual Development of a Structure*, n.p.

New York: Finch College Museum of Art, Contemporary Study Wing. Also in *Writings*, pp. 39–40.

"Paragraph from a Fictive Artist's Journal." 1966. In *Art in Process: The Visual Development of a Structure*, n.p. New York: Finch College Museum of Art, Contemporary Study Wing.

"The Domain of the Great Bear." Fall 1966. By Mel Bochner and Robert Smithson. *Art Voices* 5, no. 4:44–51. Also in *Writings*, pp. 24–31.

"Response to a Questionnaire from Irving Sandler." 1966. In *The Writings of Robert Smithson*, ed. Nancy Holt, pp. 216–217. New York: New York University Press, 1979.

"The Shape of the Future and Memory." 1966. In *The Writings of Robert Smithson*, ed. Nancy Holt, p. 211. New York: New York University Press, 1979.

"An Esthetics of Disappointment." 1966. On the occasion of the "Art and Technology" show at the Armory. In *The Writings of Robert Smithson*, ed. Nancy Holt, p. 212. New York: New York University Press, 1979.

"Sol LeWitt." 1966. Dwan Gallery press release. In *Writings*, p. 210.

"Quasi-Infinities and the Waning of Space." November 1966. *Arts Magazine* 41, no. 1:28–31. Also in *Writings*, pp. 32–36.

"Language to Be Looked At and/or Things to Be Read." June 1967. Dwan Gallery press release. In *Writings*, p. 104.

"Towards the Development of an Air Terminal Site." June 1967. *Artforum* 6, no. 10:36–40. Also in *Writings*, pp. 41–47.

"Ultramoderne." September/October 1967. *Arts Magazine* 42, no. 1:31–33. Also in *Writings*, pp. 48–51.

"Letter to the Editor." October 1967. *Artforum* 6, no. 2:4. Also in *Writings*, p. 38.

"Some Void Thoughts on Museums." November 1967. *Arts Magazine* 42, no. 2:41. Also in *Writings*, p. 58.

"From Ivan the Terrible to Roger Corman or Paradoxes of Conduct in Mannerism as Reflected in the Cinema." 1967. In *The Writings of Robert Smithson*, ed. Nancy Holt, pp. 213–215. New York: New York University Press, 1979.

"The Monuments of Passaic." December 1967. *Artforum* 7, no. 4:48–51. Also in *Writings*, pp. 52–57.

"Dialogue with Allan Kaprow: What Is a Museum?" 1967. *Arts Yearbook*, pp. 94–107. Also in *Writings*, pp. 59–66.

"Pointless Vanishing Points." 1967. In *The Writings of Robert Smithson*, ed. Nancy Holt, p. 208. New York: New York University Press, 1979.

"Strata: A Geophotographic Fiction." Fall/Winter 1967. *Aspen Review*, no. 8. Also in *Writings*, pp. 129–131.

"A Museum of Language in the Vicinity of Art." March 1968. *Art International* 12, no. 3:21–27. Also in *Writings*, pp. 67–78.

"A Thing Is a Hole in a Thing It Is Not." April 1968. *Landscape Architecture* 58, no. 3:205.

"The Establishment." June 1968. *Metro* 14:n.p. Also in *Writings*, pp. 79–80.

"A Note on Non-Sites." Typescript, 1968. In Lawrence Alloway, "Introduction," *Directions 1: Options*, p. 6. Milwaukee: Milwaukee Art Center, 1979.

"Minus Twelve." 1968. In Gregory Battcock, ed., *Minimal Art: A Critical Anthology*, pp. 402–406. New York: E. P. Dutton. Also in *Writings*, p. 81.

"Nature and Abstraction." c. 1968. In *The Writings of Robert Smithson*, ed. Nancy Holt, p. 219. New York: New York University Press, 1979.

"Outline for Yale Symposium: Against Absolute Categories." 1968. In *The Writings of Robert Smithson*, ed. Nancy Holt, p. 218. New York: New York University Press, 1979.

"A Sedimentation of the Mind: Earth Projects." September 1968. *Artforum* 7, no. 1:44–50. Also in *Writings,* pp. 82–91.

"0 to 9." January 1969. New York: Vito Acconci.

"Fragments of a Conversation." February 1969. Ed. William C. Lipke. In *The Writings of Robert Smithson*, ed. Nancy Holt, pp. 168–170. New York: New York University Press, 1979.

"Aerial Art." February–April 1969. *Studio International* 175, no. 89:180–181. Also in *Writings*, pp. 92–93.

"Project: Overturning Rocks and Mirror Trails." March 28, 1969. In *One Month,* ed. Seth Siegelaub, 1100 Madison Avenue, New York.

"Dialectic of Site and Nonsite." April 1969. In Gerry Schum, ed., *Land Art*, n.p. Hannover: Fernsehgalerie.

"Incidents of Mirror-Travel in the Yucatan." September 1969. *Artforum* 8, no. 1:28–33. Also in *Writings*, pp. 94–103.

"Art and Dialectics." 1970. In *The Writings of Robert Smithson*, ed. Nancy Holt, p. 219. New York: New York University Press, 1979.

"Statement." September 1970. In "The Artist and Politics: A Symposium." *Artforum* 9, no. 1:39.

"Symposium." 1970. In *Earth Art.* Exhibition Catalogue, Andrew Dickson White Museum of Art, Cornell University, n.p. Also in *Writings*, pp. 160–167.

"From the Center of the Spiral Jetty." November 1970. *Art Now: New York* 2, no. 9:n.p.

"A Cinematic Atopia." September 1971. *Artforum* 10, no. 1:53–55. Also in *Writings*, pp. 105–108.

"Untitled, 1971." In *The Writings of Robert Smithson*, ed. Nancy Holt, p. 220. New York: New York University Press, 1979.

"Documenta 5: A Critical Preview." Summer 1972. By Bruce Kurtz and Robert Smithson. *Arts Magazine* 46, no. 8:31.

"Proposal, 1972." (For reclamation of a strip mine in terms of Earth art.) In *The Writings of Robert Smithson*, ed. Nancy Holt, p. 221. New York: New York University Press, 1979.

"The Spiral Jetty." 1972. In Gyorgy Kepes, ed., *Arts of the Environment*, pp. 222–232. New York: Braziller. Also in *Writings*, pp. 109–116.

"Cultural Confinement." October 1972. *Artforum* 11, no. 2:32. Also in *Writings*, pp. 132–133.

"Untitled, 1972." In *The Writings of Robert Smithson*, ed. Nancy Holt, p. 220. New York: New York University Press, 1979.

"Frederick Law Olmsted and the Dialectical Landscape." February 1973. *Artforum* 11, no. 6:62–68. Also in *Writings*, pp. 117–128.

"Gyrostasis." 1974. In Abram Lerner, ed., *Hirshhorn Museum and Sculpture Garden Catalogue*, p. 749. New York: Harry N. Abrams. Also in *Writings*, p. 37.

Part II. Published interviews and conversations with Smithson

Cummings, Paul. "Interview with Robert Smithson for the Archives of American Art/Smithsonian Institution." Interview conducted on July 14 and 19, 1972. In *The Writings of Robert Smithson*, ed. Nancy Holt, pp. 137–156. New York: New York University Press, 1979.

"Discussions with Heizer, Oppenheim, Smithson." *Avalanche* 1, no. 1 (Fall 1970):48–71. Also in *Writings*, pp. 171–178.

Kurtz, Bruce. "Conversation with Robert Smithson on April 22nd 1972." Ed. Bruce Kurtz. In *The Fox II*, 1975, pp. 72–76. Also in *Writings*, pp. 200–204.

Müller, Gregoire. ". . . The Earth, Subject to Cataclysms, Is a Cruel Master." *Arts Magazine* 46, no. 2 (November 1971):36–41. Also in *Writings*, pp. 179–185.

Norvell, P. A. "Robert Smithson: Fragments of an Interview with P. A. Norvell, April, 1969." Ed. Lucy R. Lippard and Robert Smithson; a few additions made by the artist. In Lucy R. Lippard, *Six Years: The Dematerialization of the Art Object . . .*, pp. 87–90. New York: Praeger, 1973.

Pettena, Gianni. "Conversation in Salt Lake City." *Domus*, no. 516 (November 1972), pp. 53–56. Also in *Writings*, pp. 186–188.

Robbin, Anthony. "Smithson's Non-Site Sights." *Art News* 67, no. 10 (February 1967):50. Also in *Writings*, pp. 157–159.

Roth, Moira. "Robert Smithson on Duchamp: An Interview." *Artforum* 12, no. 2 (October 1973):47. Also in *Writings*, pp. 197–199.

Sky, Alison. "Entropy Made Visible." *On Site #4* (Fall 1973), pp. 26–30. Also in *Writings*, pp. 189–196.

Part III. Articles, books, and sections of books

Alloway, Lawrence. "Network: The Art World Described As a System." *Artforum* 6, no. 1 (September 1972):28–32. A

discussion about how art and art ideas are disseminated. The point is made that Smithson's article "The Crystal Land" first appeared in *Harper's Bazaar*, and that *The Saturday Evening Post* discussed Earth art earlier than *The New Yorker*.

———. "Robert Smithson's Development." *Artforum* 11, no. 3 (November 1972):52–61. From *Enantiomorphic Chambers* (1965) to *Broken Circle/Spiral Hill* (1971). With bibliography.

———. "Art." *The Nation* 218, no. 4 (January 26, 1974):126. Establishes connections between the film *The Spiral Jetty* and popular cinema.

———. "The Expanding and Disappearing Work of Art." In Lawrence Alloway, *Topics in American Art since 1945*, pp. 207–212. New York: W. W. Norton, 1975. This article is divided into seven clusters of recent artistic modes that have led to recognition problems for spectators. The fifth cluster is "Earthworks," which are described as being samples as well as metaphors. First appeared in *Auction* 3, no. 2 (October 1969):34–37.

———. "Site Inspection." *Artforum* 15, no. 2 (October 1976):49–55. Based on visits to the sites of Earthworks in Arizona, Nevada, Texas, and Utah. Discusses Smithson's *Spiral Jetty* and *Amarillo Ramp*, as well as works by Walter DeMaria and Michael Heizer.

Alpers, Svetlana. "Is Art History?" *Daedulus* 106, no. 3 (Summer 1977):1–13. How an art object may function as history in and of itself. Smithson is cited for his views on Frederick Law Olmsted and for *Spiral Jetty*.

Anderson, Wayne. *American Sculpture in Process: 1930/1970*. Boston: New York Graphic Society, 1975. Pp. 239–259. The concluding chapter of this book about recent American sculpture deals with Earthworks and Process art. Smithson's work is discussed from the first *Nonsite* to *Spiral Jetty*.

Andre, Carl. "Robert Smithson: He Always Reminded Us of the Questions We Ought to Have Asked Ourselves." *Arts Magazine* 52, no. 9 (May 1978):102. An artist's personal recollection of his relationship with Smithson.

Antin, David. "It Reaches a Desert in Which Nothing Can Be Perceived but Feeling." *Art News* 70, no. 1 (March 1971):69. Concerning the Boston Museum of Fine Arts "Elements of Art" exhibition. Smithson is said to be "mapping metaphors."

Ashton, Dore. "Art." *Arts and Architecture* 83, no. 11 (December 1966):4–5. The author describes what she labels "purist" art in New York. Discussion of the "10" exhibition at the Dwan Gallery.

———. "Exercises in Anti-Style: Six Ways of Regarding Un, In, and Anti-form." *Arts Magazine* 43, no. 6 (April 1969):45–57. Speculations regarding avant-garde art, including Cornell University's "Earth Art" exhibition.

Baker, Elizabeth C. "Artworks on the Land." *Art in America* 64, no. 1 (January/February 1976):92–96. The "American Landscape" issue. Smithson's *Spiral Jetty* and *Amarillo Ramp* are viewed as counterstatements to works by Walter DeMaria and Michael Heizer and as Earth art's greatest contributions to the landscape.

———. "Traveling Ideas: Germany, England." *Art News* 69, no. 4 (Summer 1970):38–40, 70–72. Traces international vanguard art through the galleries of Europe.

Baker, Kenneth. "The End of the Art Object and Other Ideas from Robert Smithson." *Boston Phoenix*, August 21, 1979, p. 10. A commentary on Smithson's style of writing, emphasizing his dialectical approach to thinking, writing, and life. Baker believes his book of writings "will be one of the essential documents of post-war American art."

Baro, Gene. "American Sculpture: A New Scene." *Studio International* 175, no. 896 (January 1968):9–19. A survey of sculpture as the most important American art form in the 1960s. Donald Judd, Sol LeWitt, Robert Morris, Tony Smith, and Smithson are grouped together for their interest in modular systems.

Battcock, Gregory. "Informative Exhibition at the Museum of Modern Art." *Arts Magazine* 44, no. 8 (Summer 1970):24–27. A critical review of the "Information" exhibition at MOMA, July 2–September 20, 1970. Smithson's *Asphalt Rundown* is pictured.

———. "Celluloid Sculptors." *Art and Artists* 6, no. 7, issue no. 66 (October 1971):24–27. A discussion of Smithson's *Spiral Jetty* and also of films by Nancy Graves (*200 Stills at 60 Frames, Goulimine, Izy Boukir*) and Les Levine (*Blank*).

———. "Art Exhibitions and the Negation of Art." In Gregory Battcock, ed., *Why Art?* pp. 8–17. New York: E. P. Dutton, 1977. How art exhibitions as structures and events affect our perception of the objects. Sol LeWitt, Charles Ross, and Smithson are grouped as serial artists.

———, ed. *Minimal Art: A Critical Anthology*. New York: E. P. Dutton, 1968. An anthology of writings on Minimal art. Smithson's "Minus Twelve" is discussed on pp. 402–406.

Bear, Liza, and Nancy Holt. "Amarillo Ramp." *Avalanche*, Fall 1973, pp. 16–21. A report on the posthumous completion of Smithson's final Earthwork.

Beardsley, John. "Robert Smithson and the Dialectical Landscape." *Arts Magazine* 52, no. 9 (May 1978):132–135. Smithson and land reclamation; discussion of projects for strip mining and tailings ponds that Smithson proposed near the end of his life. Also examines the reclamation work of Harvey Fite, Robert Morris, Charles Simonds, and Alan Sonfist.

Bellman, David. "Robert Smithson and Frederick Law Olmsted: Earthworks in the Future Anterior." *Arts Magazine* 52, no. 9 (May 1978):126–129. Comparison of Smithson and Olmsted as workers of the earth.

Benedikt, Michael. "Sculpture as Architecture: New York Letter, 1966–67." In Gregory Battcock, ed., *Minimal Art*, pp. 61–91. New York: E. P. Dutton, 1968. A discussion of the architectural aspects of Minimalist sculpture. Reference to "10" at the Dwan Gallery and "1966 Annual" at the Whitney Museum of American Art.

Bierman, William. "Burn the Woodshed! Spare the Woodshed!" *Beacon: The Sunday Magazine of the Akron Beacon Journal*, July 20, 1975, pp. 4–7, 14–15, 18. The future of *Partially Buried Woodshed*, which was partially destroyed by an arsonist, is debated.

Blok, C. "Minimal Art at The Hague." *Art International* 12, no. 5 (May 1968):18–24. A review of the "Minimal Art"

show at The Hague's Gemeentemuseum, March 23–May 26, 1968, provides a springboard for a discussion of essential concerns of Minimalist sculpture. Smithson's proposal for the Dallas–Fort Worth airport is discussed; *Pointless Vanishing Point* is reproduced.

Blotkemp, Carel. "Sculpture at Sonsbeek." *Studio International* 182, no. 936 (September 1971):70–73. A review of the "Sonsbeek '71" exhibition that includes a description of *Broken Circle*. Here it is wrongly stated that the boulder was "placed" in the center of the circle; actually it was there originally and proved impractical to move.

Bochner, Mel. "Primary Structures." *Arts Magazine* 40, no. 8 (June 1966):32–35. A declaration of the new "phenomenological nature of art" as defined by the Jewish Museum's "Primary Structures" exhibition.

——. "Art in Process—Structures." *Arts Magazine* 40, no. 9 (September/October 1966):38–39. A consideration of the "Art in Process" exhibition at the Finch College Musuem of Art, Contemporary Study Wing. Discussion of *Enantiomorphic Chambers*, with a photograph of its installation.

Bongartz, Roy. "It's Called Earth Art—and Boulderdash." *New York Times Magazine,* February 1, 1970, pp. 16–17, 22–24, 26–28, 30. This article defines the goal of Earth art as the elimination of the object and predicts failure in this quest. Much emphasis is placed on the concept of "hipness."

Borden, Lizzie. "The New Dialectic." *Artforum* 12, no. 6 (March 1974):44–51. Advances the argument that Smithson is the key to the shift, found in both art and criticism, from romantic and existential concerns to phenomenological problems.

Bourdon, David. "What on Earth!" *Life* 66, no. 16 (April 25, 1969). A report on Cornell University's "Earth Art" exhibition. Color photographs.

Burton, Scott. "Reviews and Previews." *Art News* 65, no. 9 (January 1967):18. Review of an exhibition at the Dwan Gallery. *Doubles*, *Terminal*, *Plunge*, and *Alogon #2* are described.

——. "New York: Robert Smithson's 'Nonsites.'" *Art Scene,* April 1969, pp. 22–23. A report on New York's art scene that uses Smithson's Nonsites as examples of new and different uses of gallery spaces.

Butterfield, Jan, and Paul Stitelman. "Robert Smithson, 1938–1973." *Arts Magazine* 48, no. 1 (September/October 1973):57. Obituary and appreciation of Smithson. Report on completion of *Amarillo Ramp*.

Castle, Frederick. "Threat Art." *Art News* 67, no. 6 (October 1968):54–55, 65–66. A critic identifies some negative aspects of New York art in the 1960s; covers artists from Jim Morrison and The Doors to Joseph Kosuth and the Art-Language Group.

Castle, Ted. "Robert Smithson from New Jersey." *Arts Magazine* 52, no. 9 (May 1978):103. Personal recollections of Smithson.

Celant, Germano. *Arte Povera.* Milan: Gabriele Mazzota, 1969. Pp. 139–175. Smithson's *Dog Tracks* from the First Stop of *Six Stops on a Section*. Photographs of *Nonsites* and

Mirror Displacements. The book includes similar renderings of other artists' works and an essay by Celant in Italian.

——. "La natura è insorta." [Nature has arisen] *Casabella,* no. 339–340 (August/September 1969):104–107. Italian with English synopsis. Celant describes the problems of critically evaluating Earth art. In his opinion the essence of Earth art is the creative act itself, and not the process of representation. This approach leaves the critic in a void, since the final and mute material object is less important than the process of production, which speaks for itself.

Chandler, John, and Lucy R. Lippard. "Visible Art and the Invisible World." *Art International* 11, no. 5 (May 1967):27–30. This article begins as a review of the books in Gyorgy Kepes's *Vision and Value* series. Arguing that the main fault of the series is the exclusion of many younger artists, Chandler and Lippard examine the work of some young artists who they feel address issues raised by Kepes's books and by modern intellectual history in general. Smithson's *Plunge* (1966) is reproduced.

——. "The Dematerialization of Art." *Art International* 12, no. 2 (February 1968):31–36. A report on the trend toward elimination of the object in art in favor of the idea. Smithson's maps and project for a mercury pool are mentioned.

Clay, Grady. "The New Leap—Landscape Sculpture." Editorial in *Landscape Architecture* 61, no. 4 (July 1971):296–297. An introduction to a special issue that explores the connection between Earth art and landscape architecture from the perspective of the latter. The author is optimistic about cooperation between the two.

Davis, Douglas. "Last Flight." *Newsweek* 82, no. 6 (August 6, 1973):52. Obituary.

——. "Art without Limits." *Newsweek* 82, no. 26 (December 24, 1973):68–74. The national newsmagazine devotes an issue to the state of the arts in America. This essay attempts to encapsulate American art of the 1970s. Color photograph of *Amarillo Ramp*.

Deutsch, Stanley I. "Robert Smithson," *57th Street Review,* December 15, 1966, pp. 1–2. The reviewer is troubled by the formulaic quality of the sculptures.

Domingo, Willis. "Galleries: Robert Smithson at Dwan." *Arts Magazine* 45, no. 3 (December 1970/January 1971):56–57. Review of the *Spiral Jetty* film.

Driscoll, Edgar J. "Back to Nature." *Art News* 73, no. 7 (September 1974):80–81. Review of an exhibition at the Hayden Gallery, Cambridge, Massachusetts, in the spring of 1974.

"Earth Art in Great Salt Lake." *Quarterly Review: Utah Geological and Mineralogical Survey* 5, no. 2 (May 1971):1. Provides pertinent information on *Spiral Jetty*. The *Jetty* cost $25,000 to build.

"Earth Movers." *Time* 92, no. 15 (October 11, 1968):84. A brief review of the "Earthworks" exhibition at the Dwan Gallery, New York, which takes the position that Earth art is still another extravagance, another art fashion in the trendy sixties.

Farrow, Moira. "An Island of Glass to Appear in Strait." *Vancouver Sun,* January 27, 1970. Announces the artist's inten-

tion to transport 100 tons of tinted glass to a rocky islet 50 yards long.

———. " 'Glass Island' Dump Site Is Strictly for the Birds." *Vancouver Sun*, January 29, 1970. Journalist sides with Smithson in environmentalist dispute concerning Miami Islet.

———. "Artist's Glass Island Hope, 'Wouldn't Hurt the Birds.' " *Vancouver Sun*, January 31, 1970. David Silcox, senior arts officer of the Canada Council, agrees with Smithson that cormorants will not be hurt by *Island of Broken Glass*.

Foote, Nancy. "The Anti-Photographers." *Artforum* 15, no. 1 (September 1976):46–54. The problems of documentation's relationship to the art object: "Incidents of Mirror-Travel in Yucatan," "Monuments of Passaic," and various "Mirror Displacements" are cited.

Friedman, Bruce Jay. "Dirty Pictures." *Esquire* 75, no. 5 (May 1971):112–117, 42. The author identifies Smithson and Michael Heizer as probably the most enduring of the Earth artists.

George, L. "Robert Smithson." *57th Street Review*, December 15, 1966, p. 1. The author thinks Smithson illustrates theories rather than manifests them.

Gilardi, Piero. "Micro-emotive Art." *Museum Journal* 13, no. 4 (Amsterdam, 1968), pp. 198–202. Analysis of Earth art as each individual's response to social forces.

Gilbert-Rolfe, Jeremy, and John Johnston. *"Gravity's Rainbow* and *The Spiral Jetty."* Part 1: *October*, no. 1 (Spring 1976), pp. 65–85. Part 2: *October*, no. 2 (Summer 1976), pp. 71–90. Part 3: *October*, no. 3 (Spring 1977), pp. 90–101. Attempts to establish connections between Thomas Pynchon's monumental novel and Robert Smithson's novel monument. Two "entropic" testimonials.

Gildzen, Alex. " 'Partially Buried Woodshed': A Robert Smithson Log." *Arts Magazine* 52, no. 9 (May 1978):118–120. The construction and preservation of *Partially Buried Woodshed*, Kent, Ohio.

Glueck, Grace. "Moving Mother Earth." *New York Times*, October 6, 1968, p. 38D. A review of the Dwan Gallery's "Earthworks" exhibition. Includes three quotations from Smithson that do not appear in any other article or collection.

Gorgoni, Gianfranco, and Gregoire Müller. *The New Avant-Garde: Issues for the Art of the Seventies*. New York: Praeger, 1972. Pp. 16–17 (text), 80–93 (photographs). Concentrates on the work of twelve artists confronting the 1970s. Text (by Müller) discusses the issues that inform *Spiral Jetty*; photographs (by Gorgoni) document its construction.

Gottschalk, Earl C., Jr. "Earthshaking News from the Art World: Sculpturing the Land." *Wall Street Journal*, September 10, 1976, pp. 1, 19. A firsthand view of Michael Heizer's *Complex One* and general observations on Earthworks, with particular emphasis on monetary aspects.

Graham, Dan. "Models and Monuments: The Plague of Architecture." *Arts Magazine* 41, no. 5 (March 1967):32–35. A consideration of three exhibitions that dealt with large outdoor works: "Macrostructures" at the Richard Feigen Gallery; "Architecture Sculpture, Sculpture Architecture" at the Visual Arts Gallery; and "Scale Models and Drawings" at the Dwan Gallery. The last exhibition included Smithson's *Tar Pool and Gravel Pit*.

Greenberg, Clement. "The Recentness of Sculpture." *Art International* 11, no. 4 (April 1967):19–21. This article deals with the prospect of Minimal sculpture as vanguard art. Greenberg is finally ambivalent about assigning Minimalism vanguard status, for he finds that too often primary structures are "good designs" rather than great art, yet he still hopes that some members of the group will develop as artists. Written for the catalogue of the "American Sculpture of the Sixties" exhibition at the Los Angeles County Museum.

Grillo, Jean Bergantini. "The Museum without Walls, MFA Version." *Boston Phoenix*, January 26, 1971. *Spiral Jetty* is a major piece in the Museum of Fine Arts' exhibition "Earth, Air, Fire, Water: Elements of Art."

Harrison, Charles. "Art on TV." *Studio International* 181, no. 929 (January 1971):30. An explanation of Gerry Schum's Fernsehgalerie (TV Gallery) screening of "Land Art" on April 15, 1969. Works of eight Earth artists were filmed and shown on television without commentary.

Henry, Gerrit. "New York Letter; *Spiral Jetty.*" *Art International* 15, no. 1 (January 1971):42. Argues that *Spiral Jetty* is beautiful, campy, and comic.

Herrera, Hayden. "A Way of Thinking Out Loud: The Drawings of Robert Smithson." *Art in America* 62, no. 5 (September–October 1974):98–99. Herrera reviews the "Robert Smithson Drawings" exhibition at the New York Cultural Center and sees the works not as aesthetic objects but as aids to the artist's visual imagination.

Herrmann, Rolf-Dieter. "In Search of a Cosmological Dimension: Robert Smithson's Dallas–Fort Worth Airport Project." *Arts Magazine* 52, no. 9 (May 1978):110–113. Smithson's conception of the universe is related to his plans for the Dallas–Fort Worth airport. Essay touches on entropy, timelessness, and Heidegger.

Hess, Thomas B. "The Condemned Playgrounds of Robert Smithson." *New York* 7, no. 22 (June 3, 1974):88–89. The critic praises Smithson for his direct "stupid" drawings, which are more conceptual tools than arty renditions.

Hickey, David. "Earthscapes, Landworks and Oz." *Art in America* 59, no. 5 (September–October 1971):40–49. Makes the point that Earth art is not about the abolition of objects, but rather about the marking out, activating, and controlling of spaces. It is also intimately connected with the American West, both physically and metaphorically, and therefore may be related to the attitudes of the men who have mapped and traversed that area: cowboys and truck drivers.

Hoberman, J. "Short Circuits: The Writings of Robert Smithson." *Village Voice*, August 27, 1979, pp. 89–90. Smithson is cited as a key figure in the revolt against the precious art object. He is praised for his original Gothic sensibility).

Holt, Nancy. "The Time Being (For Robert Smithson)." *Arts Magazine* 52, no. 9 (May 1978):144. Light-and-shadow photograph with poetic caption.

———. "Notes from a Conversation, October 1979, New York City." *Cover* 1, no. 1 (January 1980):16–17. A recounting

of how *The Writings of Robert Smithson* came to be published.

———, ed. *The Writings of Robert Smithson*. New York: New York University Press, 1979. Introduction by Philip Leider. Published and previously unpublished writings, edited by Holt, who was married to Smithson.

Howett, Catherine. "New Directions in Environmental Art." *Landscape Architecture* 67, no. 1 (January 1977):38–46. Earthworks as the cutting edge in environmental design. Discussion of Smithson and Olmsted.

Hunter, Sam. *American Art of the Twentieth Century*. New York: Harry N. Abrams, 1972. Pp. 389–394. Earth art as a turning point in American art, Smithson as a leading practitioner. General textbook.

———. *American Art*. New York: Harry N. Abrams, 1978. P. 521. According to Hunter, *Spiral Jetty* is essentially a romantic enterprise, a form of architectural rebellion.

——— and John Jacobs. *Modern Art from Post Impressionism to the Present*. New York: Harry N. Abrams, 1976. Pp. 324–325. *Spiral Jetty* as a landmark in the history of modern art.

———. "Science Fiction: An Aesthetic for Science." *Art International* 12, no. 8 (October 1968):32–34, 41. The art of Larry Bell, Donald Judd, Lila Katzen, and Smithson as artistic manifestations of science fiction. A drawing for *Enantiomorphic Chambers* and the work itself are reproduced.

Hutchinson, Peter. "Mannerism in the Abstract." In Gregory Battcock, ed., *Minimal Art*, pp. 187–194. New York: E. P. Dutton, 1968. An explanation of 1960s art in terms of a traditional art category. *Enantiomorphic Chambers* is reproduced.

———. "Earth in Upheaval: Earthworks and Landscape." *Arts Magazine* 43, no. 2 (November 1968):19, 21. A discussion of the state of Earth art in 1968. Smithson's *Nonsites* described in general.

Insley, Will. "Seriocomic Sp(i)eleology: Robert Smithson's Architecture of Existence." *Arts Magazine* 52, no. 9 (May 1978):98–101. Speleology: the scientific study or exploration of caves. Various suggestions for approaches to Smithson's work are offered.

Junker, Howard. "The New Sculpture: Getting Down to the Nitty Gritty." *Saturday Evening Post* 241, no. 22 (November 2, 1968):42–47. An early overview of the Earth art movement. Smithson is cited as the central figure and chief polemicist.

———. "Down to Earth: Earthworks at Cornell University." *Newsweek* 73, no. 12 (March 24, 1969):101. A review of the "Earth Art" exhibition at Cornell University, with a picture of Smithson next to *Mirror and Gravel Piece*.

———. "The Apocalypse of Our Time Is Over." *Rolling Stone*, no. 76 (February 18, 1971), pp. 42–47. Prophetic revelation of imminent cosmic cataclysm in the work of Robert Smithson.

———. "Jackson Pollock/Robert Smithson: The Myth/The Mythologist." *Arts Magazine* 52, no. 9 (May 1978):130–131. Comparisons of and contrasts between Pollock, the myth, and Smithson, the mythologist.

Kozloff, Max. "Art: Presence of Earth Sculpture at This Moment Ramified by Political Situation." *The Nation* 208, no. 11 (March 17, 1969):347–348. Kozloff's thesis is that Earth art is an expression of the fragmented nature of late 1960s America. But, he argues, the art also embodies the promise of free, open space that was so much a part of the counterculture's dreams. So Earth art, as presented in Cornell University's 1969 exhibition, is cultural commentary that reveals and also creates contradictions as it interrelates with the rest of the art world and beyond.

Kramer, Hilton. "The Emperor's New Bikini." *Art in America* 57, no. 1 (January–February 1969):49–55. Minimal art objects do not present enough evidence of aesthetic value to be called a vital new art form. Rather, they exist in the area between real art and the real world, and so may be categorized as exercises in form.

Krauss, Rosalind. "Problems of Criticism X: Pictorial Space and the Question of Documentary." *Artforum* 10, no. 3 (November 1971):68–71. Tenth in a series of articles. The *Spiral Jetty* Earthwork is evidence of process art; the *Spiral Jetty* film is evidence of the evidence.

———. "A View of Modernism." *Artforum* 11, no. 1 (September 1972):48–51. Personal recollections and views on why some critics have problems with recent sculpture.

———. *Passages in Modern Sculpture*. London: Thames & Hudson; New York: Viking, 1977. Pp. 281–286. Smithson's *Spiral Jetty* is discussed as an event in both space and time, and is identified with a Proustian notion of passage.

Kurtz, Bruce. "Sonsbeek '71: Beyond Lawn and Order." *Arts Magazine* 46, no. 1 (September/October 1971):50–52. Observation of Sonsbeek exhibition. *Broken Circle/Spiral Hill* is commented on.

Kuspit, Donald. "Sol LeWitt: The Look of Thought." *Art in America* 63, no. 5 (September–October 1975):43–49. Quotes Smithson's articles "A Museum of Language in the Vicinity of Art" and "Minus Twelve" in explicating the metaphysical qualities of LeWitt's art.

Larson, Kay. "New Landscapes in Art." *New York Times Magazine,* May 13, 1979, pp. 20–23, 28, 30, 33–35, 38. Against the background of Smithson's theories about land as an artistic medium, the author discusses several desert Earth projects by Michael Heizer, Nancy Holt, Charles Ross, and Jim Turrell. The author concludes that landscape is testing the limits of our definitions of art.

Lee, David. "Serial Rights." *Art News* 66, no. 8 (December 1967):42–45, 68–69. About the Finch College "Art in Series" exhibition.

Leider, Philip. "How I Spent My Summer Vacation, or, Art and Politics in Nevada, Berkeley, San Francisco and Utah." *Artforum* 9, no. 1 (September 1970):40–49. A visit to Rozel Point for a walk on *Spiral Jetty*.

———. "For Robert Smithson." *Art in America* 61, no. 6 (November/December 1973):80–82. Text of Leider's eulogy at Smithson's funeral. Color photographs of *Asphalt Rundown* and *Spiral Jetty*.

———. "Robert Smithson: The Essays." *Arts Magazine* 52, no. 9 (May 1978):96–97. An assertion of Smithson's importance as a critic and theoretician.

Lerner, Abram, ed. *The Hirshhorn Museum and Sculpture Garden Catalogue, Smithsonian Institution*. New York: Harry N. Abrams, 1974, p. 749. In the "Catalogue" section of this book a short list of exhibitions and references for Smithson is presented, as well as the artist's statements concerning *Gyrostasis*, his work in the Hirshhorn collection.

Levin, Kim. "Reflections on Robert Smithson's *Spiral Jetty*." *Arts Magazine* 52, no. 9 (May 1978):136–137. *Spiral Jetty* as the culmination of a decade in which art was a powerful object in the world.

Linker, Kate. "Books: The Writings of Robert Smithson." *Artforum* 18, no. 2 (October 1979):60–63. An analysis of Smithson's thought, with special emphasis on ways in which the writings function as art. The critic views Smithson's writings as original productions in the genre of artists' writings.

Linville, Kasha. "Sonsbeek: Speculations, Impressions." *Artforum* 10, no. 2 (October 1971):54–61. Consideration of *Broken Circle* and *Spiral Hill*, with a color photograph of *Spiral Hill*.

Lippard, Lucy R. "The Art Workers Coalition: Not a History." *Studio International* 180, no. 927 (November 1970):171–174. A description of the movement to organize artists politically in the late 1960s. Smithson, Richard Serra, and Philip Leider are mentioned as the AWC's "notorious sightseers."

——. *Six Years: The Dematerialization of the Art Object*. New York: Praeger, 1973. Pp. 19, 34, 44–45, 56, 79, 87–90, 183–184. Various statements and fragments of articles by Smithson are worked into this account of the attack on object art.

——. "Obituary." *Studio International*, Part 1: 186, no. 959 (October 1973):162; Part 2: 186, no. 960 (November 1973):202. Personal reactions to Smithson and his death.

——. "In and Out of the Public Domain." *Studio International* 193, no. 986 (March/April 1977):83–90. A discussion of the varied nature of public artworks and their relevance to specific social groups. Refers to Smithson's *Broken Circle*, *Spiral Jetty*, and *Glue Pour*. Points out Smithson's concern for industrial wastelands and their rehabilitation, and his conception of what art in the public domain should be.

——. "Gardens: Some Metaphors for a Public Art." (Dedicated to R. Smithson.) Willard Cummings Memorial Lecture, Skowhegan, Maine, July 1979.

Louw, Roelof. "Sites/Non-Sites: Smithson's Influence on Recent Landscape Projects." *Tracks 3* 3, no. 1–2 (Spring 1977):5–15. Smithson's presence is felt at Far Hills, New Jersey, exhibition: "Projects in Nature," Marriewold West, September 22–October 31, 1975.

McConathy, Dale. "Keeping Time: Some Notes on Reinhardt, Smithson and Simonds." *Artscanada* 32, no. 2, issue 198/199 (June 1975):52–57. The art of Ad Reinhardt, Charles Simonds, and Smithson as visual answers to the writings of Borges, Calvino, and Nabokov—all creators of fantasy worlds populated by the creations of their intellects.

McDarrah, Fred W. "Harmless Horror." *Village Voice*, November 1, 1962, p. 17. A review of Smithson's November 1962 show at the Castellane Gallery. Some early quotations describe the artist's shift from religious to scientific imagery.

——. "Robert Smithson." *Village Voice*, July 26, 1973.

Masheck, Joseph. "Spiral Jetty, a Film by Robert Smithson." *Artforum* 9, no. 5 (January 1971):73–74. The film is praised not only as a well-done documentation of Smithson's *Spiral Jetty*, but as a thing of beauty in itself, particularly in the way Smithson's verbal commentary aligns with the visual emergence of the spiral of the jetty.

——. "Sorting Out the Whitney Annual." *Artforum* 9, no. 6 (February 1971):70. This review of the Whitney Annual calls *Spiral Jetty* the most magnificent piece of American sculpture in recent years.

——. "The Panama Canal and Some Other Works of Art." *Artforum* 9, no. 9 (May 1971):38–42. Cites Joseph Pennel (1857–1926) as an artistic precursor of Smithson. The role of the Panama Canal as a subject for artists is reviewed, with Smithson's proposed "Panama Passage" as the most recent example.

Mekas, Jonas. "Movie Journal." *Village Voice*, February 15, 1973, p. 77. Covers the film *Swamp*, made by Smithson and Holt, and comments on the fact that a man gives the orders and a camerawoman follows them. Praises the film for its limitations of camera vision.

Mellow, James R. "New York." *Art International* 11, no. 2 (February 1967):66–67. A review of Smithson's show at the Dwan Gallery. Installation photograph of *Doubles, Plunge,* and *Terminal*.

——. "New York Letter." *Art International* 12, no. 5 (May 1968):66–67. A review of Smithson's show at the Dwan Gallery. *Gyrostasis* is reproduced.

Meyer, Ursula. "De-Objectification of the Object." *Arts Magazine* 43, no. 8 (Summer 1969):20–22. Smithson's *Gravel Mirror with Cracks* (1969) is pictured and described as "non-site non-object."

Michelson, Annette. "10 × 10: Concrete Reasonableness." *Artforum* 5, no. 5 (January 1967):30–31. A review of the Dwan Gallery exhibition "10 × 10." *Alogon* is discussed.

Morgan, Robert C. "Art and Physicality." *New York Arts Journal*, no. 15 (September 1979), pp. 14–15. A review of *The Writings of Robert Smithson*, with emphasis on the artist's thought. The critic finds Smithson's interest in William Burroughs and Roland Barthes significant.

Morgan, Stuart. " 'An Art against Itself': Functions of Drawing in Robert Smithson's Work." *Arts Magazine* 52, no. 9 (May 1978):121–125. States that Smithson draws to conjure, not to render.

——. *The Writings of Robert Smithson:* Essays with Illustrations." *Art Journal* 39, no. 3 (Spring 1980):217, 219, 221. Smithson's writings are analyzed in terms of two major concerns: an opposition to Greenbergian formalism and a forceful move away from Duchamp's "cult of the disappearing object."

Morris, Robert. "Notes on Sculpture, Part 4: Beyond Objects." *Artforum* 7, no. 8 (April 1969):50–54. Sculpture's changing form; a Smithson *Mirror Displacement* is reproduced.

Müller, Gregoire. "The Scale of Man." *Arts Magazine* 44, no. 7 (May 1970):42–43. A discussion of Michael Heizer, Richard Serra, and Smithson, concentrating on *Partially Buried Woodshed*.

Mussman, Toby. "Literalness and the Infinite." In Gregory Battcock, ed., *Minimal Art*, pp. 236–250. New York: E. P. Dutton, 1968. The first part of this two-part article deals with Robert Rauschenberg, the second with Smithson, and specifically with the 1966 Dwan Gallery exhibition. Smithson's writing is linked to his sculpture.

"Now It's Neon: Exhibition at University of Pennsylvania, Institute of Contemporary Art." *Life* 58, no. 20 (May 21, 1965):116–119. Smithson's *Eliminator* is pictured.

O'Doherty, Brian. "One Face of the Faceless Future." *Diplomat*, May 1966, p. 53. Smithson is viewed as a major artist in this review, which also deals with Peter Hutchinson, Donald Judd, and Sol LeWitt. Basic tenets of the group are outlined.

Onorato, Ronald J. "The Modern Maze." *Art International* 20, no. 4–5 (April/May 1976):21–25. A discussion of the labyrinth as an image that artists have conceived, shaped, and interpreted. Smithson is mentioned as one of the developers of this idea.

Owens, Craig. "Earthwords." *October 10*, Fall 1979, pp. 121–130. *The Writings of Robert Smithson* is reviewed in light of Frankfurt School and Structuralist criticism, with particular emphasis on Benjamin's theory of allegory and the textual analyses of Derrida and Barthes.

Perreault, John. "Union Made: Report on a Phenomenon." *Arts Magazine* 41, no. 5 (March 1967):26–31. Deals with Minimalism as an aesthetic and as an art movement.

——. "Audible Shadows." *Village Voice*, March 14, 1968, p. 17. A review of Smithson's second show at New York's Dwan Gallery. Contends that the pieces dealing with serial progression, such as *Shift*, *Pointless Vanishing Point*, and *Gyrostasis*, have carried segmentation so far as to produce a boring "neo-cubism." *Palisades Nonsite*, however, continues to advance Smithson's status as an artist.

——. "Long Live Earth." *Village Voice*, October 17, 1968, p. 17. A laudatory review of the "Earthworks" exhibition at the Dwan Gallery.

——. "Down to Earth." *Village Voice*, February 13, 1969, pp. 18, 20. This review of Smithson's "Nonsites" exhibition at the Dwan Gallery attempts to take the form of a Nonsite itself. Perreault posits a series of questions concerning our notions of vision and perception, and so attempts to show that Nonsites are Smithson's most profound works.

——. "Nonsites in the News." *New York* 2, no. 8 (February 24, 1969):44–46. Describes a trip by Smithson, Holt, and Perreault into New Jersey to collect rocks and take photographs. The critic asserts that the development of the Nonsite makes Smithson an important artist.

——. "Earth Show." *Village Voice*, February 27, 1969, pp. 16, 18, 20. A chronicle of the "art junket" undertaken by Perreault and a group of art-world figures to Cornell University's "Earth Art" exhibition.

——. "Off the Wall." *Village Voice*, March 13, 1969, p. 14. A report on Seth Siegelaub's "One Month" exhibition, including Smithson's *Overturning Rocks* proposal.

——. "Other Things . . ." *Village Voice*, October 2, 1969, pp. 17–21. Rather than use his space as a soapbox from which to defend the work of Roy Lichtenstein, the critic would like to discuss Smithson's *Urination Map of the Constellation Hydra*, or "Piss Piece" (Perreault). Yet he feels compelled to do the former, while being sure to mention the latter.

——. "Vicious Circles." *Village Voice*, November 12, 1970, pp. 20, 22. A review of the film *The Spiral Jetty*, as shown at the Dwan Gallery. The review compares the film to a bin containing a Nonsite, and goes on to speculate about some possible meanings of spirals.

——. "It's Only Words." *Village Voice*, May 20, 1971, pp. 24–25. Reprinted in Gregory Battcock, *Idea Art*, pp. 135–139. New York: E.P. Dutton, 1973. An article about Conceptual art. *Spiral Jetty* is pointed out as a more photogenic avant-garde work than most Conceptual pieces.

——. "Field Notes for a Dark Vision." *Village Voice*, May 9, 1974, pp. 37–38. A review of the "Robert Smithson: Drawings" exhibition at the New York Cultural Center.

——. "Smithson Earthworks Doomed?" *Soho Weekly News*, May 19, 1975. Report on *Partially Buried Woodshed*'s controversial existence.

Pierce, James Smith. "Design and Expression in Minimal Art." *Art International* 12, no. 5 (May 1968):25–27. An answer of a sort to Greenberg's "Recentness of Sculpture." Argues that Smithson's work praises pure design, rather than good design, particularly in "The Monuments of Passaic."

Pincus-Witten, Robert. "New York." *Artforum* 7, no. 8 (April 1969):69–70. A review of an exhibition at the Dwan Gallery; discusses Nonsites.

Plagens, Peter. "The Possibilities of Drawing." *Artforum* 8, no. 2 (October 1969):50–55. A discussion of new drawing.

——. "557,087." *Artforum* 8, no. 3 (November 1969):64–67. A review of an exhibition organized by Lucy Lippard for the Seattle Art Museum and including Smithson's *400 Seattle Horizons*. The show's title refers to the population of Seattle.

"Plan to Glaze Gulf Island Meets with Glassy Stare." *Vancouver Sun*, January 28, 1970. The artist does not understand why the British Columbian government has vetoed his plans for *Island of Broken Glass*.

"Poetic Emptiness." *Time* 88, no. 26 (December 23, 1966):51. Robert Smithson and Tony Smith, two sculptors represented at the Whitney Annual, seek out the poetry in emptiness.

Ratcliff, Carter. "The Compleat Smithson." *Art in America* 68, no. 1 (January 1980):60–65. A review of *The Writings of Robert Smithson* that attempts to unravel the various selves embodied in the texts.

Reise, Barbara. "Untitled 1969: A Footnote on Art and Minimal Stylehood." *Studio International* 177, no. 910 (April 1969):166–172. Discusses the artists in the "Minimal Art" exhibition at The Hague's Gemeentemusem.

Robbin, Anthony. "Smithson's Non-Site Sights." *Art News*

67, no. 10 (February 1969):50–53. An excerpt from an interview and an essay dealing with Nonsites as speculative systems making.

"Robert Smithson." *Art Now: New York* 2, no. 9 (November 1970):n.p. A brief synopsis of the artist's career; "From the Center of the Spiral Jetty" is printed as an illustration of his art.

Rose, Barbara. "Problems of Criticism V: The Politics of Art, Part II." *Artforum* 7, no. 5 (January 1969):44–52. Fifth in a series of articles. Defines American art of the 1960s as a polarization between color abstraction on the one hand and Pop/Minimal tendencies on the other. Smithson's photographs are termed "found monuments."

———. "Problems of Criticism, VI: The Politics of Art, Part III." *Artforum* 7, no. 9 (May 1969):46–51. Sixth in a series. Pragmatic criticism, such as that of William James, as an approach to objectless art.

Rosenberg, Harold. "Art and Words." In *The De-Definition of Art*, pp. 59–60. New York: Horizon Press, 1972. In this chapter Rosenberg briefly discusses Smithson and the Nonsite: art as speculative philosophy.

Rubenfeld, Florence. "Robert Smithson: A Monograph." Master's Thesis, Goddard College, 1975. An exploration of the significance of Smithson's work, with emphasis on the Jungian interpretation of his most frequently used forms, such as the circle and the spiral.

Russell, John. "He Dreamed of Floating Islands." *New York Times*, April 28, 1974, p. 19. Smithson is praised as an artist who provides a vantage point from which to view the history of the human race. He is also viewed as Frederick Law Olmsted's descendant.

Schjeldahl, Peter. "New York Letter." *Art International* 12, no. 4 (April 1969):62–63. A review of Smithson's Dwan Gallery exhibition, featuring *Six Stops on a Section*, *Gravel Mirror with Cracks and Dust*, and *Double Nonsite*, all of which the reviewer finds lugubrious, indistinct, and discouraging.

———. "Robert Smithson: He Made Fantasies as Real as Mountains." *New York Times*, August 12, 1973, p. 21. Obituary.

Seaberg, Libby, and Cherene Holland. "Biography." In Tom Armstrong et al., *200 Years of American Sculpture*, pp. 311–312. New York: Whitney Museum of American Art, 1976. A brief chronological synopsis of Smithson's life and work is provided in a section that includes similar treatments of a wide range of American sculptors, past and present.

"Scenes." *Village Voice*, October 10, 1974, p. 36. A report that the Great Salt Lake, Utah, has risen and submerged Smithson's *Spiral Jetty* under two feet of water.

Shirey, David. "Impossible Art—What It Is." *Art in America* 57, no. 3 (May–June 1969):31–32. A general discussion of Earth art that explains Earthworks by simply describing them.

Shapiro, David. "Mr. Processionary at the Conceptacle." *Art News* 69, no. 5 (September 1970):58–61. Conceptacle: an external cavity in algae containing reproductive cells. The review is a whimsical look at the Museum of Modern Art's "Information" exhibition.

———. "Ideas and Earth." *Artforum* 18, no. 3 (November 1979):52–56. A review of the "Contemporary Sculptures" exhibition at the Museum of Modern Art in the summer of 1979. Smithson's collected writings are discussed as an appropriate introduction to the exhibition.

Sky, Allison, and Michelle Stone. *Unbuilt America*. New York: McGraw-Hill, 1976. Pp. 226–228. Seventh in an ongoing series of publications entitled "On Site." Some of Smithson's unrealized projects are documented here.

Spector, Naomi. Review of *The Writings of Robert Smithson*, ed. Nancy Holt. *Print Collector's Newsletter* 11, no. 1 (March/April 1980):22–23. Selected excerpts from the text are used to point out the priorities behind Smithson's writings and projects.

Tatransky, Valentine. Unpublished catalogue of Smithson's library, c. 1974. On file at the Herbert F. Johnson Museum of Art, Cornell University.

———. "Themes with Meaning: The Writings of Robert Smithson." *Arts Magazine* 52, no. 9 (May 1978):138–143. The structure of Smithson's thought as shown in his writings: revelation rather than rationalization.

Thibeau, Jack. "The Man Who Cast the Land." *Rolling Stone*, August 15, 1974, p. 58. A poet recalls his friendship with Smithson.

Tillim, Sidney. "Earthworks and the New Picturesque." *Artforum* 7, no. 4 (December 1968):42–45. The transition from Minimal Art to Earth Art is observed and explained in terms of late-eighteenth- and early-nineteenth-century notions of the "picturesque."

Tomkins, Calvin. "Onward and Upward with the Arts." *New Yorker* 47, no. 51 (February 5, 1972):53–57. Tomkins recounts his visit to the *Spiral Jetty*. Some background discussion of Smithson's preoccupation with natural problems and Nonsites. Tomkins calls Smithson the theoretician of the Earth art movement.

Townsend, Charlotte. "Smithson Looks for Larger Fields to Extend Art Work in Glass, Earth." *Vancouver Sun*, January 24, 1970. Contains a description of *Glass Strata with Mulch and Soil*.

Trini, Tommaso. "Robert Smithson: Un Libro." *Domus*, no. 599 (October 1979), pp. 52–53. A recollection of the excitement felt in Italy at the time "Entropy and the New Monuments" was translated into Italian. Smithson's combining of theory and practice is viewed as characteristic of Renaissance artists.

Truman, Jock. "10" (exhibition at Dwan Gallery). *57th Street Review*, November 15, 1966, pp. 1, 3. Ad Reinhardt, Smithson, and Sol LeWitt are cited for their interest in "the hypothetical void."

Wheeler, Dennis. "The Spiral Jetty Is a Verb!" *Artscanada* 28, no. 2 (April/May 1971):78–79. A review of the film *The Spiral Jetty*.

Wilson, William S. "Robert Smithson: Non-Reconciliations." *Arts Magazine* 52, no. 9 (May 1978):104–109. Subject and object, artist and art, Smithson and the world.

Zaniello, Thomas A. " 'Our Future Tends to Be Prehistoric': Science Fiction and Robert Smithson." *Arts Magazine* 52,

no. 9 (May 1978):114–117. How traditional literature and popular culture interact in the work of Robert Smithson.

Part IV. Essays in catalogues of exhibitions

Alloway, Lawrence. "Serial Forms." In *American Sculpture of the Sixties*. Ed. Maurice Tuchman. Los Angeles County Museum of Art, 1967, pp. 14–15. "Serial" refers to the internal parts of a work of art when they are seen in uninterrupted succession. Alloway uses Smithson's stepped pieces as examples of the complexity of some so-called Minimal works.

———. "Introduction." In *Directions 1: Options*. Milwaukee Art Center, 1968, pp. 3–7. Introduction to an exhibition that showed Smithson's *A Nonsite, Pine Barrens, New Jersey*. A discussion of various aspects of contemporary art.

———. "Artists and Photographs." Introductory essay to "Artists and Photographs" show at Multiples Gallery, New York, 1970, pp. 3–5. Introduction to an exhibition that showed photographs as documentation of absent works of art, as documents of documents, and as works of art themselves. Alloway mentions the possibility that documents of Earthworks and street events may acquire the preciousness of limited graphic editions.

Amman, Jean-Christophe. "Robert Smithson." In *Spiralen und Progressionen*. Kunstmuseum, Luzerne, March 16–April 20, 1975, n.p. An essay on Smithson in the context of an exhibition focusing on the spiral as a motif in modern art. The exhibition included Paul Klee, Richard Long, Mario Merz, and Bruce Naumann as well as Smithson.

Beardsley, John. "Probing the Earth: Contemporary Land Projects." In *Hirshhorn Museum and Sculpture Garden*, 1977, pp. 9–30, 81–96, 105–107. This important exhibition included the works of ten Earth artists, from Harvey Fite to Robert Smithson. Smithson's work is described as having a sense of both the creative and the destructive aspects of nature. A useful bibliography is included.

Beeren, Wim A. L. "Introduction." In *Op Losse Schroeven* [Square pegs in round holes], Stedelijk Museum, Amsterdam, 1969, n.p. In Dutch. Reprinted in German in *Verborgene Strukturen*, Museum Folkwang, Essen, 1969, pp. 9–16. An essay that pairs Smithson and Richard Long as artists who use the earth less as a material than as an environment in which to demonstrate processes. They are thus contrasted to Heizer and DeMaria. Smithson's proposal to overturn rocks at selected sites and trace the trail between them on a map is included here.

Burton, Scott. "Notes on the New." In *When Attitudes Become Form, Works—Concepts—Processes—Situations—Information*. Institute of Contemporary Art, London, 1969, n.p. Smithson's Nonsites are characterized as witty and complex forms of industrial archaeology that place him in the vanguard of contemporary art.

Develing, Enno. "Introduction." In *Minimal Art*. Haags Gemeentemuseum, The Hague, 1968, pp. 11–16. Smithson is here characterized as coming closest of all the so-called Minimal artists to the constructivist ideal of the artist-engineer.

Gilardi, Piero. "Politics and the Avant-Garde." In *Op Losse Schroeven*. Stedelijk Museum, Amsterdam, 1969, n.p. A sweeping essay dating from December 1968 that states that art, in linguistic and structural aspects, is finished, absorbed into the entropy of the political system. Printed as a typed draft on red paper.

Ginsburg, Susan. "Introduction." In *Robert Smithson: Drawings*. New York Cultural Center, 1974, pp. 7–17. Robert Smithson's drawings are viewed as a key to his thinking and to his sculpture. The aesthetic qualities of the drawings themselves are deemphasized.

———. "Introduction." In *3D into 2D: Drawing for Sculpture*. New York Cultural Center, 1974, pp. 3–4. Drawings for sculpture of the 1960s and 1970s are discussed. Smithson's drawings are called documentary rather than illustrative.

Hunter, Sam. "Introduction." In *Critics Choice, 1968–69*. New York State Council on the Arts and the State University of New York, 1969, n.p. Smithson is called the most difficult and unprecedented of the eleven new artists represented in this exhibition. Hunter compares Smithson's Instamatic camera with the sketch pad of a nineteenth-century artist.

Leering, Jean. "Introductory Comments." In *Land Art*. Fernsehgallerie (Television Gallery), Gerry Schum, Hannover, April 1970, n.p. In German. Discusses Smithson's use of mirrors, comparing them to the television set, which is the means of transmission of this exhibition.

Lipke, William C. "Earth Systems." In *Earth Art*. Andrew Dickson White Museum, Cornell University, 1970, n.p. Lipke asserts that Smithson and the other artists represented in the exhibition adopt a literal attitude toward nature which is antithetical to the picturesque, and that they stress the physicality of the works over abstract aesthetic values.

Lippard, Lucy R. "10 Structurists in 20 Paragraphs." *Minimal Art*. Haags Gemeentemuseum, The Hague, 1968, pp. 25–31. In Dutch. Minimal-style criticism for Minimal-style exhibition. The essay consists of a numbered sequence of paragraphs dealing with the issues raised by Minimal art.

———. "Preface." In *Recorded Activities*. Moore College of Art, Philadelphia, 1970, n.p. A chronicle of Lippard's efforts to think of a suitable format and content for the Introduction to this exhibition.

McShine, Kynaston. "Introduction." In *Primary Structures*. Jewish Museum, New York, 1966, n.p. Introduction to the important sculpture exhibition at the Jewish Museum. Provides a balanced view of Minimalism, as it attempts to bring to light the diversity of individual styles.

Masheck, Joseph. "Smithson's Earth: Notes and Retrievals." In *Robert Smithson: Drawings*. New York Cultural Center, 1974, pp. 19–29. An essay on Smithson's art that emphasizes its antecedents in historic and prehistoric art.

O'Doherty, Brian. "Lesser Known and Unknown Painters." *Art '65*. American Express Pavilion, New York World's Fair, 1965, pp. 5–8. Thirty-five "lesser known" artists were represented in this exhibition. Smithson's *Quick Millions* is described as having a beautiful and dumb presence.

Prokopoff, Stephen S. "Introduction." In *Between Object and Environment: Sculpture in an Extended Format*. Institute of

Contemporary Art, University of Pennsylvania, April 1969, n.p. A short essay that describes Smithson's work as being based on readily perceived geometry.

Ratcliff, Carter. "Diagrams and Drawings by American Sculptors." In *Diagrams and Drawings*. Rijksmuseum Kröller-Müller/Otterlo, 1972, n.p. This essay analyzes American sculptors' return to drawing, which Ratcliff sees as a rejection of the emotional expressionism of the 1950s and a turn toward the economy of writing, a system of signs and symbols. Smithson's drawings are termed unique and practical uses of graphics to convey instructions to workmen.

Sharp, Willoughby. "Notes Toward an Understanding of Earth Art." *Earth Art*. Andrew Dickson White Museum, Cornell University, 1970, n.p. A useful essay pointing out some of the art-historical and general ideological roots of Earth art. The essay also documents the genesis of this important exhibition.

Speyer, James A. "Introduction." In *69th American Exhibition*. Art Institute of Chicago, January 1970, p. 5. Among the twenty-five artists represented in this exhibition, Robert Morris and Smithson are cited for their use of materials in ways that give the viewer insight into the elements and composition of the world.

Tuchman, Maurice. *A Report on the "Art and Technology" Program of the Los Angeles County Museum of Art*, 1971, p. 320. A synopsis of Smithson's unsuccessful attempts to produce art in collaboration with Kaiser Steel and American Cement. His drawing proposals are reproduced.

van der Marck, Jan. *American Art: Third Quarter Century*. Seattle Art Museum Pavilion, 1973, pp. 85–86, 131–132. An extensive catalogue essay that deals with American art from Abstract Expressionism to Conceptualism. Smithson's *Mono Lake Nonsite* is reproduced.

Walker Art Center. "Introduction." *6 Artists, 6 Exhibitions*. 1968, n.p. A short essay that attempts to find relationships among the exhibited works of the six artists represented: Larry Bell, Chryssa, Will Insley, Robert Irwin, Smithson, and Robert Whitman. Smithson is said to share the other artists' concerns about the problems of perception and the ambiguities of volume and space.

INDEX

ROBERT SMITHSON: SCULPTURE

Designed by Richard E. Rosenbaum.
Composed by Vail-Ballou Press, Inc.
in 10 point Times Roman, 2 points leaded,
with display lines in Helvetica Bold.
Printed offset by Vail-Ballou Press, Inc. on
Warren's Lustro Offset Enamel Dull, 80 pound basis.
Bound by Vail-Ballou Press in Joanna book cloth.

Library of Congress Cataloging in Publication Data

Hobbs, Robert Carleton, 1946–
 Robert Smithson—sculpture.
 Bibliography: p.
 Includes index.
 1. Smithson, Robert. I. Title.
NB237.S5694H6 709′.2′4 80-69989
ISBN 0-8014-1324-9 AACR2